Masters
of Early Travel
Photography

Masters of Early Travel Photography

Rainer Fabian
Hans-Christian Adam

The Vendome Press *New York Paris*

English translation: Bruni Mayor
Editor: Victor Schuller
Design: Marlene Rothkin Vine
Layout: Dietmar Meyer
Cartography: Ekkhart Blunck
Picture research: Alfred Siercke and Brigitte Sander

Originally published under the title *Frühe Reisen mit der Kamera*
Copyright © 1981 Stern-Bücher im Verlag Gruner and Jahr AG & Co., Hamburg

English Language copyright © The Vendome Press
First published in 1983 in Great Britain by Thames and Hudson, London
Published in the United States and Canada by
The Vendome Press, 515 Madison Avenue, New York, N.Y. 10022
Distributed in the United States of America by
The Viking Press, 40 West 23rd Street, New York, N.Y. 10010

Distributed in Canada by Methuen Publications

Library of Congress Cataloging in Publication Data
Fabian, Rainer, 1935–
 Masters of early travel photography.
 Translation of: Frühe Reisen mit der Kamera.
 Bibliography: p.
 1. Travel photography. I. Adam, Hans-Christian,
1948–. II. Title.
TR790.F313 1983 779′.99104 83-12495

ISBN 0–86565–034–9
Printed and bound in Italy by Grafiche Editoriali Ambrosiane SpA, Milan

Contents

Introduction

Today it would be almost impossible to project ourselves into the primitive visual condition of those who first viewed these photographs of distant, exotic places, places that until photography brought its truth and rectitude had, in Western consciousness, all the fragility of grapevine hearsay, of golden realms evoked by myth, or, if illustrated, of visions limned by some fantasist. The initial impact of these photographic images of remote lands and cultures must have given credence to things only vaguely known, in the same way that a builder's plan of an ancient ship might have enforced the truth of the line: "Helen, thy beauty is to me as those Nicaean barks of yore."

A longing for the picturesque entailed a fear of losing it, which not only contributed to the desire for photography but also to the great success of the medium once it had been invented. As early as 1844 an American writing on travel asserted that its "romance is rapidly disappearing.... Next year Venice will be connected by bridge to the mainland.... Steam is annihilating space." But the regret here seems genuine, experienced by someone who had just discovered the world and longed to hold on to first impressions, to a keenly felt sense of place—unlike the cynicism of today's flip wit: "Of course you remember Venice! That's where we had the omelet."

Try, if you can, to match your own late-twentieth-century ideas of sublime nature with these two passages from Hittel's first photographically illustrated guide to the Yosemite Valley (1868):

> Nature had lifted her curtain to reveal the vast and the infinite. It elicited no adjectives, no exclamations. With bewildering sense of divine power and human littleness, I could only gaze in silence till the view strained my brain and pained my eyes, compelling me to turn away and rest from its oppressive magnitude.

I cite this text not in jest but in envy of an enthusiasm we now express so differently and feel so differently. But perhaps that difference represents no lessening at all. One could believe it when, for instance, comparing the point of view adopted by Watkins, Muybridge, and Jackson (and every photo reflects the photographer's prejudice) and that taken from the same spot a century later by, for instance, Ansel

Adams, a man fully conversant not only with Beethoven but with MGM as well.

After a hundred years the pictures in this book have become archaeology. For their photographers, however, they constituted a new kind of reality. The melody that lingers on leans towards nostalgia, but to some degree the tendency was clearly there from the beginning.

Whatever their value as nostalgia, past or present, the photographs reproduced here counted among the many fair new forms of art, but their truth seemed more like that of science. In the nineteenth century, of course, both science and art had been converging upon objective reality, and suddenly it could be apprehended, even arrested, by the growing perception of people endowed with a miraculous new image-catcher. Carlyle's wife declared photography to be equal to another freshly minted miracle of almost the same moment: anesthesia.

That the majority of the pictures reproduced here were thought to be of scientific value, in addition to any artistic aspirations they may have embodied, is reflected in the reticence that Francis Frith evinced in regard to his craft. This great pioneer photographer of the Nile wrote almost exclusively of place or incident, with only a few trade hints admitted here and there: "…with most people these photographs will derive their chief interest from their relation to history…artistic excellence is of secondary consideration." He spoke of choosing prints for their "mechanical excellence," and of "delicate detail…which a human hand cannot attain," or of "mastery of detail which is one of the chief merits of photography." If Frith mentioned "art" at all it was to josh the reader and himself: "I flatter myself, too, somewhat upon the quality of my Photograph [Philae]—light transparent shadows, sweet half-tones, oh discriminating Public!"

It seems to have been a well-known fact that of all the fruit in Queen Victoria's empire, the single one which the then slow speed of transport could not deliver to her table fresh enough to eat was the mangosteen. One eats them today flown in to Paris—at any rate, in Vietnamese restaurants. For what they meant to John Thomson's contemporaries, take a look at the still life reproduced on page 236, an image so wonderfully evocative of the age's subjective, nostalgic longing for a strange and exotic form of reality *and* its close, scientific observation and analysis of that reality. Then let Kipling explain the picture's invisible iconography for you:

You'll know what my riddle means
When you've eaten mangosteens.

Sam Wagstaff

1
The Birth of Photography

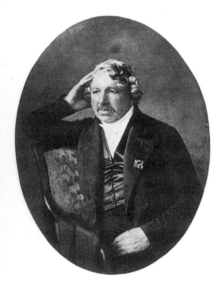

Louis Jacques Mandé Daguerre
(1787–1851).

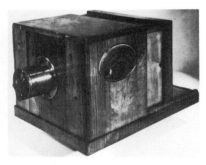

The first daguerreotype camera made
by Giroux, Paris.

Monday the 19th of August 1839 Paris sweltered in the heat of late summer. By noon a large crowd had gathered in the lecture hall of the Institut de France on the left bank of the Seine opposite the Louvre. Hundreds more of the curious had been turned away and left to wait in the courtyard. At three o'clock François Arago, the famous physicist, astronomer, and politician, made his way to the lectern and announced the beginning of a new era: Louis Jacques Mandé Daguerre had invented the photographic process now known by his name.

Hardly had Arago finished speaking when Parisians flocked to the shop of the paper-dealer Giroux to buy the first of the "Daguerre boxes." A few days later they were carrying these unwieldy cameras down to the Seine embankment and up to Montmartre. Their earliest efforts captured Notre-Dame Cathedral, the Stock Exchange, the Pont-Neuf, as well as an audience of viewers who recognized "not only the Pont-Neuf itself, but its stones, its street lights and even the cobblestones of the roadway." The press did not exaggerate when it reported that a veritable daguerreotype craze was sweeping the country.

Photography came into being and spread in less time than any technical process in history. Only three weeks after Arago's announcement the first camera arrived in neighboring Germany. Later in the year guests at a benefit for the victims of an earthquake in Martinique saw the very first exhibition of photographs. And as early as November the first daguerreotypes crossed the Atlantic in the hull of a merchant ship.

The new photographic images left New Yorkers dumbfounded. "So far we have only heard the half of it," concluded one newspaper, "and are at a loss for words to describe adequately the fascination of these pictures that no mortal hand has drawn." Mayor Philip Hone wrote in his famous diary: "Every thing, however small, like the gravel on the path, the hair on someone's head, the delicate weave of a silk

curtain—all these things are represented exactly as they were created in art or nature."

As a scene painter for the opera Daguerre was an old hand at surprising the public. In 1810 he had delighted Parisians with his backdrop for a play entitled *The Vampire*, the necessary atmosphere created by a moon gliding across a dark "bat-colored" cardboard sky and a graveyard bathed in an eerie, bleaching light. Paris had never seen anything like it, and Daguerre quickly became the most sought-after stage illusionist in France. He achieved his best effects with dioramas presented in rotating auditoriums, one in London and another in Paris. Staggered backdrops suggested space, while cleverly lit, translucent canvases produced moving clouds and billowing fog. In no time Daguerre was considered France's greatest showman. He would have done very well in contemporary Hollywood.

For another spectacular at his Paris Diorama, Daguerre created *A Midnight Mass at St. Étienne-du-Mont*, in which he compressed twelve hours as if a film had been run at twice the normal speed. The "play" opened in a church with daylight streaming through stained-glass windows. Slowly this faded into twilight, candles were lit in the darkness, and the pews slowly filled with worshipers. Organ music signaled the beginning the of the service. At its conclusion the candles died down, and all remained dark for a while, until dawn once again flooded the church with light.

The demise of Daguerre's Paris Diorama coincided with the birth of photography. During the night of March 3, 1839, a fire destroyed the

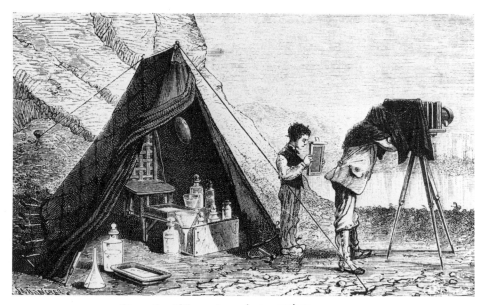

Since the 19th-century photographer
could take a picture only while the plate was wet,
he had to travel with a well-stocked laboratory.

moving tableau after a workman placed a kerosene lamp too close to a freshly varnished backdrop. By the next morning the illusions had all been reduced to a heap of ashes. Five months later, however, Professor Arago was able to make his historic announcement. Meanwhile, Daguerre himself worked hard to assure the popularity of the new image-making process. He sent his best daguerreotypes to Kings and statesmen and lectured constantly about this new art, which many still considered to be a kind of black magic. When he wrote a book of instructions, it became a best-seller in a matter of weeks and was quickly translated into no less than thirty-two languages.

Daguerre invited the last of the doubters, the journalist Jules Janin, for a private demonstration at his house on the Boulevard Saint-Martin. Through fumes from iodine and other chemicals, Janin and his companions saw shelves crammed with tubes and beakers. An hour later they had become wholehearted believers in the new medium. "We shouted many 'bravos' and, clustering around Monsieur Daguerre, observed the process with the kind of excitement that overcomes children when their father shows them for the first time how to fire a gun."

Not unexpectedly, France took great pride in the native son who had contributed to the glory of the nation. No one seemed to notice that Daguerre minimized the importance of the role played by his late colleague Nicéphore Niépce in the development of the process. It was Daguerre who received his country's cross of the Legion of Honor, Berlin's Prussian Order of Merit, and the Austrian Emperor's token of esteem in the form of a diamond-encrusted snuffbox and a gold medal worth eighteen ducats. The beneficiary of all this could also look forward to a secure income for the rest of his life. He had applied for a state pension such as that "received by a soldier mutilated on the field of honor or by a civil servant turned gray in the discharge of his duty." Thanks to a special law, duly registered as number 8099 and signed by King Louis-Philippe, Daguerre would enjoy a pension of six thousand francs a year.

Soon, Daguerre's invention went on the road. The train had replaced the stagecoach, and sail had given way to steam, bringing distant places closer. Making pictures by mechanical means must have appealed to people with the new sense of speed that travel by machine gave them. "Staying home is the exception," reported the German writer Karl Immermann. Those with enough money "traveled at least five hundred miles a year. They traveled for travel's sake, to get away from the daily grind."

The typical bourgeois of the early 19th century did not travel for the same reasons as his forebears. In the Middle Ages Europeans had made pilgrimages to Jerusalem for the salvation of their souls. During the Renaissance the educated traveler went to Rome and Florence to immerse himself in the new Humanist civilization of those power centers. With the advent of bourgeois dominance in the early 19th century, "escapism" became the rage. At this point in the Industrial Revolution, which would reduce hundreds of thousands to abject poverty, the middle-class burgher wanted to flee the drabness of it all. Indulging this desire for distant horizons, he dreamed of exotic paradises on South Sea islands. So pervasive was the feeling that Friedrich Nietzsche, the philosopher, even coined a term for it: *Fernstenliebe*.

Poets were the first to express such longings. When Heinrich Heine saw an East India clipper tied up at a pier in London, he declared himself to be "utterly enchanted." "I was transported into Sheherazade's stories," he wrote, "and thought I saw palm fronds and long-necked camels and other fairy-tale trees and animals before me. I was so tired of our dull Western world, so weary of Europe." Any unfamiliar landscape had become symbolic of freedom. And these strange new spaces—the unexplored regions of the American West, the Arabian deserts, the Himalayas—promised a new and different life.

As the title for a book, the German novelist Ernst Willkomm used the term "Europe-weary" *(Der Europamüde)*, expressing the yearning of a whole era. Disappointed by the inhuman machinery and plodding bureaucracy of the authoritarian state, the hero leaves for America and a new life in a healthy, young society. "My characters will not appeal to the sluggish," Willkomm wrote. "Those former radicals who have meanwhile been destroyed by vanilla tea, raspberry ices, and candy pose a problem. I do not suffer from indigestion in the face of nature in the raw, however grotesque; it is in her painted state that I cannot bear her."

In the promised land the "Europe-weary" protagonist meets a pioneer, a man like Daniel Boone or a John Wayne character, and comes to realize what he has been missing in decadent Europe: "Whoever leaves Europe in disgust to seek a cure for his burning heart has to leave behind the large crowded cities where selfishness and greed rule as they must wherever humanity is too confined."

Europeans of the time typically saw America as a land of vast, open spaces and no past. Emigrants in large numbers responded to the lure of the New World, and so did photographers. The Trans-

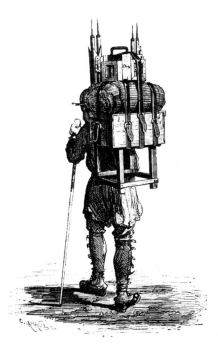

The early photographer, around 1855, with his portable equipment, including a darkroom tent.

Mississippi West seemed like an empty page in a history book and, by extension, in a man's life. All this emptiness, evidently made for a new beginning, simply invited people to stake claims, put up structures, and found communities. Immigrants left the overpopulated eastern United States to venture west into unknown territory. In their wake came scientists and cartographers, who described and mapped the wilderness as they went. And once the Civil War had ended, a number of photographers left their studios, packed their equipment into the kind of covered wagons the pioneers had used, and set off to expose their plates in the Yosemite Valley, along the Yellowstone River, and on top of Colorado's mountains.

The photographers were apparently getting away from it all too. In an era that witnessed the spread of tenements and mass poverty, of factory work and the production line, of the urban jungle and industrial congestion, the flight from cities to photograph open spaces seemed the last chance to many denizens of the middle class. Samuel Bourne, for instance, did not want to end his days in a bank in Nottingham and set out for the source of the Ganges instead. Francis Frith was so disgusted with his shopkeeper's lot in Liverpool that he dragged his darkroom fifteen hundred miles up the Nile, all the way to the Fifth Cataract. And William Henry Jackson left provincial Troy, New York, for the wilds of California.

Even Alexander von Humboldt, the German naturalist and explorer, found traveling and photographing a good mixture. What he admired most in a daguerreotype was "its inimitable truthfulness to nature." In these early photographs everything looks very real. One seems to be able to smell the trees, touch the rock, feel the slipperiness of wet leaves underfoot. And "if, as the inventor claims, the material in which sunlight can be caught, can also be easily taken along on a journey," wrote Humboldt, then Monsieur Daguerre's country must give honor where honor is due.

Travel proved no less tempting in St. Petersburg, but there everyone wanted to go up. While photographers elsewhere were frantically deciphering Daguerre's instructions, Russia was asking for photographs of glaciers. "I hope we shall be able to bring down from the higher regions of Alpine glaciers true-to-life representations of at least a few interesting sections of these fantastic ice formations," wrote the secretary of the Imperial Academy of Sciences. "I have asked the courageous mountaineer Mademoiselle d'Angeville, who has ascended Mont Blanc, to take a camera up as high as possible and to bring back from the great laboratory of Nature a few genuine pictures of the

awe-inspiring products of her forces." A Swiss newspaper tried to stifle the general enthusiasm, for "it was not as if a traveler could take a picture of the landscape or monument of his choice in the time it would take, say, for a mail cart to climb up the hill. On the contrary, he has to take along half a pharmacopoeia and juggle fire, water, light, and metal for his purposes. And for all this equipment, it is necessary to take along a vehicle resembling the peddler's with all the pots and pans dangling from it." The writer had a point, of course, but no hunter for daguerreotype material paid the slightest attention to such jibes.

Little similarity exists between the pioneer photographers of the 19th century and our own snap-happy tourists. The early photographers somewhat resembled itinerant organ players or knife and scissors grinders moving their cumbersome gear from fairground to fairground. The early photographer's journey was therefore considered an "expedition," his machine a "traveling camera," and the actual taking of the photographs an "operation."

To make a daguerreotype, the "operator" rendered a silver-coated copper plate light-sensitive by placing it face down over a box containing iodide crystals, the vapor from which reacted with the silver to form a compound, silver iodide. He then put the prepared plate into the camera and exposed it to record an image that, however, remained latent. To develop the image—make it visible—he now placed the exposed plate, again face down, in another box, this one containing mercury heated by a spirit burner. Fumes from the mercury reacted with the exposed areas of the plate to form a frostlike amalgam, or alloy, with the silver, thereby bringing out the bright, or light-struck, areas of the image. To fix the image, the photographer next bathed the plate in a solution of sodium chloride, which dissolved the unmodified silver iodide, leaving the bare, mirror surface of the plate to form the dark areas of the picture. Finally, he rinsed the plate in distilled water and dried it. When held to reflect a dark field, the etched plate became a positive picture.

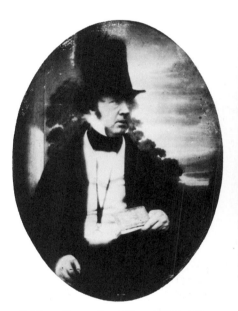

William Henry Fox Talbot (1800–77), the inventor of calotypes and the positive-negative process.

In those days the daguerreotype was considered a work of art, a precious object kept in a plush-lined, leather-covered box. And indeed each daguerreotype was unique, since no technique existed for printing or reproducing it. To look at the image, one opened the box and tilted it up to the light.

Meanwhile in England, William Henry Fox Talbot had been conducting independent experiments with photography at his country house, Lacock Abbey, near Chippenham. Like many others, Talbot

wanted to copy nature exactly but found the *camera oscura*, a device used by traveling painters since Leonardo's time, too complicated for his purposes. Thus, while sketching on the shores of Lake Como in 1833, Talbot grew increasingly dissatisfied with the situation, especially his lack of graphic skill. "It was during these thoughts," he wrote, "that the idea occurred to me—how charming it would be if it were possible to cause these natural images to imprint themselves durably, and remain fixed upon the paper." "The traveler in foreign lands," he continued, "who, like most of his breed, cannot draw, would benefit immensely from the discovery of such a material. All he has to do is to set up a number of small cameras in different locations and a host of interesting impressions are his, which he did not have to draw or write down."

Unlike Daguerre, Talbot experimented with small cameras, which the village carpenter made for him and which his wife called "mousetraps." And instead of Daguerre's silver-plated copper sheets, he used writing paper coated first with sodium chloride and afterward with a solution of silver nitrate. The reaction of the chemicals formed light-sensitive silver chloride insoluble in water. By placing an object on the sensitized paper and exposing them to light he realized a silhouette of the object. By June 1840 Talbot had formulated a technique that shortened the exposure time and thus became the basis of modern photographic chemistry. He exposed the paper only long enough for a latent image to be formed upon it. To bring out the image, he then developed it in a bath of silver oxide treated with gallo nitrate of silver. Hardly able to believe his eyes as they beheld the transformation that was slowly occurring on the once-blank paper surface, he declared: "I know of few things in the realm of science that are as miraculous as the gradual appearance of an image on white paper." Seized with pleasure, he called his invention *calotype*, after the Greek words for "beautiful" (*kalos*) and "impression" (*typos*). The image he had produced was, of course, a negative. To realize a positive, he placed the negative against another sheet of prepared paper and exposed them both to light, a process that anticipated the modern one of contact printing. By now Talbot was employing a fixing technique invented by the British astronomer and scientist Sir John F. W. Herschel, who, as early as 1819, had discovered that hyposulphite of soda would dissolve silver salts, and by January 1839 he had succeeded in using the chemical to fix photographs. Now known as sodium thiosulfate, the compound was immediately adopted by both Daguerre and Talbot, and it has remained fundamental to the

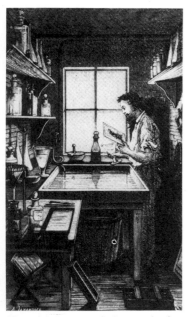

The 19th-century darkroom had windows with red panes.

photographic process ever since. Herschel also gave us the words *photography*, *positive*, and *negative*.

The next important discovery came from France, where Louis Désiré Blanquart-Evrard, working with the calotype technique, realized that if "one processed thirty or forty negatives a day in a factory, one could produce illustrated books at reasonable prices." Thus, in 1851 Blanquart-Evrard founded the Imprimerie Photographique in Lille, the first photographic workshop of any size. The mass production of calotypes required a developing paper that would reduce the printing time to six seconds in sunlight and thirty to forty seconds in the shade, making it possible to turn out some four thousand prints a day. This industrialization of photographic printing depended upon a paper with a surface made smooth with an application of glue. The best binding agent for the new "glossy print" proved to be albumen, or egg white, beaten, filtered if cloudy, and left to stand overnight. The next morning the paper was brushed free of dust and air bubbles and then dried with a hot iron run over the reverse side. So successful was the albumen process that by the end of the century photography had consumed a vast number of eggs, their yolks either thrown away or sold to tanners and bakers. When egg prices declined, manufacturers seized on the occasion and produced great stocks of paper. Anthony's, the largest American manufacturer, kept batteries of chickens for the sole purpose of laying eggs to be used for photographic paper.

Daguerreotypes and calotypes required exposures of considerable duration, sometimes hours. In 1851 Frederick Scott Archer solved the problem so satisfactorily that his method remained standard until 1880. It involved a glass plate, which offered the

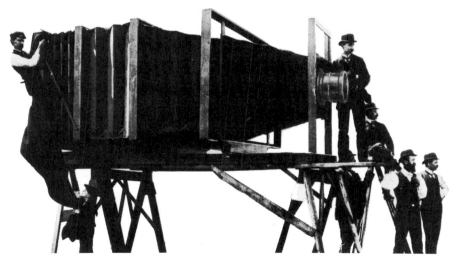

This camera (c. 1890), one of the largest in the world
to use glass plates, served for publicity photographs made
on behalf of an American railway company.

daguerreotype's fineness of detail and the calotype's reproducibility. And when sensitized with an emulsion of silver salts bound in wet collodion, exposures could be as brief as two seconds in the open and ten seconds in the studio. A viscous nitrocellulose dissolved in alcohol and ether, collodion quickly dries to form a durable, waterproof, transparent film, which property made it useful for closing skin wounds. But because once dried the collodion became impervious to processing solution, the plate had to be exposed and developed—in pyrogallic acid or iron sulfate—while still damp. Thus, for all its virtues, the "collodion wet-plate" process obliged the photographer to travel with a fully equipped darkroom, all the way to Mexican temples, the banks of the Ganges, the top of Mont Blanc, the Arctic, the Grand Canyon, and the garden at Gethsemane.

To prepare the wet plate, the photographer cleaned the glass with care, removing every speck of dust and every smudge. Balancing it on three fingers, like a waiter holding a tray, he poured the collodion, mixed with potassium iodide, onto the surface, preferably in one smooth motion. Then, in a low light, he immersed the plate for a few minutes in a solution of silver nitrate, after which he clamped it into a wooden cassette. With this he ran to the camera, made the exposure, hurried the exposed plate back into the darkroom—probably a tent pitched in the open—and developed the negative. After fixing in hypo, he washed the plate, dried it over a candle or spirit burner, and finally sealed the surface with a coat of lacquer.

Auguste Bisson, the first photographer to climb Mont Blanc, employed a giant for the preparation of his plates. This man had huge hands and could hold a plate in one while using the other to pour on the collodion, without causing bubbles, spatters, or streaks.

The largest plates of the century were those made by John Kibble, a photographer from Glasgow. He built a camera the size of a carriage and had it mounted on wheels pulled by a pair of horses. As big as grand piano lids, his glass plates weighed more than forty pounds each.

Because of their size and weight, glass plates truly encumbered the photographer. For a day's outing, he had to take along "a tent, the camera, a tripod and its bolt, cassettes, lenses, a rangefinder, a box for the plates, the glass plates themselves, very clean, a duster, silver, hooks, two black cloths, a water pitcher or bag with water for rinsing, a basin for silver nitrate solution, a spirit burner, a lamp, collodion solution, silver nitrate solution, developer, silver for intensification, pyrogallol, distilled water, calcium cyanide, empty bottles with tops,

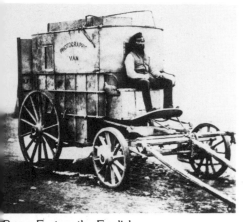

Roger Fenton, the English war photographer, traveled with this darkroom wagon in 1855.

lacquer for the negatives, a measure, two funnels, test tubes, alcohol for the burner, blotting paper, writing paper (for removing foam from the solutions), matches, a pair of scissors and a knife, string, a few pins, a small bottle of saltpeter, another of mercury to remove spots from clothes, and towels."

For short trips photographers loaded their equipment into wheelbarrows and prams, on bicycles and sleds. Farther afield, they used local transportation—elephants, mules, camels, or coolies. Professional photographers traveling across the Wild West by train could rent a darkroom compartment. And the Mississippi River boats had darkrooms as early as 1856.

The traveling photographer's classic vehicle became the darkroom wagon. Its prototype had been invented in 1842 in Switzerland by Johann Baptist Isenring, who took his "sun wagon" to the fair at Munich three years after the invention of photography. There it was admired as one of the great wonders of the world. All other attractions paled before the studio in which the "portraitist on wheels" lived and worked. Watching him in action became very popular, and to look over his shoulder would set the curious back twelve pennies. Visitors to the fair were amazed at the speed with which the sitter "was taken." A Bavarian reported to his local newspaper that "one did not have time to fall asleep during the session," that "the whole process ran smoothly like a train; in fact, before one could say three 'Our Fathers,' the face is printed, no matter how hideous it is!"

Before leaving for the Crimean War, the English photographer Roger Fenton bought a horse-drawn wagon from a Canterbury vintner. In it, next to the darkroom, he installed a bed, bookshelves, and a larder, leaving the corners free for the horses' oats and gear. To prevent the enemy from mistaking his movable studio for a munitions vehicle, Fenton painted "Photographic Van" on the canvas top.

Bad weather posed a constant threat to the traveling photographer. The Austrian officer Captain Giuseppe Pizzighelli complained that "it was almost, if not entirely, impossible to take landscapes when the wind rustles the leaves. If there is movement, the lens cover must be closed." To prevent wobbling, the camera was weighted with rocks and tied down like a tent. Some photographers used open umbrellas as wind breaks. In the darkroom, even the slightest drafts, blowing in dust, grass seeds, or bits of leaves, could be disastrous once the collodion had been spread on the glass plate. "Wind alone can complicate the spreading of the collodion, but it is heat that causes lumpish streaking," noted Julius Krüger.

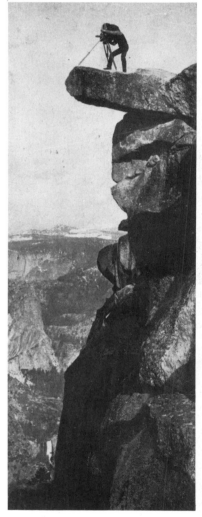

William Henry Jackson atop Glacier Point in the Yosemite Valley, California.

Without a sound knowledge of chemistry, the traveling photographer might find himself in trouble, especially at great distances from home. There were no instruction books for taking photographs under extreme conditions. Wilhelm von Herford, who photographed ancient monuments in Jerusalem in the mid-1850s, felt like an alchemist. "When I was mixing my brews in the still of the night, stirring the mess in the test tube with the glass stick, and the combination of chemicals would heat up without benefit of flame and hiss and fume, and steam pervade the room despite open door and windows, how could I not think of Dr. Faustus!" John Thomson, a Scotsman, went off well prepared because he had studied chemistry at Edinburgh University. When the French photographer Tissandier complained that collodion did not spread properly when hot, Thomson gave his advice: "Sometimes I have used a little orange juice, or regular bottled beer with a pinch of sugar."

The photographers tried everything to keep the collodion damp. They added raspberry juice and honey, malt and milk, tobacco and tea, sherry and glycerine, lime and caramel and even opium. Each practitioner developed his own process and sometimes patented it, even if it belonged to the so-called "larder school of photography."

The photographer who handled his chemicals carelessly might suffer anything from the loss of teeth or a damaged nasal septum to nervous disorders and blindness. "Wet plate" photographers lived dangerously, especially when the collodion, which was combustible, came in contact with fire.

Hot climates made the photographer's lot difficult indeed. Franz Stolze asked his readers to "imagine the sun beating down and a temperature of 105° even in the shade. In this broiling heat one has to crawl into a black bag and very slowly and carefully change the plates. The air in the small space is, of course, suffocating. Sweat is running from every pore; to try and prevent even the smallest drop from falling on the plate requires almost superhuman care. One's pulse rises to 120 beats a minute, and scrambling from the tent, one barely manages to reach one's bed before collapsing."

In Africa, Hermann Vogel found that termites had eaten the cardboard boxes containing his plates. The strange cracks on them seemed due to supernatural causes, but then he discovered a lizard sweeping its tail across the plates until the surface looked like the cracked varnish on an old oil painting. Frederick Monsen managed to take the miseries of a photographer's life in the desert with a touch of humor. "I dug a hole in the sand," he wrote, "balanced my tripod over

In 1874 Gustav Haertwig of Magdeburg transported his camera all over Germany on this velocipede.

it and covered it with enough blankets so that no light shone through. It worked, but it was rather tropical. I christened this invention my 'Turkish bath-cum-darkroom-cum-tent combination' and will send directions for its use to all interested parties."

Another tribulation of the traveling photographer was the superstition of the local population. In Egypt, where Captain Payer was taking photographs for the Viceroy in 1863, the fellahin took his camera to be Pandora's box. Certain that the black bellows concealed cholera, they smashed the whole instrument. In Jerusalem, Payer found himself in court because a donkey was said to have died from the "devilish" fumes emanating from his darkroom. On their return home, early travelers with cameras were acclaimed like conquerors, decorated by heads of state, and awarded gold medals at the world fairs. Many 19th-century photographers benefited from the general fascination with expeditions to unknown parts of the world: the Arctic, the Asian steppes, and the Alpine peaks, especially the latter, still considered inaccessible and quite unfit for humans. Only a hundred years earlier this "barbaric" landscape had prompted the German archaeologist and art historian Johann Joachim Winkelmann to pull the curtains in his carriage as he passed over the Alps on his way to Italy.

Bisson was not so sensitive. At his departure from Chamonix in July 1861 with his twenty-five bearers, the inhabitants sent him off with a cannon salute. But fireworks exploded when he returned with the first photograph of Europe's highest mountain.

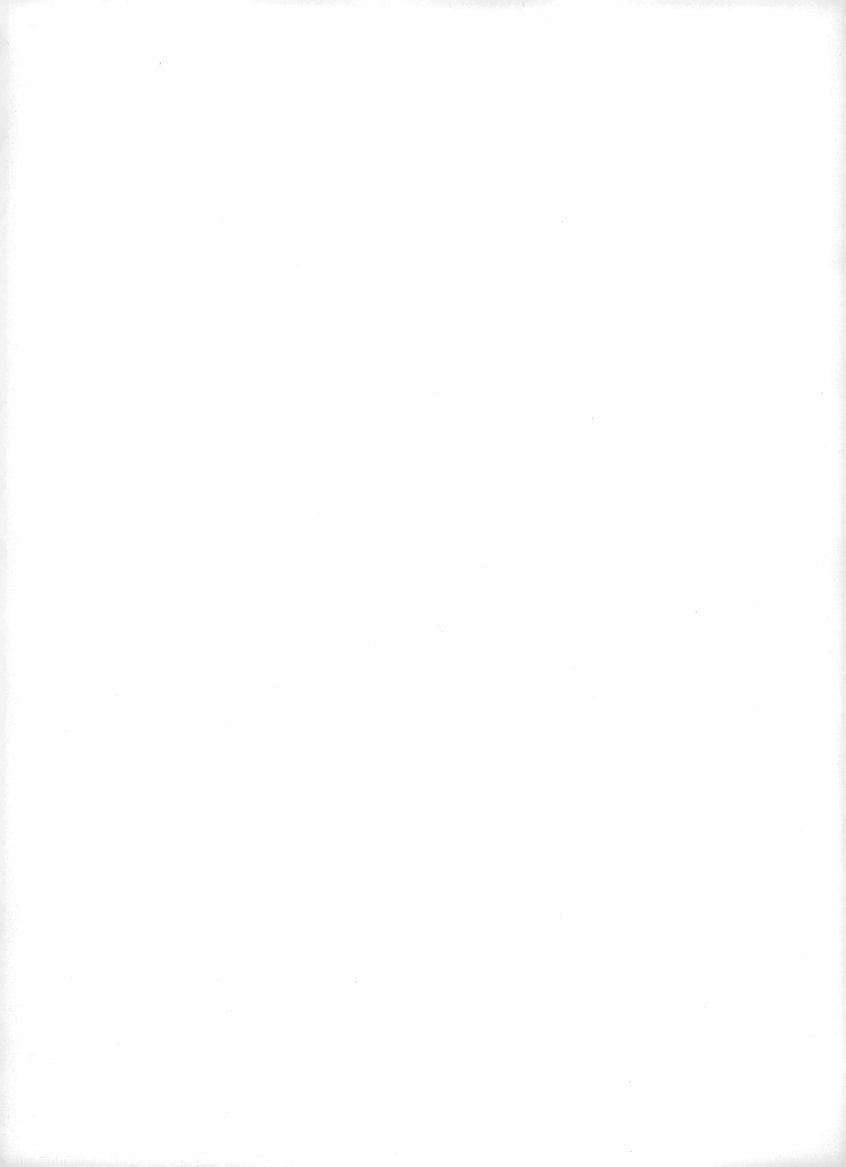

2
Egypt

Lion-hearted Journey to the Temples of the Nile

Francis Frith and Maxime Du Camp

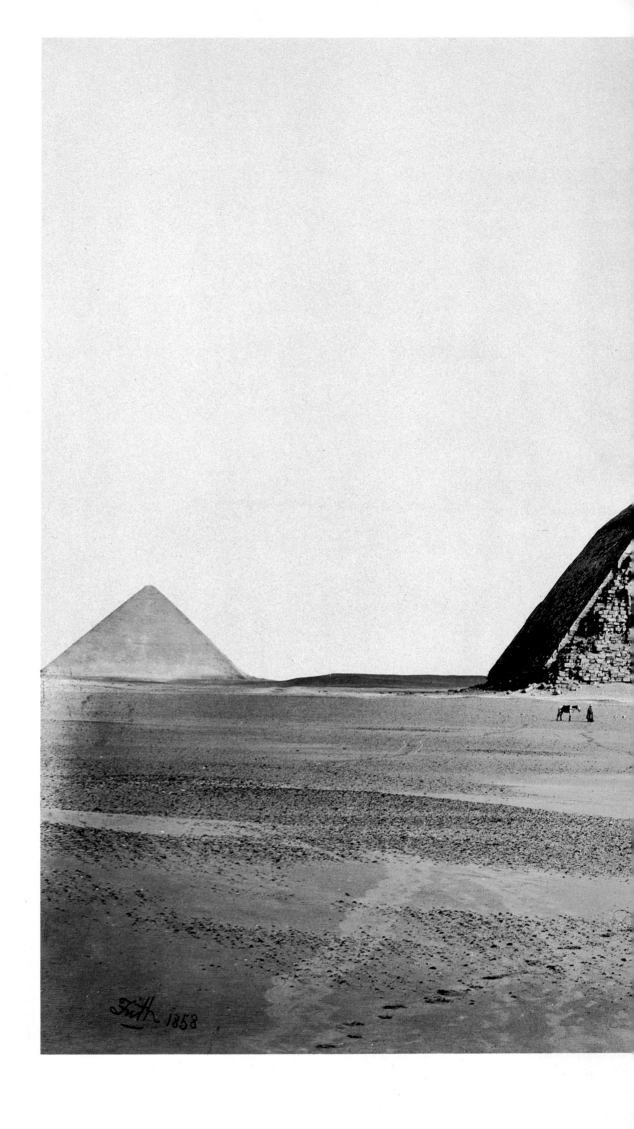

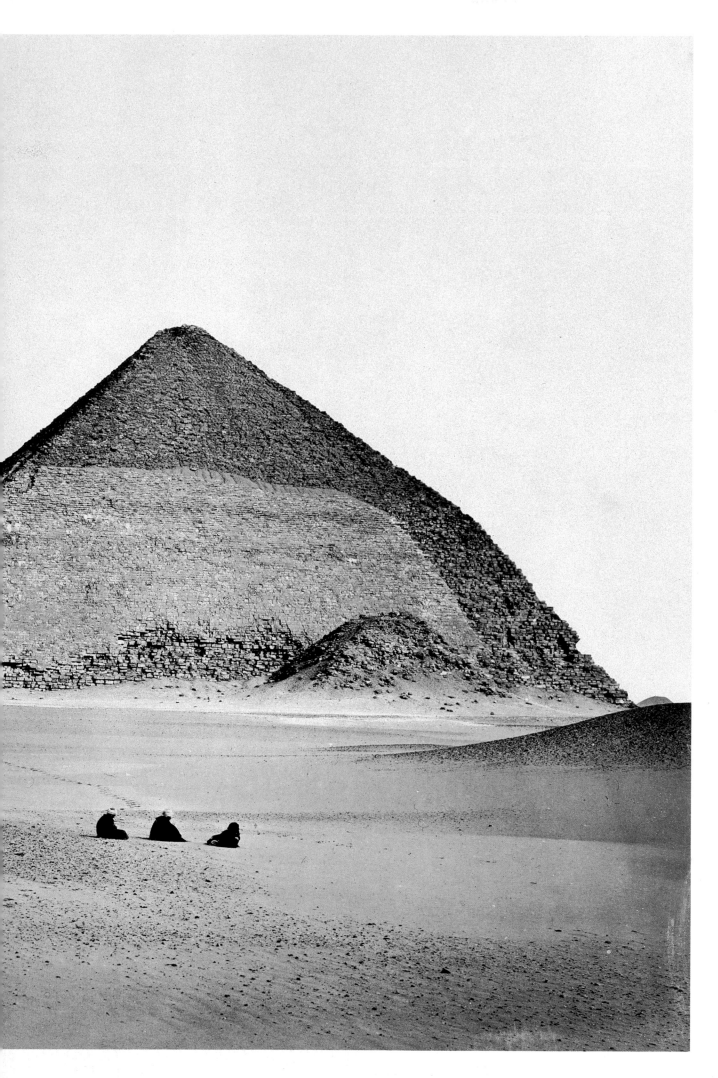

Francis Frith, The Pyramid of Dahsur, 1858.
International Museum of Photography, George Eastman House, Rochester, N.Y.

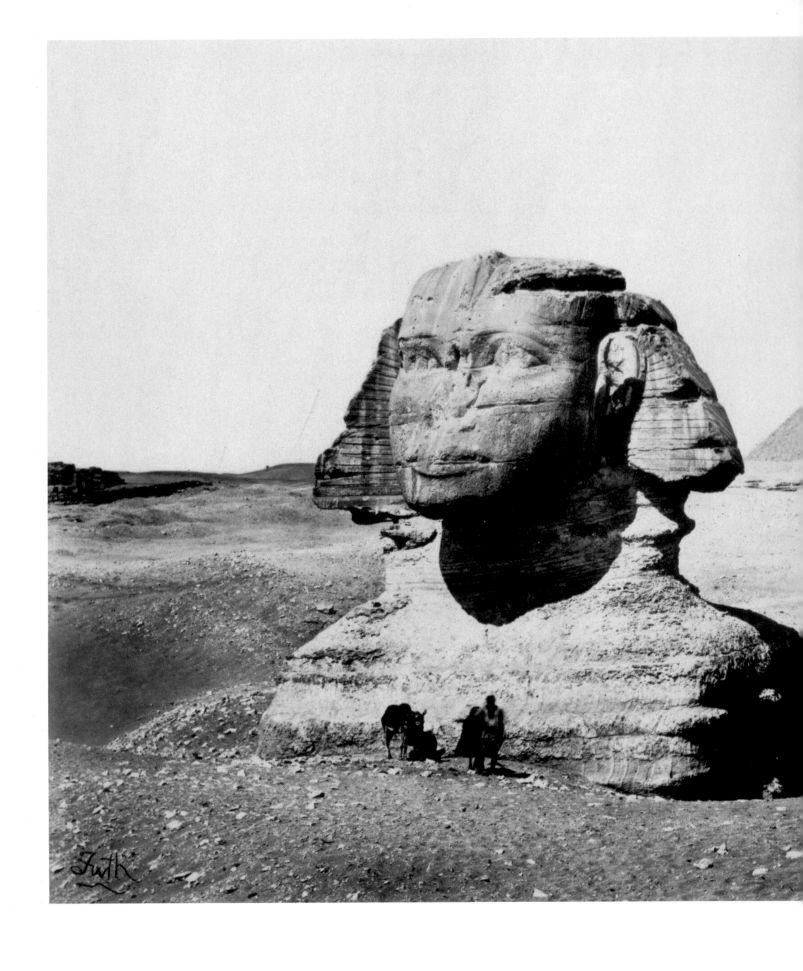

Note that the front paws were still buried in the desert sand, which in the 19th century alone had to be cleared away three times. While in Egypt, Frith photographed only ancient monuments, following, as he said, the siren call of a romantic and perfect past, so much more fascinating than the unnatural and hectic 19th century.

Francis Frith, The Sphinx, c. 1858.
Daniel Wolf Gallery, New York.

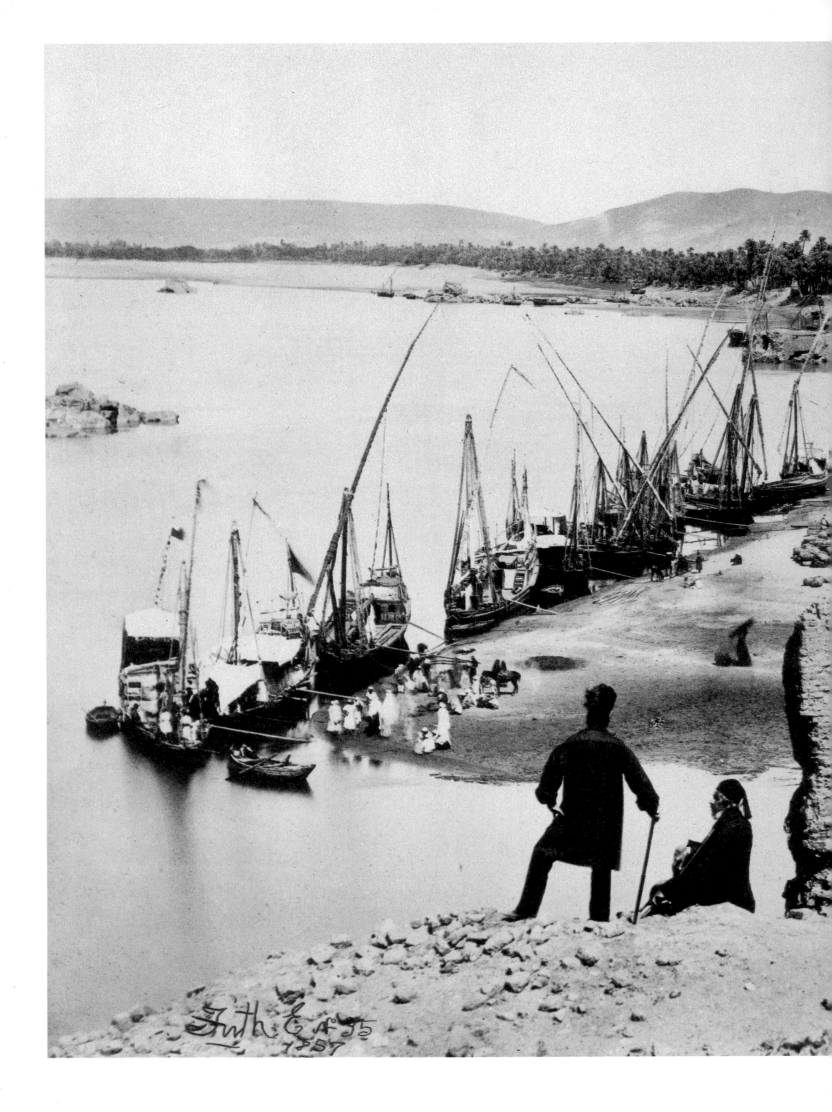

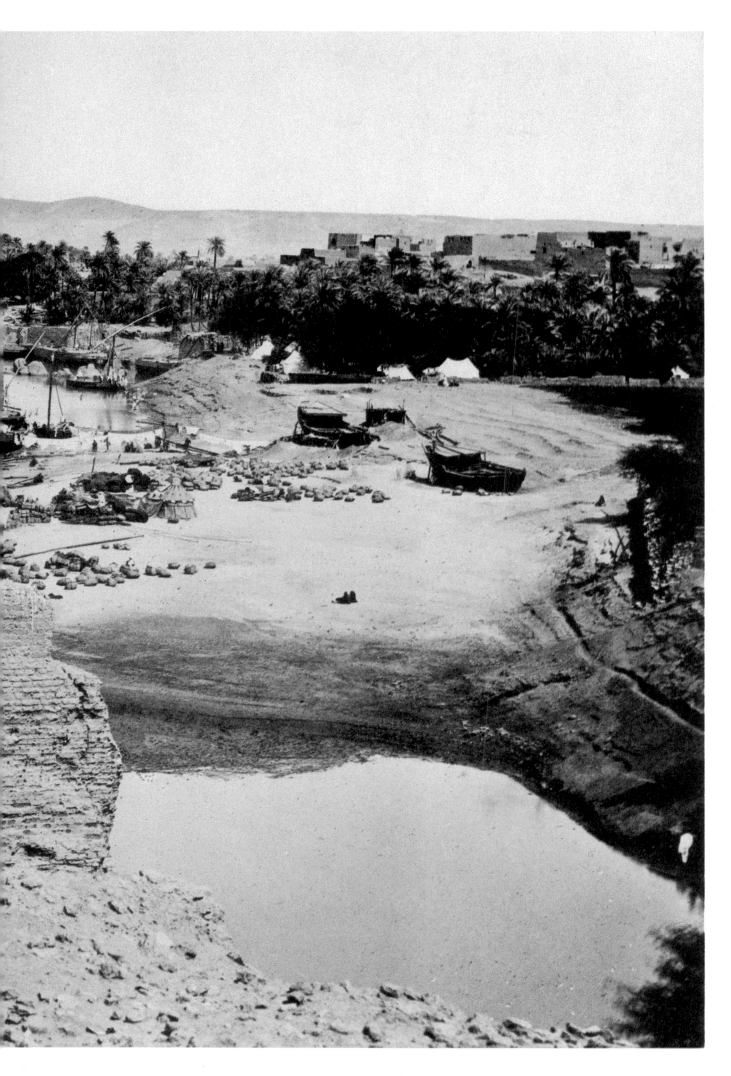

Francis Frith, The Landing at Aswan, 1857.
Strand Book Store, New York.

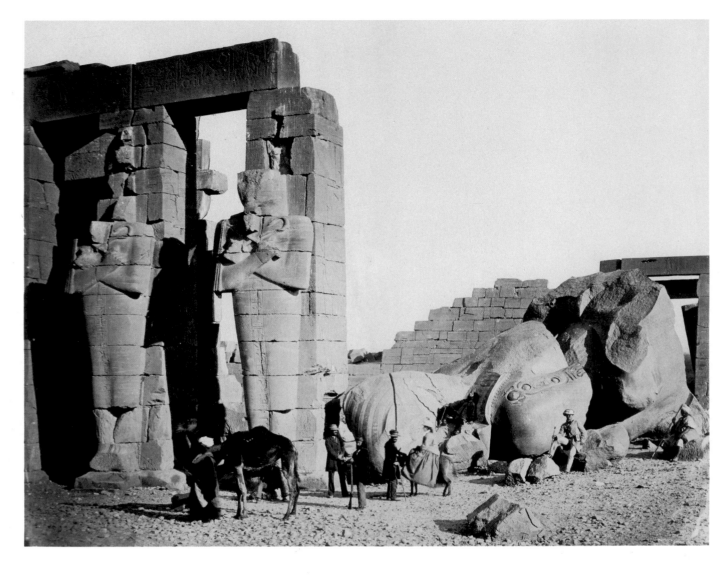

Francis Frith, The Fallen Colossal Statue of Ramses II at Thebes, 1857.
Gilman Paper Company, New York.

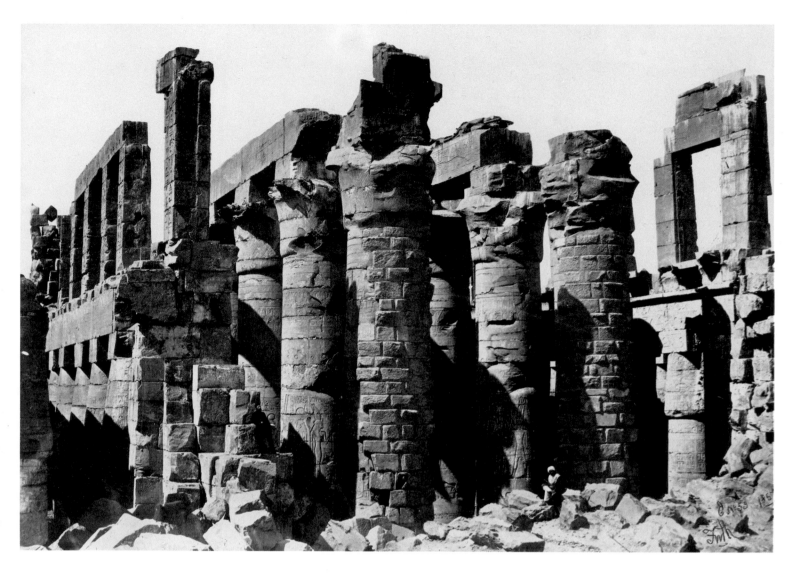

Francis Frith, Hypostyle Hall at Karnak, 1857.
Strand Book Store, New York.

Frith sailed up the Nile in a *dahabije,* the classic watercraft of the Nile, which took seventy days to travel to the First Cataract and back. The cost for four people making the journey in comfort was considerable, but the price covered all services on board and all trips to the sites on land. The organizer of the excursion, who served as translator and general factotum, was a so-called *dragoman* hired in Cairo before departure. His responsibilities included fitting the boat out with sufficient quantities of food and sherry or port, hiring the donkeys for forays overland, and transmitting the travelers' wishes to the captain of the boat. *Baedeker* and other guidebooks urged that the dragoman be chosen with care, perhaps through referral from the consulates to avoid being overcharged.

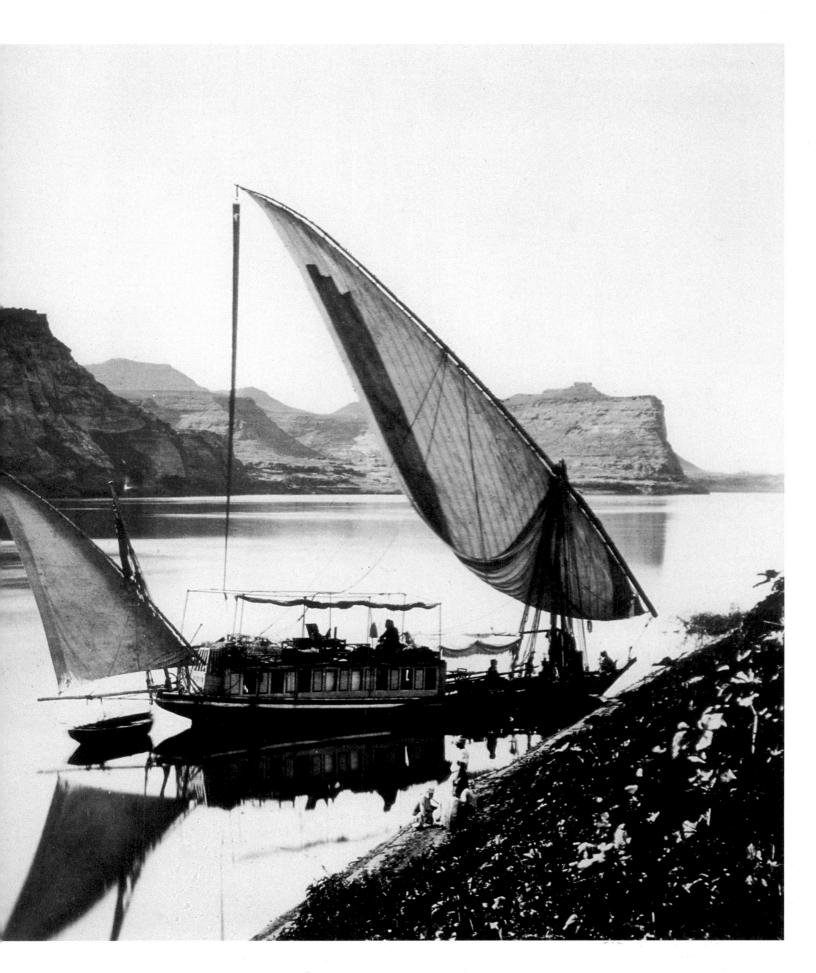

Francis Frith, Sailboat for Travelers on the Nile, c. 1857.
International Museum of Photography, George Eastman House, Rochester, N.Y.

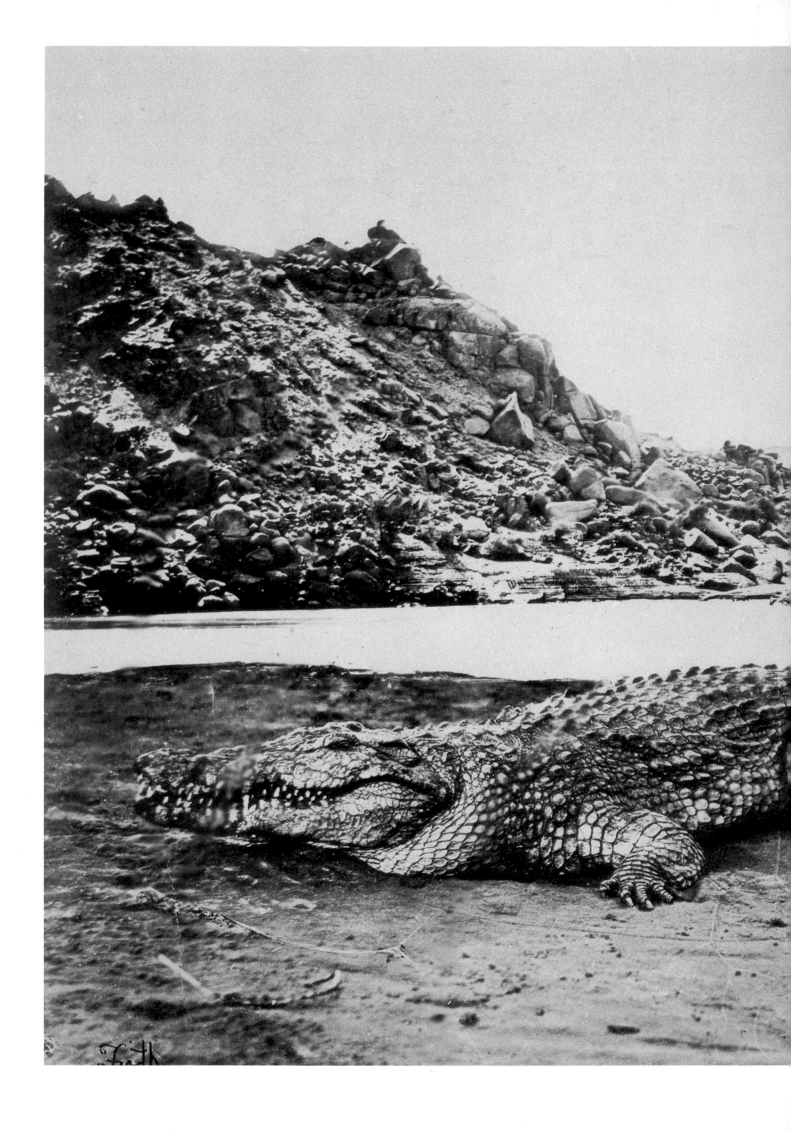

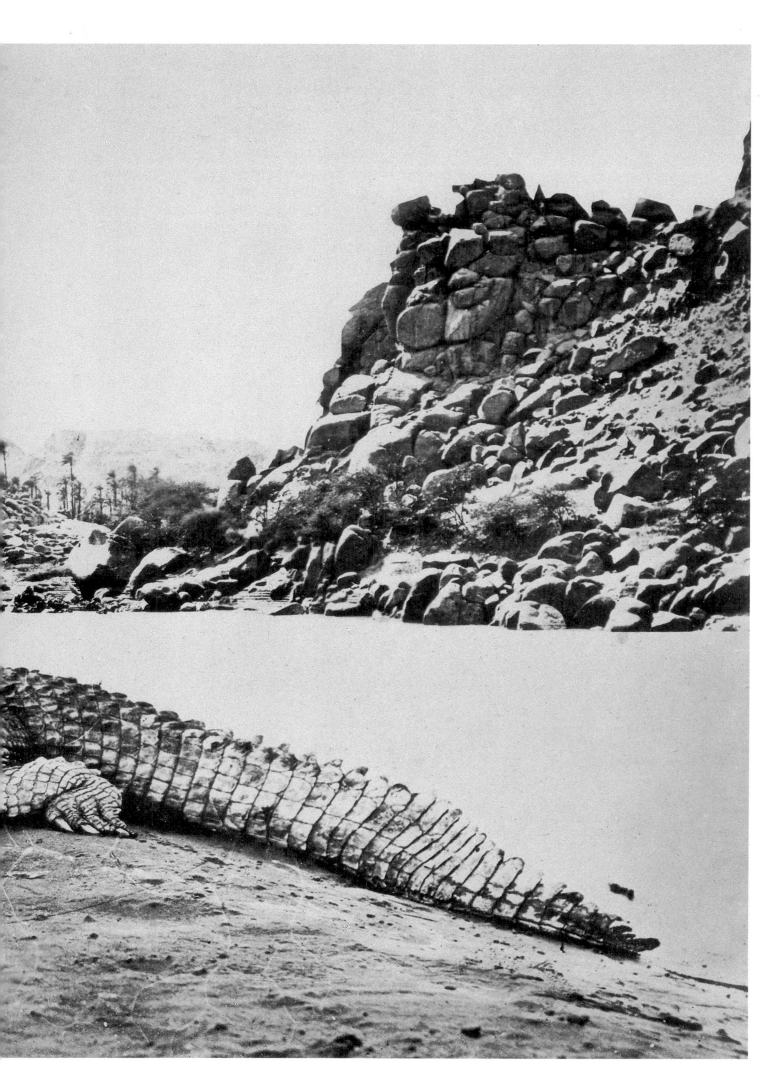

Francis Frith, Crocodile on a Bank of the Nile, 1857.
Daniel Wolf Gallery, New York.

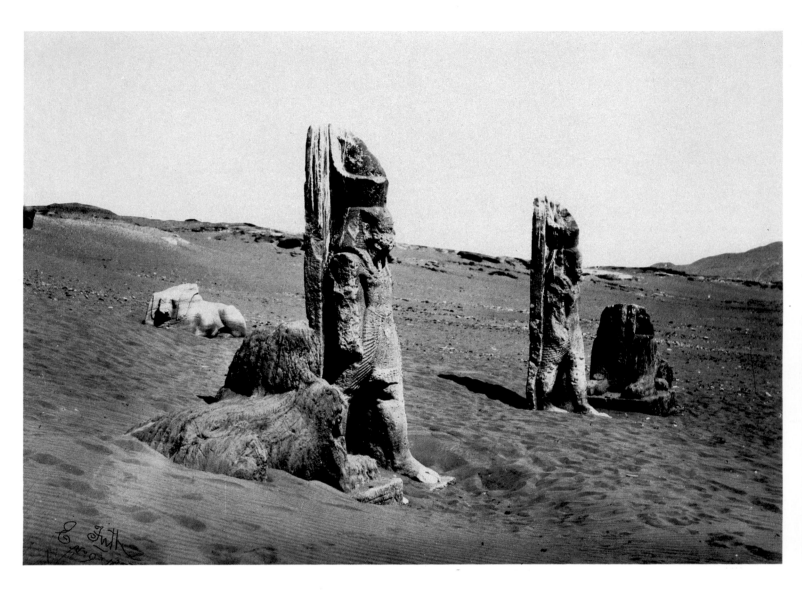

Francis Frith, Colossi in the Nubian Desert, 1857.
Daniel Wolf Gallery, New York.

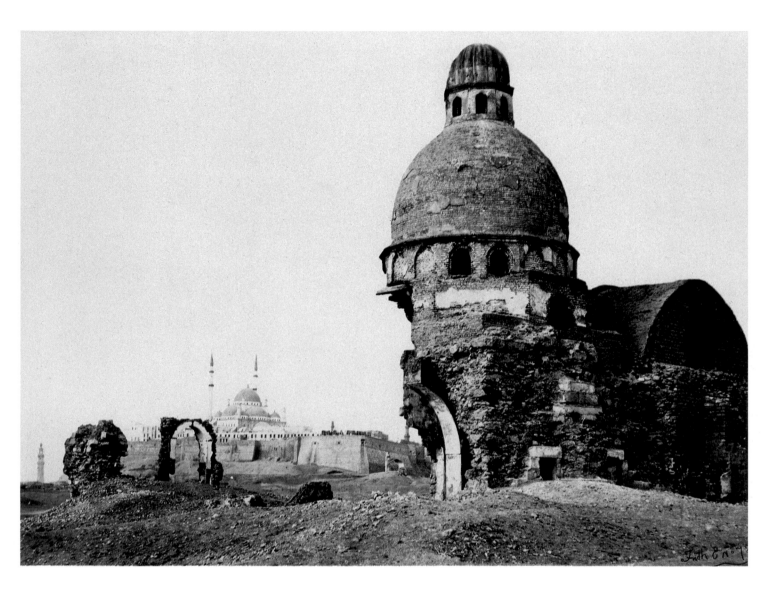

Francis Frith, Tombs of the Caliphs on the Outskirts of Cairo, c. 1857.
Daniel Wolf Gallery, New York.

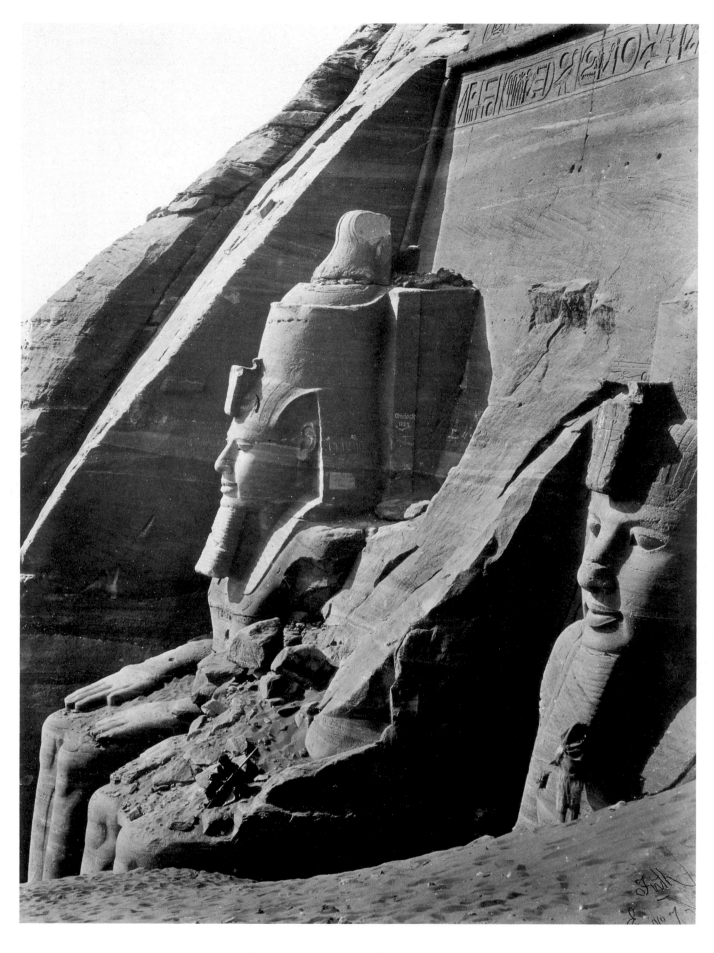

Francis Frith, Abu Simbel, Nubia, 1857.
Daniel Wolf Gallery, New York.

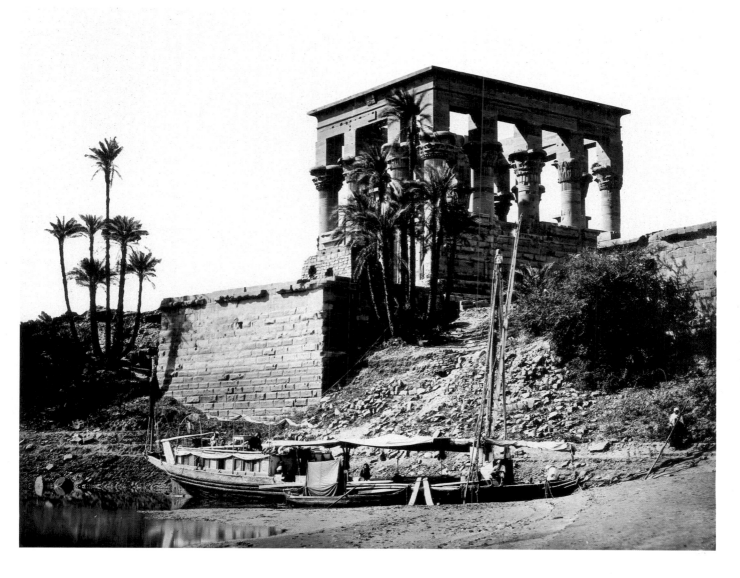

Francis Frith, Temple on the Island of Philae, 1857.
Janet Lehr Gallery, New York.

In 1857 the Temple of Isis still stood on the Island of
Philae. A little more than a century later the Philae
temples had to be moved to another island, because of
water rising behind the second dam at Aswan. For his
pictures of Philae, Frith set up a darkroom tent in the
dahabije's dinghy.

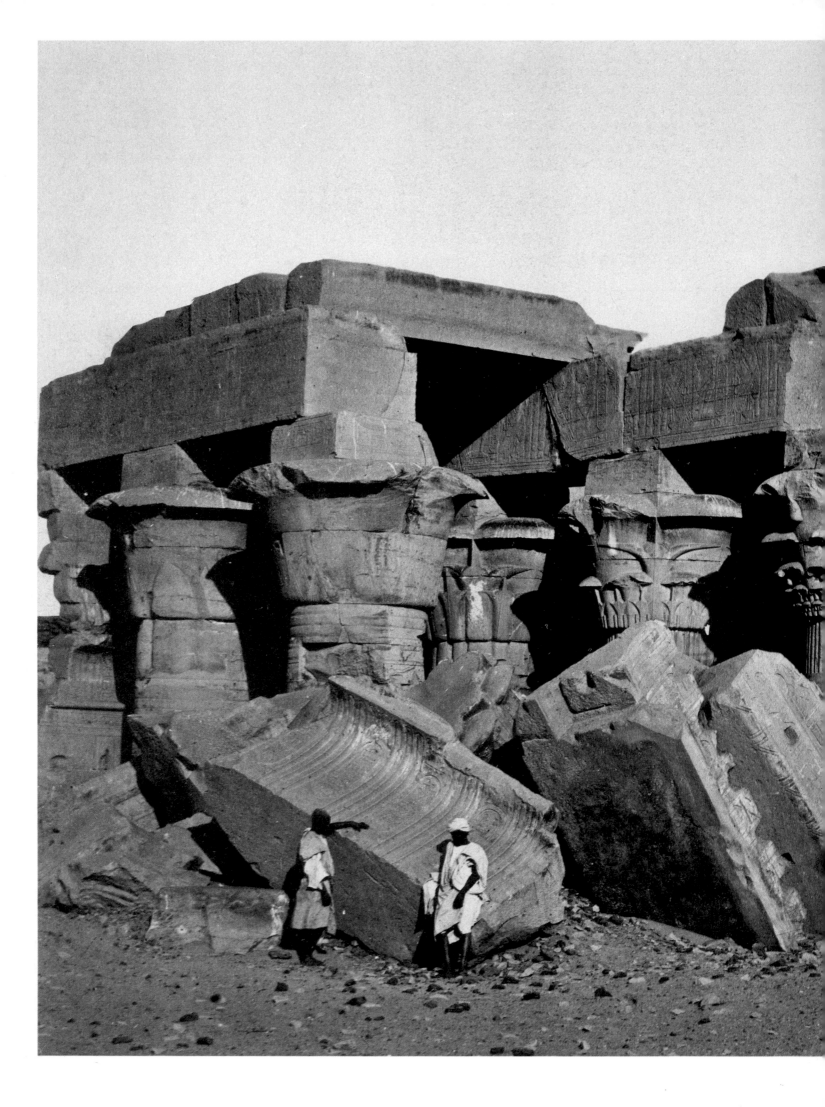

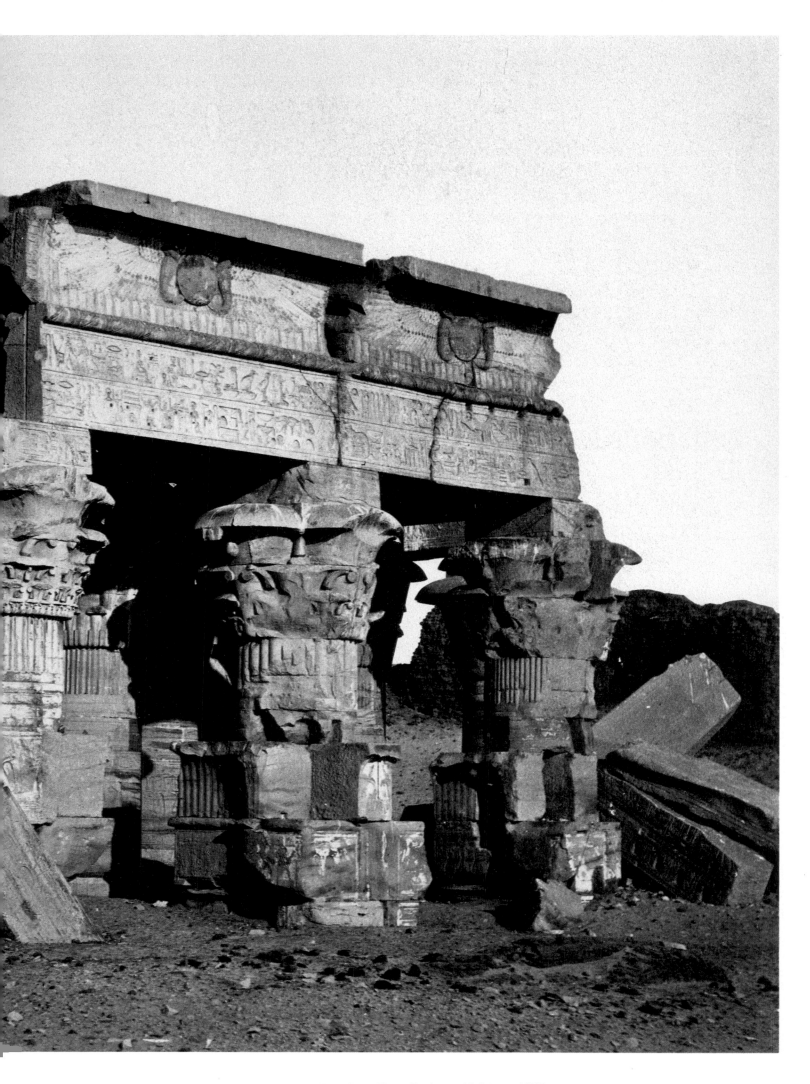

Francis Frith, The Temple at Kom Ombo in Nubia, c. 1857.
International Museum of Photography, George Eastman House, Rochester, N.Y.

When Maxime Du Camp photographed the statue of Ramses the Great at Abu Simbel, the colossus was up to its neck in sand. A systematic worker, Du Camp declared himself ready to photograph every ruin, monument, and landscape that attracted his attention. He also drew plans of the temples and passed no relief of any significance without recording it. To convey the monumentality of this statue, he placed his assistant Sassetti on the monarch's crown. With his friend the novelist Gustave Flaubert, whose reaction to the wonders of the Nile consisted mainly of tired resignation, Du Camp traveled in an official capacity, as an actual envoy of France. After his return to Paris, he published *Egypte, Nubie, Palestine et Syrie* (1852), which had an instant success. Since a technology for reproducing photographs had yet to be devised, the volume was illustrated with 125 original prints, all tipped in by hand. So distinguished was the enterprise that it gained Du Camp membership in the Legion of Honor. Unlike Francis Frith, the Frenchman did not use glass plates for his photographs, but rather paper negatives, from which any number of prints could also be made. This meant that the texture of the paper negative had to be transferred to the positive, which accounts for the soft, grainy appearance of the prints. Du Camp's photographs were printed by Blanquart-Evrard in Lille, one of the first large laboratories for processing photographs.

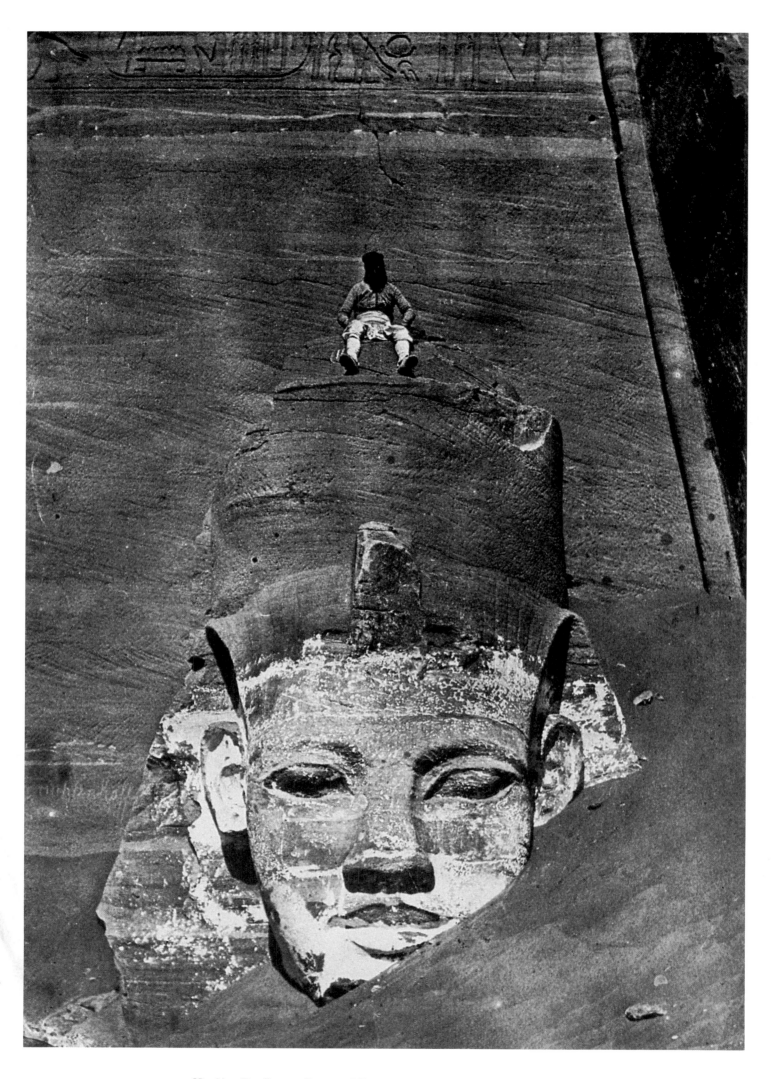

Maxime Du Camp, Statue of Ramses the Great at Abu Simbel, 1850.
Agfa-Gevaert Historama, Leverkusen, West Germany.

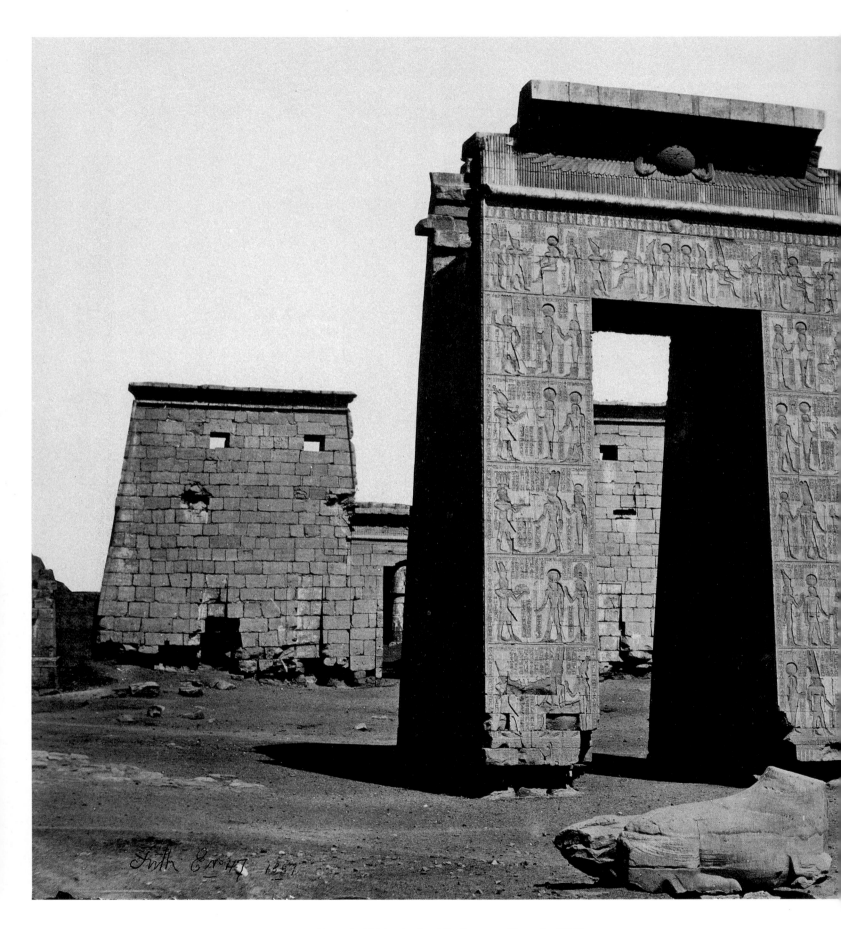

Francis Frith, Arch of Ptolemy at Karnak, 1857.
International Museum of Photography, George Eastman House, Rochester, N.Y.

The photograph's composition emphasizes the size of the arch, whose monumentality stands in marked contrast to the relatively small, delicate palms. A few years earlier Mehmet Ali, the Governor installed at Cairo by the Sultan of Turkey, had ordered the demolition of many ancient structures for materials to be used in building modern factories. As a consequence, the temples along the Nile have suffered more damage in the last 140 years than in all the millennia of their previous history. This makes such photographs as those by Frith invaluable to archaeologists.

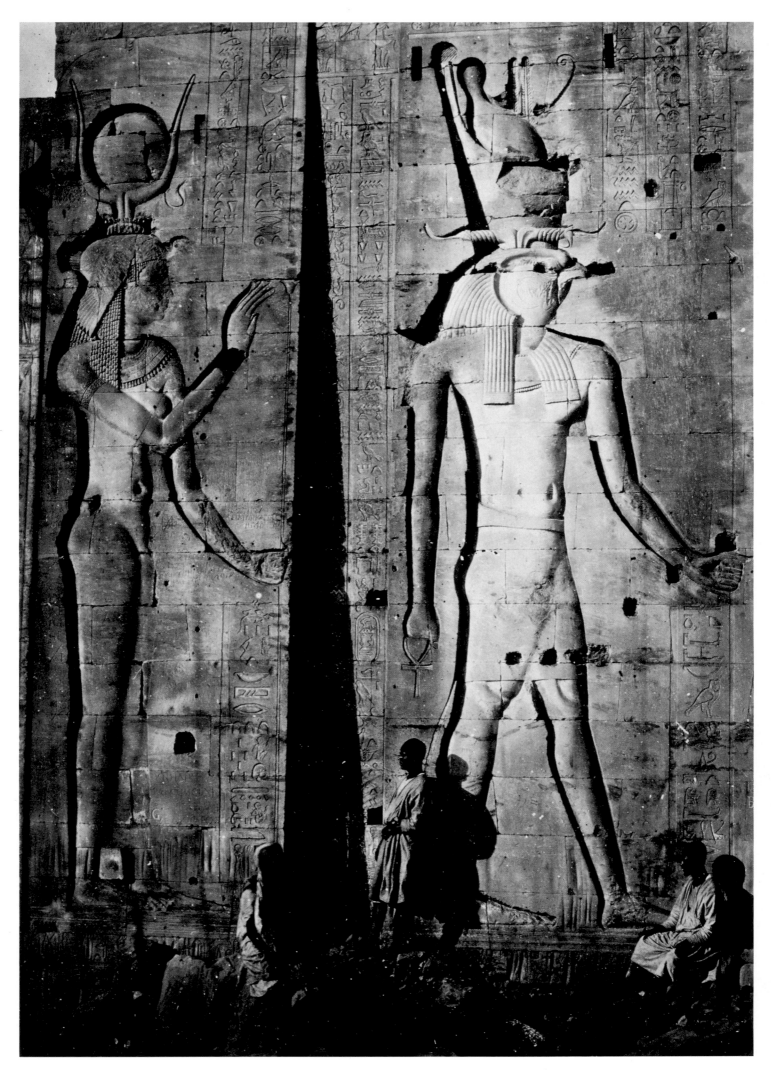

Francis Frith, Bas-relief in the Great Temple at Philae, 1857.
Daniel Wolf Gallery, New York.

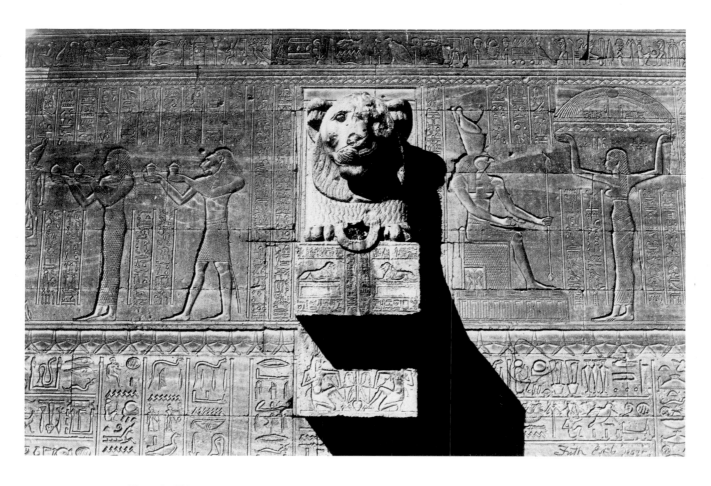

Francis Frith. Lion's Head on the Outside Wall of the Temple of Dendera, 1857.
Strand Book Store, New York.

Francis Frith, Tombs of the Caliphs on the Southern Outskirts of Cairo, c. 1857.
Daniel Wolf Gallery, New York.

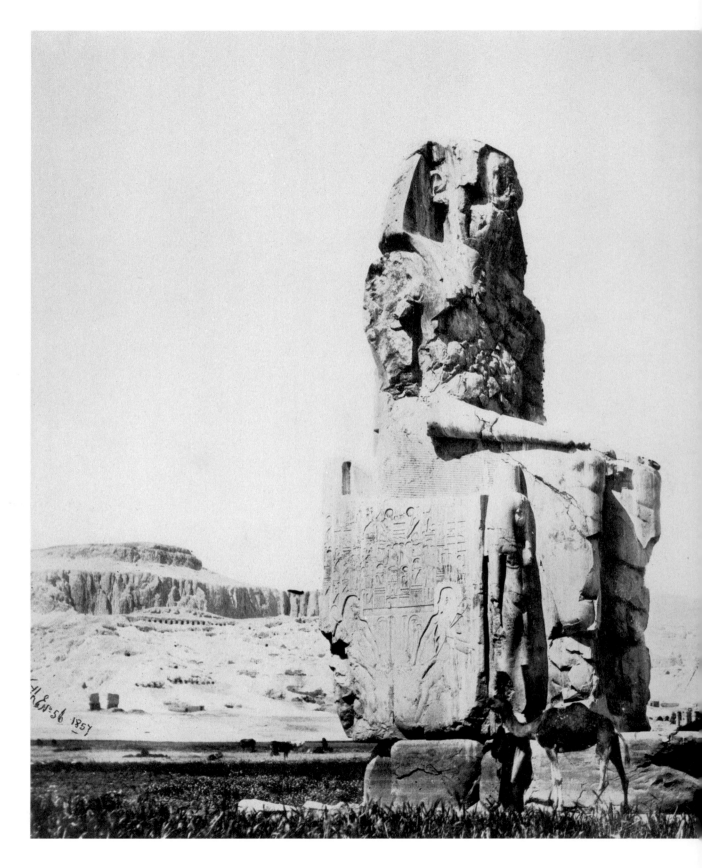

Francis Frith, The Colossi of Memnon at Thebes, 1857.
Strand Book Store, New York.

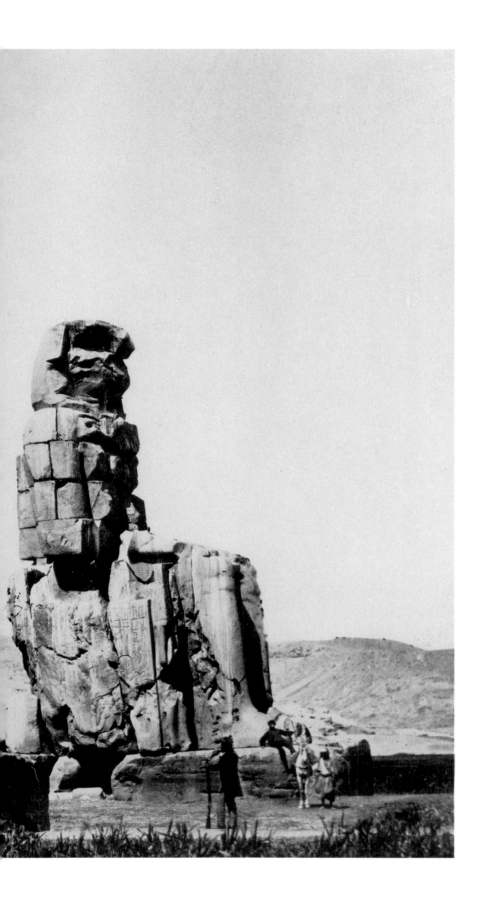

Frith went to Egypt equipped with a cultural guidebook, Sir Gardner Wilkinson's *Handbook for Travellers to Egypt.* And he proceeded to pay little, if any, attention to the natives, knowing full well that his customers back home would prefer views of the classical sites to street scenes and the like. Meanwhile, he also managed to solve the problems attendant upon working with wet plates in a hot climate. In photographing the colossi, he made several exposures, beginning with a large 15 x 15″ plate and progressing downward to the popular stereocard format. Although it was possible even then to enlarge or reduce prints from negatives, Frith preferred to travel with cameras of different sizes.

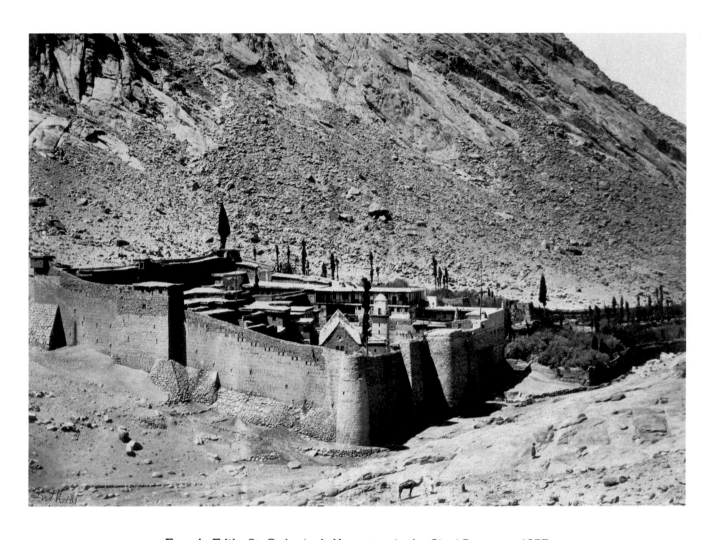

Francis Frith, St. Catherine's Monastery in the Sinai Desert, c. 1857.
Daniel Wolf Gallery, New York.

2
Egypt
Lion-hearted Journey to the Temples of the Nile

In the autumn of 1849 two writers of quite different character traveled together to the Middle East. Maxime Du Camp was fascinated by the recently invented photographic processes while Gustave Flaubert could think only of women: his mother and his creation, Madame Bovary. For many months Du Camp had tried to persuade Madame Flaubert to let her son join him on a trip abroad. His first ally in this difficult battle had been Flaubert's brother Achille. Couldn't Achille, asked Du Camp, explain to his mother that the warm climate would do Gustave's health no end of good? Despite misgivings, Achille agreed to try.

Maxime Du Camp (1822–94).

Another comrade-in-arms was Jules Cloquet, a friend of Flaubert's father, who wrote Madame Flaubert a letter suggesting that travel was just what her son needed.

The decision came one morning at breakfast. Apparently Madame Flaubert told Gustave icily that, for the benefit of his health, she would, with great reluctance, let him go with his friend. Flaubert is said to have blushed and thanked his mother profusely.

Gustave Flaubert was a volatile man, given to complaining and apparently incapable of making decisions. He found reality difficult to cope with and preferred to live in a dream world all his own. When Du Camp, overjoyed at Madame Flaubert's acquiescence, waxed rhapsodic over his vision of the two friends sailing up the Nile, Flaubert merely shrugged his shoulders. That was all very well, but they were neither going to bathe in the Ganges nor travel to Ceylon.

Gustave Flaubert (1821–80).

As the departure date approached, Flaubert became increasingly restive. He hid behind his desk or lay down on

his black sheepskin rug, declaring the trip to be madness. Why go? He would never see his home again. At the station he almost turned back. Flaubert had left his study as if going away only for a moment. His slippers were still next to his bed, his dressing gown remained draped over his armchair, and a book lay open on the table.

The two friends boarded the *Nile* in Marseilles. Soon thereafter Flaubert dried his tears and, contrary to expectation, turned out to be a cheerful passenger, despite a rough sea, slippery decks, and even seasickness. It took eleven days to reach the shores of Egypt. On November 17, 1849, Flaubert and Du Camp caught their first glimpse of the Nile delta, bathed in a bright, silvery light.

Since ancient times, the Pyramids have been the destination of travelers from many lands. After his visit, Herodotus explained Egyptian mythology and the customs of the Arabian tribes, and when Solon, the Athenian, journeyed to Cairo he had Plato to describe the occasion. The Middle Ages brought Mohammedan and Christian pilgrims, traveling through the Nile delta on their way to Mecca and Jerusalem. Europeans began to arrive by the end of the 18th century, seeking solace from the misery of the present among the monuments of an eternal past. When Napoleon led an army into Egypt in 1798 he was accompanied by scientists, and it was they who won the first battle, for a new science: archaeology. Widely published, the findings of the expedition prompted European universities to establish chairs in Egyptology. Soon architects and cabinetmakers were developing a "pharaonic" style. The armrests of chairs acquired sphinx-headed terminals, table legs ended in lion's paws, and obelisks appeared on either side of front doors. Writers, naturally, dreamed of floating in feluccas on the mysterious Nile.

Those taking up photography wasted no time before they stormed the land of their dreams. The scientist François Arago suggested that a legion of draftsmen would be needed to copy the millions of hieroglyphs covering only the exterior

Horace Vernet (1789–1863), the French painter who specialized in historical and battle scenes.

of the temples at Thebes, Memphis, and Karnak, whereas with the daguerreotype, of course, one man alone could easily do the job. He suggested that if the Egyptian Institute were to furnish an expedition with two or three of Monsieur Daguerre's machines, it would come back with precise copies of the hieroglyphs instead of drawings.

In Paris the camera-maker Nöel Marie Lerebours equipped painter-friends with his products, and in the autumn of 1839 two of the artists went to Alexandria to photograph. One of them, Horace Vernet, a painter of historical subjects and battle scenes, defied his comrades, who had already threatened to throw his camera in the Nile, and went on working with the instrument, convinced that it would have been humiliating indeed to return without photographs of the most famous monuments in the world. And so on November 7 Vernet and Frédéric Goupil made the first photograph of the Dark Continent. In Alexandria they took a picture of the harem of Mehmet Ali, who later became governor of Egypt. Their daguerreotype shows an open doorway in a white-washed wall and beyond it the harem buildings. Back in Paris, Lerebours published the picture in a series entitled

The harem of the Sultan's future Viceroy in Alexandria, seen in a copper-plate engraving, which is all that survives of the first photograph made in Egypt.

Excursions daguerriennes. In all, Lerebours had 114 copper-plate engravings made from the Vernet-Goupil daguerreotypes, to which the engravers added palm trees and mounted Arabs for verisimilitude.

In photography Egypt turned out to be very different from the topographical representations in *The New and Complete System of Geography.* A standard work of the late 18th century, this publication had depicted the Pyramids as pointed, Alp-like peaks. The desert resembled a piano lid, occupied by a dozen or more puppets. The first daguerreotype proved that reality was rather more impressive than the "scientific" illustrations had implied.

The de Saulcy case provided another example of photography's usefulness. Louis Félicien de Saulcy, an Orientalist, traveled in Syria and Palestine in 1850 to study Biblical sites. Eager to establish the exact dates of Solomon's reign, he returned to Paris with architectural drawings substantiating his thesis. These challenged what he called the "armchair theories" of people sitting at home, who retaliated with ridicule and even accusations of lying. However, de Saulcy was vindicated when the ministry of Education sent

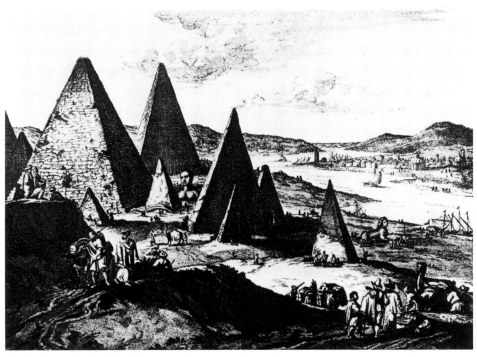

Prior to the invention of photography, this is how the highly imaginative engravers saw the Pyramids of Egypt.

the photographer Auguste Salzmann to the Holy Land, in keeping with the contemporary belief that archaeological controversy was an affair of state. In six months Salzmann took two hundred photographs, which together proved de Saulcy right. The gratitude was obviously heartfelt when the latter said that Salzmann had provided France with the most precious collection of photographs imaginable.

The writer Gérard de Nerval, photographing in Egypt in 1843, had problems with reality too. The fabled land turned out to be mostly desert. Still, on May 2 he sent his fellow-writer Théophile Gautier a letter in which his imagination got the better of him as he described Oriental women gliding along the riverbank by moonlight, orange groves laden with fruit, avenues of trees so songful they were like huge birdcages, and marble pavilions in whose pools Egyptian beauties bathed under the jealous eyes of their lords and masters. But Nerval's enchantment ended there. To his horror, the amateur photographer discovered that in the heat of the desert his chemicals bubbled dangerously. Thus, he ended up with nothing but bad, indeed useless, daguerreotypes. In a letter to his father Nerval complained that daguerreotyping had made much progress but that he evidently could not profit by it. Fortunately, he had friends whose drawings of the sites were better than his photographs. Nerval wished he possessed more talent for drawing, but admitted that one could not be proficient in everything.

Seven years later, Maxime Du Camp encountered different problems. Flaubert, his traveling companion, lacked a strong sense of adventure. Moreover, he failed to be charmed by the glorious desert evening, with its cool air slowly spreading across the sand, or invigorated by the freshness of morning, when the first rays of the sun warm limbs stiff from the cold night. During the day Flaubert tended to be bad-tempered, and he even found the Pyramids terribly boring. His Egyptian diary reads like that of an old maid fainting at the sight of every spider. He noted that fleas were apt to jump about on his writing paper, that scorpions

abounded, and that bat droppings offended his nose. The only thing which seemed to capture the great writer's interest were pretty cases of syphilis.

Flaubert eased his conscience by becoming Du Camp's half-hearted handmaiden, which meant that he knew true relief only when the day's mindless jobs were done. He polished the basins that held the developer, and watched the silver nitrate turn his fingers black. From time to time he agreed to pose. Finally, however, he decided that in photography the means did not justify the end.

Meanwhile, Flaubert dreamed of his mother and the willows along the banks of the Seine. Most of all, he let his mind dwell on the heroine of his novel. Then, suddenly, he found a name for her, as he and Du Camp stared into the muddy waters breaking on the black granite of the Second Cataract. She would be Emma Bovary, and her creator kept repeating the name, rolling it around on his tongue, oblivious to his surroundings.

Du Camp, for his part, found everything that could make him forget the banal life he had left behind. For him, traveling proved to be pure ecstasy. As a child, he had longed to float to China, stretched out under a woven bamboo tent in a cedar boat.

At the end of his life Du Camp lamented the fact that he had not become an adventurer, since he felt he had been born to travel. If circumstances had not kept him in Paris when he was thirty and unattached, he would have plunged into the wonders and dangers of Africa, there joining in the search for the source of the Nile. On the threshold of old age, Du Camp bitterly regretted not having drunk the waters of the Zambesi, the Niger, and the Congo. He envied Stanley and would have given anything to have died as Livingstone did.

Du Camp was serious about photography. In an age that systematically measured, surveyed, and catalogued the world, he did not just take snapshots. He wrote to Gautier that he was photographing every ruin, monument, and landscape

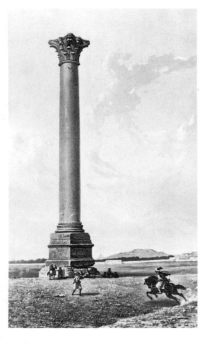

Pompey's Column in Alexandria as published in *Excursions daguerriennes* (1840–44). The artist who made this engraving from a daguerreotype added the people and horses.

that caught his attention. He made plans of the temples and passed up no relief of any significance. To provide a sense of scale, he posed the sailor Hadji Ismael against his motif. And the model always stood miraculously still for the long exposures. One day Du Camp learned why when he overheard Ismael telling the captain of their boat how Du Camp had asked him to climb on top of a column, how the Frenchman then held his head under a black cloth, aimed his camera at the poor sailor, and shouted to him not to move. Terrified, Ismael had remained frozen, and the cannon had not fired on him.

Du Camp's photographs palpably captured the decay of the great monuments, half-buried under mountains of sand. One can almost smell the sand and dust. The views delighted people at home, who indulged themselves in an exquisite new malaise they diagnosed as "yearning for ruins." To satisfy this taste, 19th-century painters of the picturesque had made veritable inventories of dilapidated buildings, everything from collapsing cathedrals to moss-covered mills. These artists liked photography for its power to render the decrepitude of their favorite motifs so faithfully. One of them, Henry Peach Robinson, discovered that even distant swirls of dust were clearly discernible in photographs. After two years of travel, Du Camp and Flaubert returned to France, and soon everybody in Paris was talking about Du Camp's photographs.

In 1852, 122 prints made from Du Camp's negatives appeared in *Egypte, Nubie, Palestine et Syrie,* a book published by Blanquart-Evrard and the first volume of original photographs to be produced in France. Louis de Cormenin lavished praise on Du Camp's mathematically exact technical aptitude and his charming and capricious artistic approach. While Flaubert continued his involvement with Madame Bovary, Du Camp was being lionized by the French capital. He received the cross of the Legion of Honor from Napoleon III personally, and from Baudelaire the dedication of *Le Voyage,* in which the poet expressed his wonder at those

travelers and the awesome stories he read in their eyes, unfathomable like the sea, and asked them to share the glittering treasures of their memories.

A few years later Du Camp had put all that behind him. Considering his passion for photography a youthful folly, he gave it up in favor of literature. Ironically, no one reads him today, while his camera work enjoys a secure and prominent place in the annals of photography.

During Maxime Du Camp's sojourn in Egypt, Francis Frith was sitting in the office of a wholesale grocery emporium in Liverpool, bored to death. He found trade in such basic necessities vulgar, unethical, even dishonest, and the mechanical accumulation of money despicable. Frith came from a Quaker family in Chesterfield. His father knew the Bible by heart and recited Shakespeare with great dramatic effect. In his youth Frith had roamed the green hills of Derbyshire, hunting snipe and robbing bird's nests. He vividly remembered his first attack of *wanderlust*, which struck him in the menagerie at Woombell. The penetrating smell of wild beasts, like the first sight of a hyena baring its sharp teeth and the proud strut of a stork, stayed with him all his life.

Frith was a typical product of the Empire in that he saw himself going to seed in gloomy old Liverpool while his compatriots appeared to be leading adventurous lives in India and China. So he decided to travel, and to do it in the Middle East, since the sight of the Pyramids would surely change his life forever. When he landed in Alexandria in September 1856 the interior of Africa was still virgin territory. Not until two years later did Sir Richard Burton and John Speke begin their search for the source of the Nile, and the famous meeting of Stanley and Livingstone would not occur for another fifteen years. Between 1856 and 1859 Frith penetrated deeper into Africa than any photographer before him. On his last expedition he lugged his collapsible wooden camera, barrels of distilled water, and darkroom tent 1,500 miles across the desert to the Fifth Cataract. On another trip he retraced

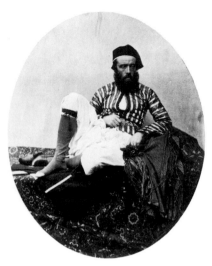

Francis Frith (1822–98) in his Turkish summer costume.

Moses' footsteps across the Wadi Feiran in the Sinai, photographing the dreary shores of the Dead Sea and discovering that the water of Lake Genesareth was too salty for washing negatives. Damascus disappointed him because it had but one mosque, whereas he had expected a forest of minarets like that in Cairo.

Frith faithfully photographed all the monuments described in Sir Gardner Wilkinson's *Hand-Book for Travellers in Egypt:* the Pyramids and the Sphinx, the colossi at Thebes and Abu Simbel, and the island of Philae. According to Frith, he merely followed the call of a romantic and perfect past, vastly more interesting than an unnatural and hectic present.

Egypt's own hectic present was of no interest to Frith. He never photographed talkative customs officials or begging Arabs, leprous Bedouins or fellahin tilling the fields with stone ploughs. Like Du Camp, Frith found the natives useful only as extras in his compositions. Drawn to the Pyramids and their "mysterious majesty," he simply did not notice the poor who lived among the ruins. His photograph of a crocodile on the Nile embankment is an exception. The creature seems posed like a prehistoric monster—a perfect symbol of dark, dangerous Africa.

In Frith's time the archaeological sites looked quite different from their present-day appearance. During the last 140 years some of the monuments have been vandalized beyond recognition, with columns sawn up for millstones, the facing of the Pyramids peeled off and used for public building, and the limestone scraped from temple walls.

Frith photographed the Sphinx when its front paws were still hidden in the sand and the temples at Philae before they had been flooded for the sake of the second dam at Aswan. He almost always took two views, one of the whole monument and another of a detail. Moreover, while photographing the thicket of columns and the monumental temples at Luxor, he never forgot small things, such as the graffiti on columns.

On his trips Frith disguised himself as a Middle Easterner. Usually he wore a Turkish costume, a saber stuck in his belt, and a turban to hide his European hair. This masquerade was practical in a time when Turkey dominated the Middle East, and it gained him the respect of the natives. His darkroom wagon also proved a great success, since villagers were convinced it contained a harem of English beauties. Frith always felt particularly Middle Eastern when he visited the souks in Cairo. There, the former grocer bargained with the same passion as the Cairenes. After months of negotiation, he acquired an illustrated Koran for a ridiculous price from a "genuine priest." He later gave the eight-hundred-year-old volume to the British Museum.

To escape the heat, Frith would put up his tent in the shadow of the temple ruins he was photographing. The tent was very dark, although woven from willow branches, which allowed air to circulate but could not prevent the temperature inside from rising to 125°. When Frith tried to do his developing in a pharaonic tomb, claustrophobia forced him out. Bats flitted overhead, and dust whirled up at the slightest movement, only to settle on his plates. Spending a night in a tomb at the foot of the Pyramids he was attacked by a pack of wild dogs and forced to seek refuge in the open desert. And even Frith suffered from homesickness. In Luxor he, like everyone else, went to the post office immediately upon landing and only then visited the temples.

By 1860 Frith was famous. When he attended a meeting at the Royal Photographic Society shortly after his return, the chairman impulsively interrupted his speech to announce the traveling photographer's arrival. For the rest of the evening Frith was the center of everyone's interest, the frenetic applause he inspired duly recorded in the minutes.

Frith's two-volume *Egypt and Palestine Photographed and Described* was issued in an edition of 2,000, the most expensive publication of its time. Each of the 140,000 photographs are albumen prints made by hand and tipped into the books. The London *Times* considered them the best

photographs ever taken. The rarest of Frith's books is a 170-copy edition of the Bible illustrated with photographs of Palestine. The publication sold for fifty guineas and proved so popular that forgeries were made.

Thereafter, Frith resumed "normal" life, married Mary Ann Rosling, a Quaker girl from his native district, and soon became what he had never wanted to be, a businessman. In 1860 he opened Frith and Co. in Reigate, sending photographers all over the world and selling their products to candy manufacturers, newspaper stalls, and tobacco shops. Some two thousand photography shops carried his postcards, and his albumen prints were readily available in England's larger towns. By the end of the 1870s Frith had become the world's largest manufacturer of photographs. In

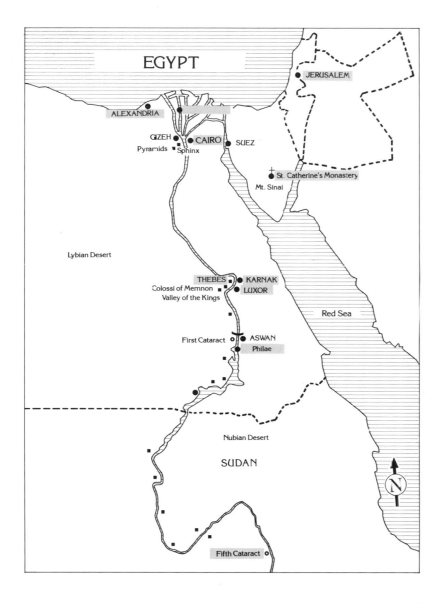

Francis Frith's travels in Egypt between 1856 and 1859 were a sort of dress rehearsal for the classic grand tours that Europeans would soon make along the Nile, beginning in Cairo with the Pyramids and continuing south to Abu Simbel via Luxor and the Island of Philae.

his warehouse near Reigate he stocked a million photographs and such accessories as lockets, frames, and leather albums. The back of the photographs revealed the imprint of the "Frith's Series" blind stamp.

Frith had developed into a solid, successful businessman, but one with a soul. He traveled with his wife and children, a nurse, and a driver in a comfortably upholstered carriage. He went to Scotland by train, got out at a promising spot, and set off on horseback to photograph castles and mansions, farmers' cottages and churches, river bends and waterfalls. He often waited hours, and sometimes days, for the right weather and the right light.

From time to time the Friths would visit Quaker acquaintances. While Mary Ann stayed in the house for tea and talk, Frith went out to take pictures. In a diary she kept of the family excursions, Mary Ann placidly reported all the activities of picnics, duly noting how Francis started a fire, boiled eggs, made tea, etc. Frith's albums of the English countryside provide a glimpse of his family life. Thus, we know that the lady in the flowered hat with her skirt spread over the bank of a lake is Mary Ann.

In middle age Frith reverted to the hobbies of his youth and went fishing in the rivers of Derbyshire. On Sundays the family assembled before the fire and someone read Browning or Longfellow, Tennyson or Carlyle, and Frith recited Shakespeare, now with dramatic effect. The winter months were spent in Cannes and San Remo to alleviate Frith's bronchial asthma. By then, the Egyptian adventure had been buried in the sands of time.

Frith and Co. went out of business a hundred years later. On February 4, 1971, the photographic historian Bill Jay reported that the Reigate factory looked like the village dump. Photographic plates in rusty tin boxes and rotting cartons of photographs lay all over the place. In the middle of the mess loomed a heap of broken glass smashed by the workmen— to transform Frith's plates into material for the foundation of a new concrete building.

3
Greenland

A Cheerful Outing Among the Icebergs

Dunmore and Critcherson

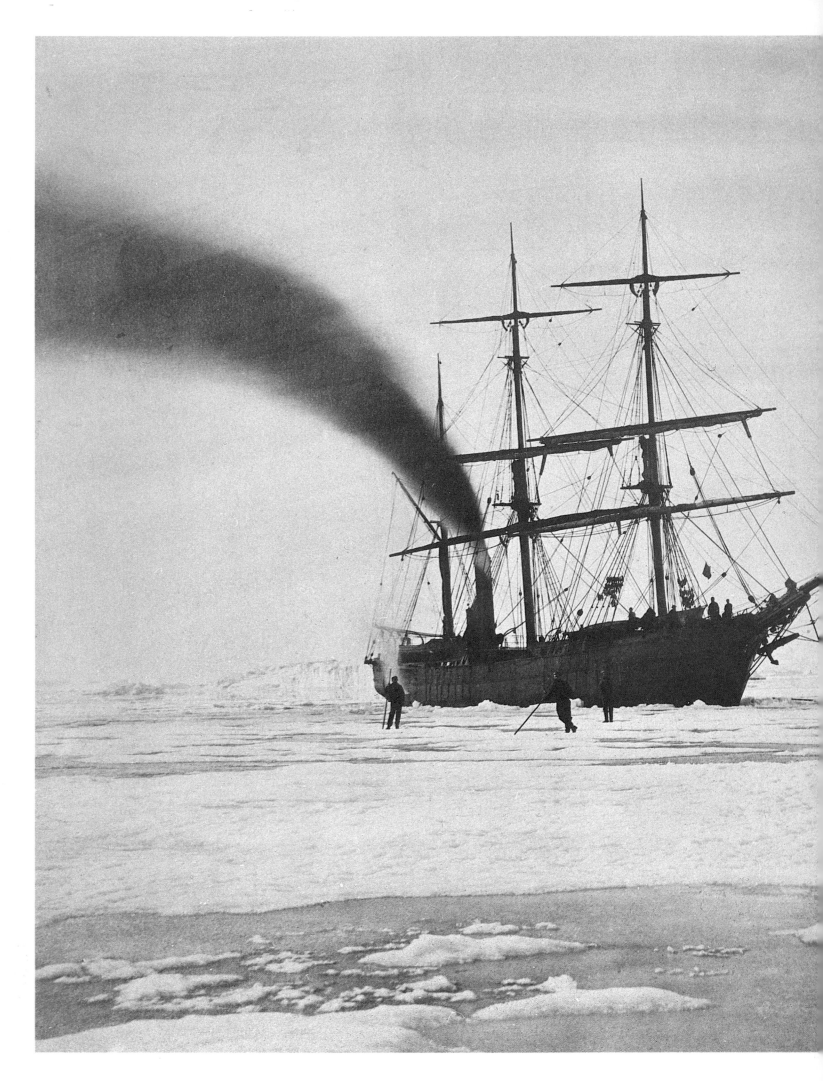

Dunmore and Critcherson, After the Polar Bear Hunt in Melville Bay, Greenland, 1869.
Agfa-Gevaert Historama, Leverkusen, West Germany.

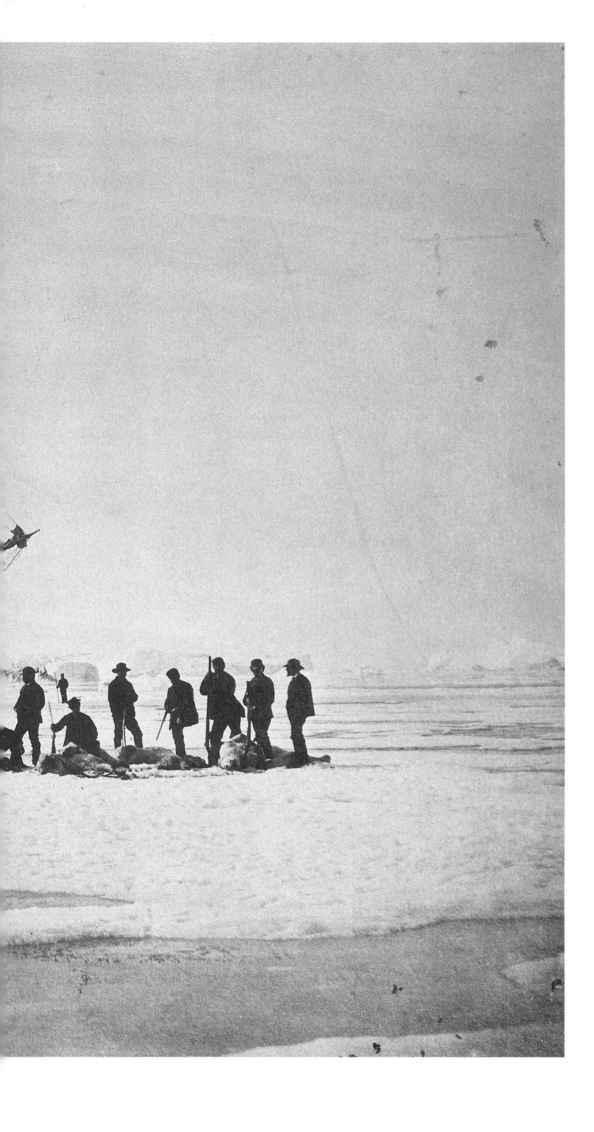

This photograph was made with a
ten-second exposure, causing the
smoke from the *Panther's* stack
to resemble a flag.

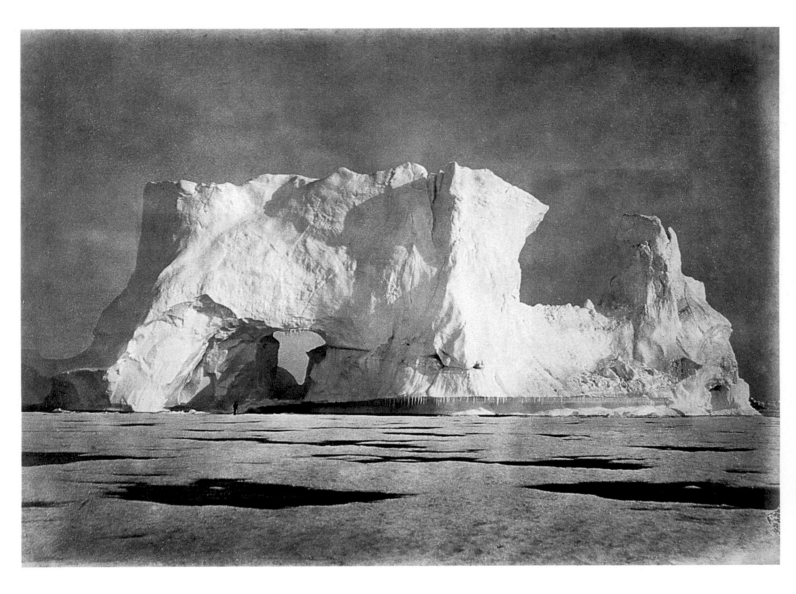

Dunmore and Critcherson, Icebergs in Baffin's Bay, 1869.
International Museum of Photography, George Eastman House, Rochester, N.Y.

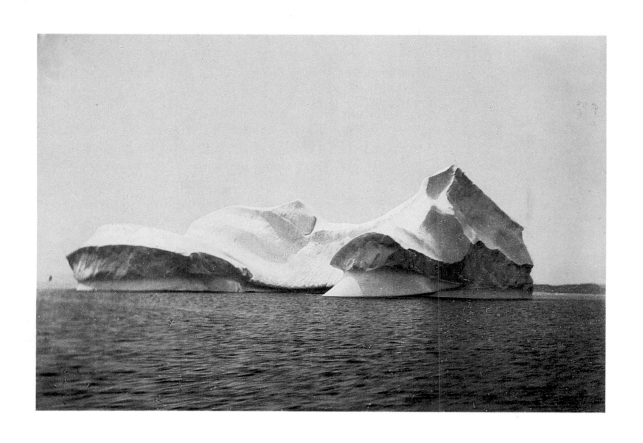

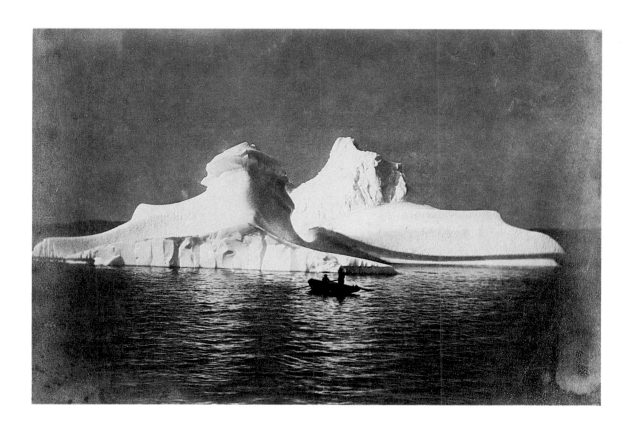

William Bradford's pleasure voyage into the Arctic regions ended on August 19, 1869, when the ice of Greenland's gathering winter threatened to immobilize the ship. Dunmore noted in his diary that it seemed high time the party sail for home.

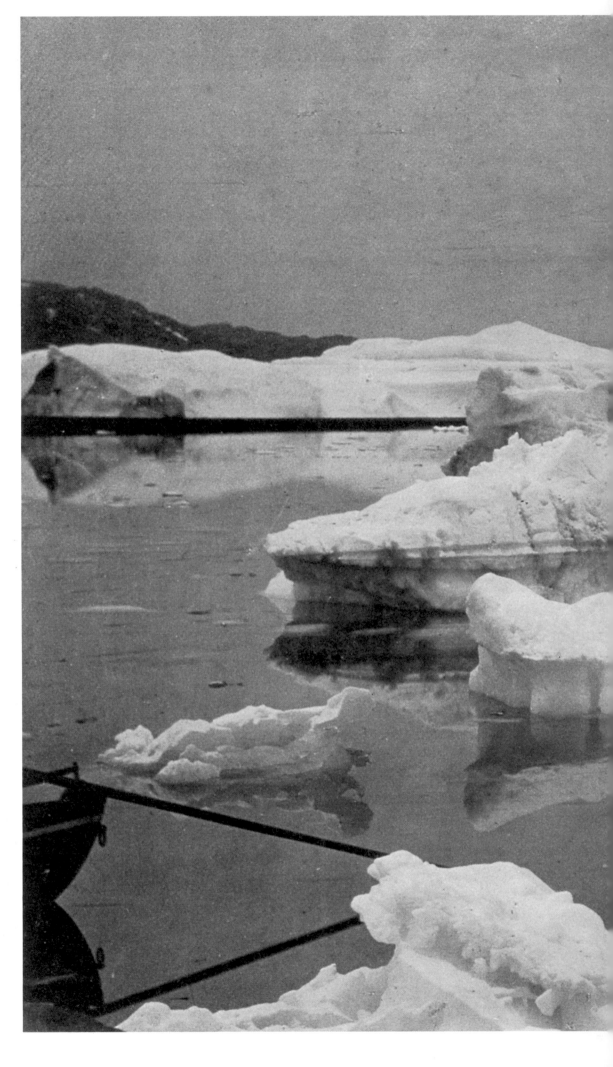

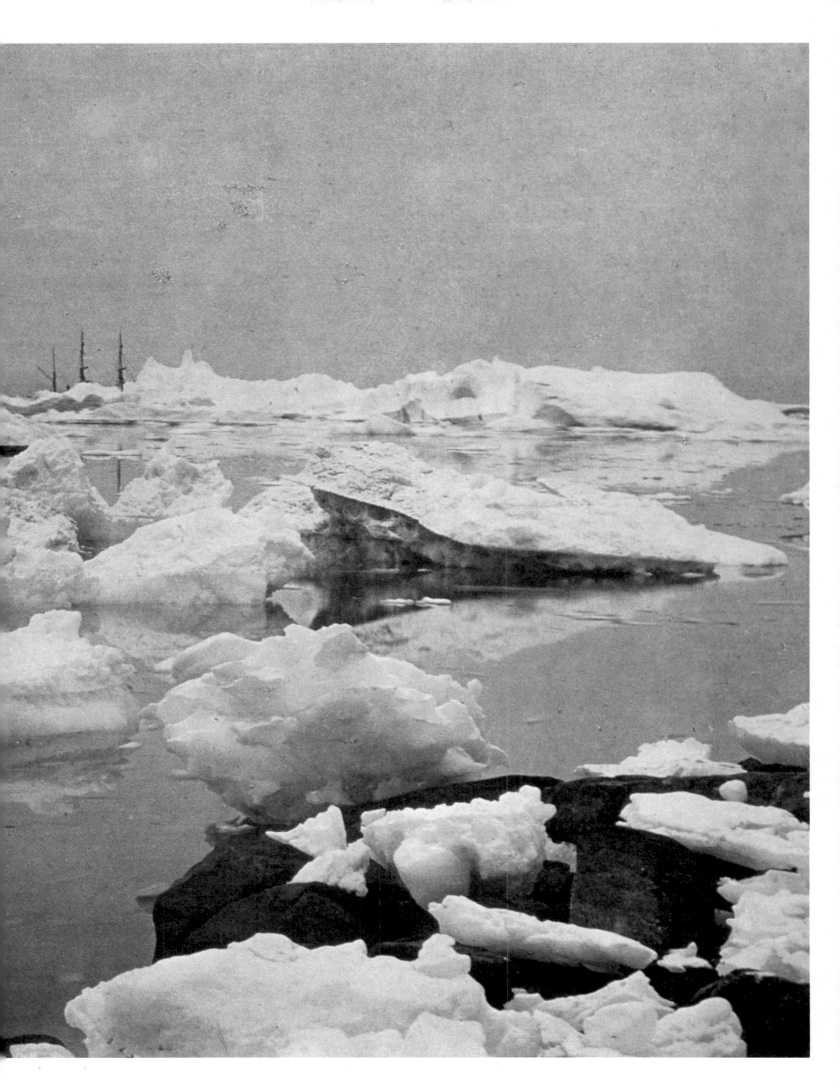

Dunmore and Critcherson, The Three-masted *Panther* Among the Icebergs Near the Coast of Greenland, 1869.
International Museum of Photography, George Eastman House, Rochester, N.Y.

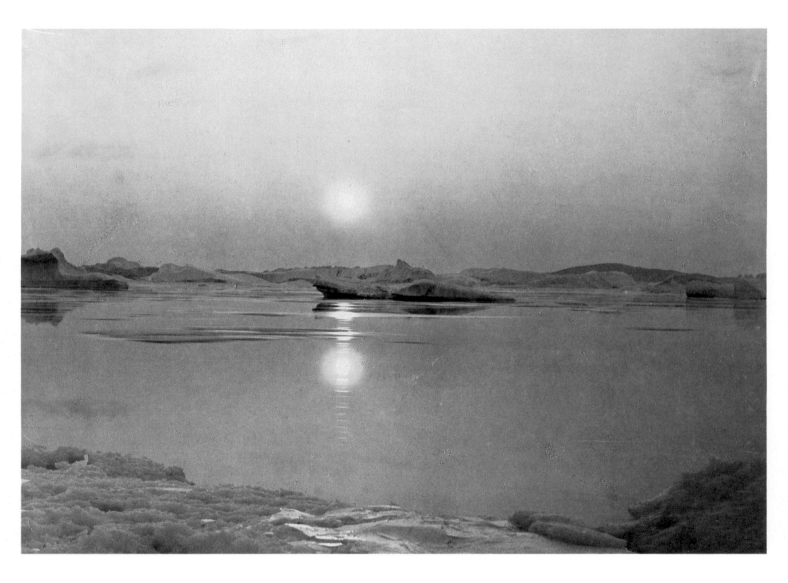

Dunmore and Critcherson, The Midnight Sun over Melville Bay in August, 1869.
Janet Lehr Gallery, New York.

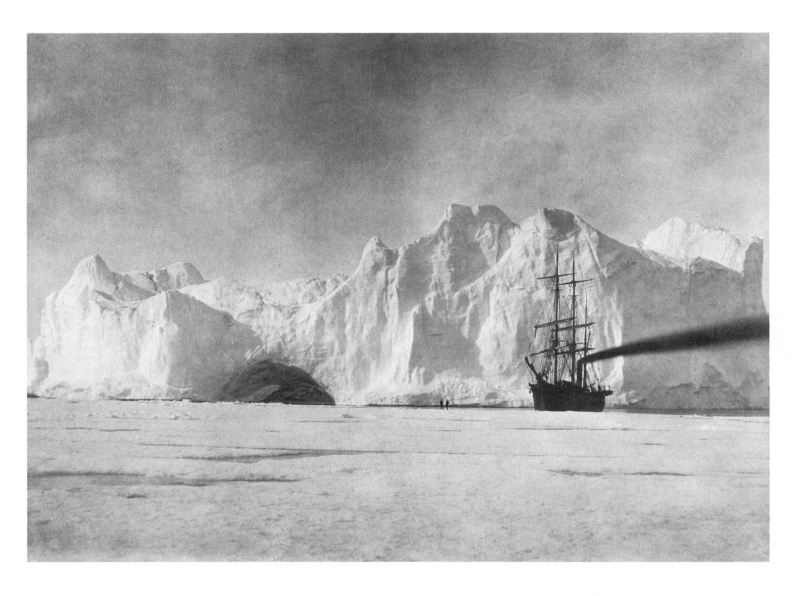

Dunmore and Critcherson, William Bradford and His Companions, 1869.
International Museum of Photography, George Eastman House, Rochester, N.Y.

Dunmore found the glare created by reflected light
to be the most serious photographic problem he
encountered in the Arctic. The picture of the midnight
sun is undoubtedly one of the finer photographs that
Dunmore and Critcherson made while visiting the
North Pole.

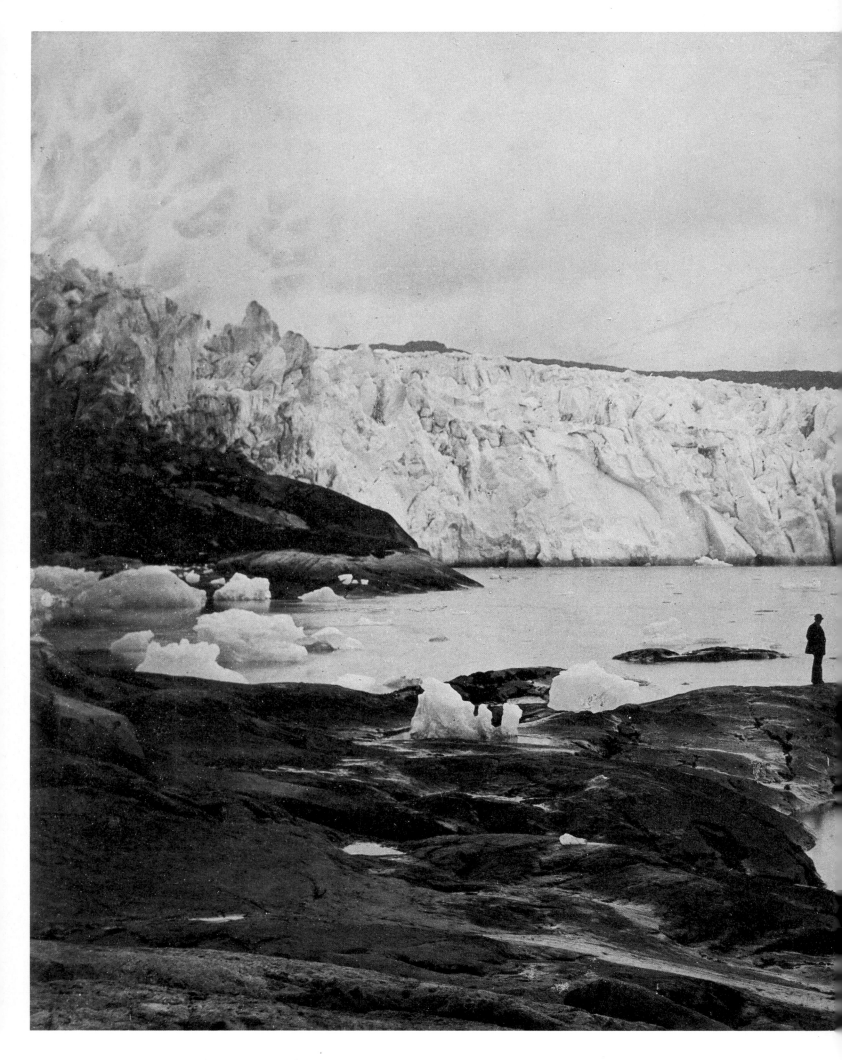

Dunmore and Critcherson, Between Icebergs and Field Ice,
the *Panther* Fires Up to Escape Being Forced into the Bergs, 1869.
International Museum of Photography, George Eastman House, Rochester, N.Y.

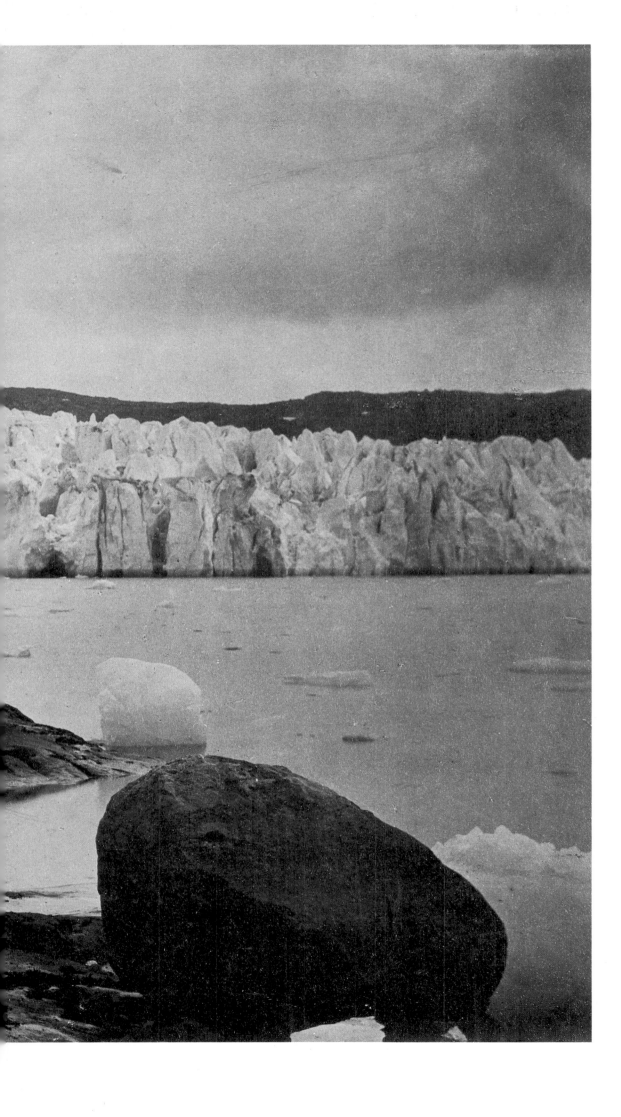

Melville Bay was the northernmost spot visited by the *Panther* in 1869 with the photographers Dunmore and Critcherson on board.

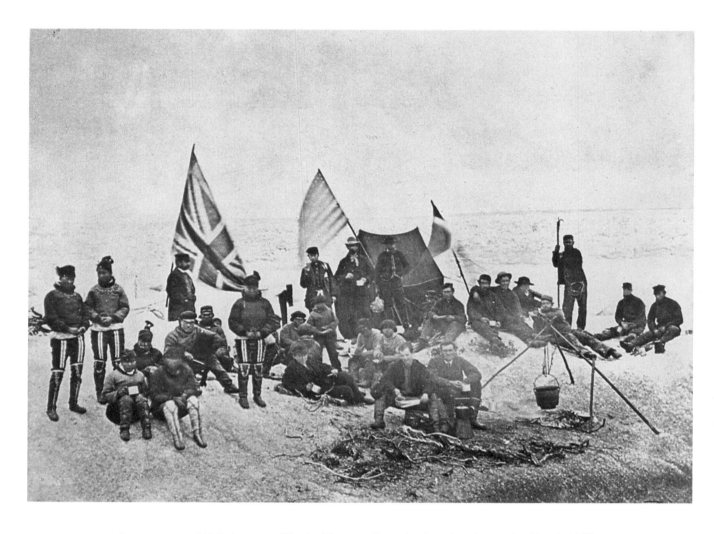

Dunmore and Critcherson, Glacier Flowing Over the Land and into the Fjord, 1869.
International Museum of Photography, George Eastman House, Rochester, N.Y.

3
Greenland
A Cheerful Outing
Among the Icebergs

On November 10, 1869, John Dunmore wrote a letter to a photography magazine in Philadelphia, telling its readers that he had recently returned from Arctic regions and thought they might like to hear about the experience. He sounded surprisingly like a tourist just back from a holiday.

Early in the summer of 1869 the American painter William Bradford had invited artists and veterans of the Civil War to join him on a journey to the Arctic. He chartered the sealer *Panther*, stocked her with food, warm clothing, and many sketchbooks, and then took along two photographers, Dunmore and Critcherson, from Black's Studio in Boston. A specialist in the Arctic, Bradford wanted "to study Nature under the terrible aspects of the Frigid Zone." He had grown up in New Bedford, Mass., in those days a great whaling center and a place where a youth could hear many firsthand tales of icebergs and seals. The young Bradford had read the just-published *Moby Dick*, as well as the local newspaper accounts of the adventures undergone by Polar explorers. Sailing on the schooner *Benjamin S. Wright*, Bradford took his own first trip to the Arctic in 1864 and there painted a number of Polar scenes.

The Arctic attracted Bradford less for the adventure it offered than for the translucent quality of the northern light. And his trip to Greenland assumed the character of a cheerful outing more than a dangerous and perhaps fatal expedition. The Sunday painters who accompanied him made it seem particularly so since their main purpose was to

acquire skill in depicting the cold Arctic light with the normal colors of a painter's palette.

Dunmore and Critcherson were not exactly rugged types on the order of Roald Amundsen, and in all probability they were not even professional outdoor photographers. By the time they made their first stop, Dunmore had already lost heart. Noting that some of his plates were broken, he had to disembark at Halifax and, in desperation, scour the town until replacements could be found.

In St. John's the travelers had to wait a full week while their boat took on coal. To kill time, Dunmore shot thirty pictures of the town and its environs. Even so, he was not exactly raring to go when they finally left St. John's. The whole party succumbed to seasickness, as well as to some form of dysentery, and Dunmore admitted that his sense of patriotic duty had grown a bit frail. By the time the party reached the southern coast of Greenland, he would not have minded turning back immediately since the landscape offered nothing but rocks and icebergs.

In Julianehaab the vacationers were almost eaten alive by mosquitoes and flies. This did nothing to lift their sinking spirits, and so they quickly sailed north. While absorbed in the "birthing" of a glacier at Kaksimuet, they suddenly got soaked in spray from a large wave. Once more they went flying back to the ship, where they changed clothes and hurriedly raised their sails.

Luckily, Bradford and company did find some outposts of civilization. In southern Greenland they were received by the Danish Governor who, only too pleased to see so many new faces, plied them with whiskey and cigars. On land they almost felt like sailors. Dunmore reported that the natives smelled of cod-liver oil and spent their time dancing. Soon, whenever they went ashore, Dunmore and Critcherson went dancing too.

At Melville Bay they came across several polar bears on an ice floe. The captain steered towards them, and, banging away, the passengers shot the splendid creatures dead.

Almost despite himself, Dunmore began to be impressed by the Polar landscape. In the Alps, glaciers slide into the valley where the sun melts them like wax, causing water to run off in rivers and streams. In the Arctic, however, pieces simply break away and tumble into the sea, a process the natives call "birthing," for by it "an iceberg is born."

Photographing the cracked and fissured icebergs was difficult, due to the blinding light reflected off the vast ice fields, and Dunmore deplored the flatness of the resulting pictures. For a change, he posed Bradford and his friends behind their slaughtered bears, as though he were taking snapshots for a travel diary. But he also photographed the pale midnight sun suffusing the ice floes with an unearthly light. Disaster struck when a large wave from a birthing iceberg rolled ashore and swept away the photographers' container of collodion. Fortunately, the camera, darkroom

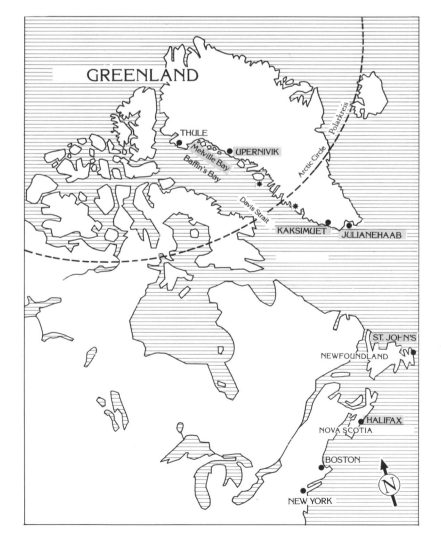

Melville Bay was the northernmost spot visited by the *Panther* in 1869 with the photographers Dunmore and Critcherson on board.

tent, and tripod were safe on top of a hill, where they had been set up.

On August 19, when snow fell all night and the temperature dropped below zero, Bradford's party, anchored in a Greenland harbor, thought it time to go home. On September 16 they went ashore for the last time to bid farewell to their local acquaintances. Then, as the Governor saluted them with cannons, they sailed south.

William Bradford's book *The Arctic Regions* contains 125 tipped-in photographs taken by the recalcitrant Dunmore and Critcherson. It constitutes the first photographic record ever made of the Arctic. In Boston, Dunmore became the hero of the year. He concluded his letter to the *Philadelphia Photographer* by pointing out that no one before him had photographed so far north, and that the remuneration had made it worthwhile.

4
Japan

Photographing the "Gate to the Sun"

Kusakabe Kimbei, Felice Beato, Baron Stillfried

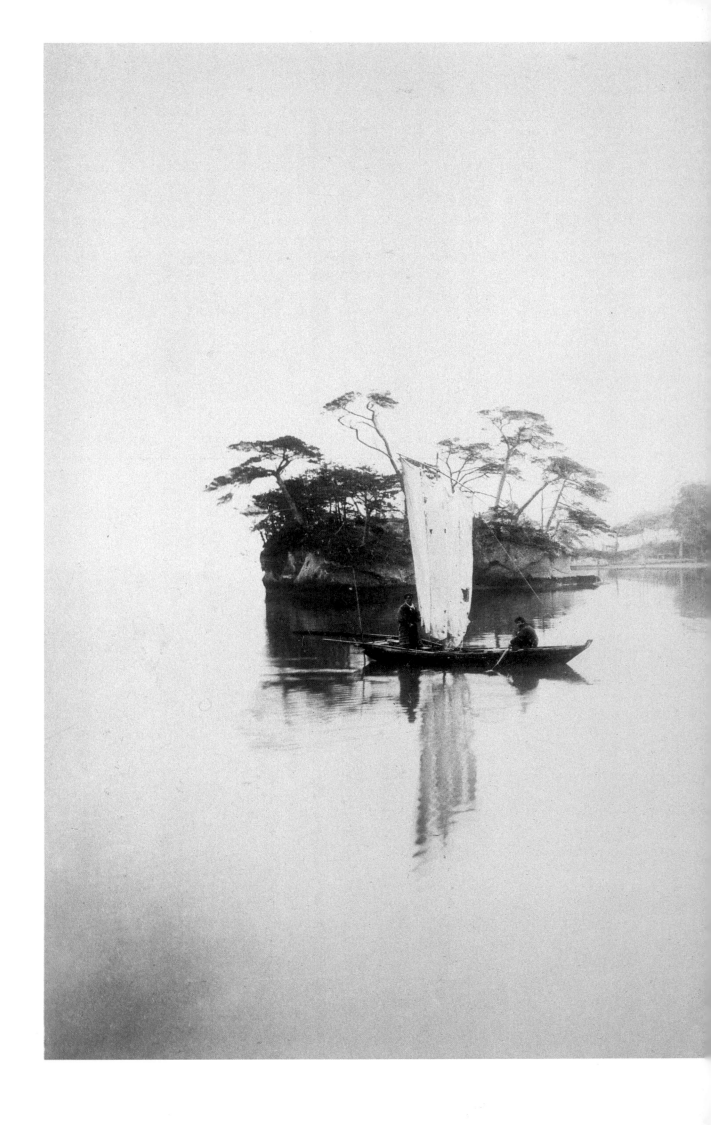

Anonymous, Coastal Landscape Along the Matsushima Inland Sea, c. 1890.
Ludwig Hoerner, Hanover.

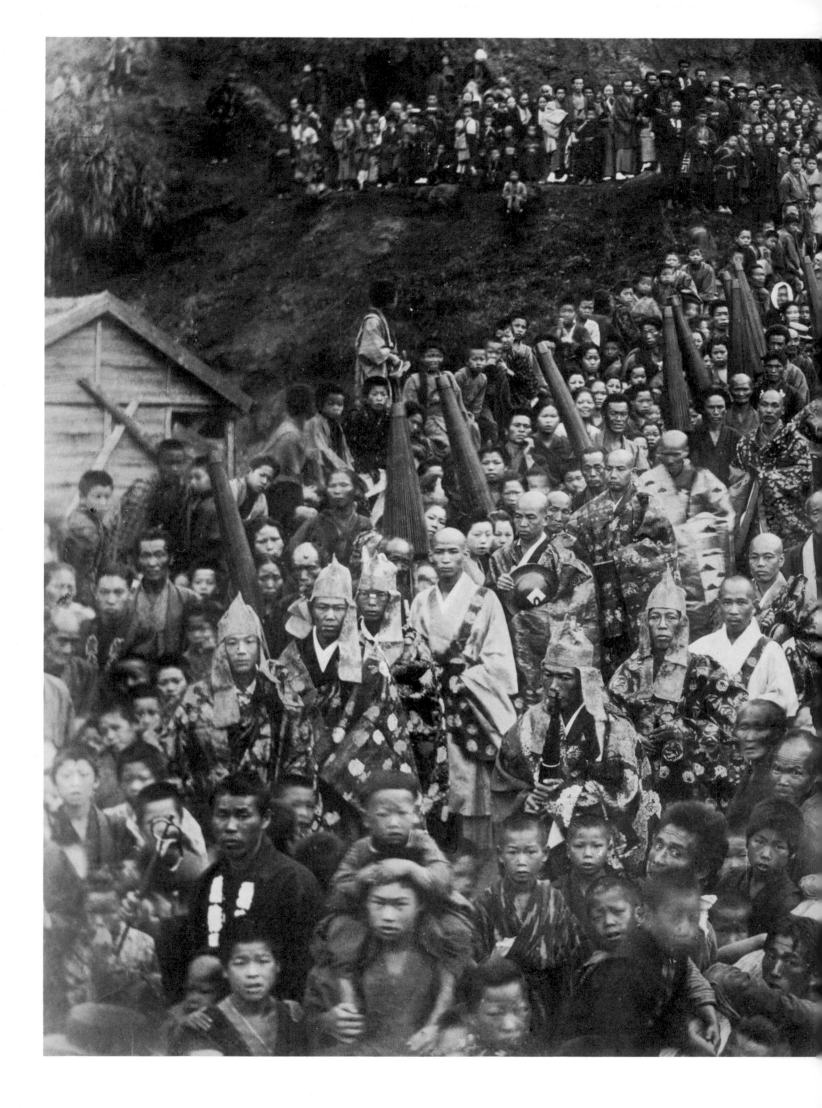

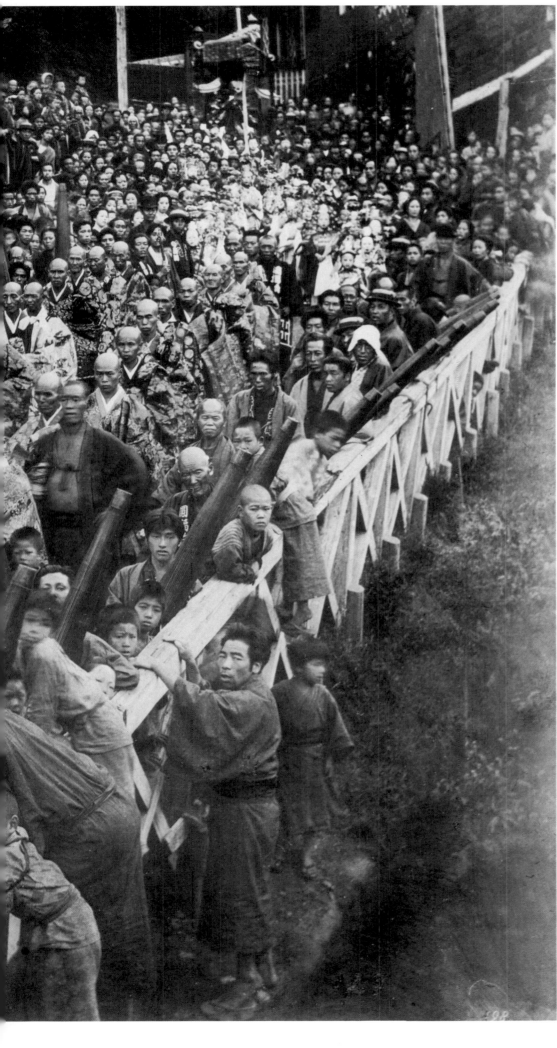

Photography in 19th-century Japan acquired its unique quality from the practice of tinting. In contrast to Westerners, the Japanese considered painted photos almost a form of art, reminiscent of their old woodcut tradition. A true master of the art was the unknown painter who colored this picture. He succeeded in suffusing two hundred faces with life, giving each one of two dozen priests a robe of different hue, and painting the fence a raw-wood color without obscuring the grain. For eyebrows and lips Japan's photographic painters used a brush composed of a single hair.

Kusakabe Kimbei, Buddhist Procession, c. 1885.
Collection Rainer Fabian, Hamburg.

83

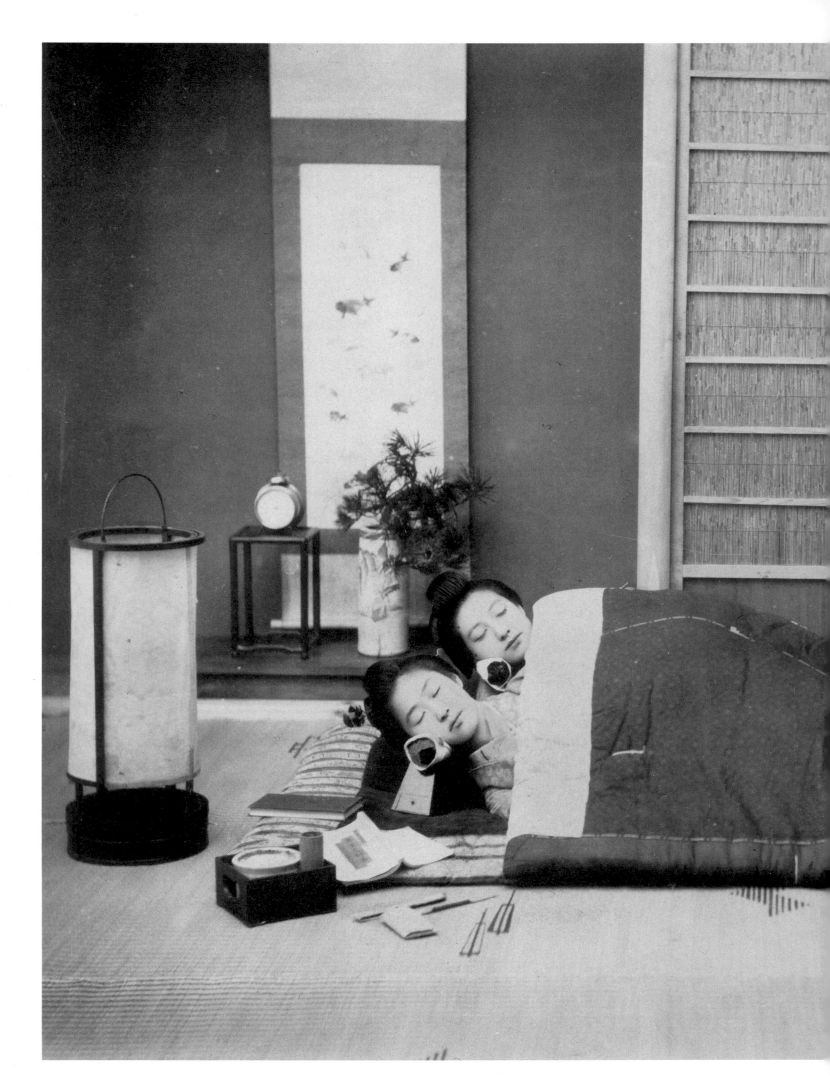

Baron Stillfried(?), Sleeping Girls, c. 1880.
Collection Rainer Fabian, Hamburg.

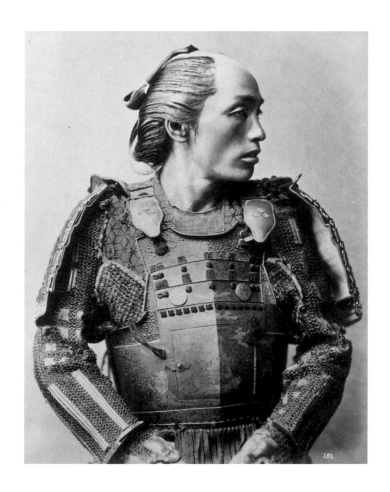

Baron Stillfried(?), Samurai in His Armor, c. 1880.
Collection Rainer Fabian, Hamburg.

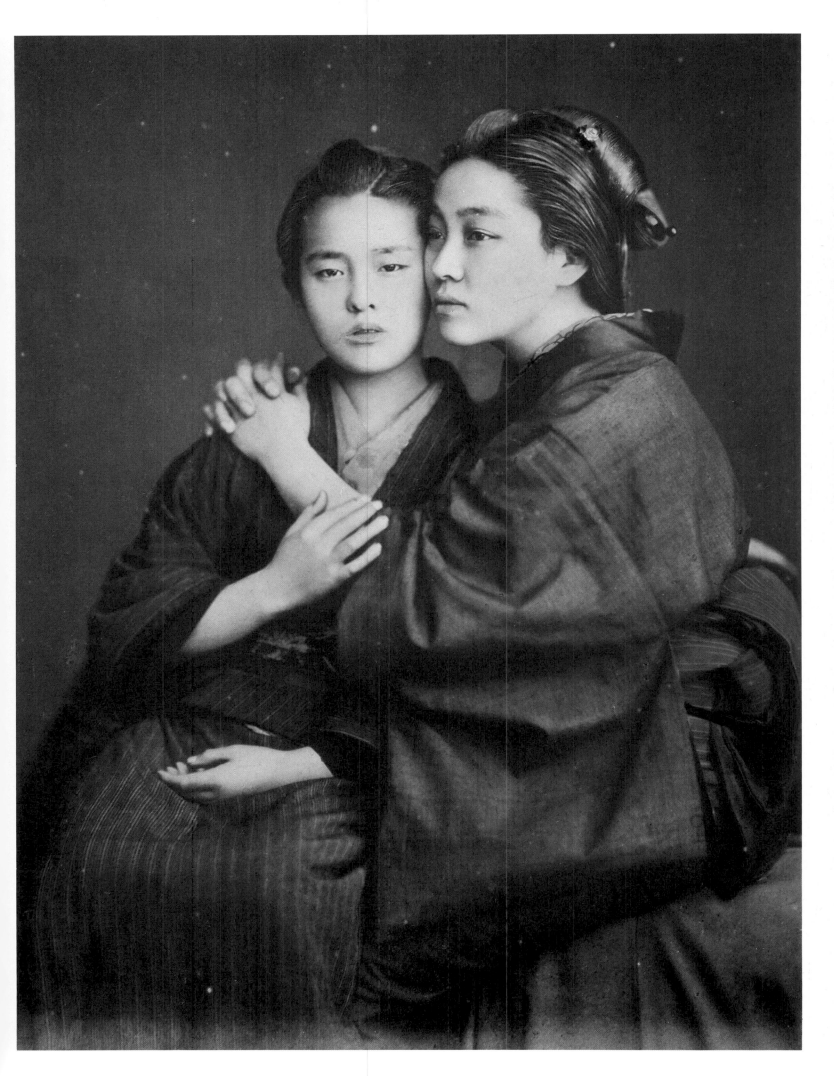

Baron Stillfried(?), Double Portrait, c. 1880.
Collection Rainer Fabian, Hamburg.

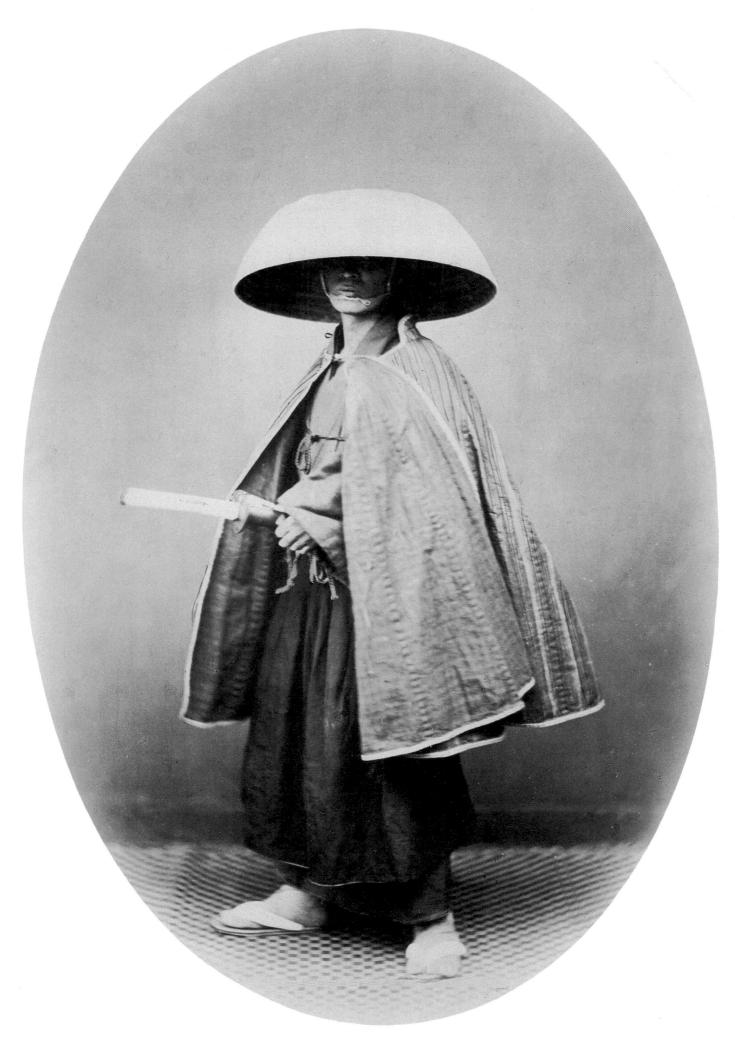

Felice Beato, Japanese Officer, c. 1875.
Collection Ken and Jenny Jacobson, Great Bardfield, England.

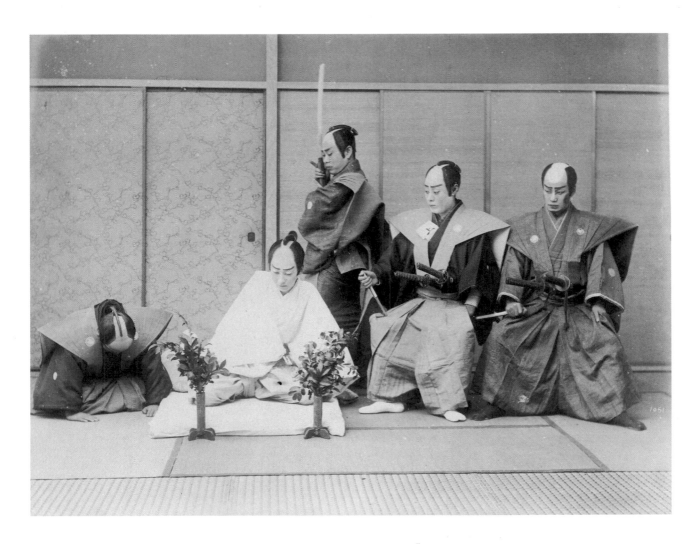

Anonymous, Harakiri in the Studio, c. 1890.
Übersee-Museum, Bremen.

Westerners loved photographs of harakiri scenes.
Although posed by actors in the studio, the images
quite realistically showed the suicide that a noble
Japanese had to commit in order to retrieve his lost
honor. In reality, when a performer of the deadly ritual
disemboweled himself, a friend would be allowed to
shorten the suffering by chopping off the victim's head.

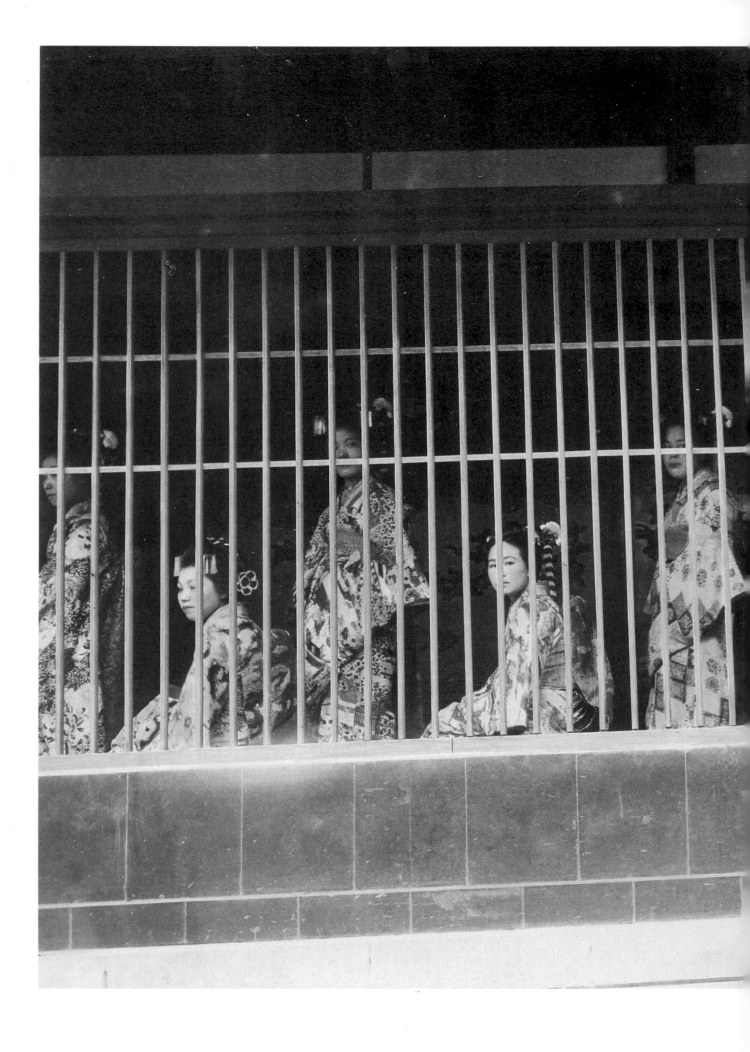

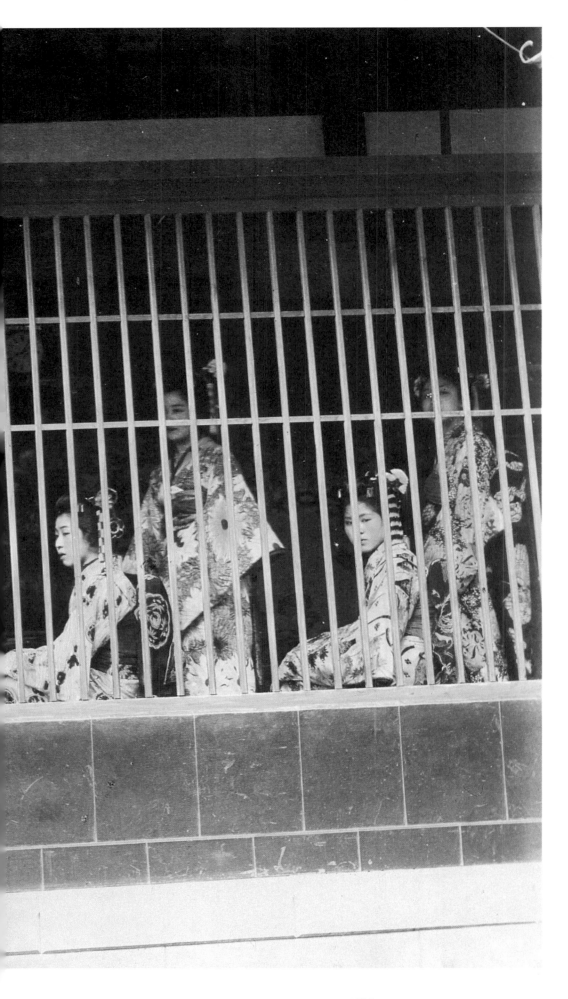

Anonymous, Japanese Prostitutes, c. 1890.
Übersee-Museum, Bremen.

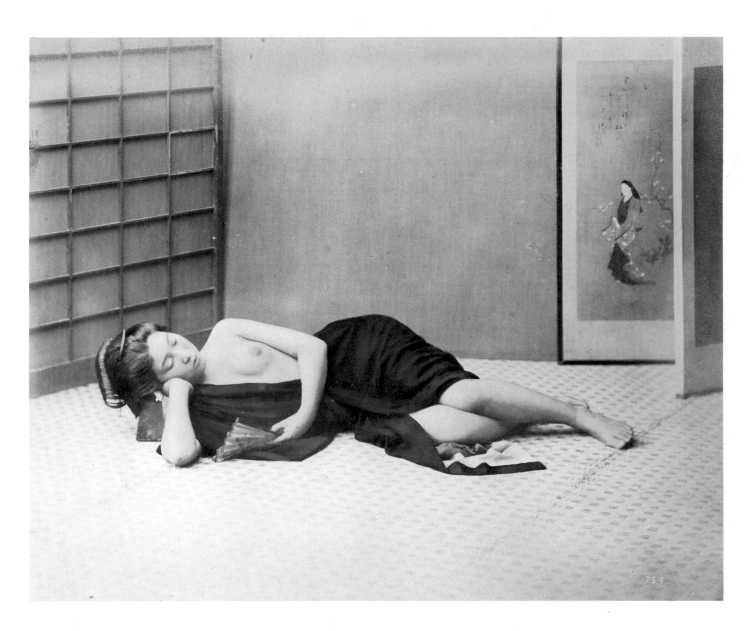

Baron Stillfried, Sleeping Woman, c. 1875.
Collection Rainer Fabian, Hamburg.

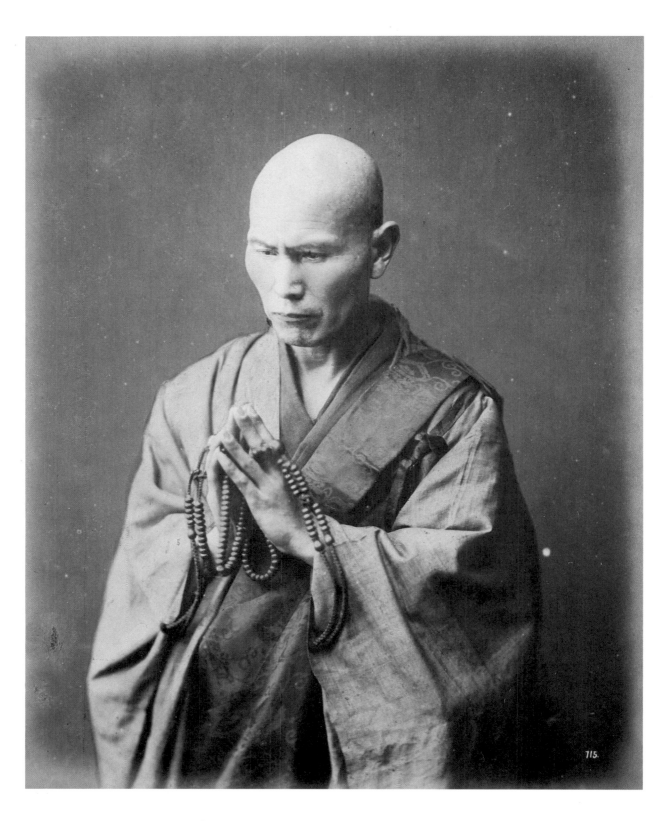

Kusakabe Kimbei, Buddhist Monk, c. 1885.
Collection Rainer Fabian, Hamburg.

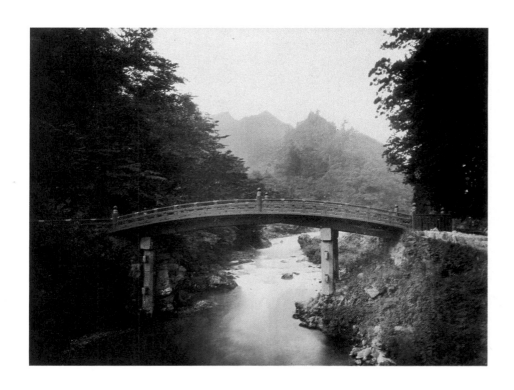

Anonymous, The Red Bridge at Nikkó, c. 1885.
Kodak Museum, Harrow, England.

Traditional colored woodcuts provided the inspiration
for Japanese landscape photography. Favorite motifs
included "idealized" landscapes in the gardens and
parks of Nikkó and along the banks of Lake Hakone,
which the poets celebrated with delicate haikus.

Anonymous, On the Banks of Lake Hakone, c. 1890.
Collection Ludwig Hoerner, Hanover.

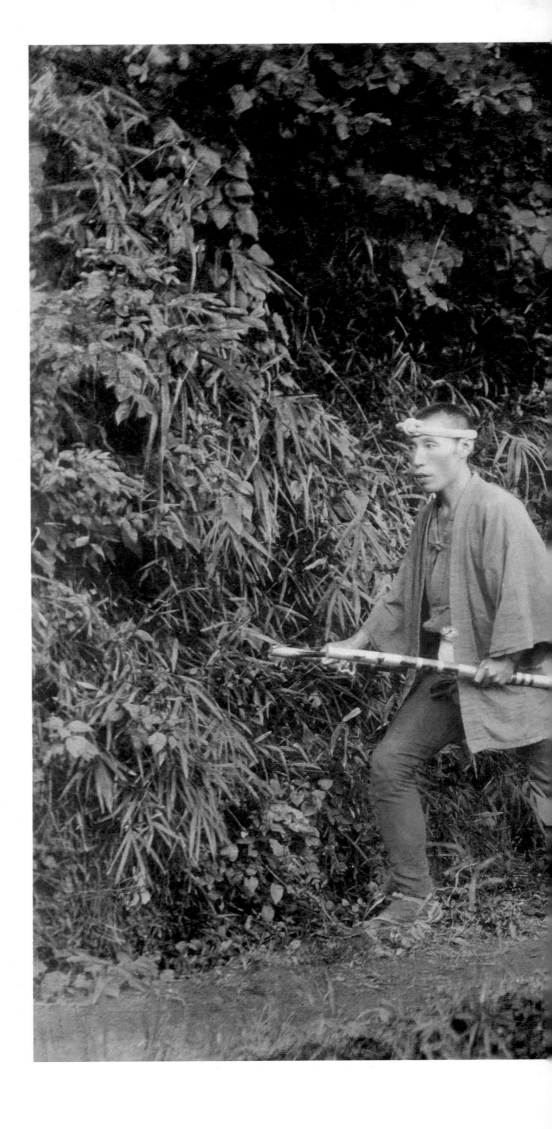

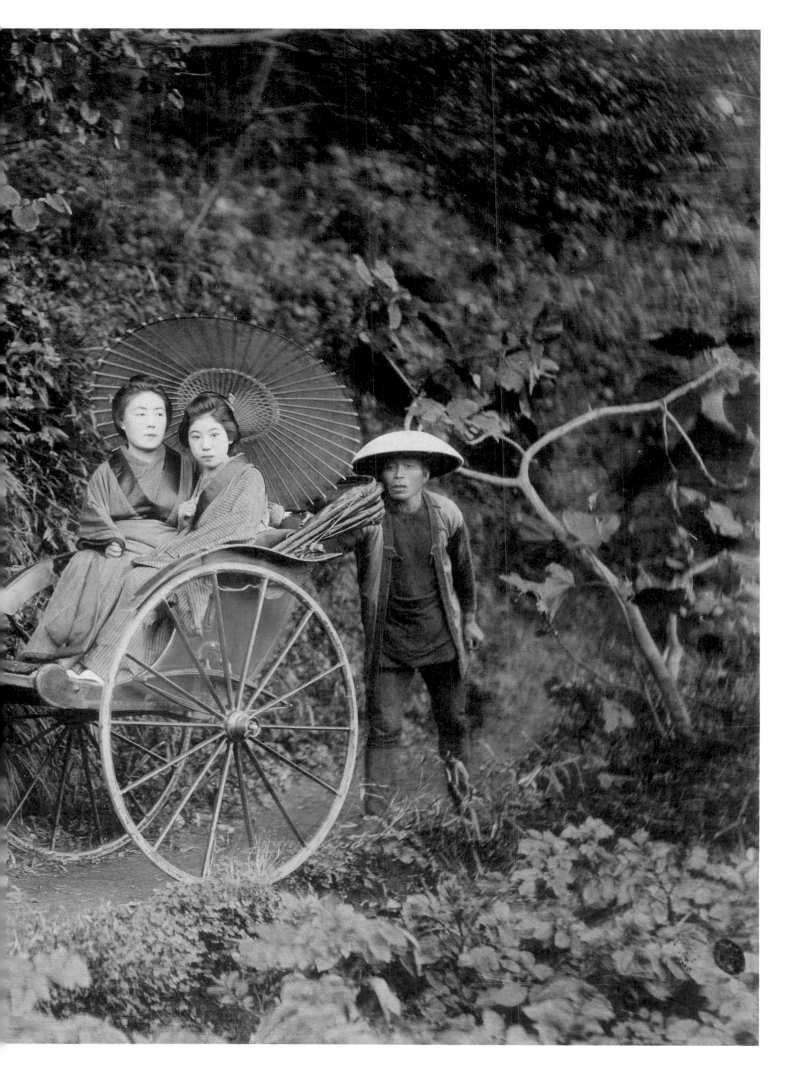

Kusakabe Kimbei(?), Two Ladies in a Riksha, c. 1880.
Collection Rainer Fabian, Hamburg.

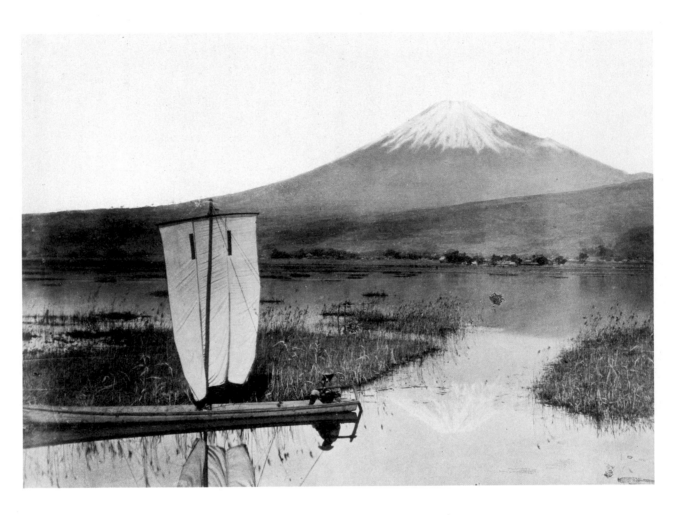

Anonymous, Fujiyama Seen from the Tokaido Highway, c. 1885.
Collection Ludwig Hoerner, Hanover.

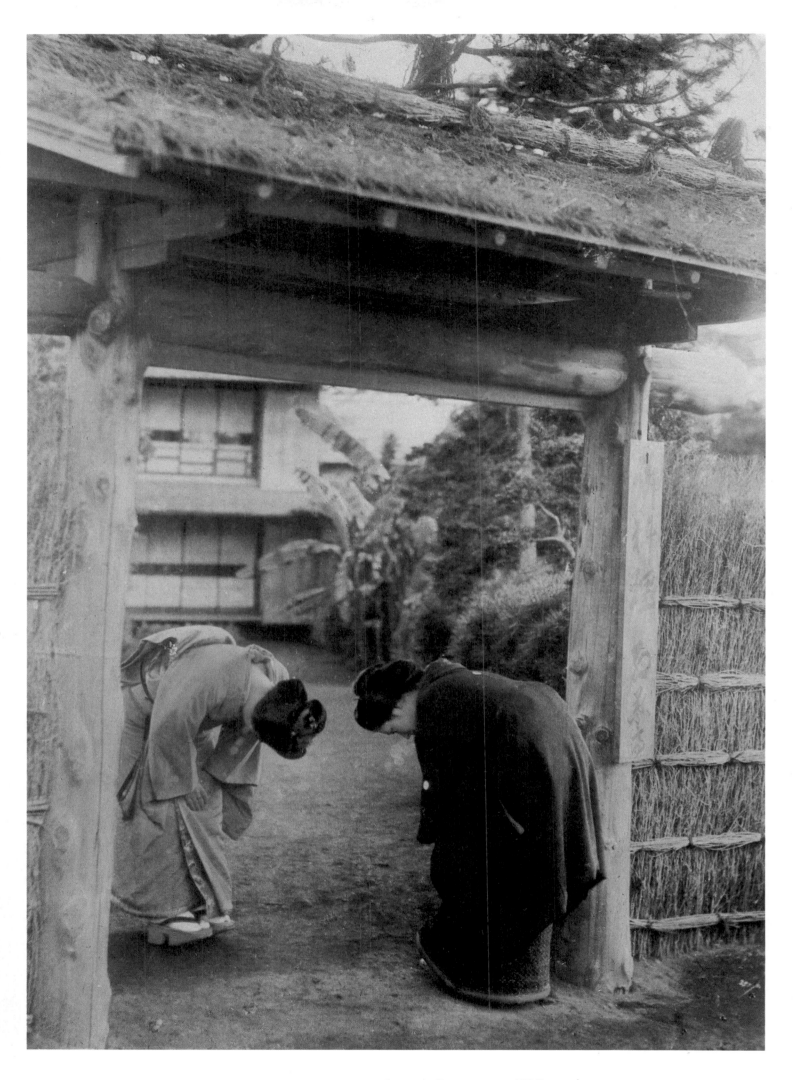

Anonymous, Japanese Greeting Ceremony, c. 1885.
Collection Ludwig Hoerner, Hanover.

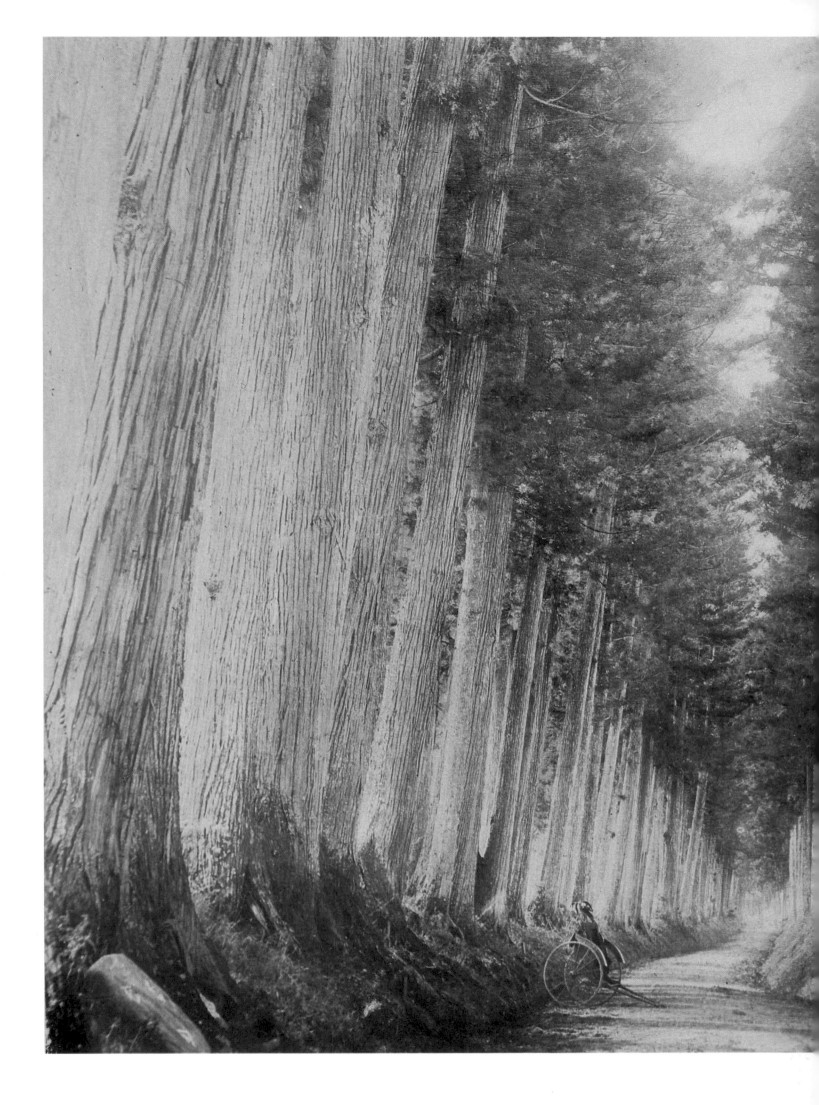

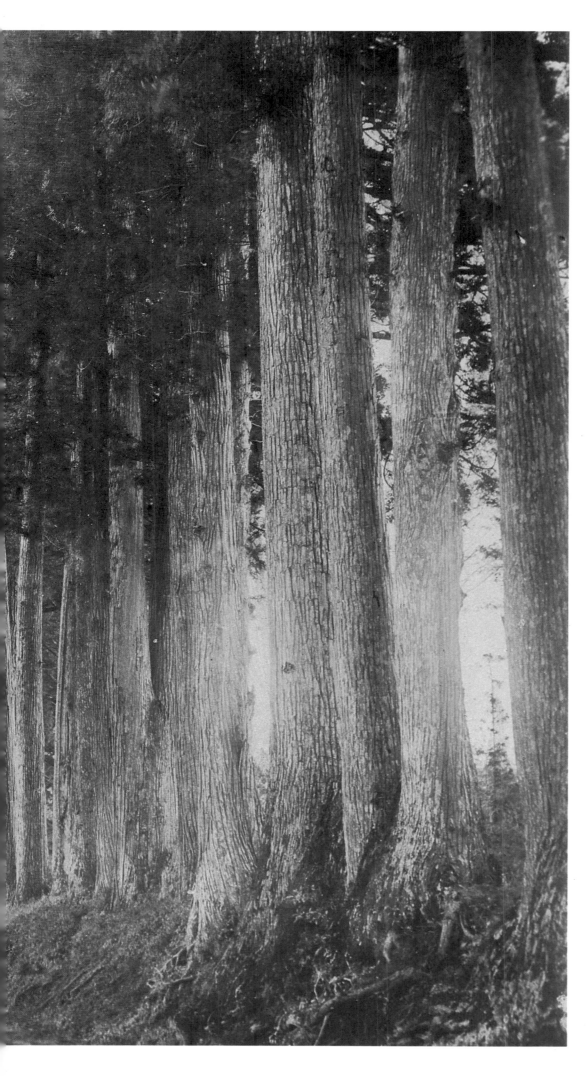

Anonymous, Allee of Giant Cedars in Nikkó, c. 1890.
Übersee-Museum, Bremen.

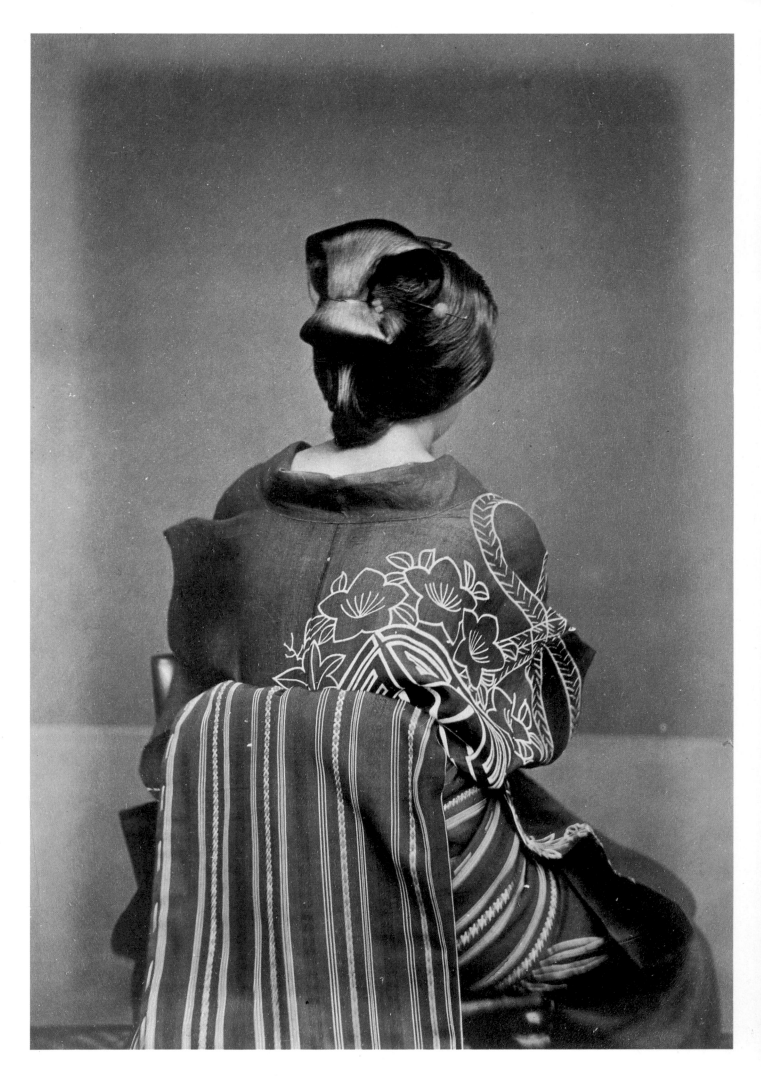

Kusakabe Kimbei(?), A Geisha with Her Back Turned, c. 1880.
Übersee-Museum, Bremen.

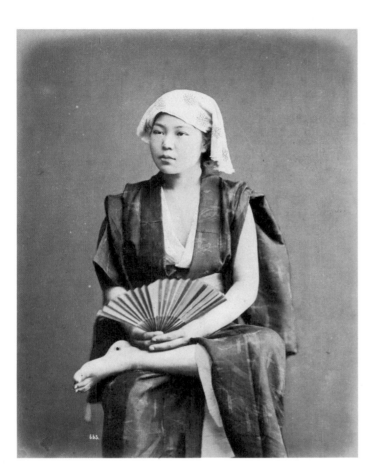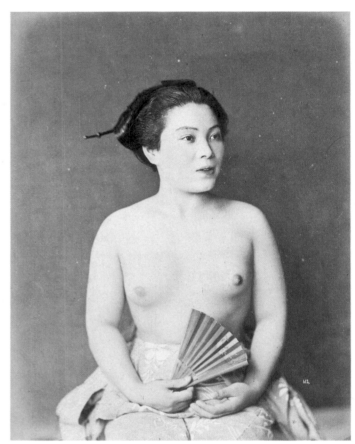

Baron Stillfried(?), Women with Fans, c. 1880.
Collection Rainer Fabian, Hamburg.

In Japan photographers occasionally worked like the director of a play, posing their "actors" in dramatic situations against some feasible background. Here thin wires were used to pull up the lady's skirt so that it would appear wind-blown. Once the picture had been taken, the photographer scratched "rain" into the glass plate. Photographs of this character often went into albums brought back by travelers. And the albums could be made of lacquered wood or even inlaid with ivory. To fill them, the buyer either ordered his pictures from photographers directly or had an agent assemble a collection for him. Despite the popularity of such genre photos, the greatest demand was for landscapes. The traveler, after all, had seen the bridge at Nikkó, and thus would have preferred a photograph of it, rather than a portrait of an unknown lady.

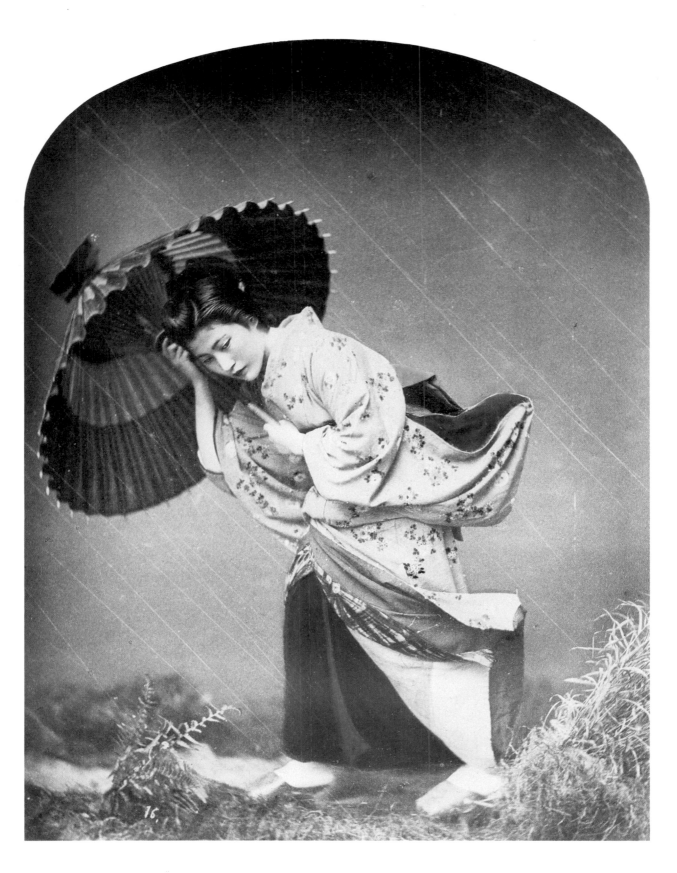

Baron Stillfried, Rain Shower in the Studio (a genre picture), c. 1875.
International Museum of Photography, George Eastman House, Rochester, N.Y.

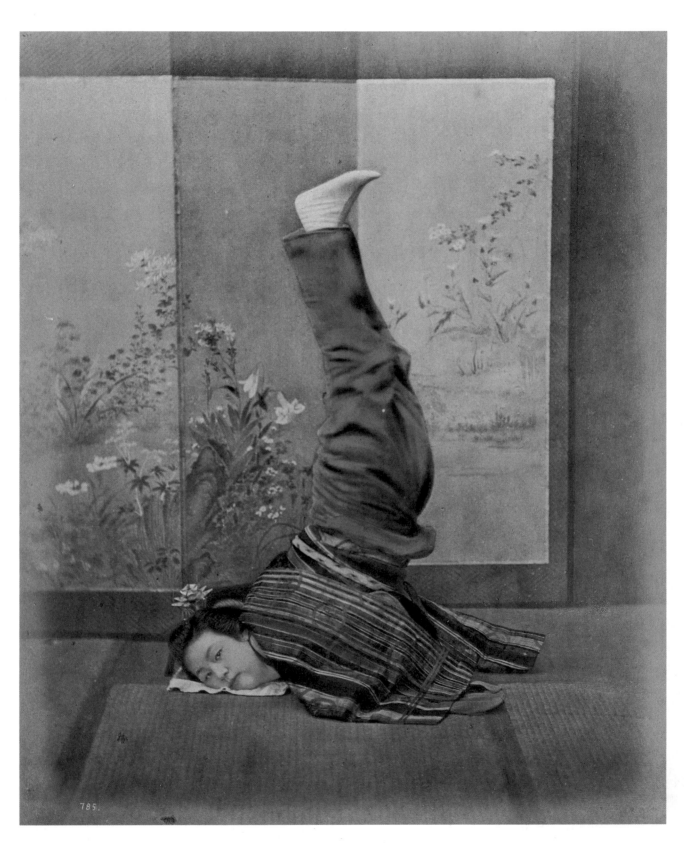

Anonymous, Gymnastics, c. 1885.
Collection Rainer Fabian, Hamburg.

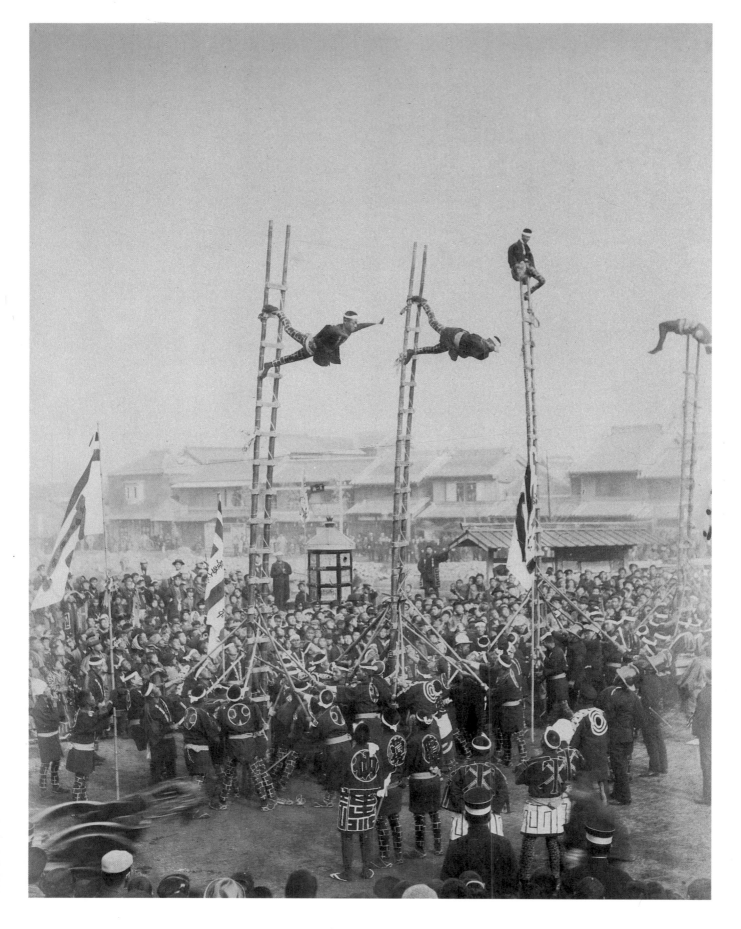

Kusakabe Kimbei, Firefighters Showing Off at the New Year's Festival, c. 1890.
Collection Rainer Fabian, Hamburg.

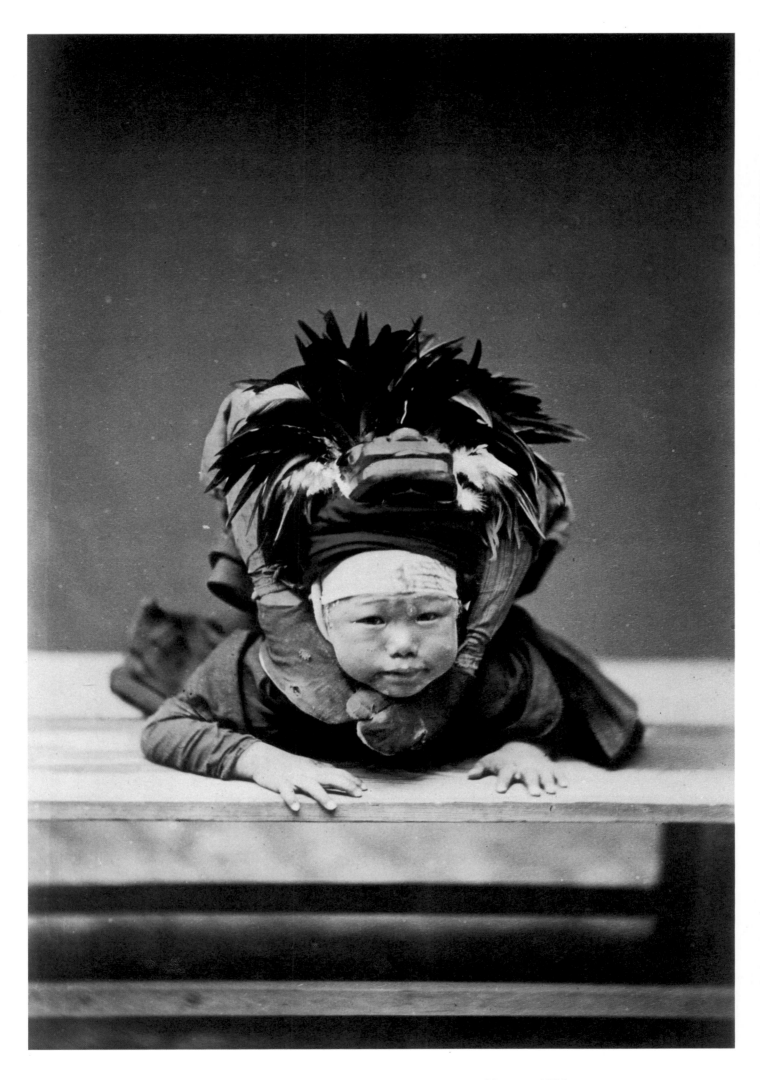

Baron Stillfried(?), Baby Acrobat with Feather Headdress, c. 1880.
Übersee-Museum, Bremen.

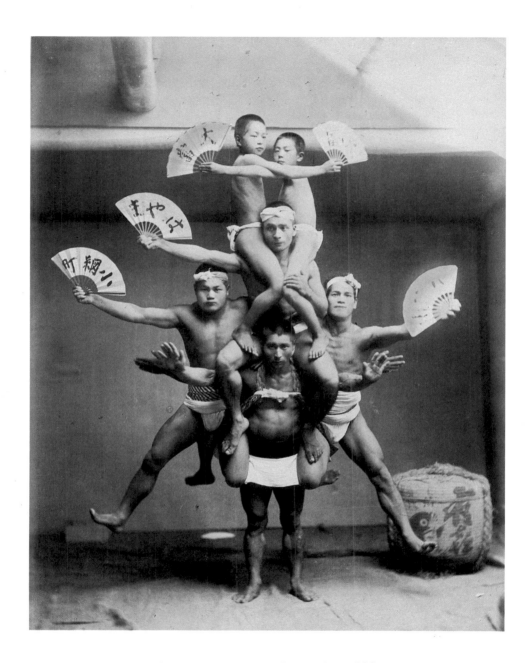

Anonymous. Human Pyramid, c. 1890.
Collection Ludwig Hoerner, Hanover.

Anonymous, Fishermen on the Coast, c. 1885.
Übersee-Museum, Bremen.

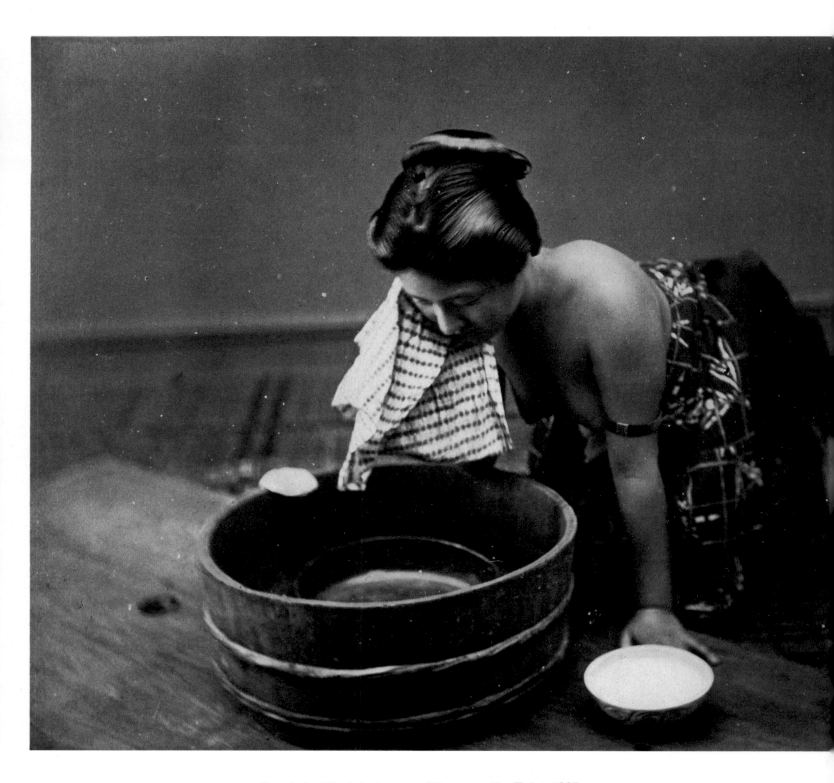

Kusakabe Kimbei, Japanese Woman at Her Toilet, 1885.
Übersee-Museum, Bremen.

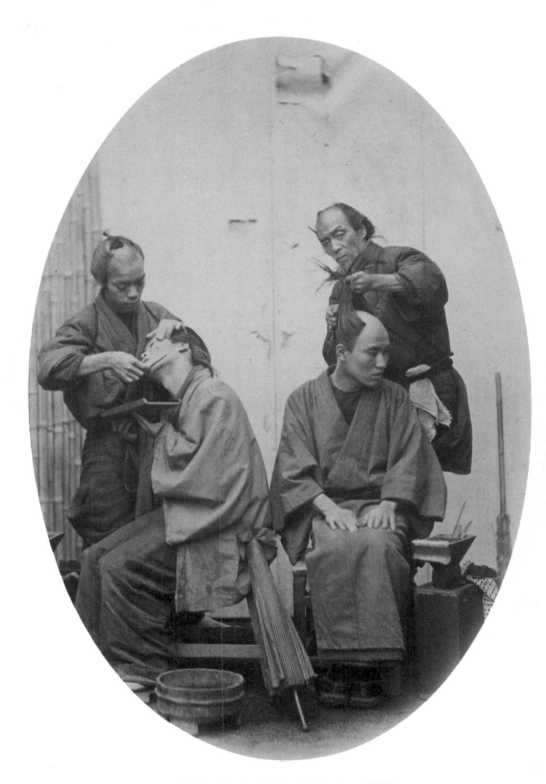

Felice Beato, At the Barber's, c. 1875.
Collection Ken and Jenny Jacobson, Great Bardfield, England.

Among the Japanese motifs most favored by photographers and their customers were idealized portraits of workers and shopkeepers, often picked off the street and brought to the studio. But the only authentic things in photographs such as this one are the subject's faces, since everything else had been "styled" just as in modern advertising photography: hairdos, costumes, and freshly scrubbed vegetables.

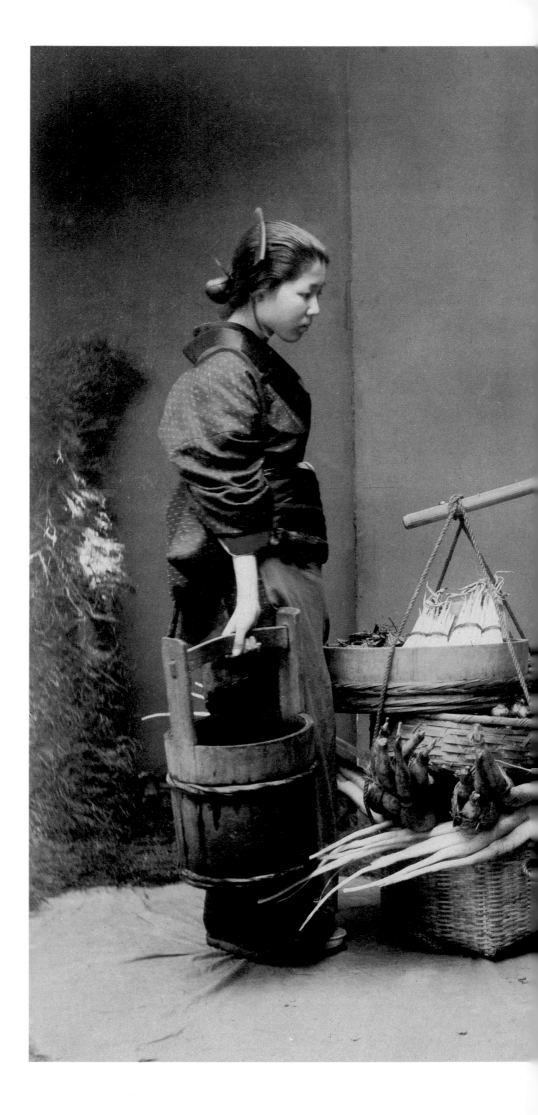

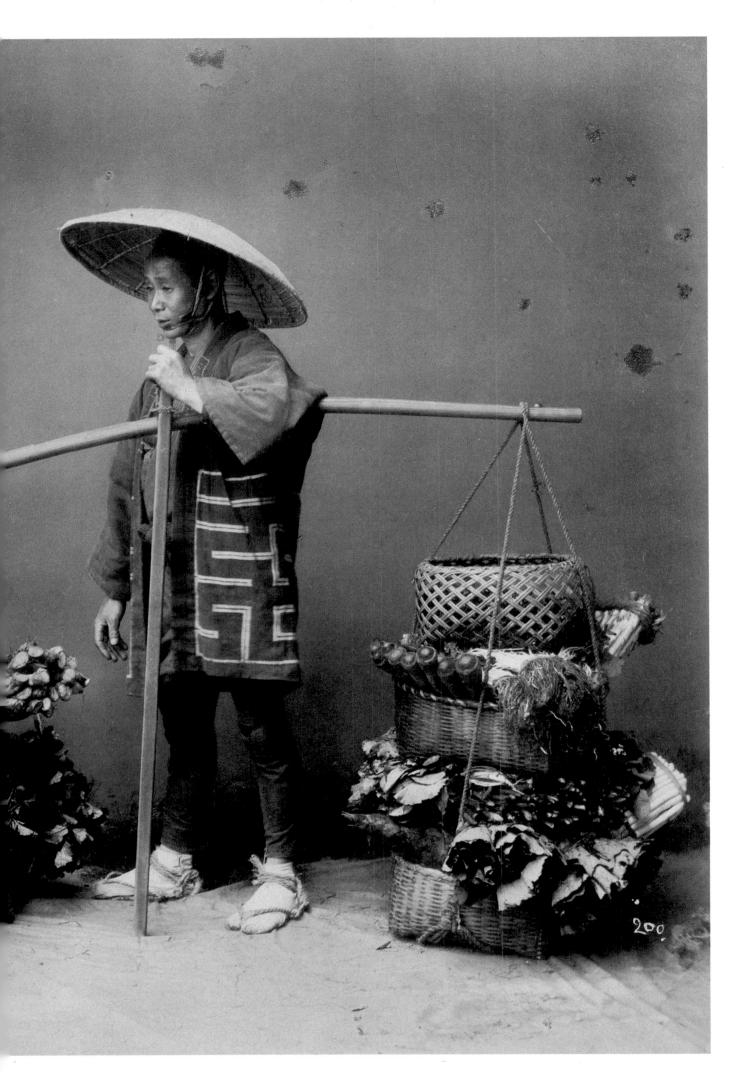

Kusakabe Kimbei, Itinerant Greengrocer, c. 1880.
Janet Lehr Gallery, New York.

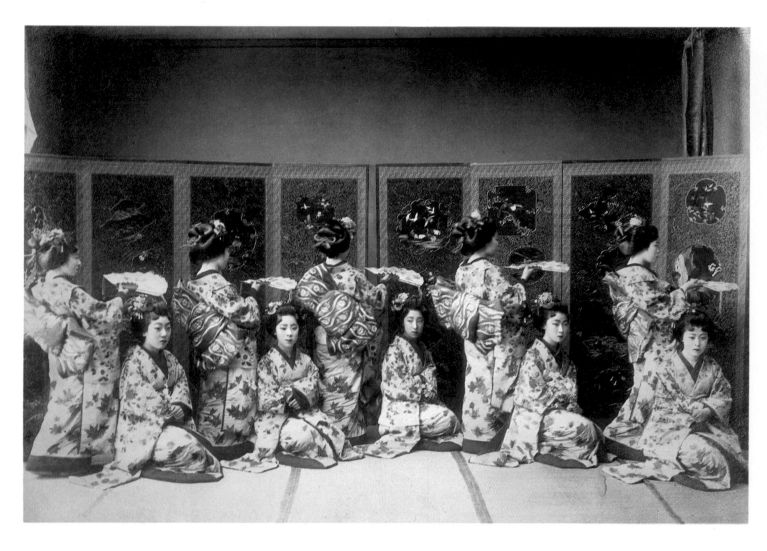

Anonymous, Dance Instruction in a School for Geishas, c. 1900.
Bildarchiv Preussischer Kulturbesitz, Berlin.

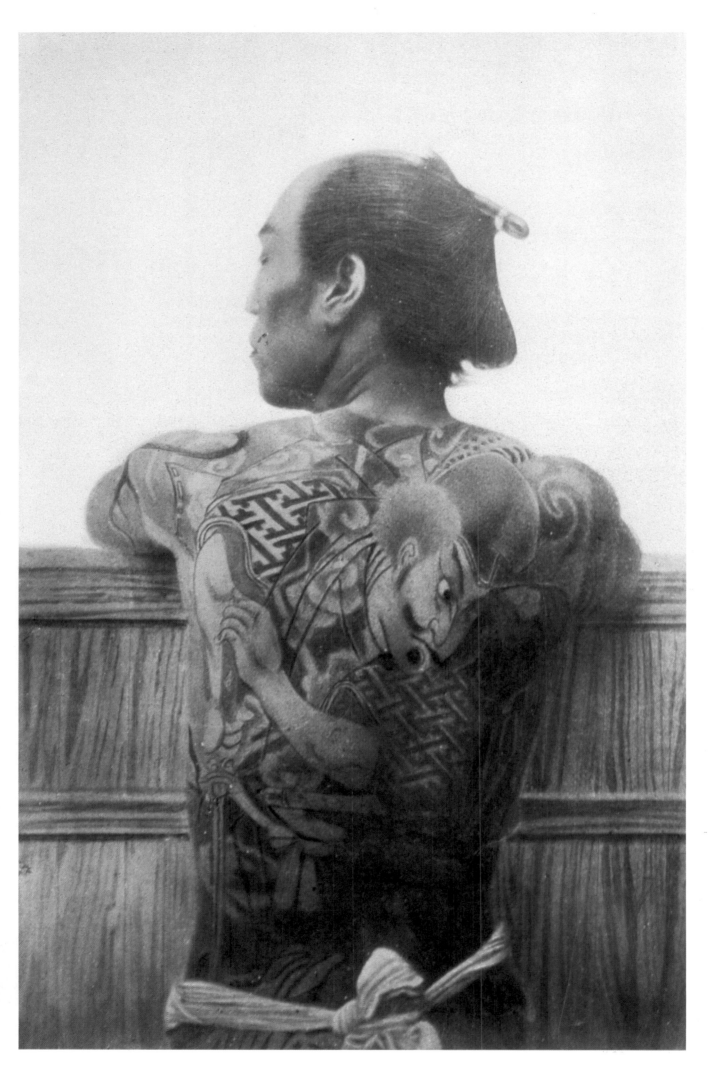

Anonymous, Tatoo, c. 1880.
Kodak Museum, Harrow, England.

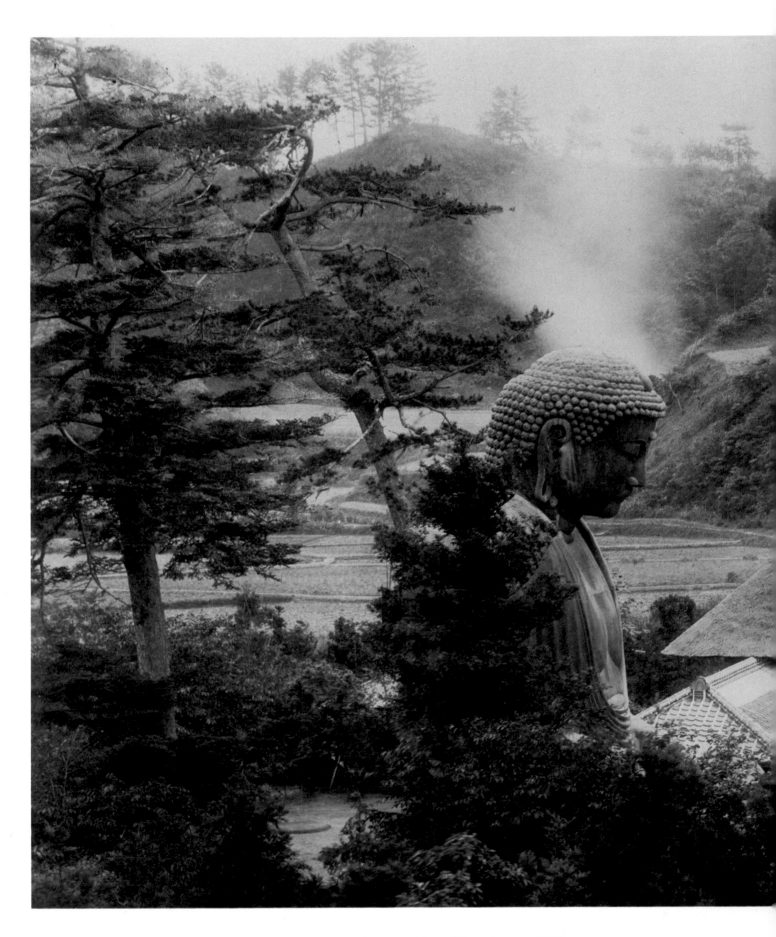

Anonymous, Great Buddha of Kamakura, c. 1885.
Übersee-Museum, Bremen.

Unlike most photographs of the Great Buddha of Kamakura, this picture was taken not from the front, as the pilgrim would have seen the representation of his god, but rather from the side.

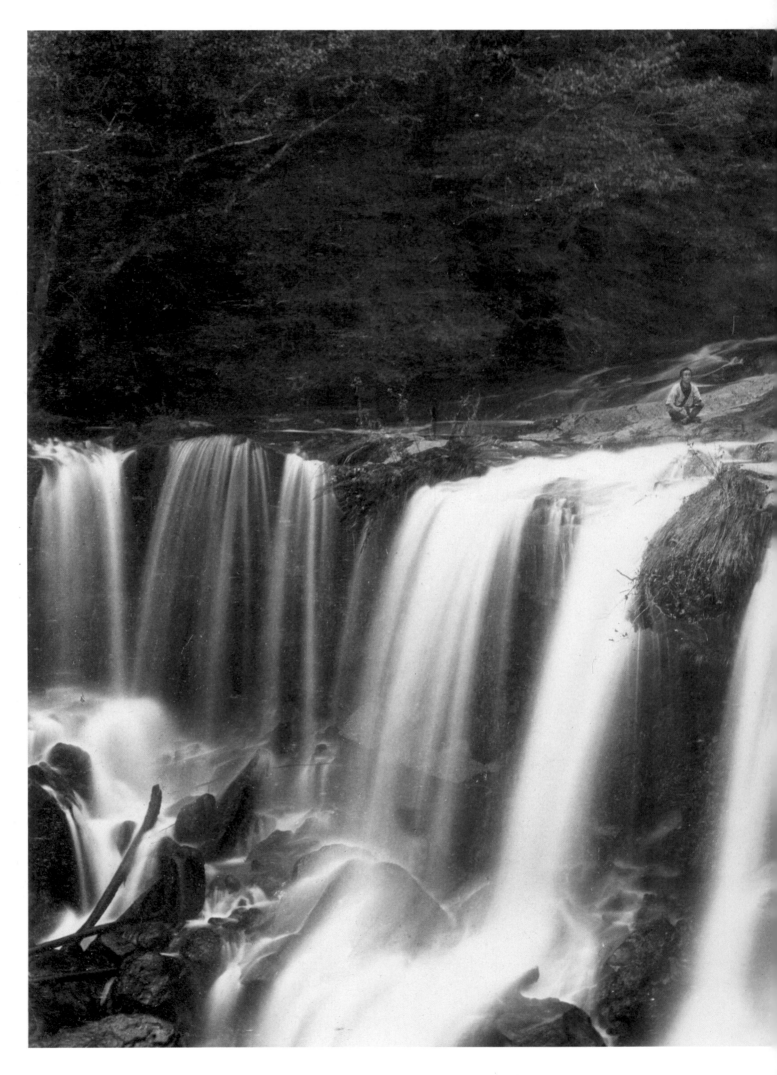

Anonymous, Waterfalls of Shiraito in the Foothills of Fujiyama, c. 1880.
International Museum of Photography, George Eastman House, Rochester, N.Y.

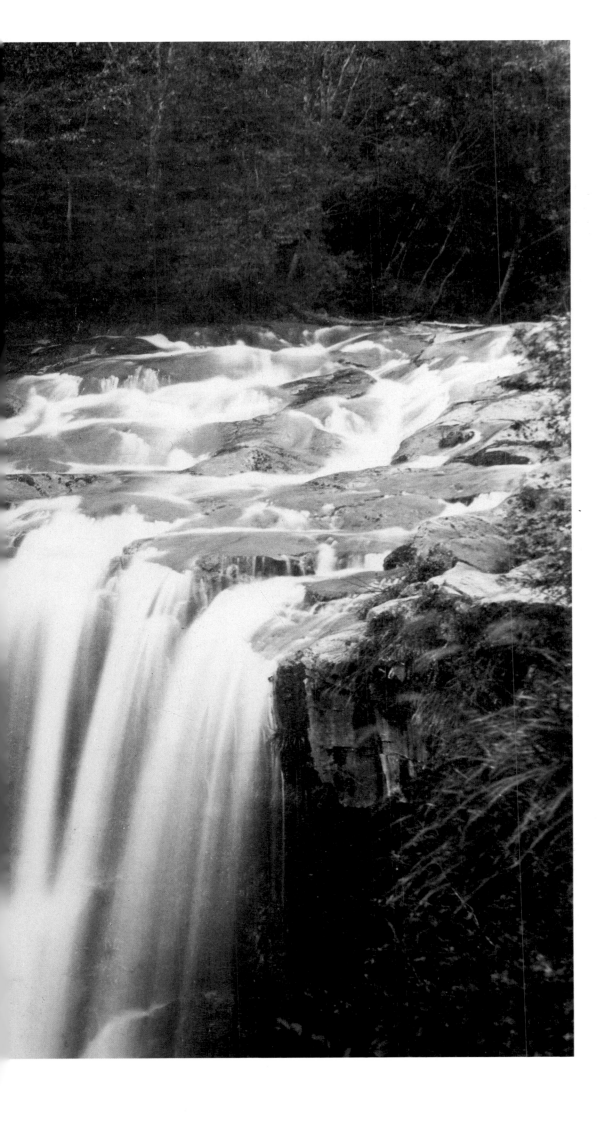

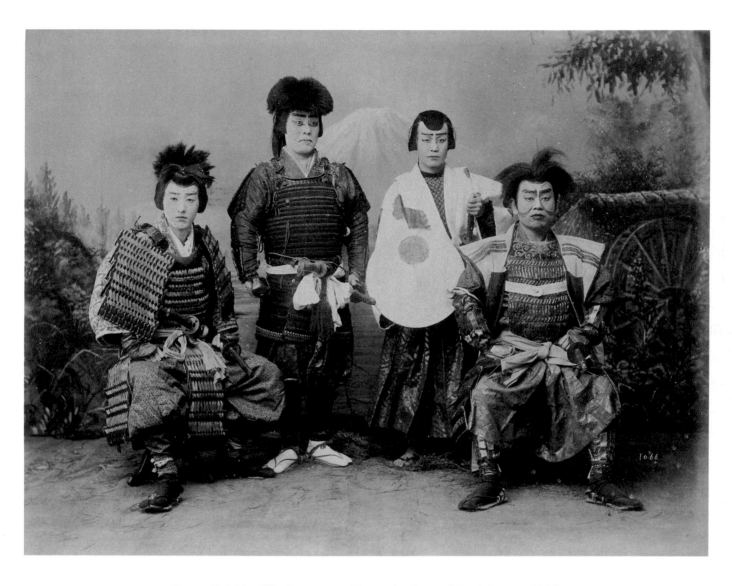

Baron Stillfried(?), Samurai in Front of a Painted Backdrop, c. 1880.
Übersee-Museum, Bremen.

4
Japan
Photographing the "Gate to the Sun"

In the summer of 1854 ships of the United States Navy dropped anchor in Tokyo Bay, and while officers searched the coast with their binoculars, Commodore Matthew Calbraith Perry ordered the frigates to direct their cannon on the city and prepare to attack. Below deck, meanwhile, Eliphalet Brown was unpacking his daguerreotype camera. He had joined the expedition as its official photographer out of eagerness to see a country he knew only by name.

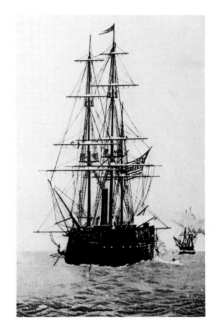

Commodore Perry's flagship as rendered by a contemporary Japanese artist.

Also anxious to record the historic American mission was the journalist Bayard Taylor, who noted in his diary that the party had sighted land at daybreak. What they saw before them was Cape Idzu, at the mouth of the large Bay of Yedo (now Tokyo). The few fishing junks sailed quickly back to the coast to warn the population that foreign ships had arrived. The appearance of these large sailing steamers, the first ever in Japanese waters, traveling at a speed of nine knots, must have filled the natives with astonishment, if not apprehension.

The Japanese took the black-hulled ships belching smoke on the horizon as a bad omen, signifying war. A Japanese historian reports that Tokyo erupted in fear and excitement over the imminent invasion by barbarians. Suddenly the streets were clangorous with pounding horses' hooves, shouting warriors, rattling supply carts, rushing fire fighters, screaming women and children, and the incessant ringing of temple bells.

The Americans could hardly have been more obvious about their intentions. Shrewdly, they wanted to anticipate the

other colonial powers in the Far East, especially the Russians and the Dutch. The *New York Herald* had indicated it was God's will that America should have a foothold in Asia. The *Presbyterian Review* chimed in and demanded that the "Gate to the Sun," as the islanders called their empire, had to be opened voluntarily or by force.

Even Commodore Perry was not immune to the patriotic expansionist fervor sweeping the country. Considering the dominions of America's great rival, Britain, its naval prowess and, especially, the number of fortified harbors it controlled, Perry felt that the United States had to take steps immediately to increase its power at sea. Fortunately, the Japanese and other islands in the Pacific remained for the taking, and a number of them were strategically situated along the trade routes—an important consideration.

Since the 16th century Japan had followed a strict policy of isolation and noninterference. In the middle of the 16th century it went so far as to execute the crews of Portuguese and Spanish ships who had dared to come ashore. The Emperor even prohibited the construction of large trading ships. When the great colonies were formed Japan continued locked up and beyond reach. Until Perry's arrival the Shogunate would tolerate only one small window open to the West: a Dutch trading post operated under humiliating conditions on an artificial island in Nagasaki Harbor.

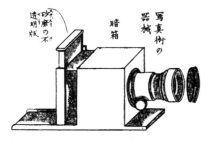

A Japanese rendering of the first daguerreotype camera seen in Japan (1854).

In America, ignorance generated widespread arrogance towards the Japanese Islands. The *American Whig Review* stated in 1852 that the Japanese were the most uninteresting people in the world, comparable only to South Sea Islanders, such as the Fijians, or to the Eskimos. Although living in a fertile country, they had shut themselves off from the rest of the world and were mired in national torpor.

It is not surprising, therefore, that a certain prejudice prevailed among Perry's crew when they landed in the summer of 1854. It was incredible to them, but apparently every Japanese carried brush, ink, and paper wherever he went, had a goldfish pond behind his house, and sat in a very

peculiar manner on his heels with toes turned out. Captain Johnson, the commander of one of the ships, was deeply shocked by Japanese bathing habits. The first Japanese he saw taking a bath was squatting lobster red in a large wooden tub full of water steaming above a fire relentlessly stoked by a servant.

Needless to say, the culture shock was not one-sided. The Japanese took a long time getting used to the hairy barbarians with their round animal eyes, strange table manners, and odd way of writing, which reminded them of crabs walking. They found the white people's noses so grotesque that in their woodcuts they portrayed Commodore Perry with an exaggeratedly long proboscis. A few years later (1860), when, at Perry's invitation, a Japanese delegation arrived in America, its members misunderstood a great variety of things. They thought, for instance, that the popping of champagne corks was a salute fired in their honor, and that their hosts' wives were geishas hired for the entertainment of the foreign guests.

The Japanese liked Perry's gifts, however. There were rifles, sabers, and pistols, cases of unfamiliar drinks, such as liqueurs, wine, and whiskey, also a telegraph, a camera, and a miniature train complete with steam locomotive, coal car, passenger car, and 360 feet of track. A witness reported that

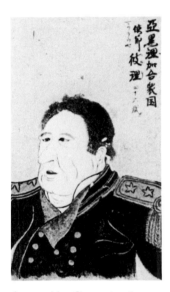

Amazed by Caucasian faces, the Japanese exaggerated Commodore Perry's nose.

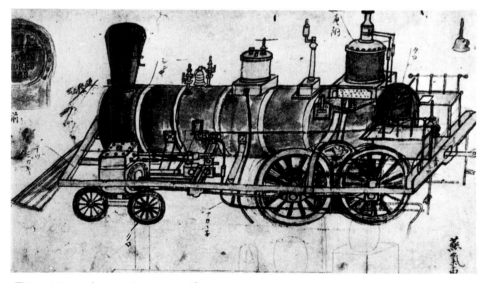

This miniature locomotive was a gift from the United States to Japan.

the multitude cheered enthusiastically when dignified elders whizzed round and round the circular tracks, kimonos flying.

Pretending to be in command of a huge navy with a hundred ships—the Shogun had no idea of its actual size—Perry held the advantage and thus managed to impose his will. Japan and the United States pledged eternal friendship in the commercial treaties of Kanawaya (1854, 1858) and celebrated with toasts alternating whiskey and sake. As a result, Japanese harbors opened to American ships, and customs tariffs went into effect. Americans could settle in Japan, lease land, and conduct business. Contrary to the arrangement between Britain and China, however, opium importation was prohibited.

Once Perry had submitted a report, his superiors did not find in it much of the missionary spirit so vigorously fanned by the American press at the outset of the voyage. His *Narrative of the Expedition of an American Squadron in the China Seas and Japan*, published by Congress in three splendid volumes, was made public only in an abridged version. The full accounts prepared by the participants, from Perry himself down to his interpreter, disappeared in the archives.

Sailboats on Lake Biwa, in a woodcut by Hiroshige. Photographers often used Japanese illustrations as models.

Eliphalet Brown, meanwhile, suffered a great misfortune. He had taken pictures of Perry's meetings with the imperial delegates, made portraits of a number of individuals, and daguerreotyped the unfamiliar landscape, only to lose everything when his silvered copper plates were destroyed in a fire at a printing plant in Philadelphia.

It was the Emperor Meiji who began to modernize Japan, realizing that, in order to pull its weight in the international balance of power, his country had to catch up with the technical progress of the West. With the famous "Oath," instituting reforms, abolishing torture, and establishing an efficient bureaucracy, the Emperor set in motion a process that within a century would transform Japan into one of the world's most important industrial nations. The "Oath" stressed that knowledge be sought everywhere, the assumption being that its discovery and application would benefit Japan. The Emperor invited experts of many kinds to come and teach his people. Among those who accepted were railway engineers, accountants and lawyers, agricultural and naval engineers, and scientists of every description. The Emperor built cotton and paper mills, chemical and concrete factories. As early as 1872 the Japanese government laid the first railway tracks between Tokyo and Yokohama. By 1878 the children in the streets of Japanese cities were singing about the "ball of civilization" while bouncing a rubber ball and counting off the ten advances that most fascinated the population: gas light, the steam engine, horse-drawn locomotion, telegraphy, lightning rods, newspapers, schools, postal service, steam boats, and . . . the camera!

Even so, photography took hold in Japan only slowly. The people were perfectly willing to emulate the West's technological progress, but they resisted Western influence whenever it threatened the purity of their art. Like 20th-century India, where a skilled laborer can work in a steel mill while also believing in sacred cows, the 19th-century Japanese accepted the machinery of a new age but insisted on the inviolability of their cultural traditions.

In 1876 Gyokusen Ukai, a Japanese photographer, closed his studio because he was tired of fighting the gentle but unshakable prejudices of his compatriots. The Japanese mentality, he declared, allowed no room for photography, a harmless process his compatriots considered to be a form of witchcraft capable of stealing people's souls. Giving his plates to those of his sitters he could locate, Ukai consigned the remainder to eternal rest in the family tomb—or so he thought. When Japanese historians opened the Ukai tomb on September 30, 1956, the images on the plates faded as soon as they came in contact with the air.

Little is known about the earliest Japanese photographers. In the 1850s photographing constituted a taboo, and taking pictures at religious sites a great sacrilege. One of the first amateur photographers in Japan was the "photographing Norwegian," whose name has been lost. Historians know about him only from a series of articles published in 1859 and 1860 in *Photographic News*, a London magazine. In 1857 the Norwegian had a job with a Dutch firm in Nagasaki. One day he was approached by a man, pseudonymously calling himself Dsetjuma, who wanted to learn photography. The Norwegian must have been a patient teacher and Dsetjuma a talented pupil, for one day they went off together into the provinces. The Norwegian had given up European dress for kimonos; he also let his hair grow and braided it in Samurai fashion. Diluting silver nitrate, he applied the solution to his skin until it turned a dull yellow. On the road he never spoke, cleverly pretending to be deaf and dumb. The collaboration of the two men must have worked well, Dsetjuma as the operator and the Norwegian as his assistant, with communication carried on in sign language. After several months they returned to Nagasaki with photographs of scenes no European had ever witnessed and no Japanese had ever taken: people committing harakiri, religious ceremonies in temples, and court trials. Clark Worswick has speculated that had the Norwegian's identity been discovered, he would surely have been put to death.

The greatest resistance to photography came from the Emperor himself. Photographers, like Felice Beato, who tried to depict court life were disgraced. In 1867 Beato accompanied the British Ambassador, Sir Harry Parkes, to Japan. When the envoy arrived to present his credentials, Beato was behind his camera to record the historic moment. The Japanese watched the proceeding with amusement, never for a moment believing that the picture would turn out. A few days later Beato took newspaper space to offer the Emperor's portrait for sale. The court was shocked, and government complained to government. Parkes promised to stop the sale of the pictures, but to no avail.

Emperor Meiji and the Empress in a woodcut made for a German newspaper of 1875.

Photographs as they were known in Europe failed to attract the Japanese. A nation esteeming politeness and formality above all else and regarding life as a series of ceremonial acts could accept photography only when it was artificial and stylized. By developing a new technique, that of tinting albumen prints, Felice Beato found a style that the Japanese could embrace.

In Europe, photographers and critics alike considered tinted photographs to be utterly tasteless—pure kitsch, if not downright dishonest. The Japanese, however, loved them. A tinted photograph was unmistakably "made in Japan," just as much as a lacquer box, a fan, or a woodcut by Hokusai or Hiroshige. It was an original as well as a perfect souvenir for the tourist.

The Japanese thought of their traditional colored woodcuts somewhat as we do posters. The prints were their most popular art, and they called it *Ukiyo-e*, pictures of a "floating world." By "floating" they meant the superficial, earthly life that quickly passes, in contrast to the deeper kind of existence attained through religion and philosophy. Thus, woodcuts typically depict women bathing nude in wooden tubs, picnics under blossoming cherry trees, geishas before their mirrors, and excursions to pastoral lakes. *Ukiyo-e* also illustrated the amusements of the middle class in Tokyo or Kyoto: ladies and gentlemen carried in litters, friends meeting

for tea ceremonies, sailing on Hakone Lake, and singing the praises of Fujiyama's perfect cone. In a way, the woodcuts served the same purpose as a society magazine on the lines of today's *Tatler* or *Town and Country*.

To create a four-color woodcut the painter made a drawing in black ink on a block of cherry. Next the carver cut around the drawing so as to "relieve it" and then printed the relief four times. Now the painter filled the appropriate areas of each print with a different color, after which the carver cut four more woodblocks, one for each color. The final print was made by printing the four blocks one on top of the other. Only the painter signed the finished work.

A similar division of labor was developed for the taking and tinting of photographs. The photographer made his black-and-white picture, and the painter colored it. In this case, however, it was the painter who remained anonymous. The best of the photograph painters were able to depict the color of human skin as faithfully as it appears in modern color snapshots. They could also color flowers so that the petals were all subtly different—from dewdrop-fresh pink to yellow and fading. In the photograph of a procession winding its way into the valley from a mountain temple, every priest wears a costume of different color, and each of the hundred participants has been endowed with his own skin tone.

In the Japanese studios of the English photographer Felice Beato, the Austrian Baron Stillfried, and the Frenchman Le Bas, Japanese painters applied brown watercolor to tree trunks, white to the peak of Fujiyama, green to vegetables, red to lips, yellow to bamboo, metallic black to the armor of the Samurai, and reddish-brown to the leaves of maple trees. For eyebrows and the dripping branches of wisteria they used very fine brushes, some consisting of a single hair.

This retouching was a craft, and sometimes it assumed the characteristics of an assembly line more than those of art. Meticulous painters required a twelve-hour day to produce two or three tinted photographs, whereas in some large shops the artisans managed to turn out ten times as many.

Felice Beato took this photograph of his Japanese colorist in 1867.

These factories adhered to a system of divided labor, with one painter tinting costumes, another the hair, and a specialist making certain that water lilies were given the correct shade of ivory.

The photographers, meanwhile, were content to make focused pictures that met the prevailing canons of harmony and beauty. Before a session in the studio, they carefully arranged kimonos, made faces up into smooth masks, chose fresh and perfect flowers for decoration, and positioned fans and umbrellas in symmetrical order.

Such collective effort seemed to affect the subject and meaning of photographs. Thus, individual personality disappeared into the identity of the group, and the sitter's identity became that of the role he was playing for the camera. The Sumo wrestler represented all Sumo wrestlers, the Samurai all warriors, and the litter-bearer all litter-bearers.

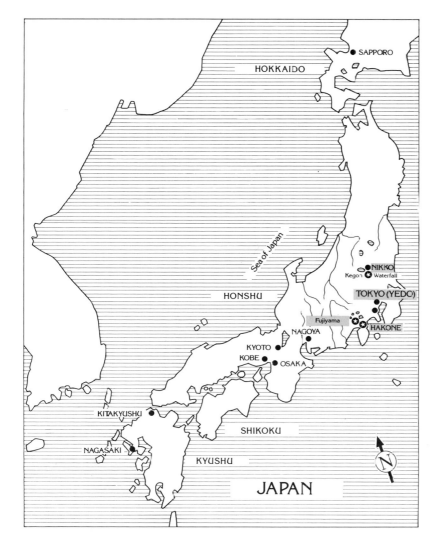

Nineteenth-century Japan had photography studios in Tokyo, Nikkó, and Kyoto. The motifs most favored by the photographers were Fujiyama and the shores of Lake Hakone.

For subject matter, photographers in Japan went to the woodcuts. In that way they avoided offending the taste of their Japanese customers, at the same time that they satisfied Western tourists who demanded pictures of classical Japan. Only traditional Japanese society held any interest for photographers until well into the 20th century. To a certain extent, this explains the amazement with which the West realized one day that Japan was not peopled entirely by geishas and litter-bearers, but had industrial workers and functionaries in gray-flannel suits as well.

The most important studio in Japan was founded by Felice Beato. In 1877 he sold it to Baron Stillfried, who in turn left the business ten years later to his assistant, Kusakabe Kimbei. The studio's props, which passed from owner to owner, left their mark on the photographers' style. All three men used the same bamboo mats, the same tea service, and the same screen.

Tinted photographs from Japan were never more than souvenirs and articles for export, their subjects limited to litter-bearers, coolies drawing rikshas, and basket weavers, geishas at their ablutions, ginseng vendors, umbrella makers, the furrows and runnels of Fujiyama's snowy peak, and the white necks of women, the symbol of perfect beauty. Nowhere is modern Japan to be found in these pictures. They show no railways or women at work in the telegraph office, but plenty of paper lanterns and Madame Butterflys. Brass gongs in mountain monasteries abound, but steam engines are conspicuous by their absence. Instead of the many incarnations of the god of progress, who arrived with Commodore Perry in 1854, the photographers working in Japan took pictures of stone Buddhas in Kyoto.

As late as the 1880s Samurai went to the photographer's studio to have their picture taken wearing a sword and their hair in the traditional bun. In reality, the Samurai had turned in their swords when the Emperor Meiji abolished the warrior caste. Their martial getup came from the photgrapher's collection of props.

5
Brazil

Imperial Photographer of the Amazon

Dom Pedro II and Marc Ferrez

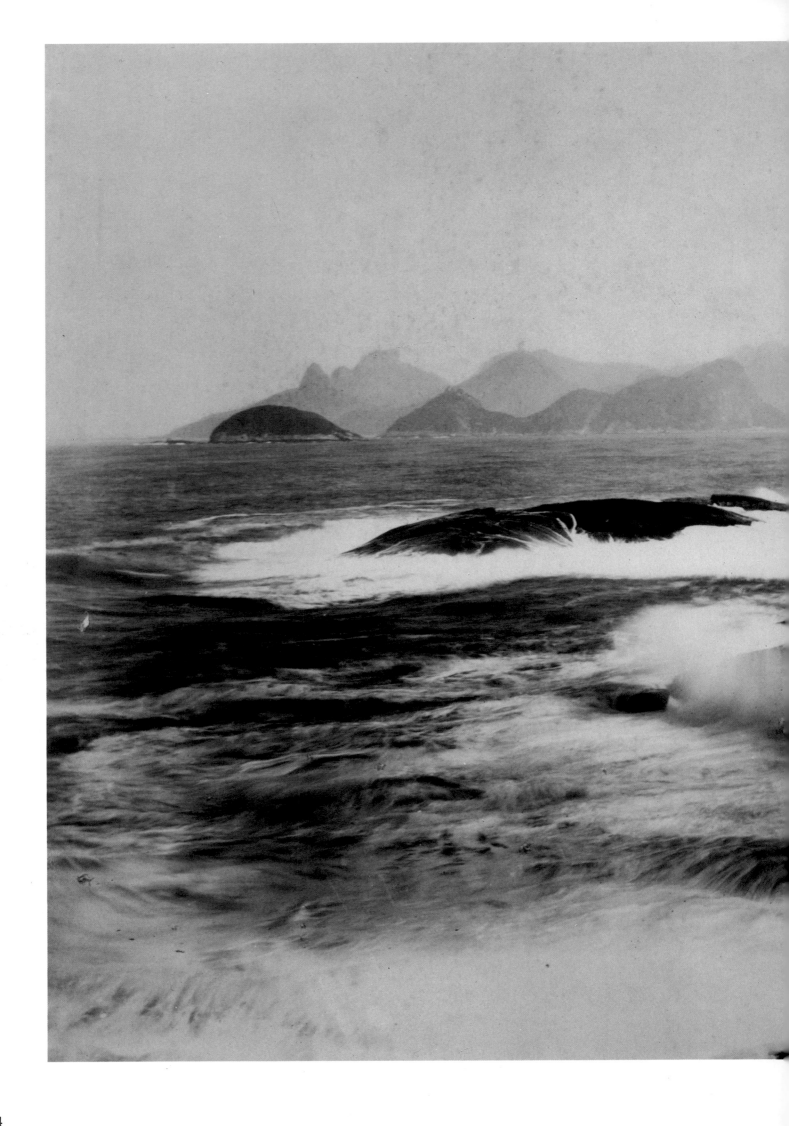

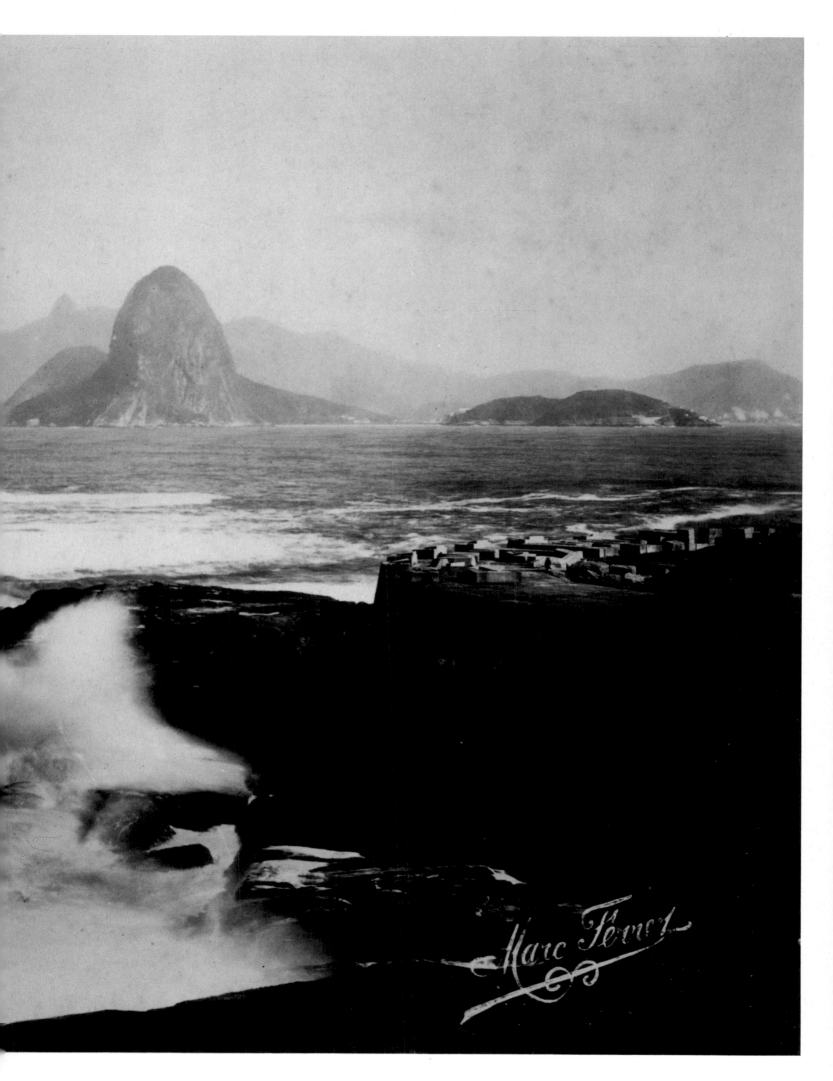

Marc Ferrez, The Bay at Rio de Janeiro with Corcovado and Sugarloaf Mountains, c. 1875.
Collection Gilberto Ferrez, Rio de Janeiro.

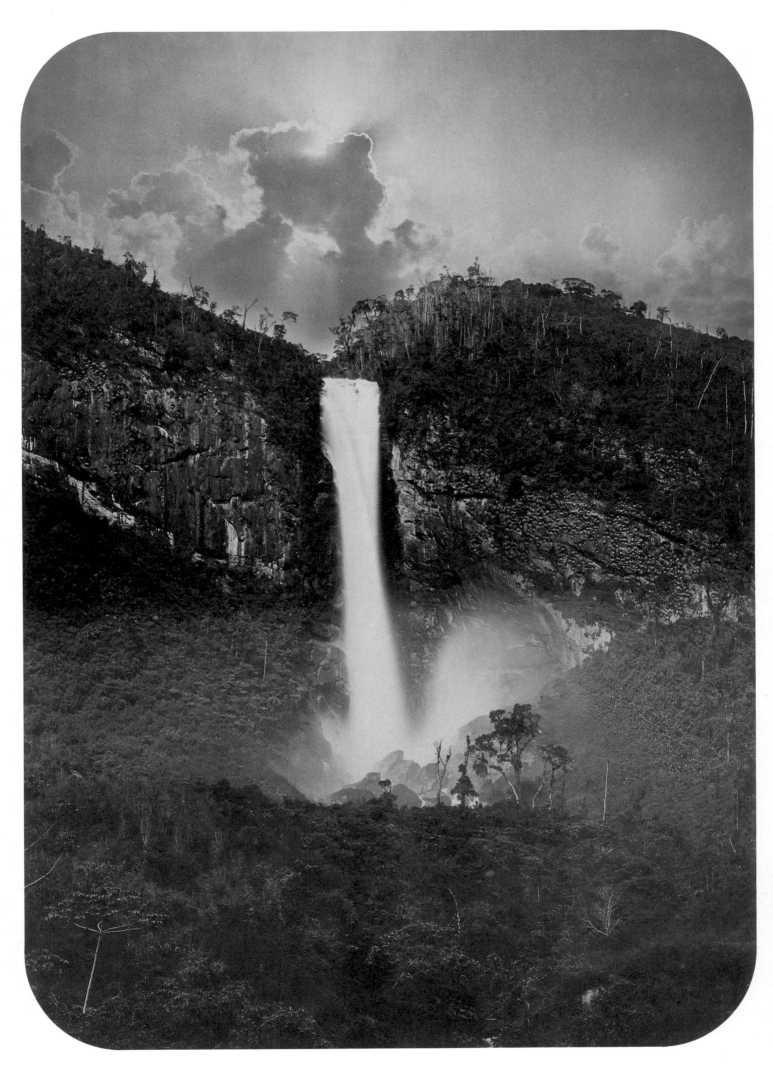

Marc Ferrez, The Waterfall at Paquequer, c. 1878.
Brazilien-Bibliothek, Robert Bosch GmbH, Stuttgart.

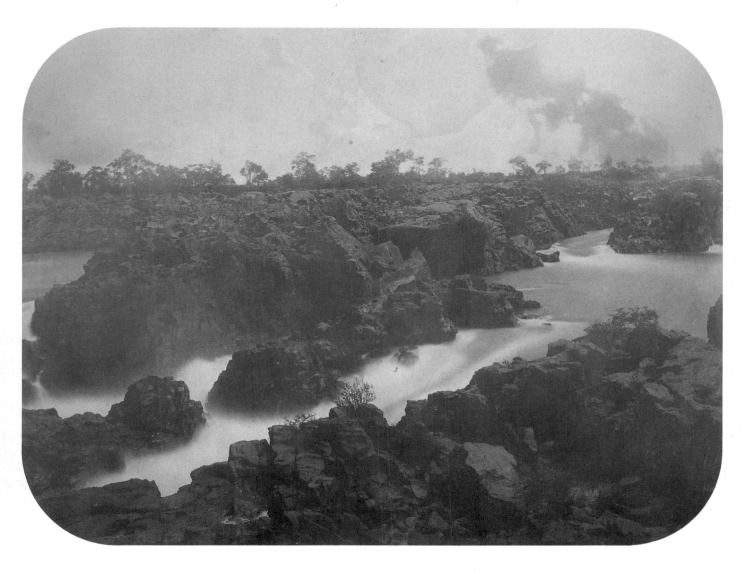

Marc Ferrez, The Paulo-Afonso Falls in the Province of Pernambuco, c. 1875.
Collection Gilberto Ferrez, Rio de Janeiro.

In the 19th century photographers found it almost impossible to record clouds and landscapes at the same time. Owing to collodion's extreme sensitivity to blue light rays, the sky often looks unnaturally bright in old landscape photographs. For his dramatic picture of Paquequer Waterfall, Ferrez made two exposures, one of which captured the tropical sky filled with thunderheads. He then combined the two exposures in the studio.

Port cities in 19th-century Brazil often succumbed to epidemics, forcing the authorities to quarantine all ships docked there. While the "yellow-fever ships" were tied up at Santos, Ferrez photographed their forest of masts. The photographer left his native Rio to record the vastness and variety of Brazil, creating a unique set of photographic documents. Unfortunately, they survive in very few albums, which Ferrez either sold to tourists or had assembled at the behest of some authority, such as the railway company. Although his work won high praise and earned a good living for him, it is largely unknown today.

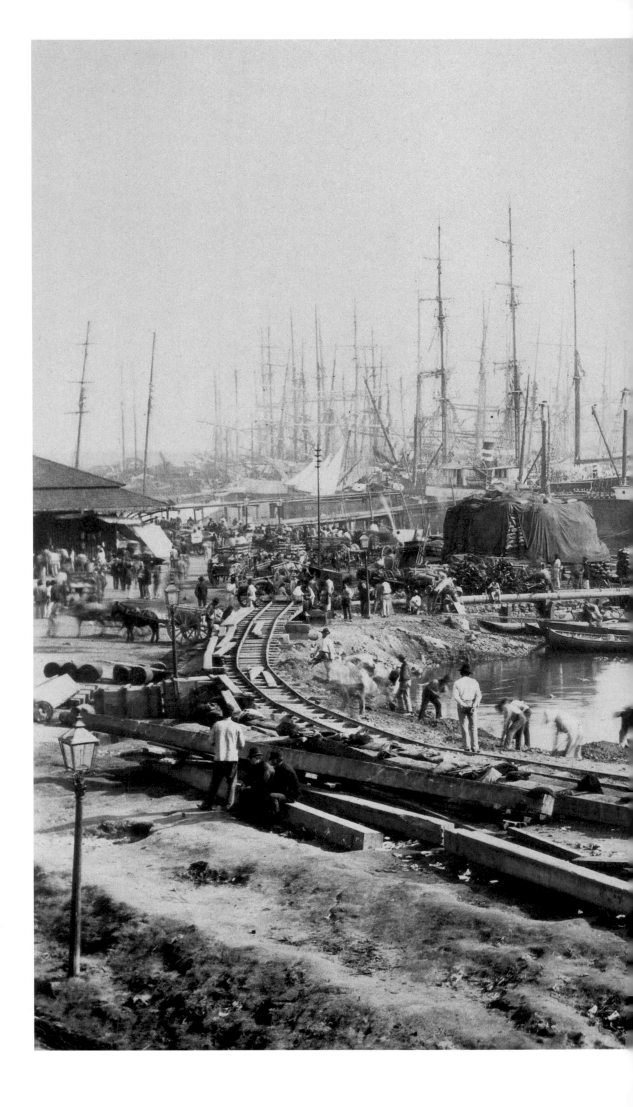

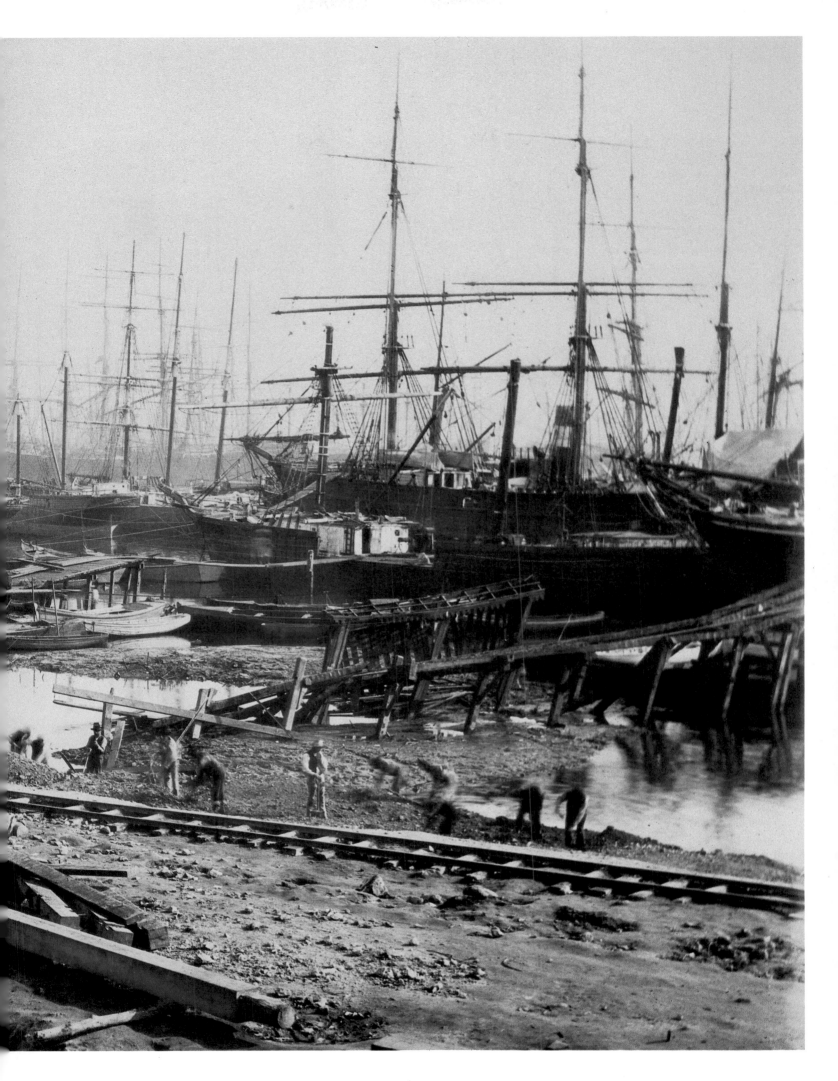

Marc Ferrez, Merchant Ships in Santos Harbor, c. 1885.
Ministerio das Relações Exteriores, Brasilia.

Marc Ferrez, Construction of a Water Line Across the Jungle to Rio, c. 1880.
Arquivo Nacional, Rio de Janeiro.

Throughout many journeys Marc Ferrez photographed
the gradual development of his country, including the
construction of railways and water lines through the
jungle to Rio de Janeiro. In 1884 he shot the "Sylvester
Bridge" on the cog railway to the peak of Corcovado.
The second such railway in the world, after the Rigi
in Switzerland, it exists today but now powered by
electricity. And Corcovado has long since been crowned
by the large figure of Christ with outstretched arms.

Marc Ferrez, Cog Railway to the Peak of Rio's Corcovado Mountain, c. 1884.
Collection Gilberto Ferrez, Rio de Janeiro.

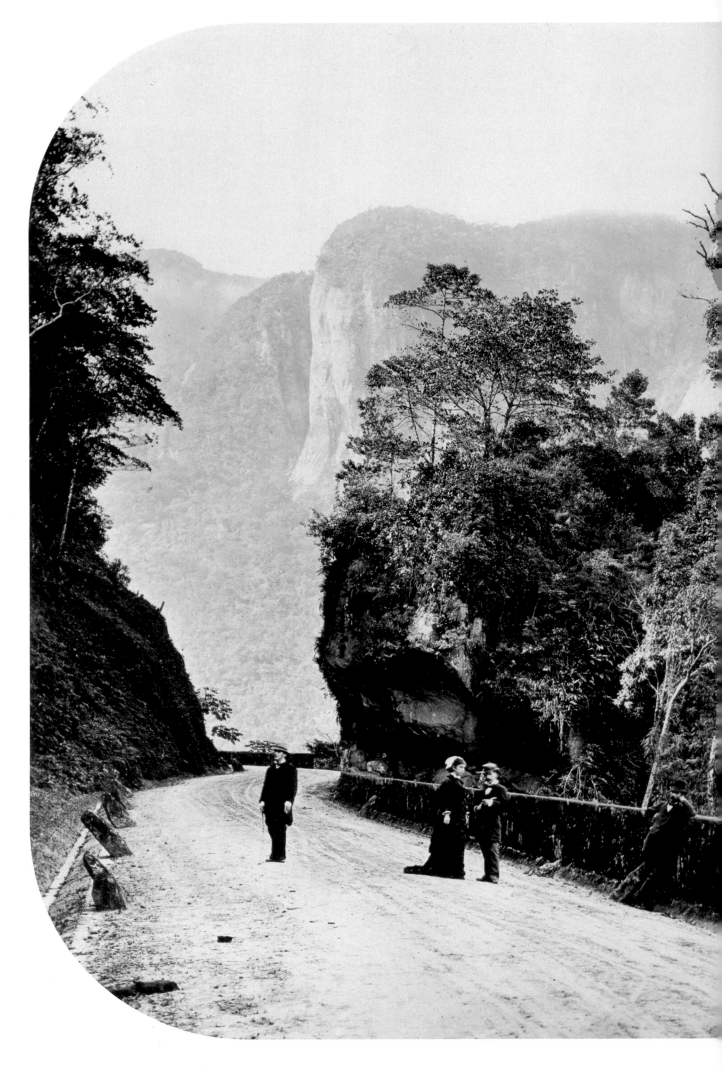

Marc Ferrez, Road to the Emperor's Summer Residence at Petropolis, 1875.
Collection Gilberto Ferrez, Rio de Janeiro.

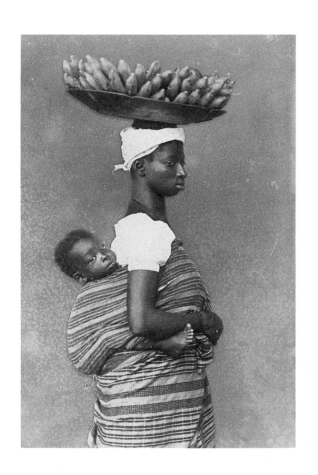 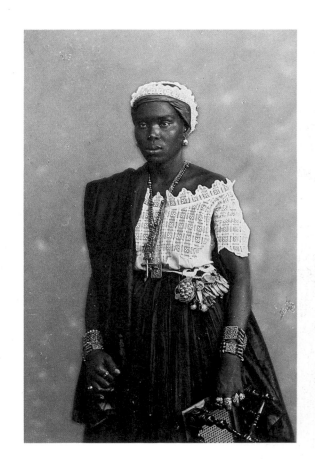

Marc Ferrez, Freed Women Slaves, 1875.
Ministerio das Relações Exteriores, Brasilia.

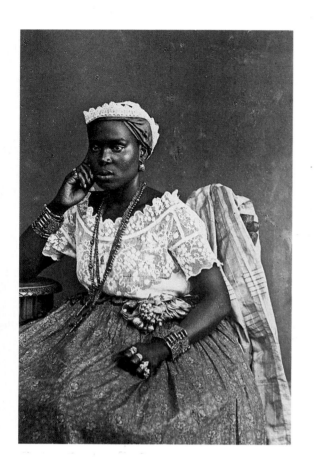 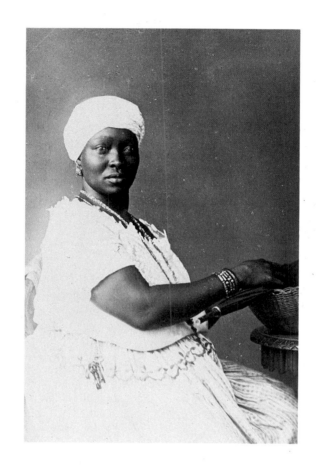

Dom Pedro II realized his greatest achievement when he
abolished slavery in Brazil. Over the objection of
landowners, he freed the slaves on the imperial
plantations and prohibited their use in the construction
of public buildings. A skilled and passionate
photographer in his own right, Dom Pedro made
portraits of former slaves from Bahia wearing all their
earthly wealth, held in the form of jewelry.

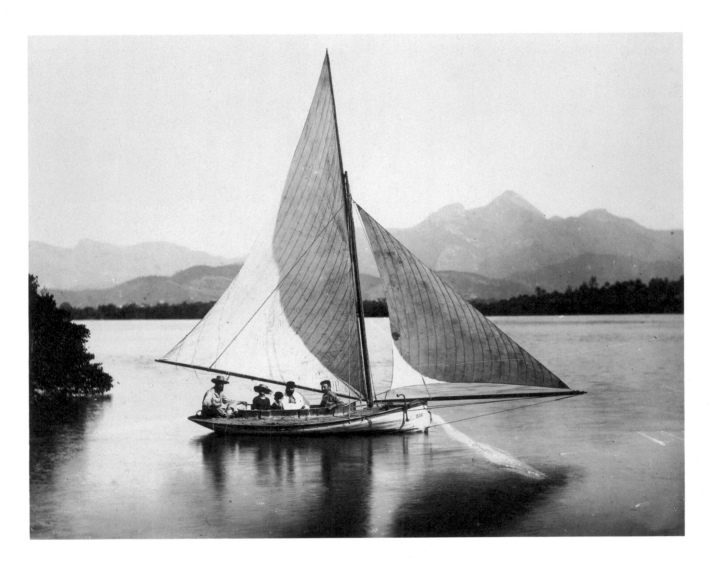

Marc Ferrez, Sailing in Rio's Guanabara Bay, c. 1890.
Collection Gilberto Ferrez, Rio de Janeiro.

In 1875 Ferrez accompanied the Harvard geologist
Charles Frederick Hartt on an expedition to the
southern part of Bahia Province. This permitted him to
take the first photographs ever of the Botocudo Indians.
For scientific reasons he laid a tape measure along the
edges of these images.

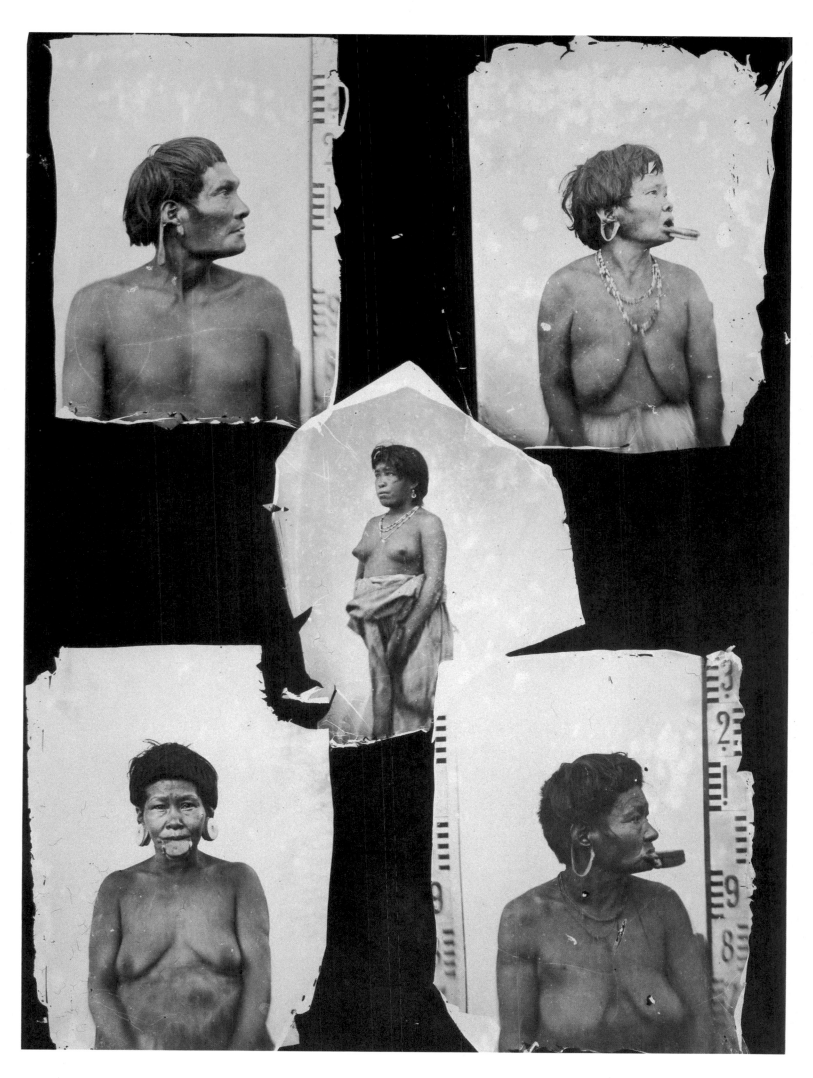

Marc Ferrez, Indians of the Botocudo Tribe in Bahia Province, 1875.
Collection Gilberto Ferrez, Rio de Janeiro.

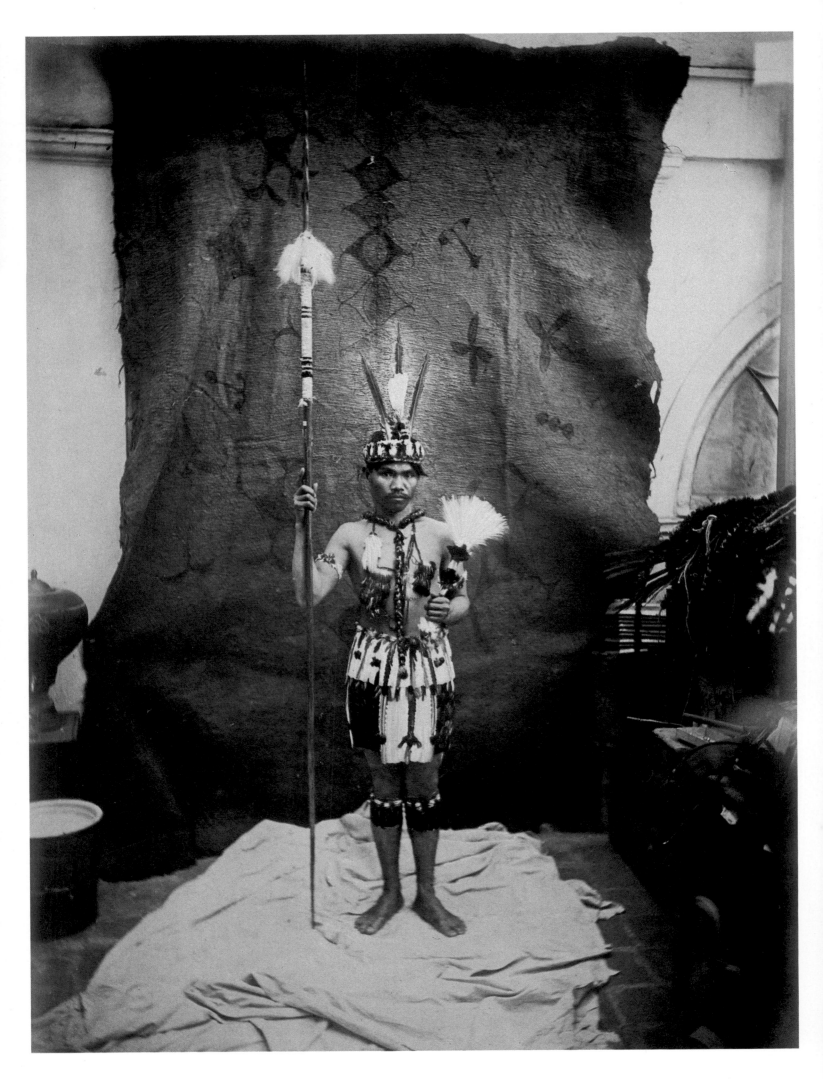

Marc Ferrez, Indian Chief Cumbo de Ucayala (studio photograph), 1875.
Ministerio das Relações Exteriores, Brasilia.

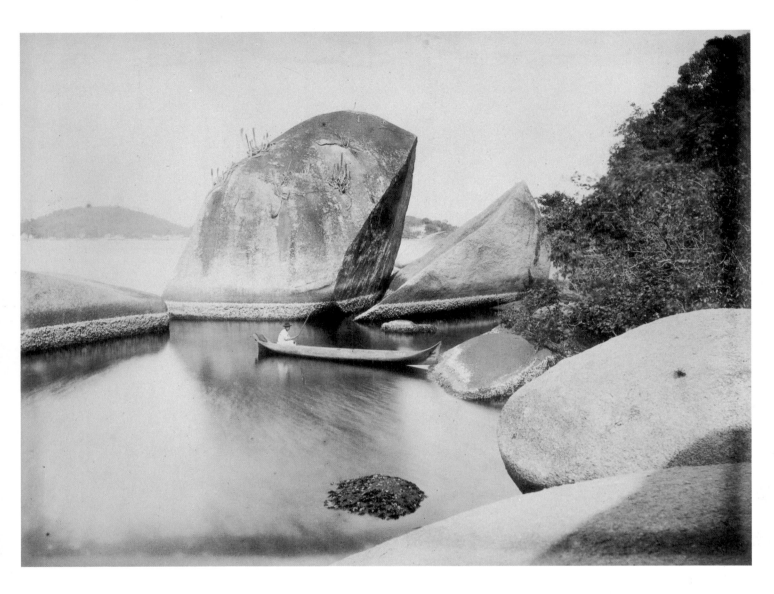

Marc Ferrez, The Split-Granite Rock on Paquetá Island in the Bay of Rio, c. 1885.
Ministerio das Relações Exteriores, Brasilia.

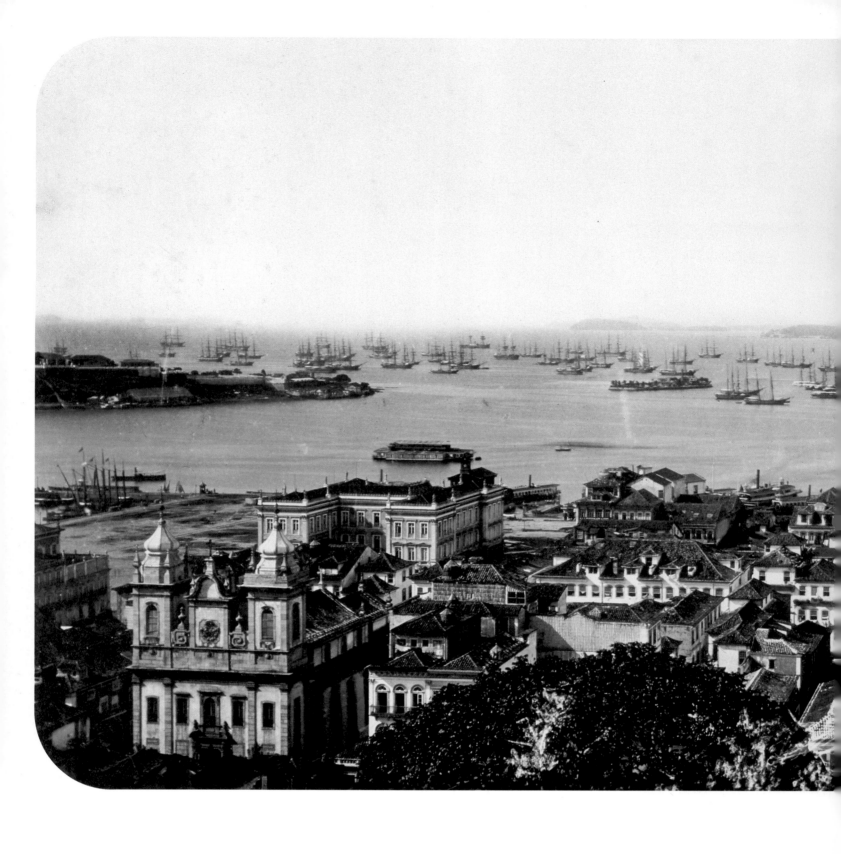

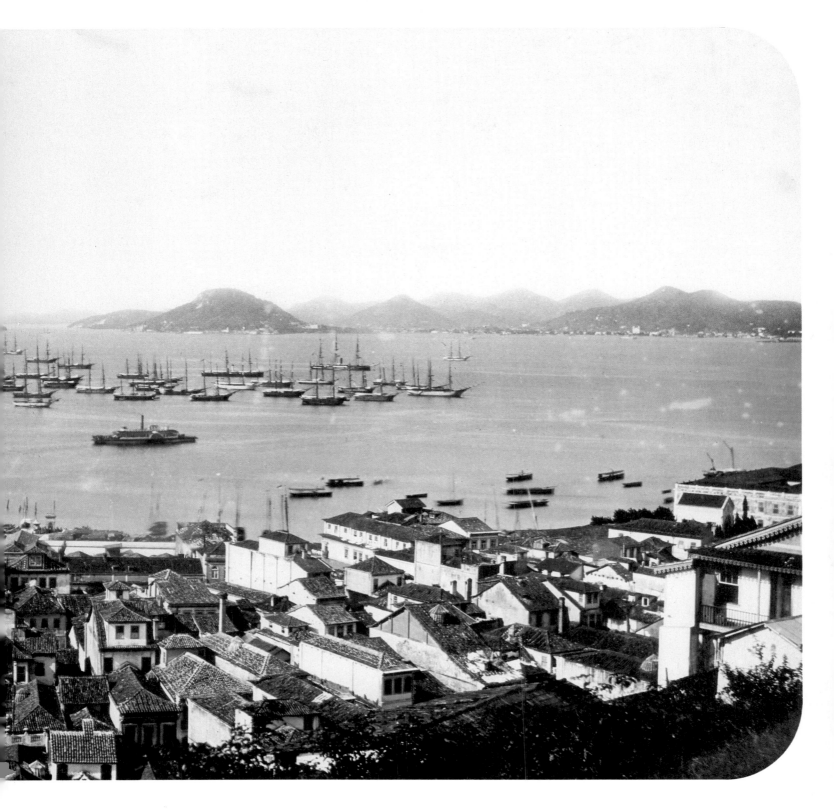

Marc Ferrez, The Port of Rio Seen from Castelo Hill, c. 1880.
Collection H.S. Hoffenberg, New York.

A few years after Marc Ferrez took this picture, the
Avenida Central was cut through the center of Rio,
demolishing large sections of colonial architecture.
Today tall office buildings dominate this part of town.

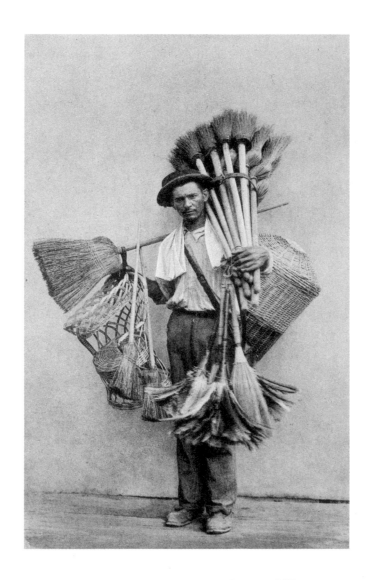

Marc Ferrez, Brush Maker in Rio, c. 1885.
Collection Gilberto Ferrez, Rio de Janeiro.

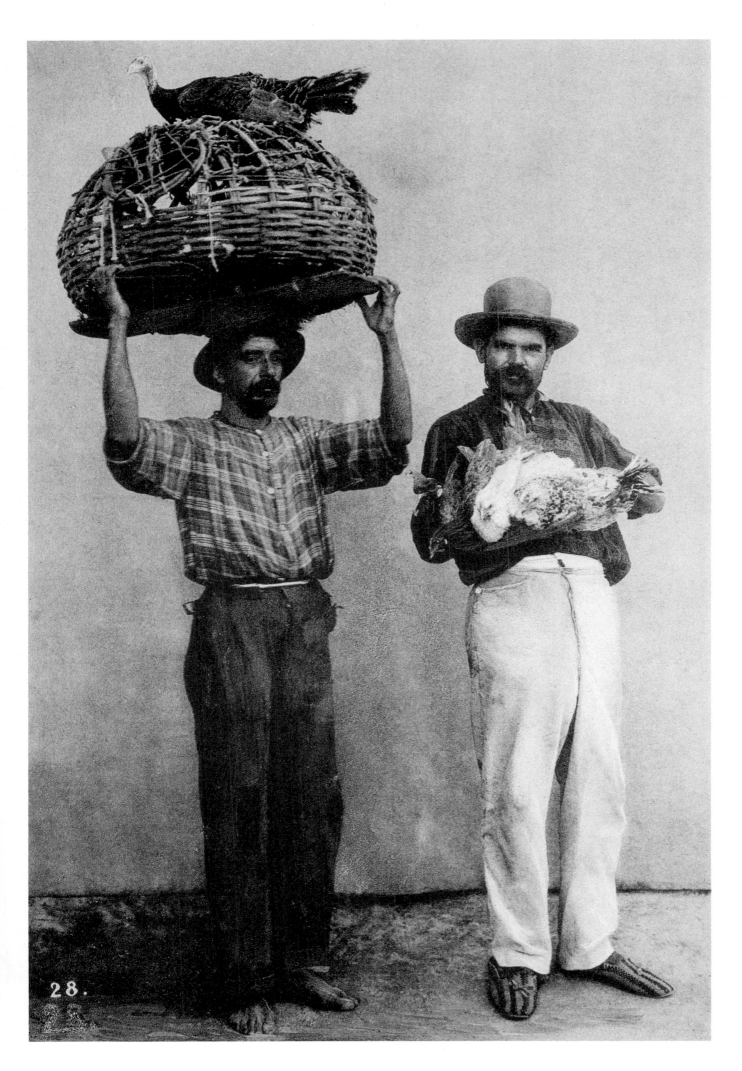

Marc Ferrez, Street Vendors in Rio, c. 1885.
Collection Gilberto Ferrez, Rio de Janeiro.

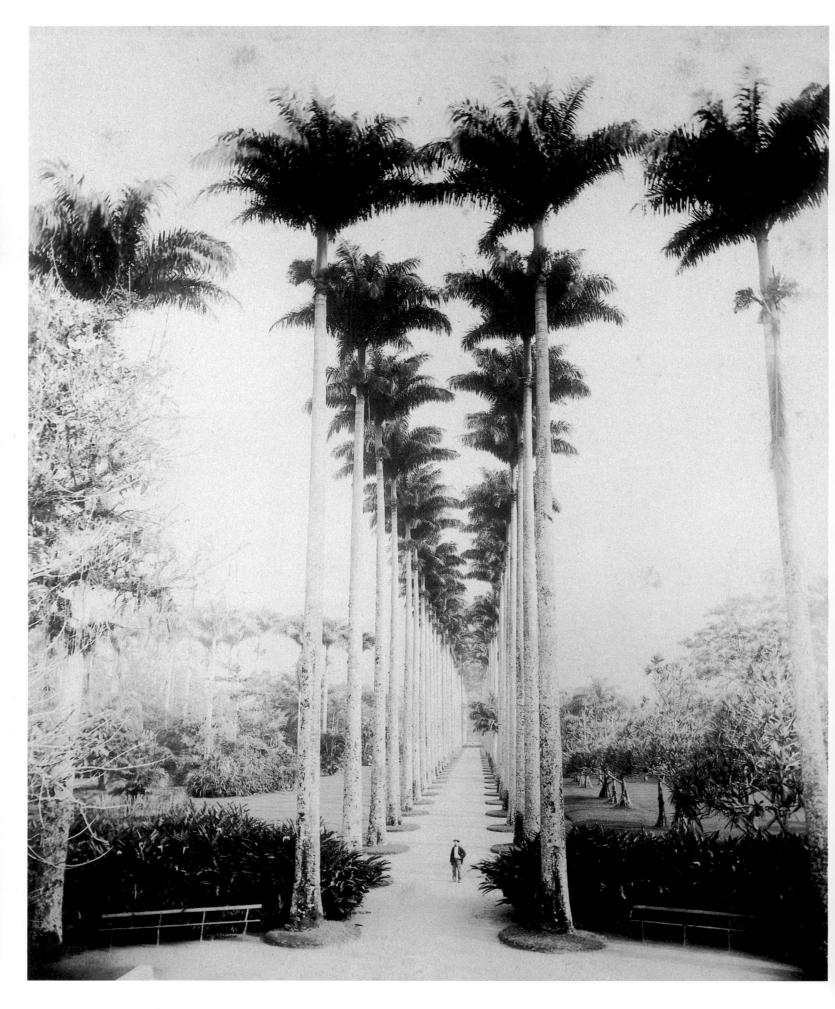

Marc Ferrez, Avenue of 128 Royal Palms in Rio's Botanical Garden, c. 1880.
Ministerio das Relações Exteriores, Brasilia.

Marc Ferrez, Working on a Coffee Plantation, c. 1882.
Ministerio das Relações Exteriores, Brasilia.

Coffee made 19th-century Brazil rich. Exports of the
"green gold" eventually rose from 300 million to
1 billion pounds a year. So much coffee was harvested
in some years that the beans were used as fuel for
locomotives.

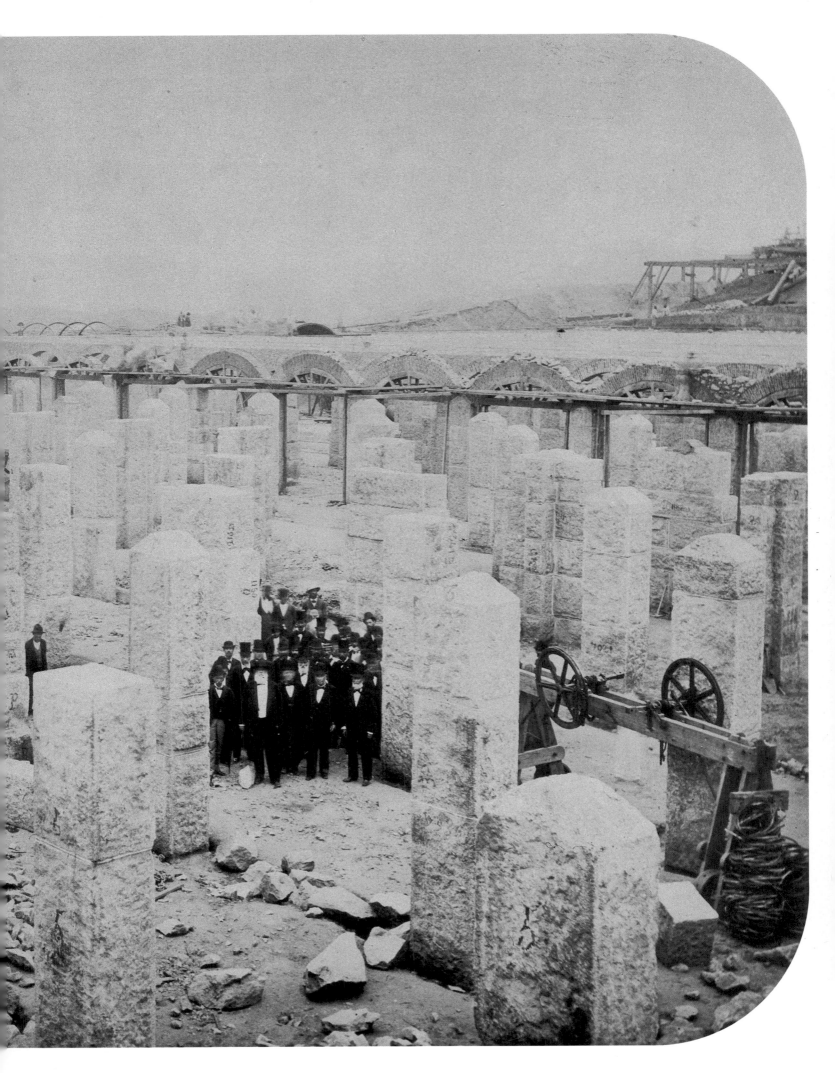

Marc Ferrez, Emperor Dom Pedro II Visiting the Construction Site of a Reservoir Near Rio, 1879.
Arquivo Nacional, Rio de Janeiro.

Marc Ferrez, The Observatory at São Paulo, c. 1875.
Ministerio das Relações Exteriores, Brasilia.

5
Brazil
Imperial Photographer
of the Amazon

razil is the land of lost photographs. In the 19th century the Amazon world literally swallowed up whatever photographic documentation existed. Rio's salt air rotted albumen prints, the hot cactus desert of the Sertao faded them, and termites devoured whatever remained. Why Brazil's historians allowed this to happen remains a mystery. Perhaps they had other problems more severe than collecting and preserving such visual records.

Consequently, not one photograph survives of the many taken by Charles DeForest Fredericks on nine journeys through the lush Brazilian countryside. Two lithographs are all that we have to remind us of the work done by two immigrant Hungarians, Biranyo and Kornis. One of the pictures depicts a balloon ascent. And a book with lithographic illustrations of picturesque Brazil constitutes the sole evidence available to us from the prolific output of Victor Frond, a Frenchman who photographed 19th-century Brazil's most important cities and sites.

Nevertheless, the history of photography in Brazil is rich in other ways. For one thing, the country had an Emperor, and the last in the line, Dom Pedro II (r. 1831–89), happened to have been the first Brazilian photographer, as well as the first photographing Emperor. In addition to Dom Pedro, Brazil could boast the inventor Hercules Florence, who used urine as a fixer and claimed to have invented a photographic process seven years before Daguerre, a claim photographic historians today consider justified. Brazil also saw

The inventor Hercules Florence.

an exhibition of daguerreotypes long before such a thing was contemplated in North America.

The first daguerreotype in Brazil was taken by Father Louis Compte, who had arrived in Rio de Janeiro on board the French ship *L'Orientale.* On January 17, 1840, he demonstrated the new art from France in the Hotel Pharoux, which prided itself on offering guests not only bathtubs but also ice cream. According to the *Jornal do Commercio,* Father Compte's photographs were so true to nature and so precise that clearly nature herself had produced them with help from the artist. A few days later Father Compte showed his camera to the fifteen-year-old Dom Pedro, who ordered one immediately and began experimenting with it.

Emperor Dom Pedro II of Brazil.

Although much admired at the time, the Emperor's photographs have long since disappeared. This is most unfortunate, because the fifty-eight-year reign of Dom Pedro is considered Brazil's Golden Age. An enlightened monarch, Dom Pedro modernized a country run by feudal landowners and worked by black slaves. As early as 1846 he ordered an investigation into the high rate of child mortality. He also founded an institute for smallpox vaccination, set up model sugar-cane plantations, created schools for teachers, and connected Brazil with the rest of the world by laying a transatlantic cable. Moreover, he abolished slavery. It is hardly surprising that such a modern sovereign wanted to record the progress of his country. In one way or another, Dom Pedro supported almost all of Brazil's important photographers.

When the Emperor went to Recife in 1859, the photographer Villela proffered as a welcoming present six gilt-framed photographs of the monarch's arrival. Dom Pedro reciprocated by asking Villela to record all subsequent royal journeys to Brazil's cities and bestowed on him the title of imperial court photographer.

Between 1847 and 1867 Dom Pedro II spent almost twenty thousand milreis on his photographic hobby, a large sum when one considers that in those days a teacher earned six hundred milreis a year. One of the largest suppliers to the

imperial court was the German immigrant Revert Henrique Klump, who also imported wine from France and Portugal, since dealing in photographs alone would not support him. Even so, the Empress Teresa Cristina bought hundreds of views of Brazil, while in 1855 the Emperor made Marc Ferrez, another photographer, a Knight of the Order of the Rose.

Ferrez was undoubtedly the most effective pictorial chronicler of Brazil in the second half of the 19th century. He photographed the imperial family, the Bay of Rio, Sugar Loaf Mountain, and Copacabaña Beach, still a deserted strip of sand. Indeed, Ferrez photographed whatever was worth looking at between Paraná and Bahia—churches, monuments, bridges, waterfalls, rivers, and ports. He accompanied geological expeditions and reported on the progress of the water lines and railways then being cut through the jungle.

Marc Ferrez (1843–1923).

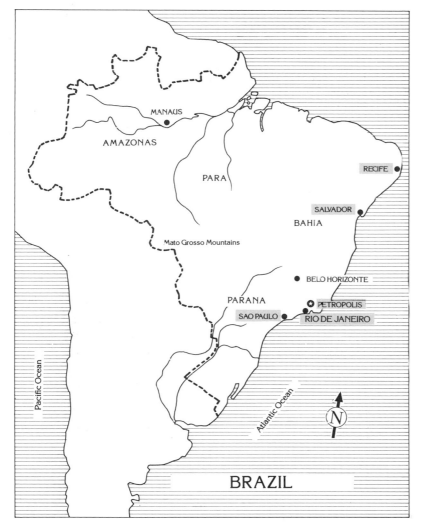

The most ambitious expedition made by Marc Ferrez led him to Bahia Province, where he took the first photographs of Botocudo Indians.

Building railways was one of Dom Pedro's favorite projects. Until the age of twenty-five the Emperor had seen nothing of his country except Rio, owing to the difficulty of getting around. For instance, Salvador de Bahia could be reached from Rio only by boat, and horseback offered the sole means of travel to São Paulo. Unlike the American West, where railway lines ran through open prairie, locomotives in Brazil almost had to cut their way through dense jungle. To prove it, Marc Ferrez photographed a roadbed hacked out of the wilderness before it was overgrown again a few weeks later.

A sizable public fell in love with Ferrez' panoramas of Rio, wide strips normally composed of five or six separate photographs spliced together. To make them, Ferrez used a panoramic camera built specially for him in Paris by Brandon, who equipped it with a clockwork mechanism that slowly turned the lens 190 degrees in anywhere from 3 to 30 minutes. When finished, the panorama was 36 inches long and 13 inches high. Ferrez invested almost all he earned in technical innovations and ordered the latest models of cameras and lenses from Europe. He took photographs through a microscope, photographed an eclipse of the sun, and X-rayed the famous Brazilian Siamese twins, Maria de Lourdes and Maria Francisca.

The benevolent reign of Dom Pedro ended in 1889. While the Emperor was in Europe, his daughter Isabella signed a law abolishing slavery. This proved to be the last straw for the rich planters, who joined with military leaders and antimonarchist republicans to stage a coup d'état.

What survives from early Brazilian photography exists in private, carefully tended collections. It was Marc Ferrez' grandson Gilberto who tracked down many of the treasures, while also taking care of his grandfather's legacy. For thirty years Gilberto searched the world for daguerreotypes with Brazilian motifs. In the end he found three rare ones from Dom Pedro's own collection.

6
India

The "Brave Photographic Warriors" of the British Empire

Samuel Bourne and Deen Dayal

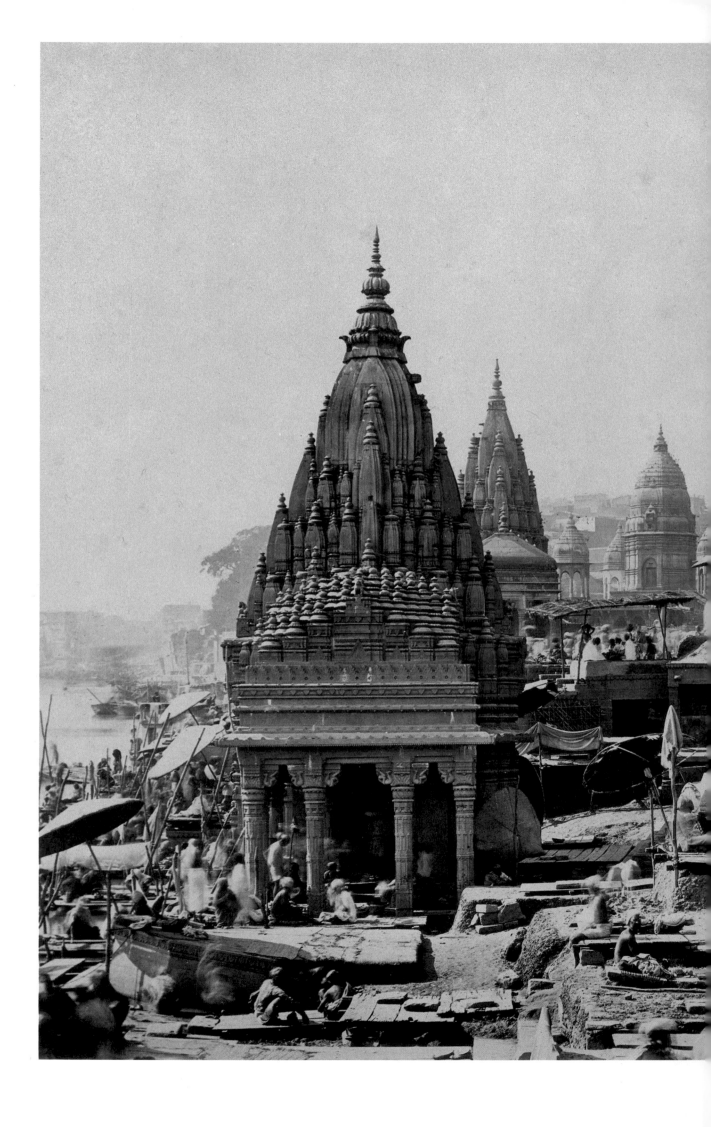

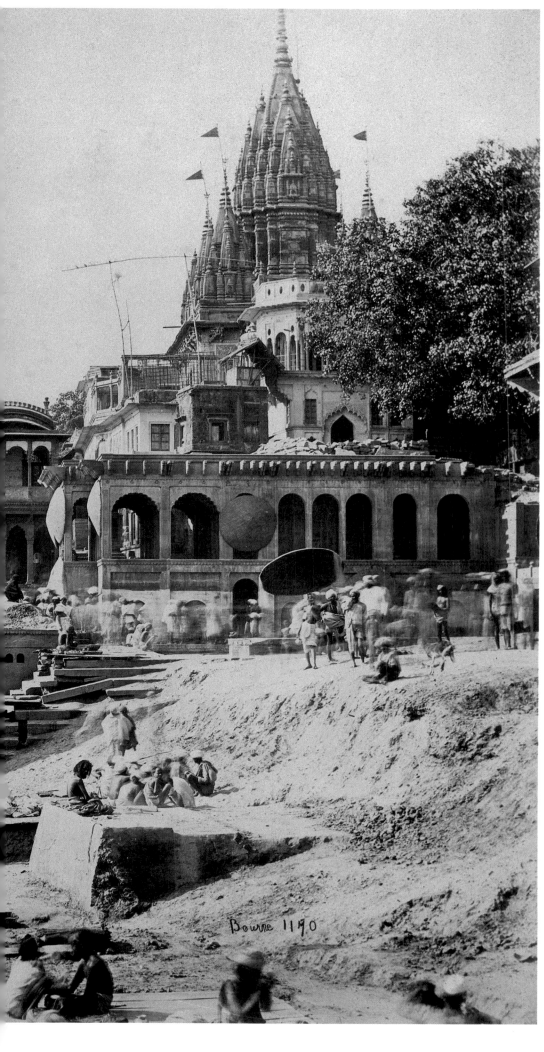

The holy city of the Hindus became a magnet for British tourists in the 19th century. It also offered wonderful subjects for Bourne, who liked to photograph sights, such as temples, mosques, bazaars, and the battlefields of the 1857 mutiny. His photographs were the most popular items in the inventory of Bourne and Shepherd, a company with branches in Calcutta and Delhi. Even at the end of the century, long after the photographer had returned to England, tourists could buy Bourne's photographs from the Bourne and Shepherd catalogue.

Samuel Bourne, Temples on the Banks of the Ganges at Benares, 1865.
International Museum of Photography, George Eastman House, Rochester, N.Y.

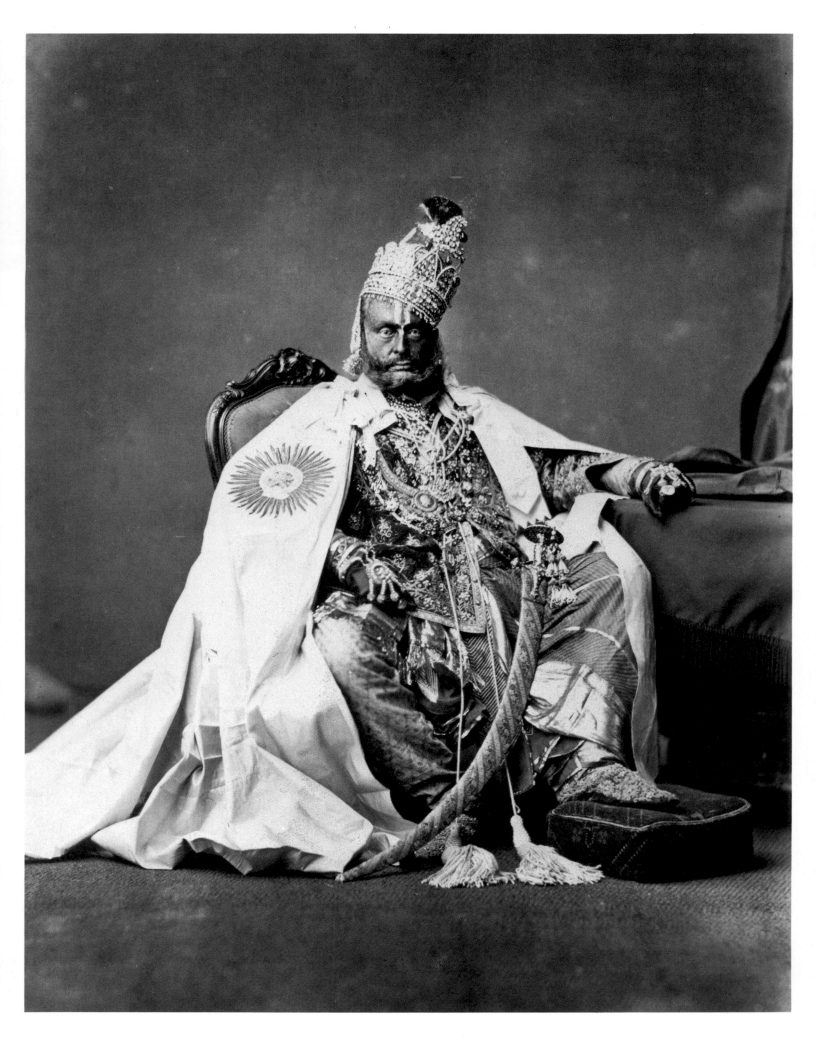

Bourne and Shepherd(?), The Maharajah of Rewah, c. 1877.
Royal Photographic Society, Bath, England.

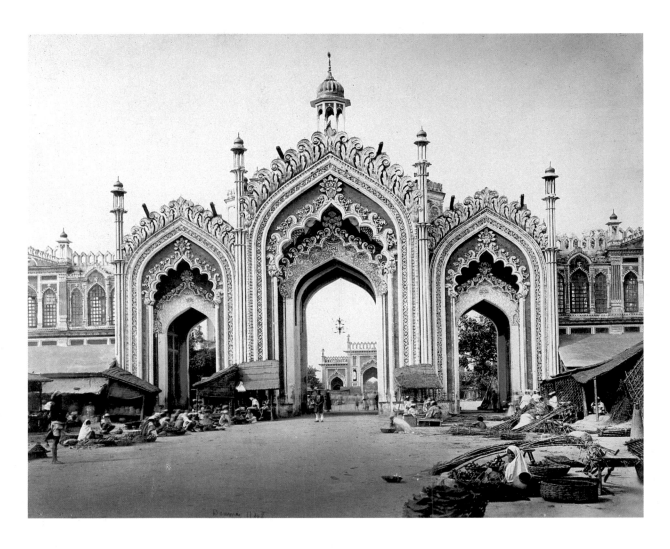

Samuel Bourne, Gate to the Lucknow Bazaar, 1865.
Collection Stephen White, Los Angeles.

During his second trip to the Himalayas in 1864 Samuel Bourne photographed scenes of the luxurious life led by the British in Kashmir Province. The idyllic waters of Srinagar reminded the photographer of his home in Nottingham, England. The boat shown here is a sort of royal barge, and it belonged to the province's highest-ranking British civil servant. Living like conquerors and convinced that the technological and social progress of the Victorian age would benefit everybody, the colonials failed to notice the damage they were doing to ancient cultures. Thus, the mutiny of 1857 caught them very much off guard, and the fact that they managed to put it down quickly only reinforced their attitudes. In general, the British did not think too highly of the Indians, and Bourne was no exception. Having chosen to work in such a place, he would at least live well, with three servants to look after him as he traveled and his private library to take along wherever he went.

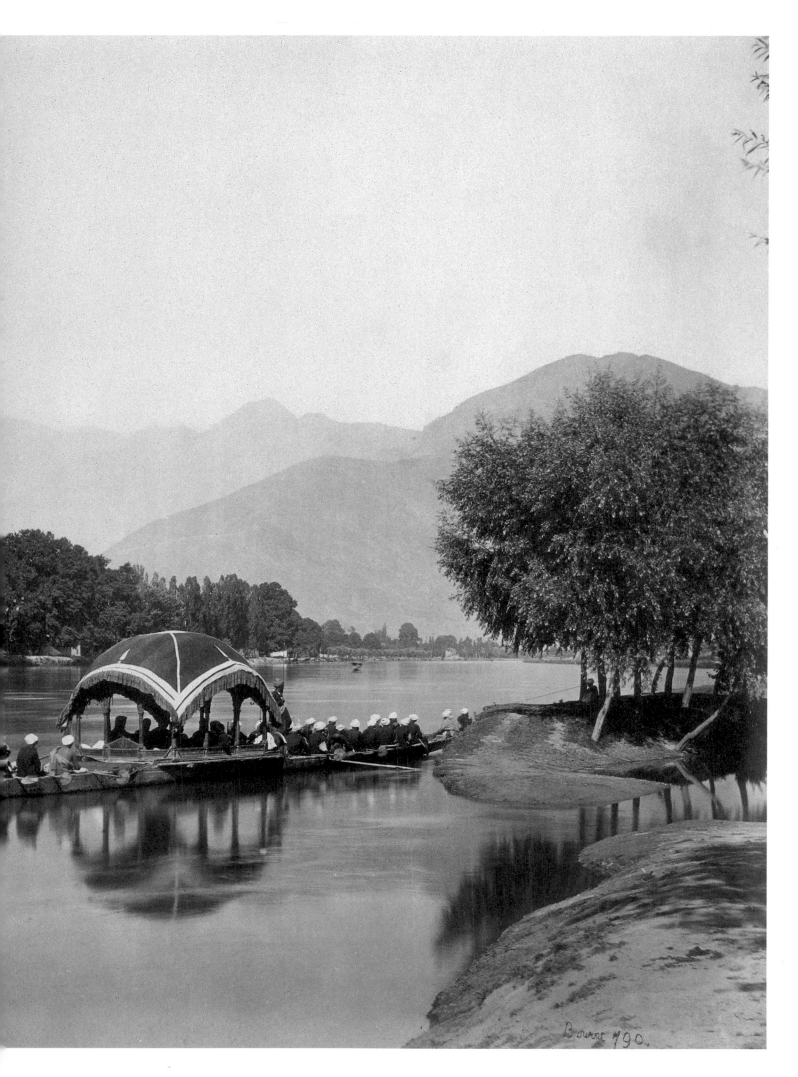

Samuel Bourne, A High-ranking British Official, Conveyed by Boat in Kashmir, 1864.
Daniel Wolf Gallery, New York.

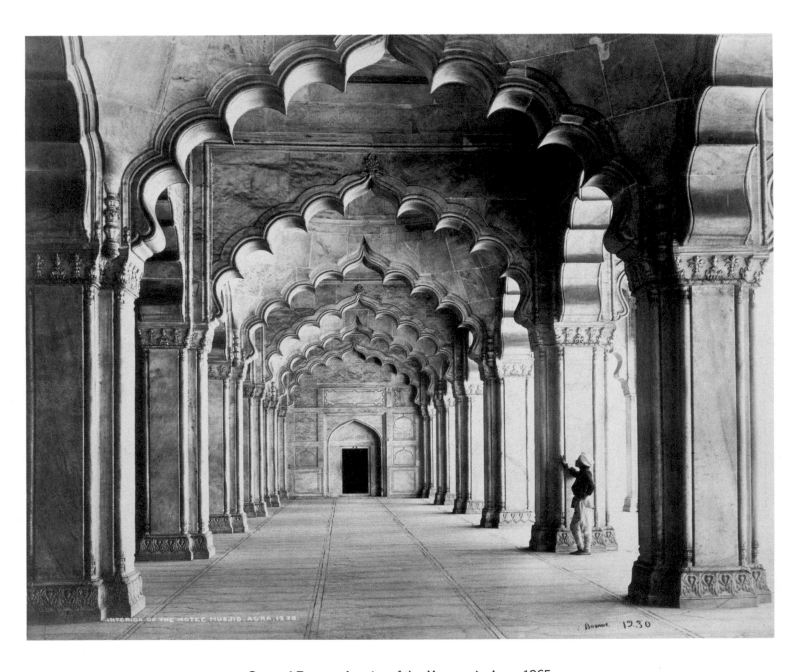

Samuel Bourne, Interior of the Mosque in Agra, 1865.
Theodore Lyman Wright Art Center, Beloit College, Wisconsin.

Bourne liked austere geometrical compositions, which
he sought by making the play of light and dark an
important ingredient of his photographs of mosques
and tree-lined avenues. To give some idea of the
monumentality of the fortress at Deig, he put a solitary
human figure next to it (page 173).

Samuel Bourne, Avenue of Poplars in Srinagar, 1864.
Daniel Wolf Gallery, New York.

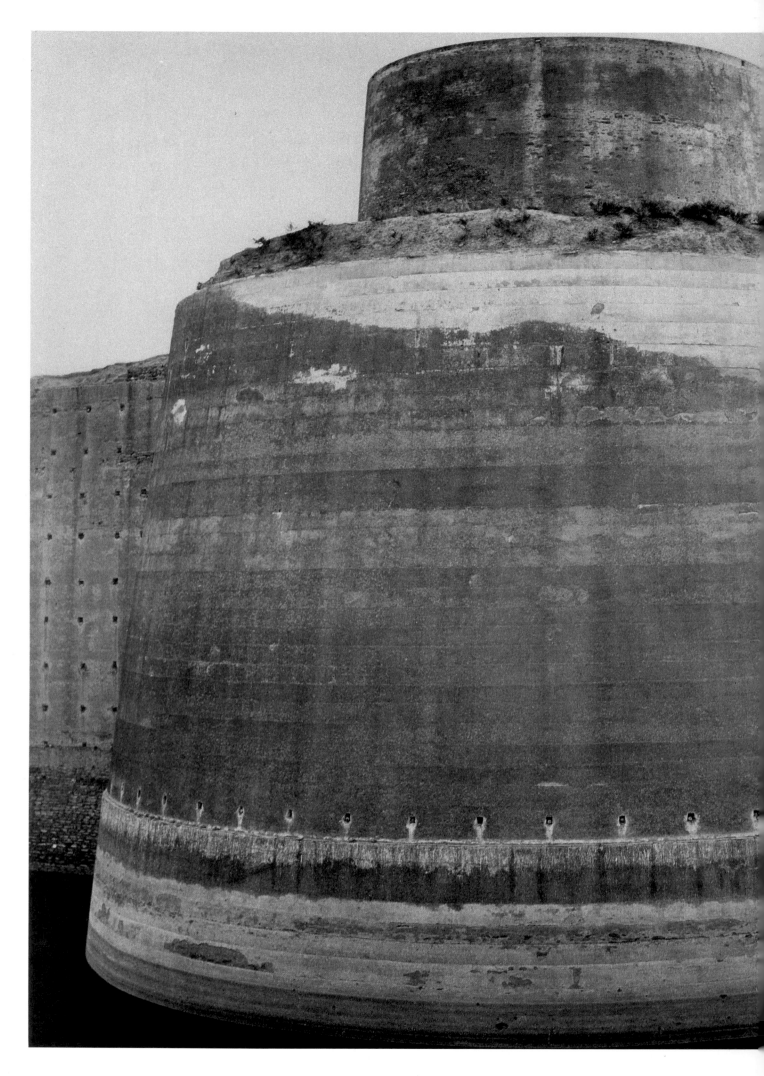

Samuel Bourne, The Fortress at Deig, 1865.
Theodore Lyman Wright Art Center, Beloit College, Wisconsin.

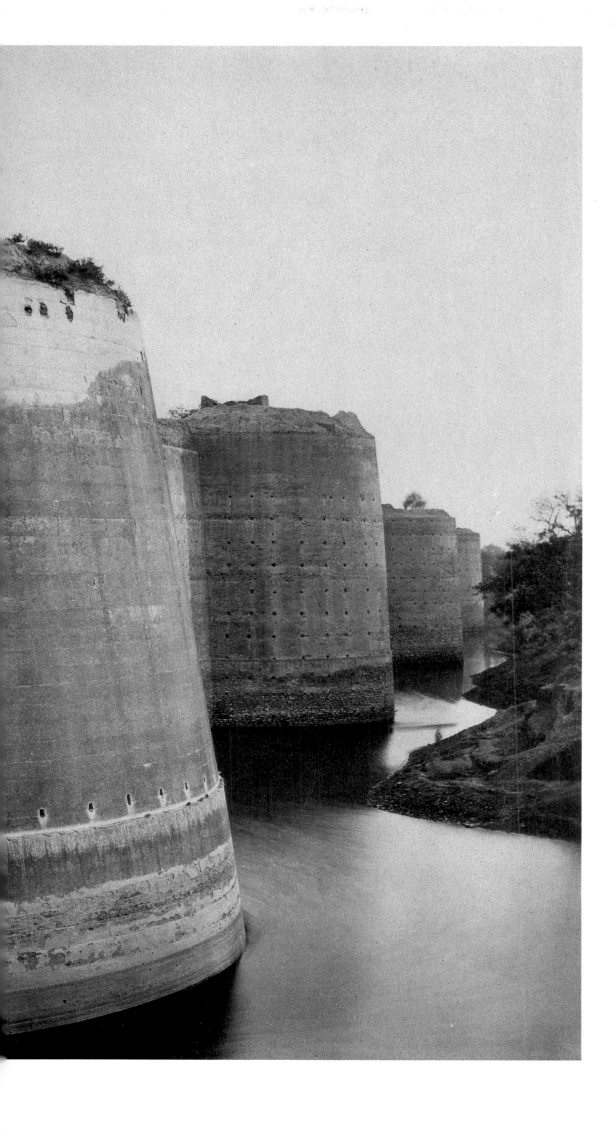

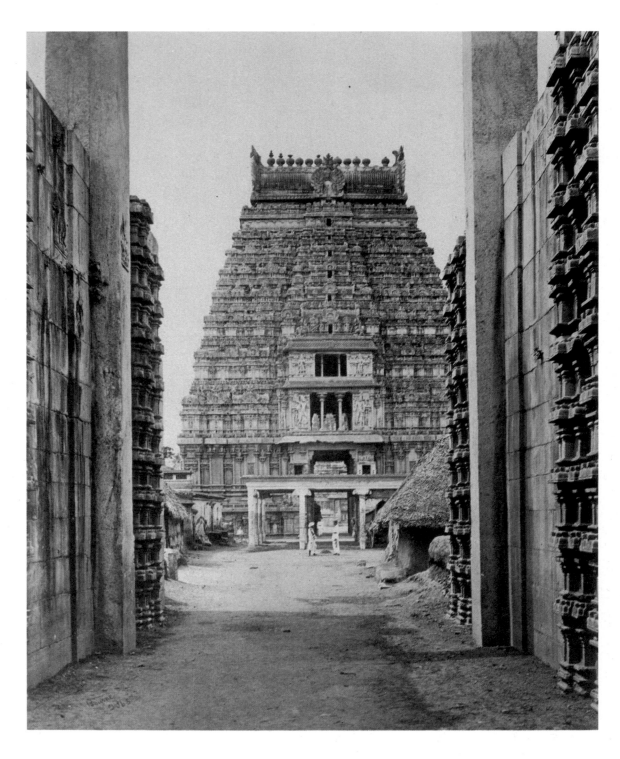

Samuel Bourne, The Eastern Temple in Trichinopoly, c. 1869.
Collection Ken and Jenny Jacobson, Great Bardfield, England.

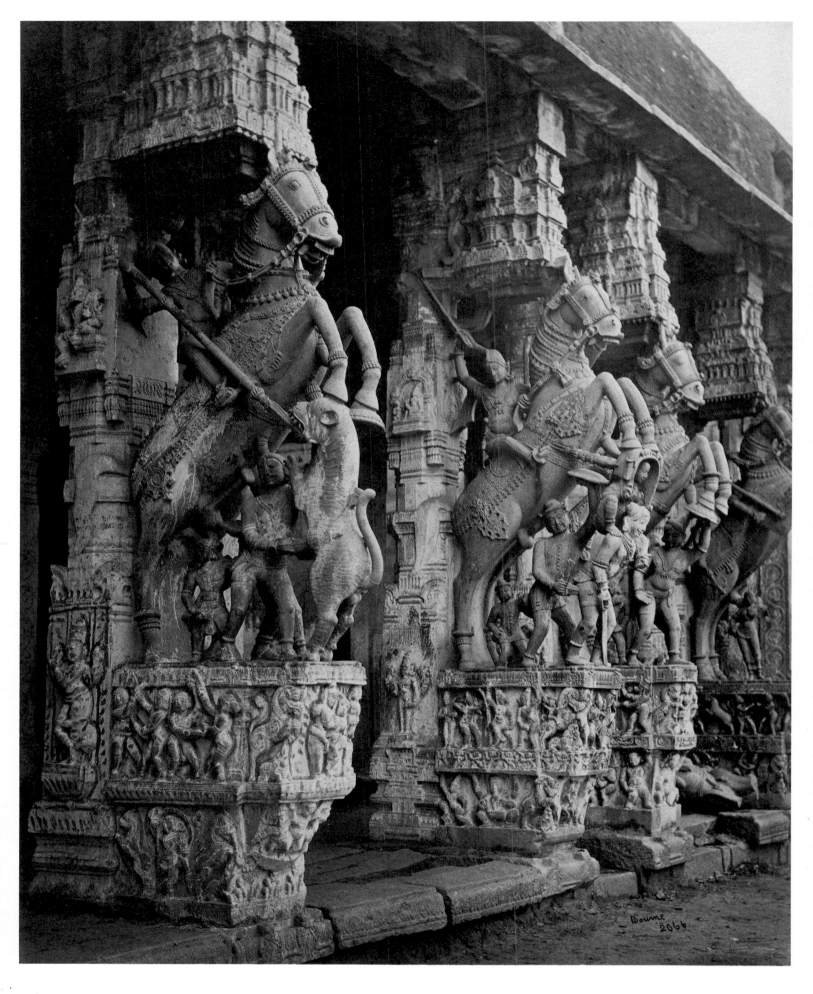

Samuel Bourne, Sculpture on the Façade of the Temple at Trichinopoly, c. 1869.
Collection Ken and Jenny Jacobson, Great Bardfield, England.

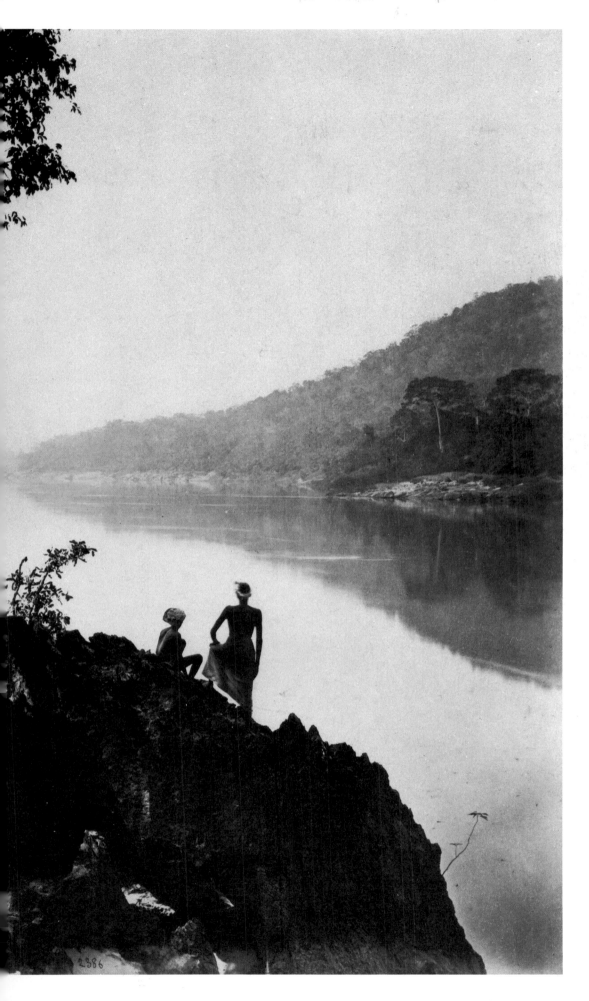

Samuel Bourne, Idyllic Landscape Along the Salween River, c. 1875.
Royal Photographic Society, Bath, England.

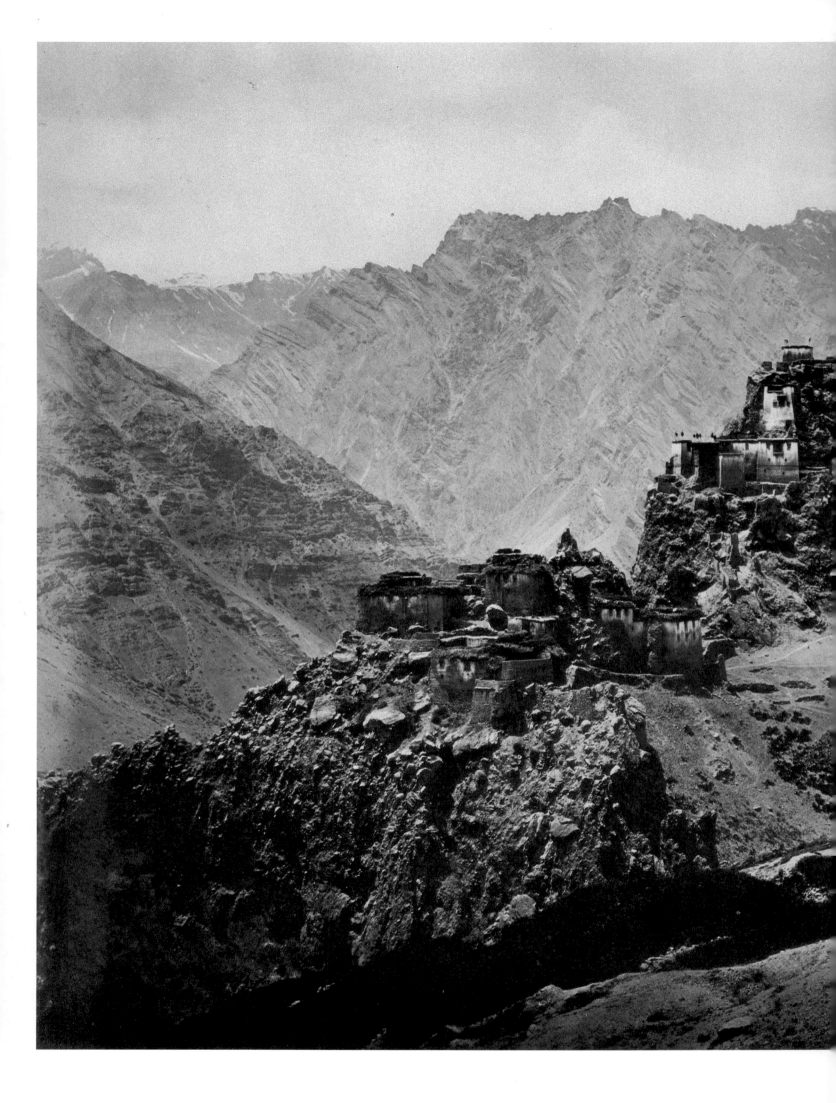

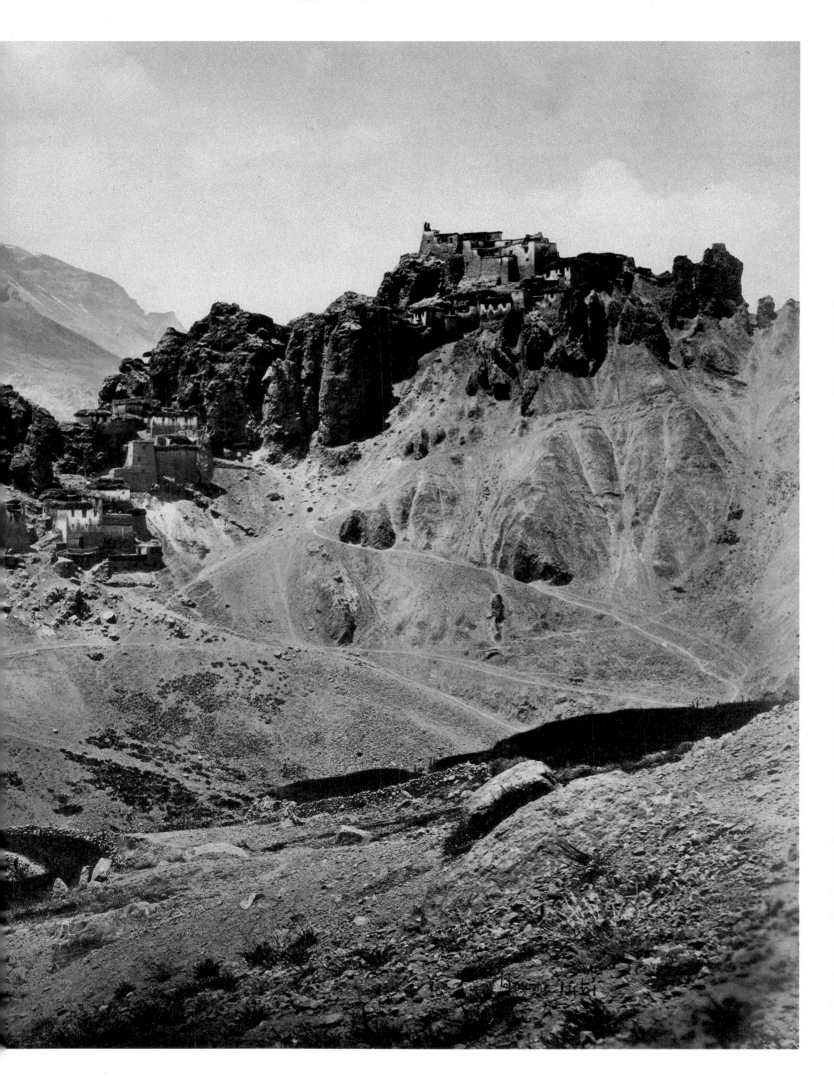

Samuel Bourne, The Village of Dunkar in the Himalayas, 1866.
Library of Congress, Washington, D.C.

179

"Photographic enthusiasm could not go much further than this," Bourne wrote in the *British Journal of Photography*. In 1866 he took three photographs of the pass, 18,600 feet above sea level, until 1880 the maximum altitude at which a glass plate had been exposed.

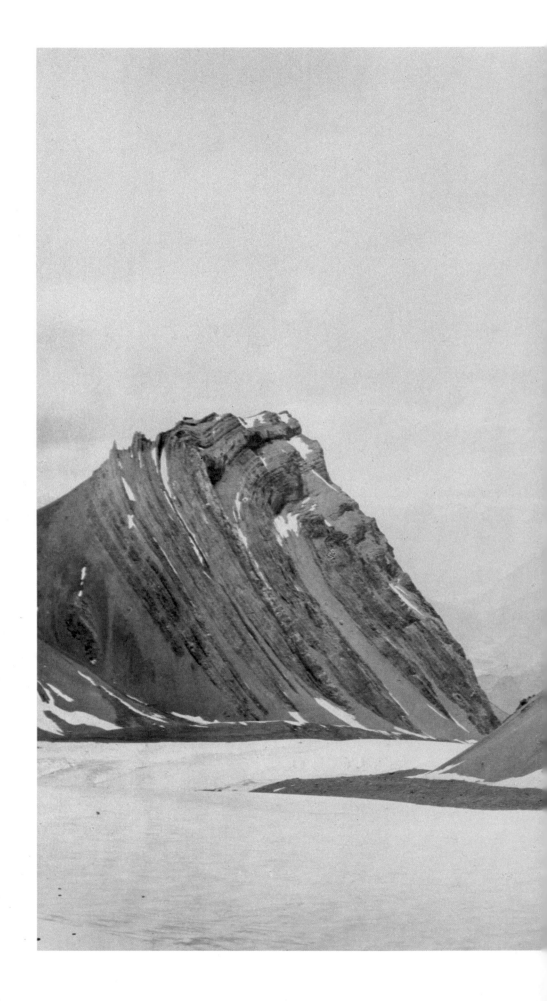

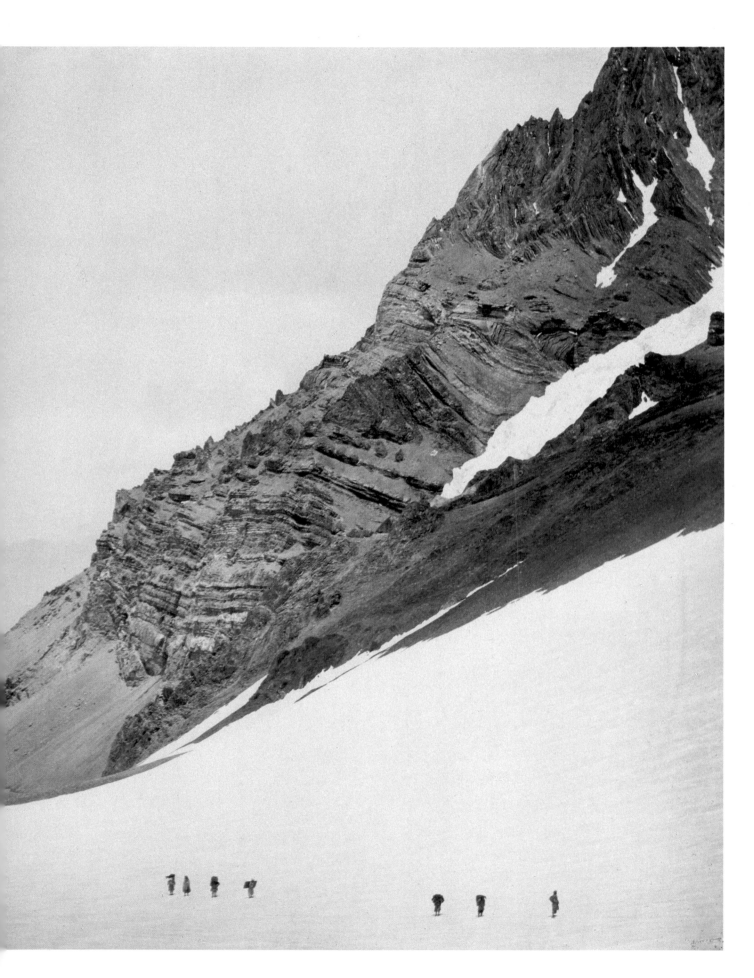

Samuel Bourne, The Manirung Pass in the Himalayas, 1866.
Carpenter Center, Harvard University, Cambridge, Mass.

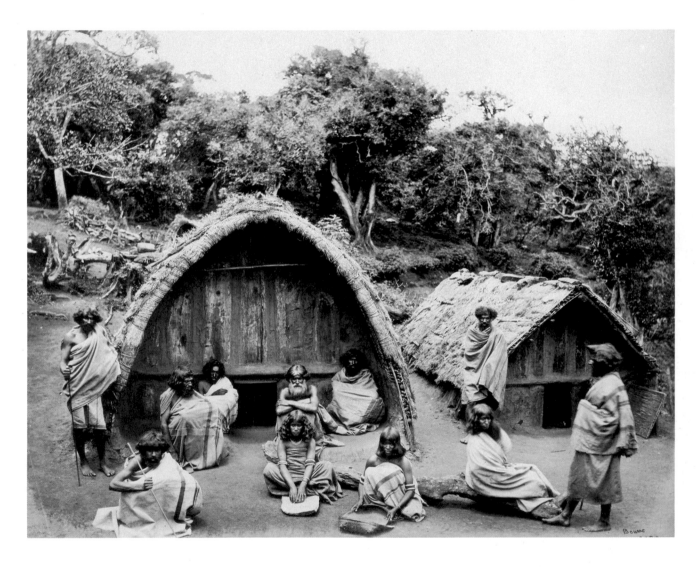

Samuel Bourne, Toda Villagers in the Mountains of South India, c. 1863.
Collection Robert Hershkowitz, London.

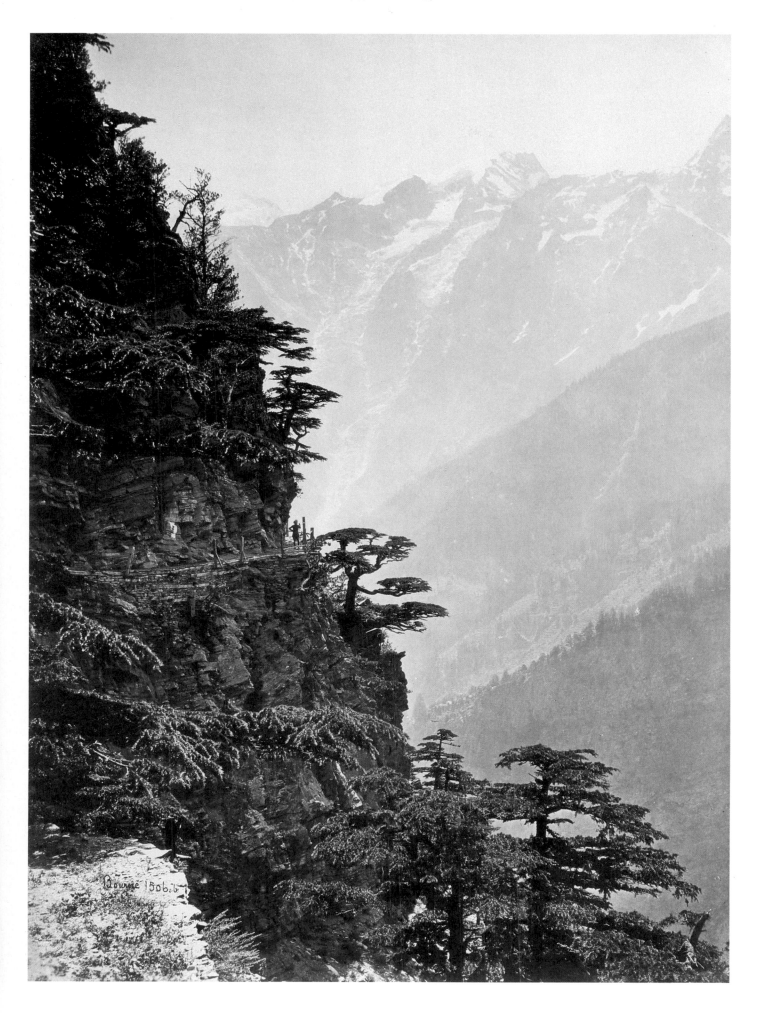

Samuel Bourne, Path in the Himalayas, 1866.
Carpenter Center, Harvard University, Cambridge, Mass.

Samuel Bourne, Tree Ferns in the Darjeeling Jungle, 1869.
Collection Ken and Jenny Jacobson, Great Bardfield, England.

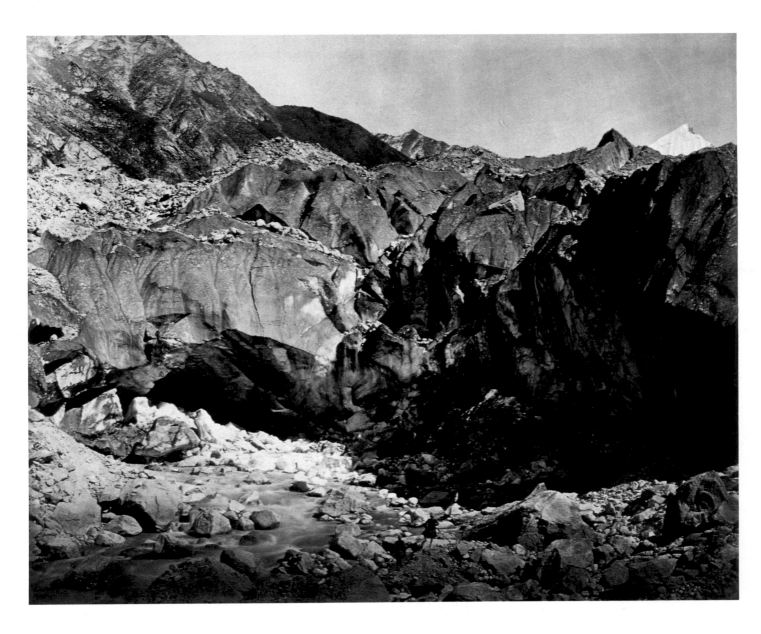

Samuel Bourne, The Source of the Ganges, 1866.
Library of Congress, Washington, D.C.

Bourne made three forays into the Himalayas, whose
population impressed him considerably less than the
grandiose settings. Being hardy, the photographer
insisted on going beyond the readily accessible Hindu
temples along the river to the very source of the Ganges
in the bed of the Gangutri Glacier.

6
India
The "Brave Photographic Warriors" of the British Empire

Samuel Bourne (1834–1912), in the only known photograph of him.

T he photographers of the colonial age were usually white, male, and often English. When they landed in Shanghai or Calcutta, smelled the exotic perfume of burning incense, heard the singsong of an unknown language, saw coolies waiting to serve and call them Sahib, the camera-laden Victorians must have felt like conquerors as well as photographers.

It was very like a conqueror that Samuel Bourne traveled through India in the 1860s. He went forth with a small army of coolies, and his caravan extended for miles. For Bourne's expedition into the mountains of Kashmir in 1864, the bearers had to lug tripod and lenses, cameras and glass plates, chemicals, trays, bottles, and tents, while twenty-two personal servants tended to the basic necessities of a gentleman on tour. These included bedding and kitchen equipment, rattan furniture, bundles of books, such "sporting requisites" as rifles, shotguns, and pistols, and a very good cure for homesickness: French brandy.

In the *British Journal of Photography* Bourne reported that for a journey of this kind, which was likely to last twelve months, it was advisable to take as many things as possible to ensure one's comfort. After all, one would be living in complete solitude, a condition in which one would never see a white man, receive any news, or hear a single word of English, only the barbaric Hindustani. Like all white masters before him, Bourne complained about his bearers.

He often found it difficult to keep the caravan together. The photographer might bellow for tripod and camera, to capture a suddenly discovered motif, but by the time the bearers caught up with him the sun had disappeared. Bourne also found that bearers from the plains were not conditioned to live at great altitudes. Once above 12,000 feet, they lay down, groaning that they would die, whereupon Bourne had to get them on their feet with a stick. But the stick did make an impression, and after it had been waved a few times, the bearers stuck by their master through thick and thin, bravely carrying their burdens across the most rugged mountain passes.

Photographers traveling in India or China could count on being provided with as many bearers or coolies as they needed. In China the rounding up of coolies was called "shanghaiing." India was dotted with caravansaries, called "chowdrees" or "lumbadars," where bearers might be rented. The latter were indentured laborers who could not run away for the simple reason that they were kept in wooden cages. To his credit, Bourne seems to have been astonished by such brutality.

Europeans had been yearning for exotic lands, among them India, for a very long time. Early in the 17th century the passionate traveler Thomas Coryate claimed to have had but three wishes: to see the famous Mogul, to ride on an elephant, and to stand on the banks of the Ganges. No idle dreamer, he packed up and went to India, much of the way on foot and often spending no more than "a penny a day." Meanwhile, as Coryate marveled at the half-naked, ash-covered Hindu ascetics called *sahus* on the steps leading down to the river at Benares, a tiny British company, with a mere £30,000 in capital, was busy installing itself in India for the purpose of exporting spices to England. Two and a half centuries later the little enterprise had become the East India Company and a world power. By the middle of the 19th century it controlled practically the whole of the subcontinent. The company surpervised the export of tea and cotton,

commanded a small army capable of making forays into every corner of the country, and pressured Indian Princes into signing contracts favorable to itself.

The educated European thought of India as a land of wonders, a fairytale world of Maharajahs, fakirs, and snake charmers, peacock feathers, musk, and ivory. Queen Victoria herself, whose portrait hung in every office, garrison and postal station on the subcontinent was no exception. When the Prince of Wales returned from a trip to India, he was laden with jewelry and precious fabrics.

The Queen, who loved being titled Empress of India, permitted a mixture of Indian teas to be called "Her Majesty's Blend" and gratefully received annual presents of cashmere shawls. Victoria reinforced her personal guard with an Indian escort, and on the occasion of her Golden Jubilee in 1887, she confided to her diary that the jewels brought her by the Indian officials were glorious. Before retiring, she spoke to Dr. Tyler, who had presented her with a pair of handsome Indian menservants, dressed very smartly in scarlet and wearing white turbans. The Maharajahs invited to audiences at Buckingham Palace were popular in England because, as compliant Oriental potentates, they provided the justification

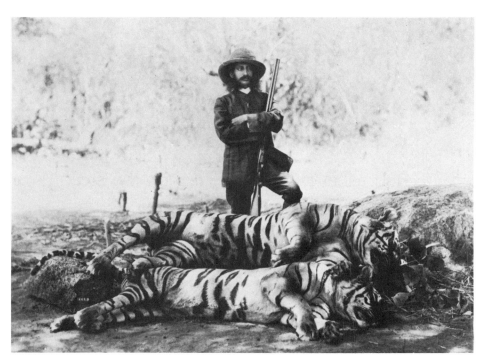

The Nizam of Hyderabad after a tiger hunt.

of British rule in India. All London enjoyed stories about the conspicuous consumption of these improbably rich Princes.

One of the Maharajahs bought an entire department store and had every object in it shipped back to India—gift-wrapped!—while another had his London hotel suite decorated with three thousand fresh roses every day. The darling of the penny press was unquestionably the Nizam of Hyderabad. At the end of the century the Nizam reigned over fourteen million people living in an area larger than England and Scotland combined. The most unlikely rumors spread about the practices of this richest of all rich Princes. It is true, however, that several times a year a ship sailed for France with the Nizam's laundry on board. It was washed in Paris and sent back. The Nizam loved everything English. Indeed, he was considered a "British Indian" and every inch a gentleman. He carried a gold-headed walking stick, wore suits made of the finest tweeds, gave bountiful parties, and played a good game of polo. The Nizam also employed a court photographer, just as Britain's royal family did. He called this man *raja musavir jung*, meaning "brave photographic warrior." His name was Deen Dayal, and he had begun as a technical draftsman. Under the Nizam, his task was to photograph Indian Princes lying on litters or Princesses almost choked by their jewels. Dayal photographed Maharajahs with water pipes, scimitars, and twirled mustaches, as well as servants standing at attention and saluting with peacock-feather dusters. He took souvenir shots of morning rides, royal picnics and excursions, and hunts that ended with the white-turbaned hunters posing, champagne glass in hand, before the tigers they had bagged. Souvenir photographs of the hunt were among the presents given to British Viceroys and Governors.

Most of Dayal's photographs of the British depict them playing one sport or another. There they are, standing nonchalantly on the putting green, conversing with their Indian caddies, pulling on a rope in a tug-of-war, drinking gin and tonic. Judging from Dayal's pictures, one might assume

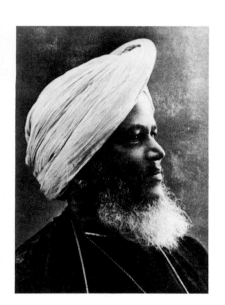

The Indian photographer
Deen Dayal (1844–1910).

that the British in India did nothing but play games, have drinks, and stand around at parties making small talk. Dayal seems to have visited the British at their clubs as frequently as he went to the Maharajah's residence. On British turf he met officers in topees and ladies hidden under parasols protecting their fair skins from the tropical sun. The two most important words to be heard at the clubs were "duty" and "service." Having done one's duty, one could rightfully expect service.

The best clubs were in the mountains, cool country houses in the colonial style. The train to Simla saved one from the heat of the plain, as well as from the swarming masses of Indian cities. The clubs provided a regular round of such diversions as regimental dances, costume balls, and farewell parties in honor of officers who, grayed in the fulfillment of their duty, were now allowed to return to the banks of the Serpentine in Hyde Park.

The Empire took good care of its sons in garrisons and outposts around the world. The typical Briton, "Smith of Asia," could indulge his Victorian sense of comfort by ordering the necessary props from a catalogue. There, for the

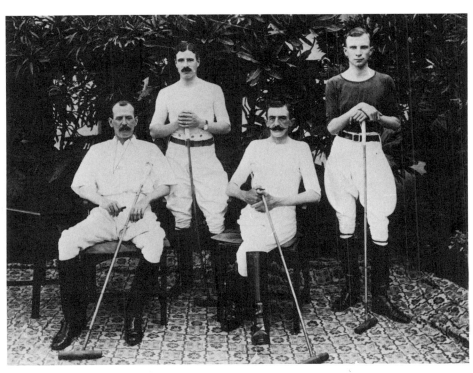

The polo team of the British 33rd Cavalry
photographed by Deen Dayal in 1908.

terrace, they would find chairs with pockets for bottles, along with patented washtubs for his preprandial bath, folding beds, and mosquito nets. He could even order his favorite barley water.

The land of milk and honey in imperial India was to be found mainly in the cities, where Maharajahs had their residences and the British their town clubs. He who traveled in open country, through areas infested with malaria and villages, where the Queen on postage stamps was thought to be a white goddess, belonged to the genus "mad Englishman."

One such was Samuel Bourne, who ventured into the rice fields of the plains, where cow manure steamed and vultures circled overhead, where the natives still prayed to the god Krishna and not to that all-powerful god known as "Cotton." Bourne's India was the dense, impenetrable green jungle, the mountains of Kashmir, and the glaciers of the Himalayas. Bourne was the prototypical outdoor photographer. Like the photographers of the Wild West, the former bank clerk from Nottingham was looking for wilderness, virgin forest, and the thrill of towering peaks.

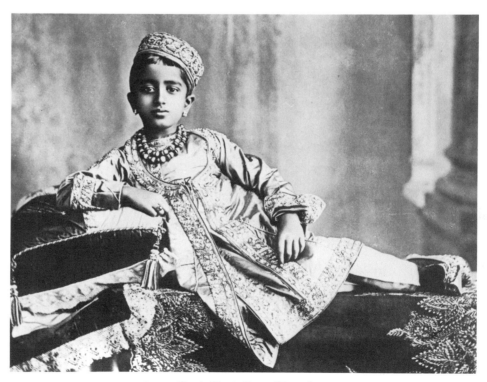

Prince Fateh Singh Rao of Baroda
as photographed in 1891 by Deen Dayal.

Bourne came to India in 1860, married in 1867, and, with Charles Shepherd, opened a photography business in Simla, the first in India. Shepherd preferred to remain in the harbor city, printing catalogues, making albumen prints, and digging up collodion, which was as hard to come by as Scotch whiskey. Officially, collodion could not be imported because its basic ingredient was also used to make smokeless gunpowder.

Bourne preferred travel to sitting in the shop. At first he limited his activities to the outskirts of the cities. Then he went off on short expeditions, and finally he stayed away for almost nine months. In 1866 Bourne dug his tripod into the snow of the 18,600-foot-high Manirung Pass, declaring that photographic enthusiasm could not go much further. Until 1880, the pass was indeed the greatest altitude ever reached by a photographer.

Bourne found the interior of India to be less deserted than one might have supposed. There were roads, albeit in bad repair, and maps as well, although these did not show rivers or mountains. The photographer could stay overnight with the representatives of the East India Company or other British enterprises. Even postal stations had been established; thus, Bourne could have newspapers, letters, and the latest issue of the *British Journal of Photography* sent out to him. While traveling, he sometimes met compatriots, among whom he magnanimously included Scotsmen. An invitation to hunt leopards would lead to a jolly evening in the company of the hunters. After all, Bourne explained, one cannot spend one's whole life talking about focus and the mysteries of collodion.

In Chumba, Bourne met a Raja who dabbled in photography. Asked to admire the Prince's equipment, Bourne found himself called upon to agree that it was better than his own. Moreover, wasn't the darkroom marvelous, with its great supply of chemicals (which the Raja called *masala*)? The Prince was fascinated by all the new technical inventions and had become the proud owner of a telescope, which, however,

A contemporary drawing of an Englishman on a tiger hunt.

he used only as a fetish. While admiring the piece and its beautiful mahogany case, he never used it for scanning the stars.

Bourne practically had to reinvent the "wet process" daily, depending on the climate. How would collodion react in freezing mountain air? How would the thin atmosphere at 12,000 or 15,000 feet affect it? What would happen in the swamps? And in the desert? How often, we wonder, did mishaps occur? Once, when he opened a box of exposed plates, Bourne discovered, to his horror, that five of the best had developed a network of cracks.

Bourne could not photograph in fog, early in the morning, or straight into the light. In his pictures of the Himalayas there is no twilight, the valleys between the mountains remain shadowless, and the bearers are picked out against what appears to be glare ice. Bourne often lamented the ineffectiveness of the wet process, because he felt that the grandeur of the Himalayas could be captured only in twilight.

The installments of Bourne's travelogue published in the *British Journal of Photography* filled amateur photographers with awe. Sitting comfortably at home, they could not, the author assured them, even begin to imagine the hardships of his kind of photography. If they thought it was fun to climb a mountain on a very cold morning and then wait, teeth chattering, for ten hours until the fog lifted, they were wrong, because at the end of the ten hours he had to climb back down, reaching his tent late at night.

There was also the time when, on the way back from the mountains, one of the bearers approached Bourne with all the symptoms of a bad conscience. It seems that a box had fallen, breaking the plates it contained. Moreover the accident caused a bearer to suffer a broken arm and another a pair of broken ribs. Meanwhile, the nearest source of plates was a month's journey away.

Bourne apparently enjoyed his reputation as a great adventurer. For his climb to the Manirung Pass he marshaled

a caravan of eighty bearers, a herd of sheep and goats for fresh meat, a yak to ride, and a group of personal "dandy" bearers. "Dandy," he explained to *Journal* readers, did not refer to a dandy being borne because he was tired of climbing, but rather to the litter the photographer sat in.

Bourne returned from the last of his three great expeditions into the Himalayas in 1868. By that time photography had become as popular as polo, and every large town on the subcontinent had its studio photographer. While Bombay's Photographic Society recruited its members from the most influential circles, the photography clubs in Calcutta and Madras organized contests. Needless to say, the importation of chemicals, darkroom tents, and glass plates had become a flourishing business.

The photographer in India came to enjoy a professional status equal to that of the colonial officer or the colonial

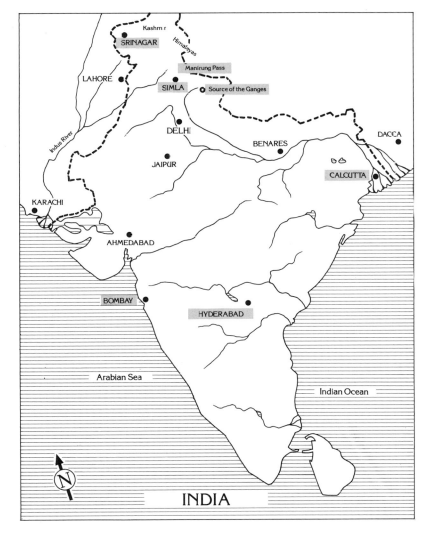

Bourne made photographic history with his three journeys into the Himalayas and his photographs of the 18,600-foot high Manirung Pass.

merchant. The government in London realized that a handful of British could not govern half the world without knowing something about those vast exotic lands. It became popular to study alien customs, forms of government, mentality, and history, because such knowledge meant power. Officials immersed themselves in ethnology and ethnography, and the photographer's work became a key means of doing this.

The East India Company dispatched colonial officers, such as Captain Biggs and Captain Linnaeus Tripe, on inspection tours during which they photographed members of the various castes, rice farmers, and itinerant vendors. A selection of one hundred thousand photographs from the archives of the East India Company were published in an eight-volume set entitled *The Peoples of India*.

By the end of the century, photography in India was no longer an adventure. Bourne and Shepherd's studio offered tourists a selection of some fifteen hundred photographs. In Bombay, Raja Deen Dayal & Sons constituted the largest studio in the city, operating with a staff of fifty.

Twenty years later the fragile, courtly life of the Nizam of Hyderabad had been shattered. But not for the last time would a dead photographer's negatives be sold for a pittance. Dayal died in 1910, whereupon his heirs sold the "brave photographic warrior's" sixty thousand plates, all carefully dated and titled, at the same price as that for glass set into the top of brick walls to discourage intruders.

Samuel Bourne returned to England in 1872 to spend his old age near Nottingham. There he bought a textile mill and a country house with a darkroom and became the president of the Nottingham Camera Club, dining out on his adventures for many years. To take photographs in England, however, one merely set up camera on a small grassy island in a river or under the shady trees of a great park. Photographing India was something else, for the India the world wanted to view always seemed to lie at the extremes of heat or cold.

7.
China

An Ancient Culture Caught Forever

John Thomson

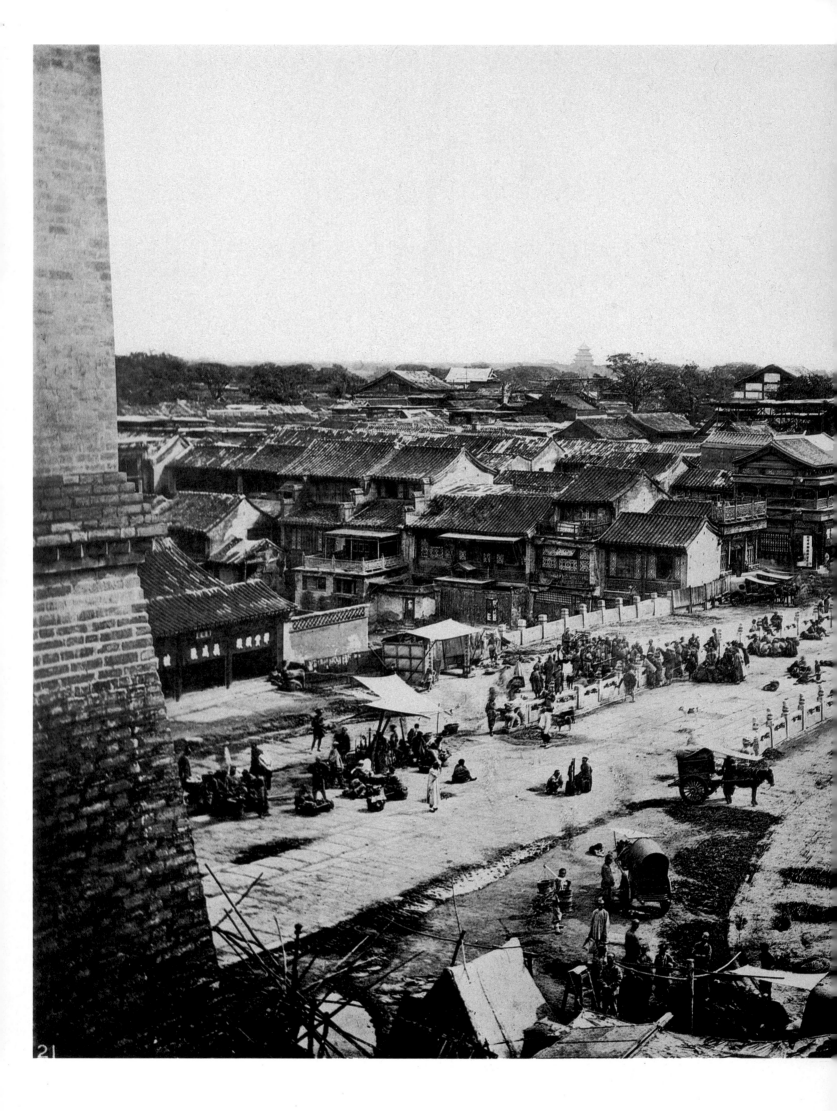

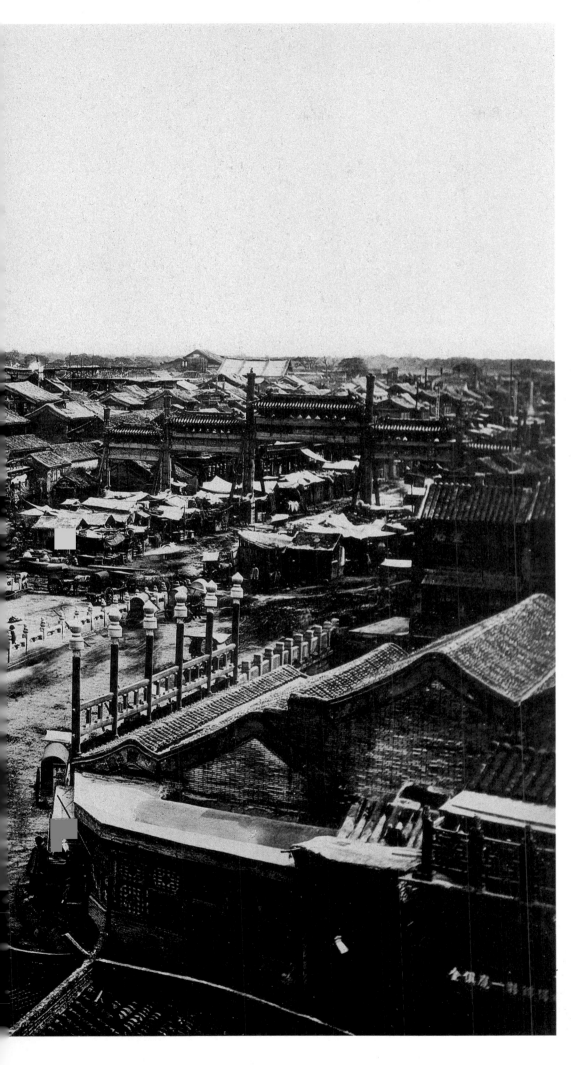

Wherever he went in China Thomson caused a stir. When he set up his camera on the wall surrounding the capital, the populace came running to take a look. The road leads to the gates separating the Chinese quarter from the Tatar quarter. No other 19th-century photographer could capture moments from everyday life as Thomson did. His pictures seem spontaneous despite the ten-second exposure time. Of course he was not only a first-class technician, but also an intelligent and perceptive human being.

John Thomson, View of the Center Street in the Chinese Quarter of Peking, 1871.
Collection Bernd Lohse, Leverkusen, West Germany.

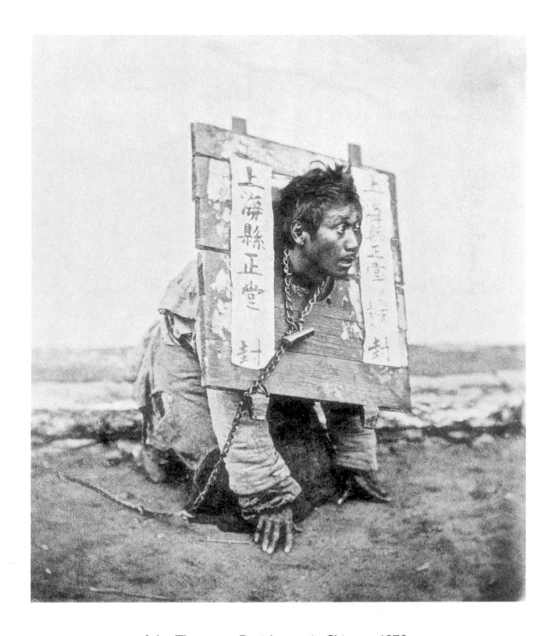

John Thomson, Punishment in China, c. 1870.
Collection Bernd Lohse, Leverkusen, West Germany.

In China criminals were punished in public. A thief had to wear a "cangue," such as the one shown here, and unless passersby or members of his family helped, he would starve since he could not put hand to mouth. Serious crimes brought imprisonment in the "cage of death," where the convict had to stand on tiptoe until his strength gave out and he strangled himself.

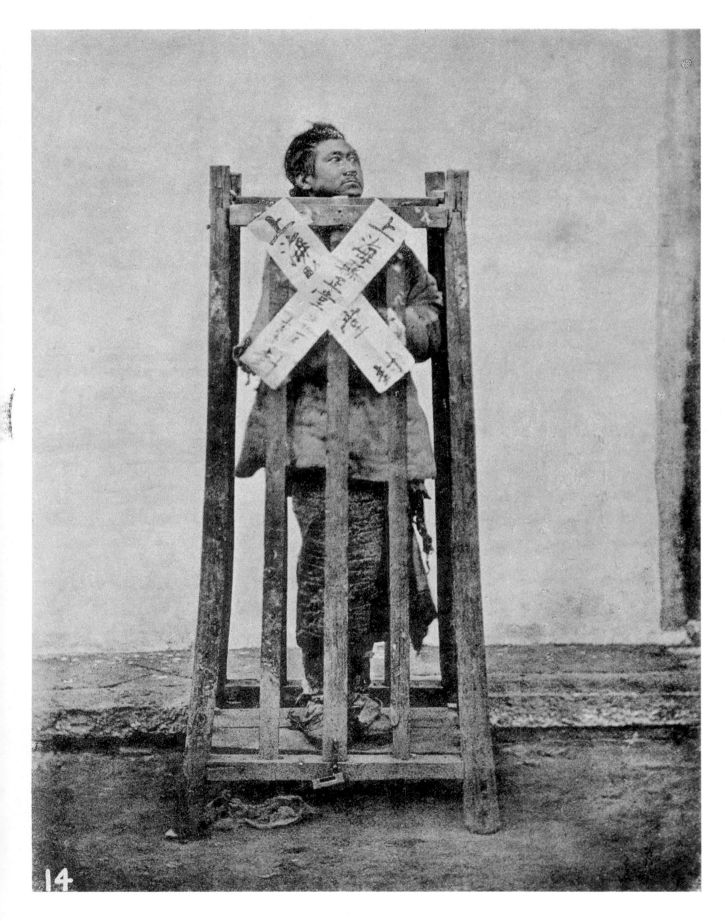

John Thomson, The Cage of Death, c. 1870.
Collection Bernd Lohse, Leverkusen, West Germany.

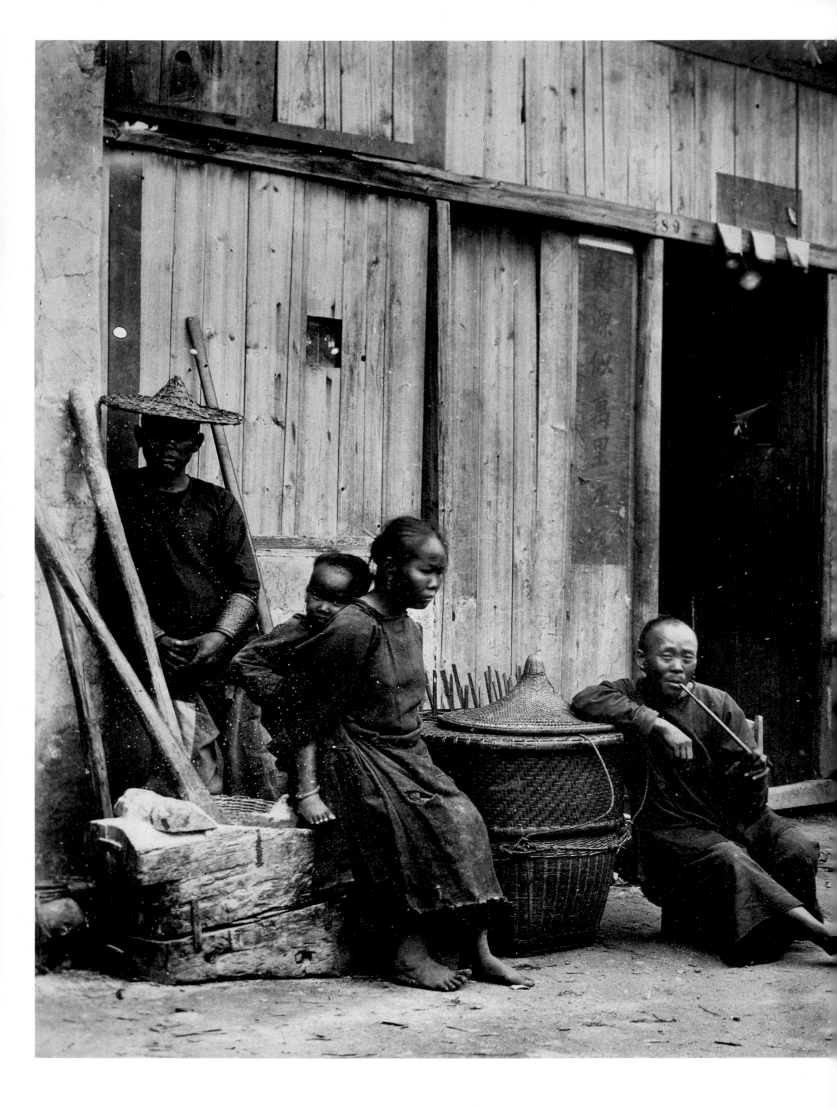

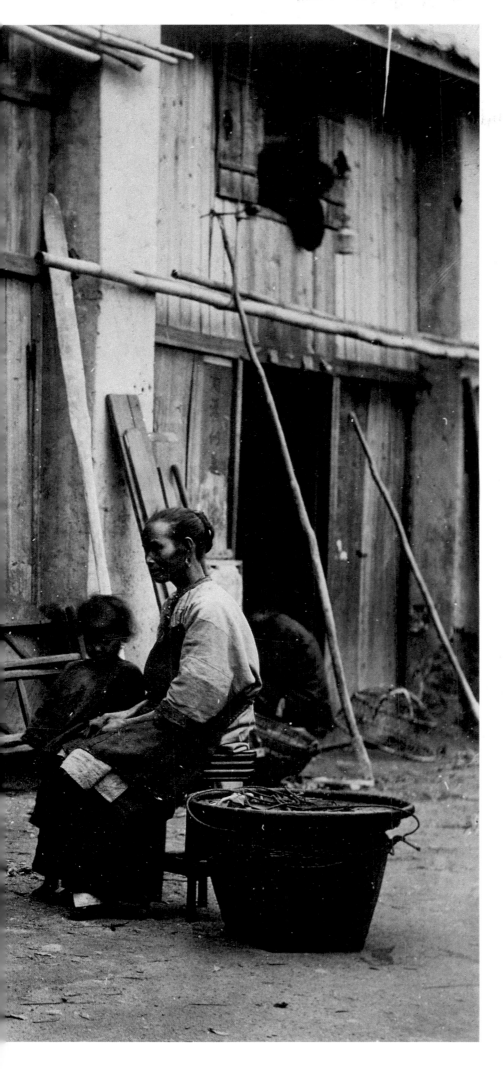

John Thomson, Street Scene, c. 1870.
Fotogalerie Dröscher, Hamburg.

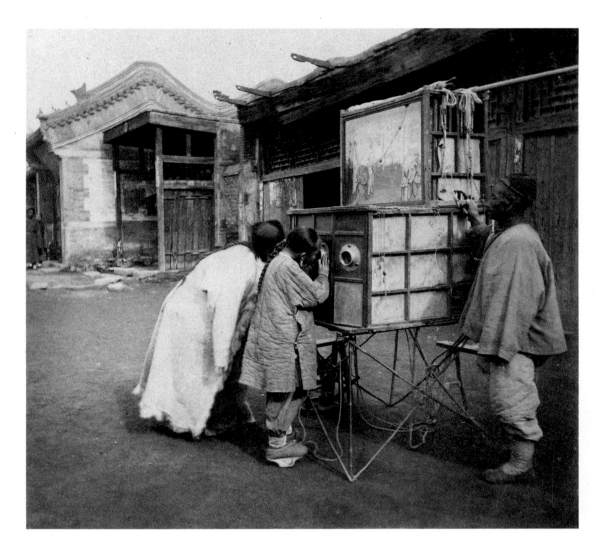

John Thomson, Street Amusements and Occupations, Peking, 1868.
Collection Stephen White, Los Angeles.

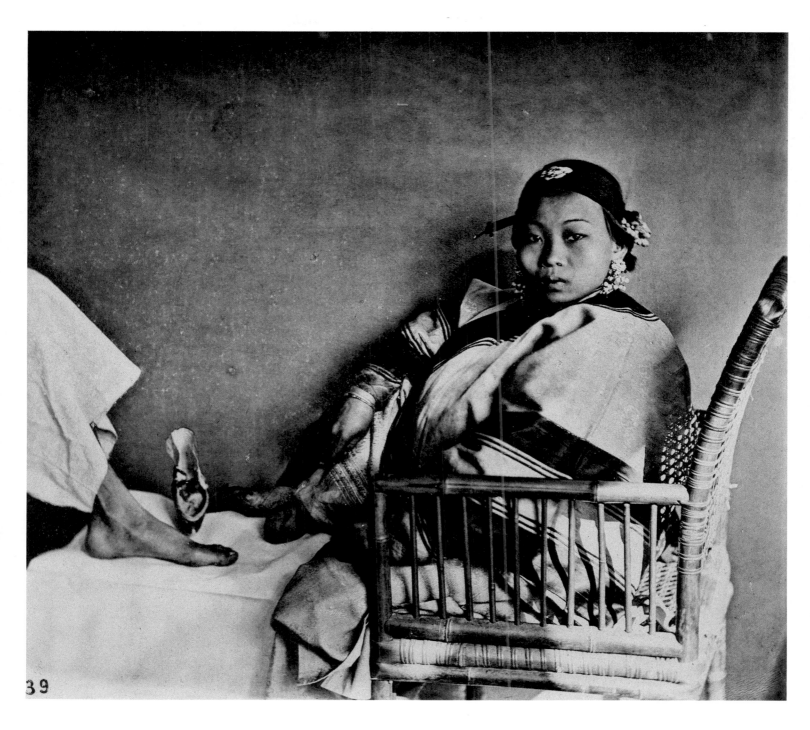

John Thomson, Bound Feet of Chinese Ladies, c. 1870.
Collection Bernd Lohse, Leverkusen, West Germany.

The crippled feet of Chinese women were called "lily feet" and considered attributes of beauty. At a very early age girls had their toes bound to prevent growth. Thomson paid a considerable bribe to persuade this woman in Amoy to bare her stumps.

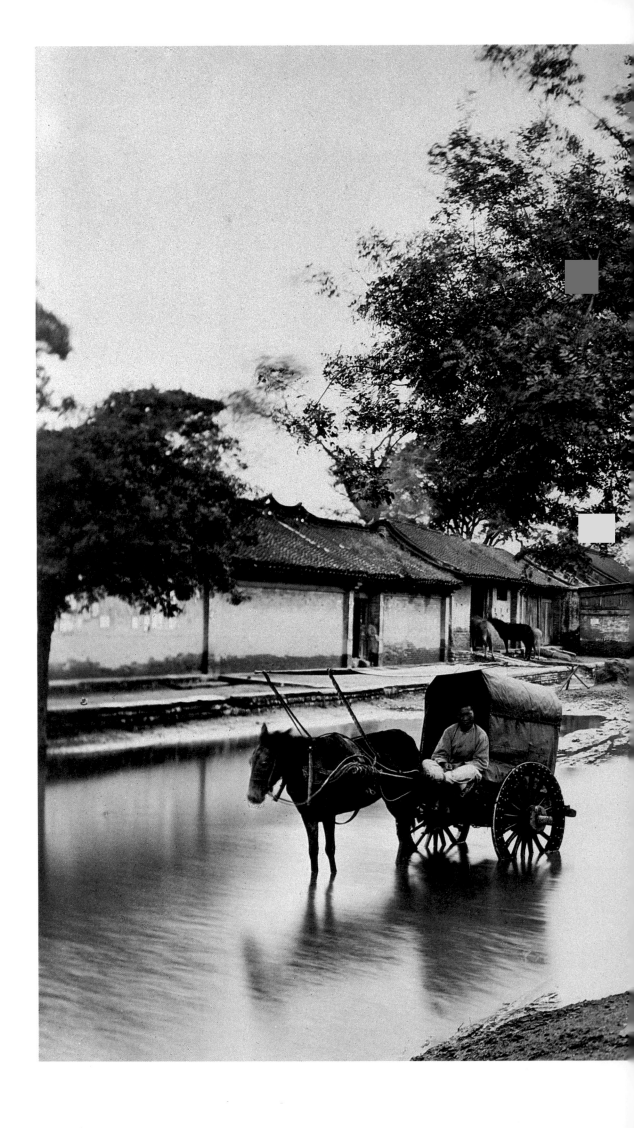

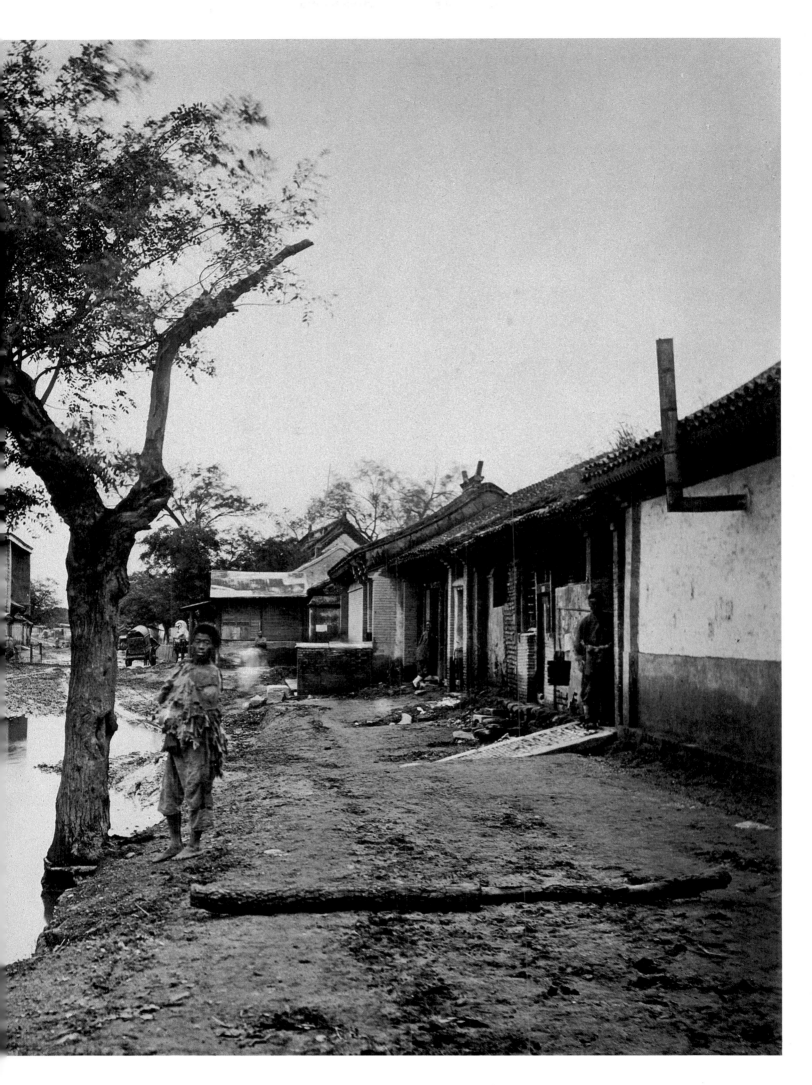

John Thomson, Rainy Day in Peking, c. 1868.
Collection Stephen White, Los Angeles.

John Thomson, Hoy-how, the Proposed New Treaty Port, Island of Hainan, c. 1868.
Collection Bernd Lohse, Leverkusen, West Germany.

In this panoramic view, fascinating even now, Thomson kept the horizon low, which permits the forts at either end to dominate the coastal landscape. The photograph appeared in Thomson's *Illustrations of China and Its People,* a splendid book published in London in 1873–74 with 200 images, all reproduced by the calotype process, which the author preferred for the high quality and durability of the prints. Albumen prints, by contrast, faded very easily. Probably the first member of the Royal Geographical Society of London with a completely objective way of looking at things, Thomson left well-observed reports along with his photographs.

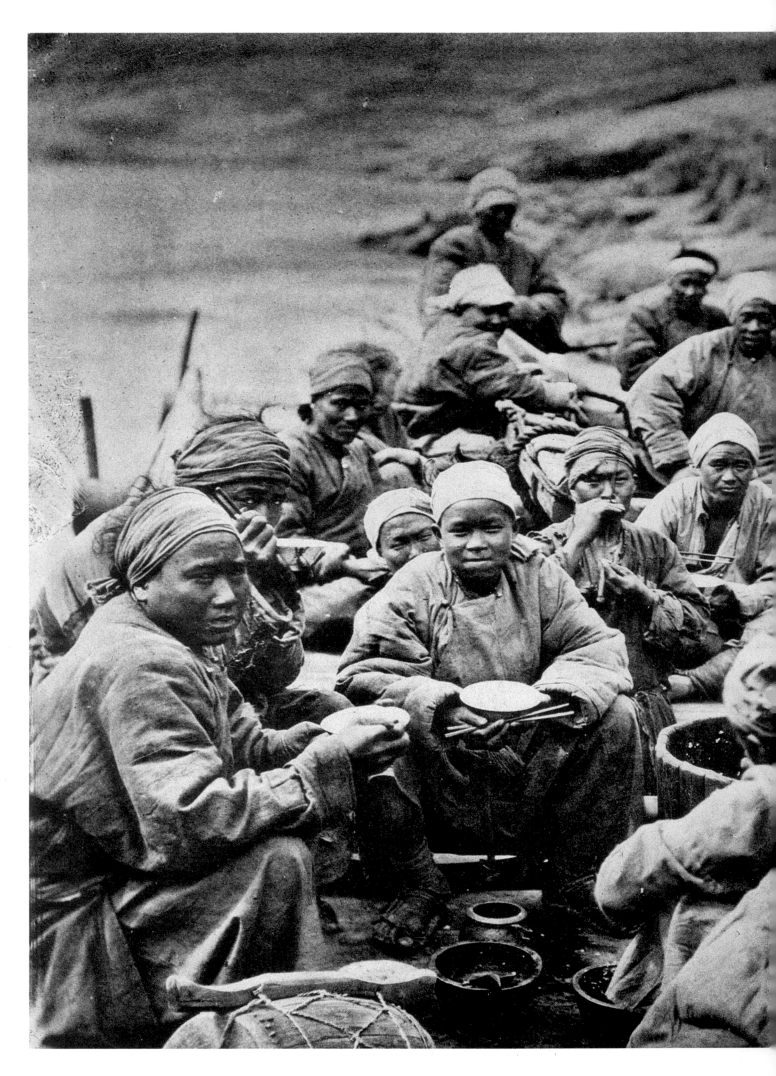

John Thomson, Breakfast on the Yangtze River, 1871.
Collection Bernd Lohse, Leverkusen, West Germany.

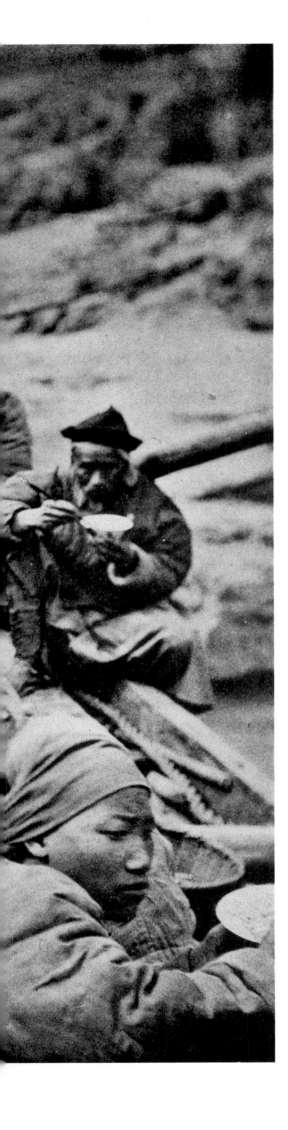

The Yangtze River junks were home to whole families. But when Thomson sailed through the gorges of the Upper Yangtze, he was not too keen on the boat hands, who neither washed nor changed their clothes. In the evening, moreover, they smoked opium and in the morning sacrificed animals to propitiate the river goddess. Worse, they set off fireworks at night, making sleep impossible. With his interest in landscapes, people, and their customs, Thomson preferred scenes from everyday life. His very precise description of Chinese cooking, abhorred by Europeans in those days, is unique. He praised the quick, economical, and hygienic way the Chinese prepared food and the marvelous levels of taste their cuisine offered. Whether this opinion extended to the galley of the river boat is not known.

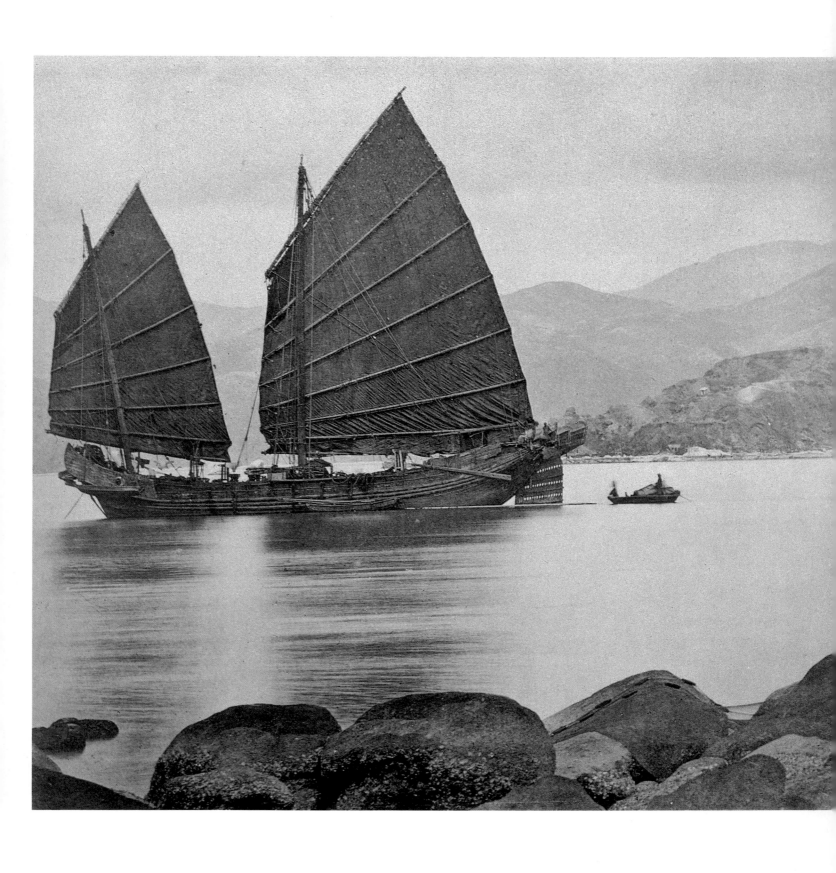

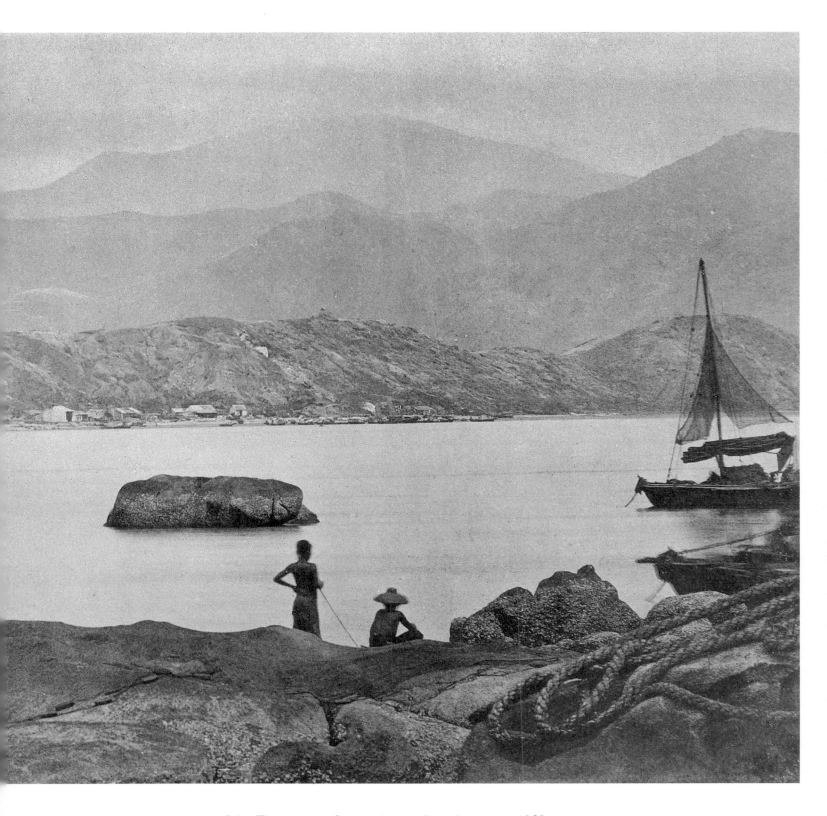

John Thomson, A Canton Junk in Bay of Amoy, c. 1868.
Collection Bernd Lohse, Leverkusen, West Germany.

Thomson supplemented his photographs with the most interesting explanations. Thus, we know that the watchman had been a soldier. Now his attire consisted of a moth-eaten sheepskin coat and ragged garments. Dressed in this way he spent the night on the stone steps in front of the hotel. From time to time he exchanged warning cries with his colleagues, and to keep thieves away he would shake his wooden rattle. Thomson made such photographs his specialty back in England, where he proceeded to document street life and the socioeconomic conditions among "the other half."

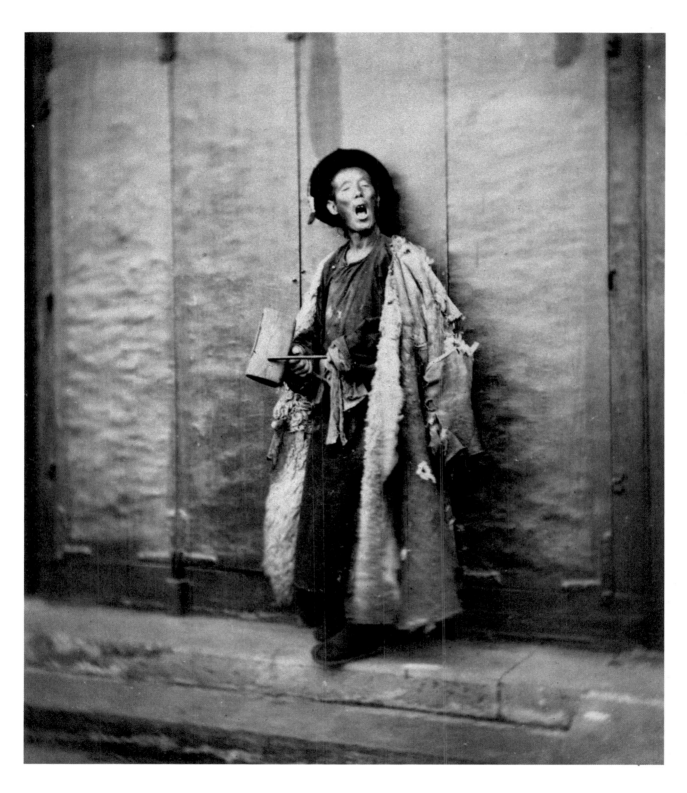

John Thomson, One of the City Guard, 1871.
Collection Stephen White, Los Angeles.

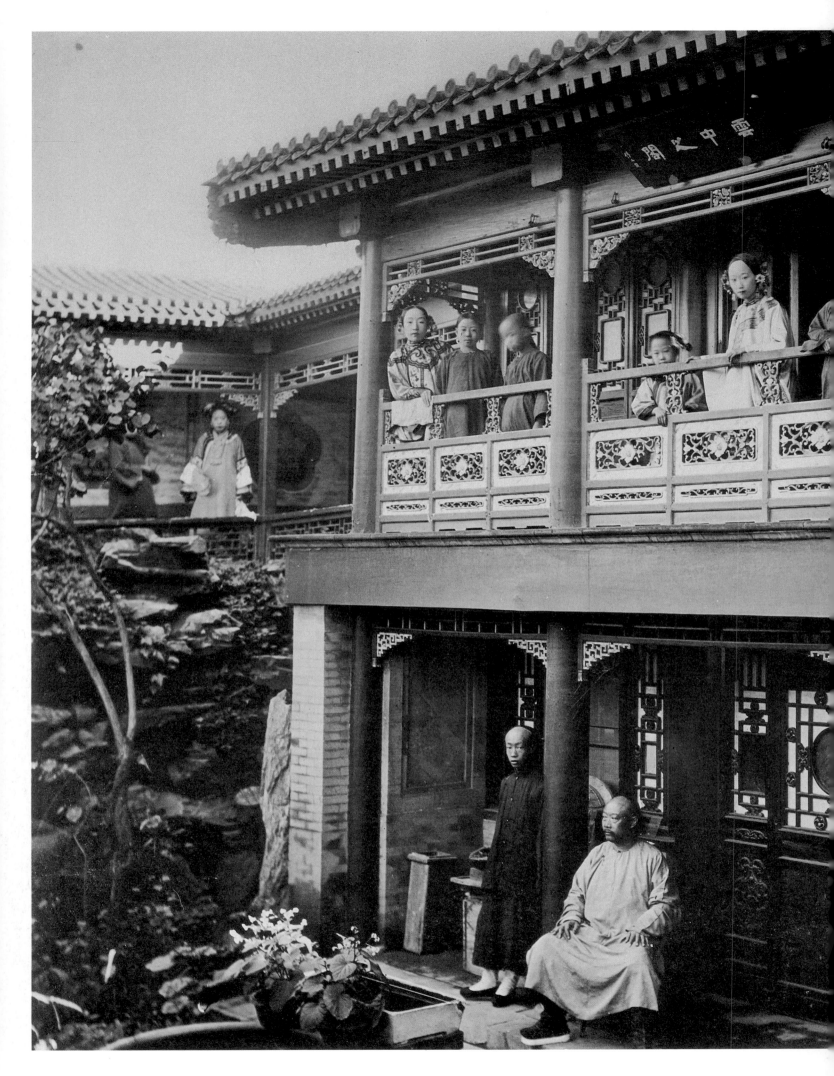

John Thomson, Chinese Family Hierarchy: Mr. Yang and His Wives, 1871.
Collection Stephen White, Los Angeles.

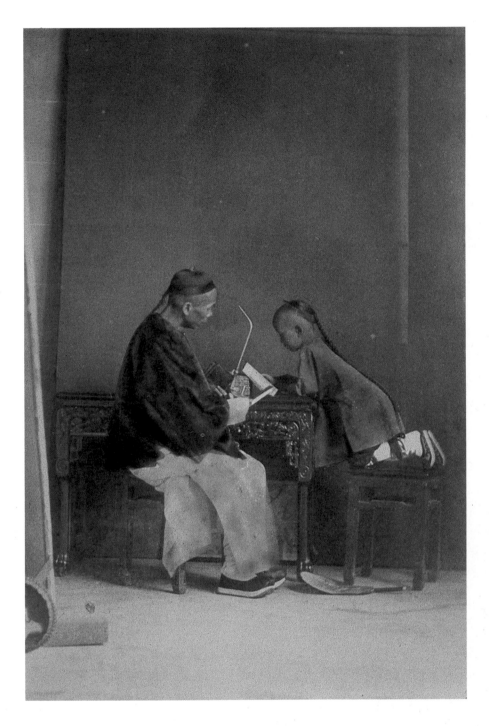

John Thomson, The Lesson, c. 1865.
Janet Lehr Gallery, New York.

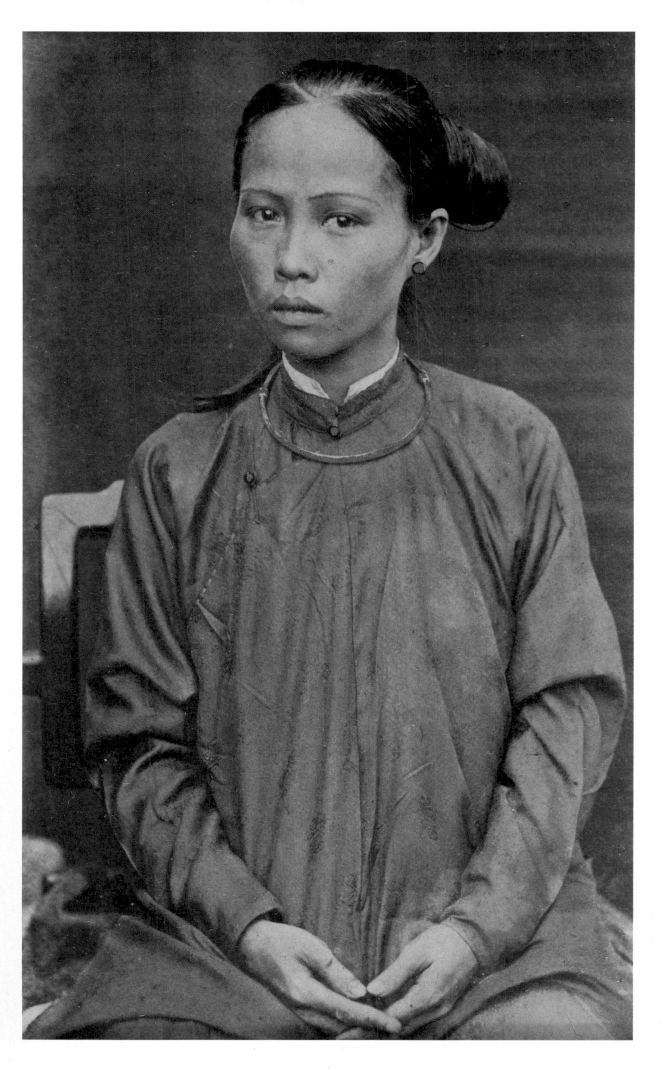

John Thomson, Colored Portrait of a Chinese Girl, c. 1868.
Janet Lehr Gallery, New York.

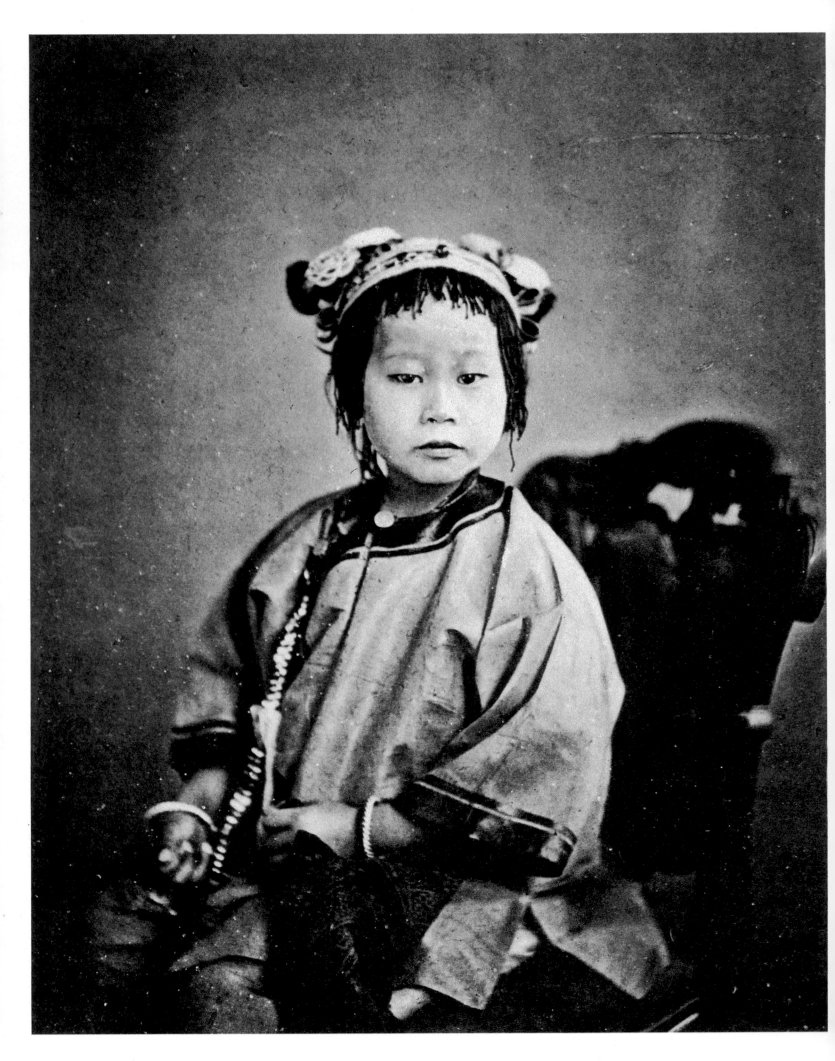

John Thomson, A Chinese Girl from Polite Society, c. 1868.
Collection Bernd Lohse, Leverkusen, West Germany.

220

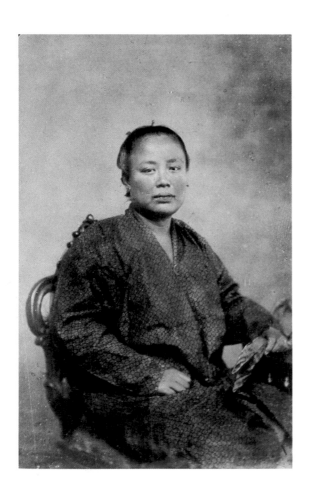 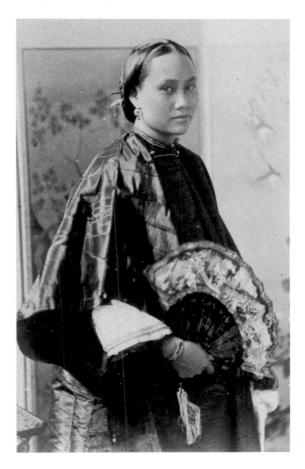

John Thomson, Two Studio Portraits, c. 1868.
Janet Lehr Gallery, New York.

John Thomson, Outside the Walls of Peking, 1871.
Collection Stephen White, Los Angeles.

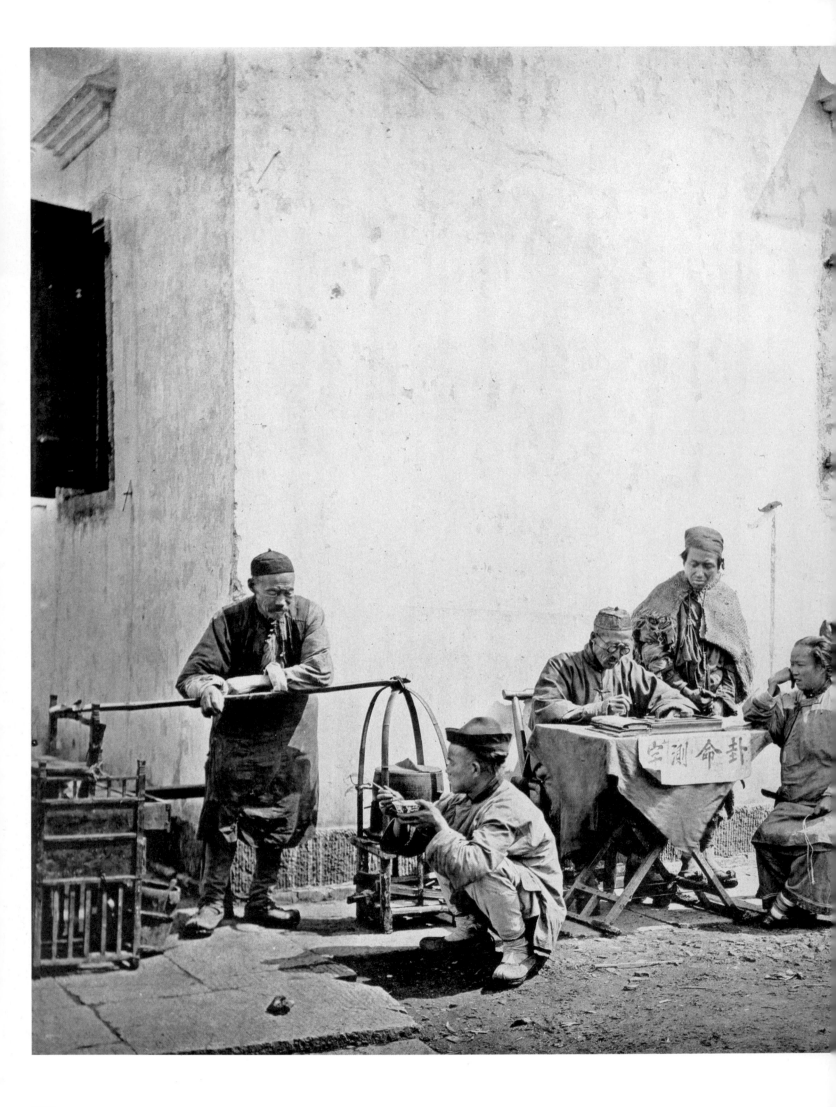

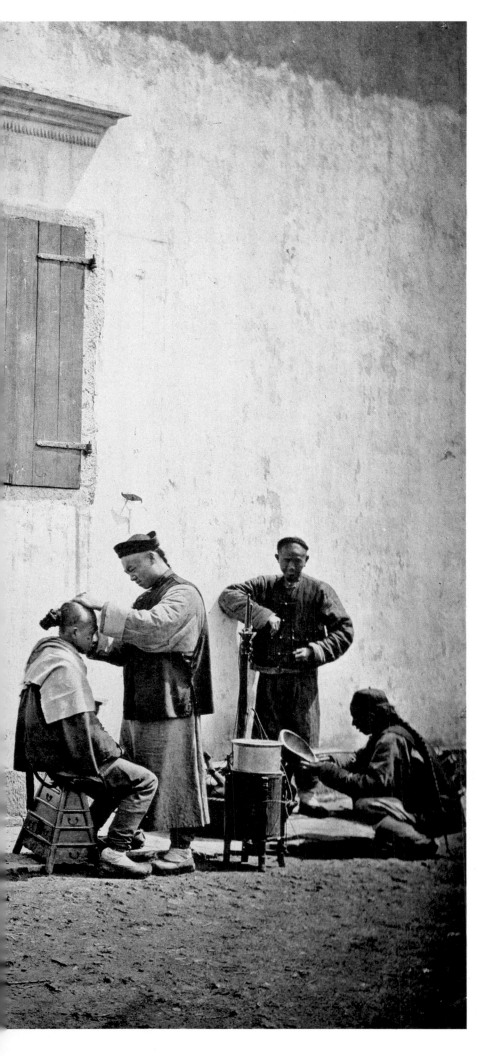

Thomson found it impossible to estimate how many Chinese supported themselves by selling goods and services in the street. The group shown here includes a soup kitchen, the public scribe drafting a letter, a barber, and a wood turner.

John Thomson, Street Vendors in Kiukiang, c. 1868.
Collection Bernd Lohse, Leverkusen, West Germany.

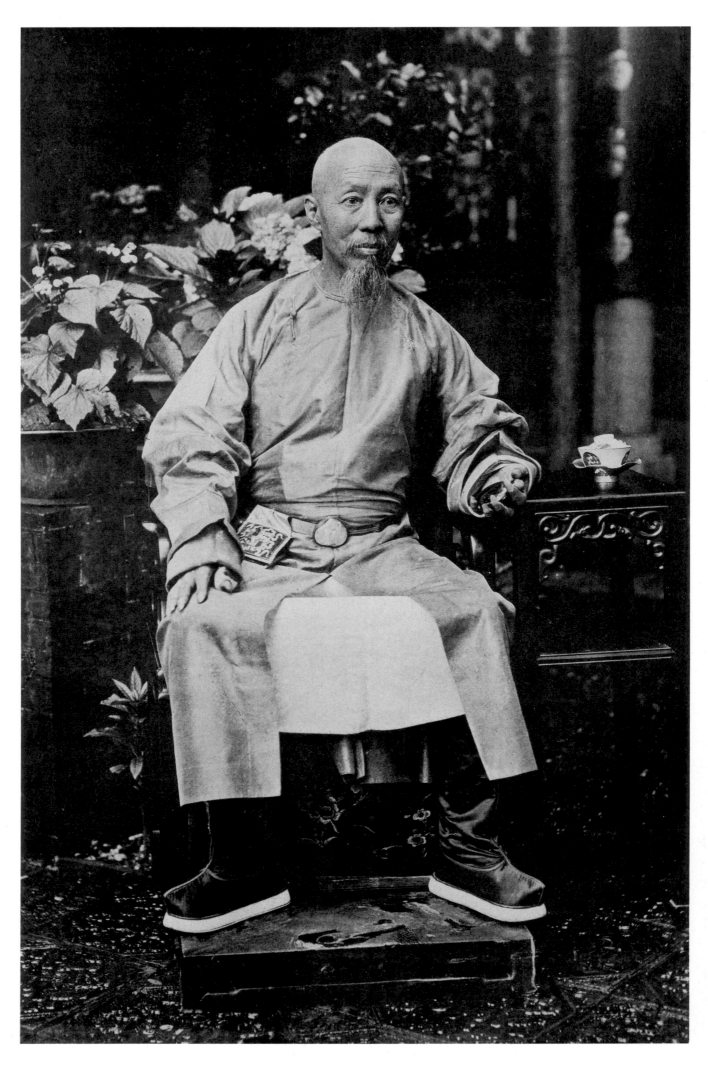

John Thomson, Governor General of Two Kwang Provinces, c. 1871.
Collection Bernd Lohse, Leverkusen, West Germany.

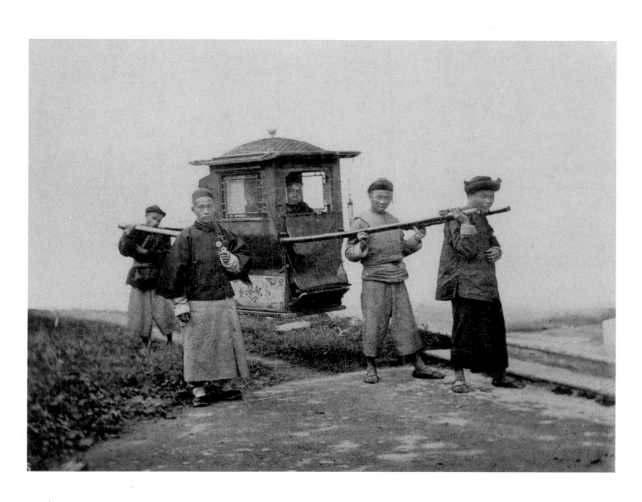

John Thomson, Sedan Chair, c. 1868.
Collection Bernd Lohse, Leverkusen, West Germany.

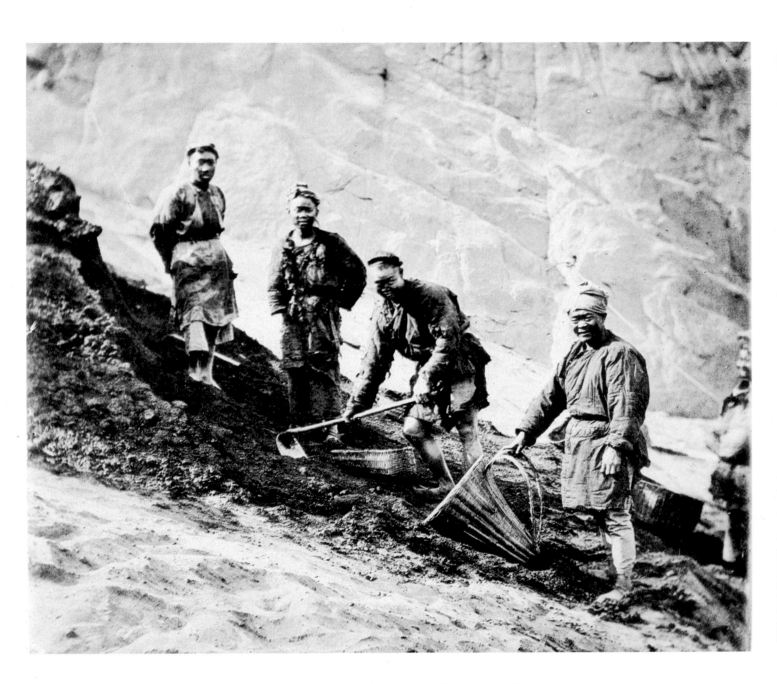

John Thomson, Chinese Coal Miners, c. 1870.
Collection Bernd Lohse, Leverkusen, West Germany.

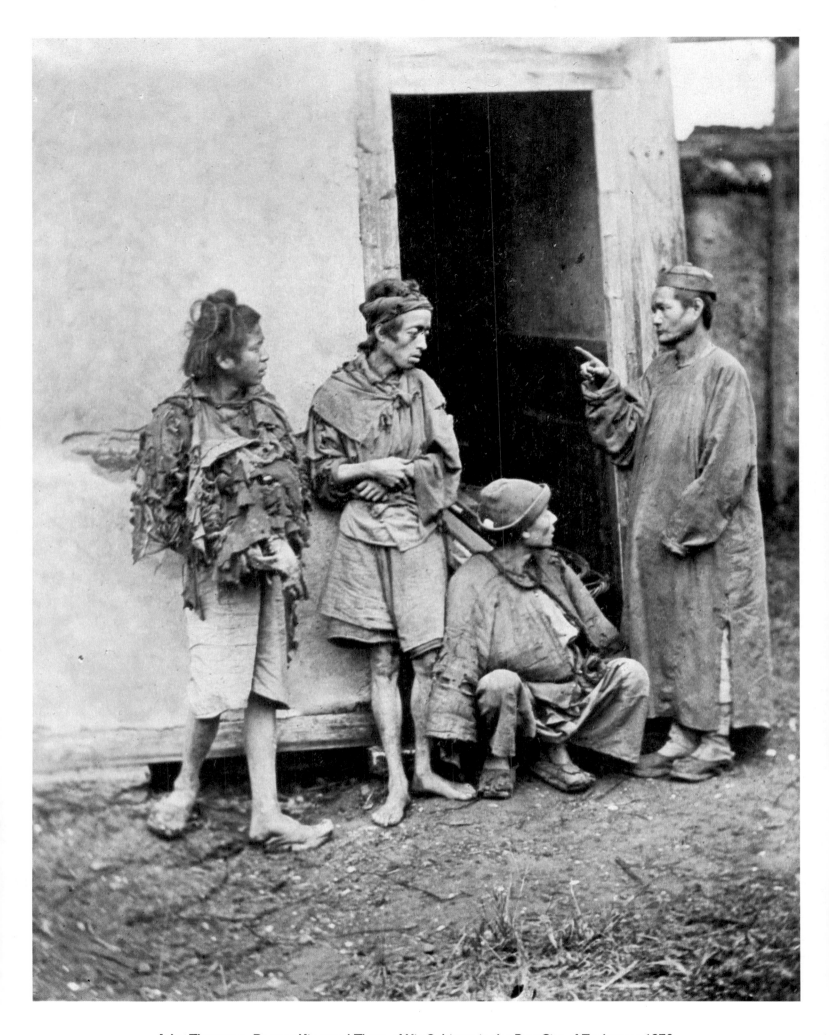

John Thomson, Beggar King and Three of His Subjects in the Port City of Fuchow, c. 1870.
Collection Stephen White, Los Angeles.

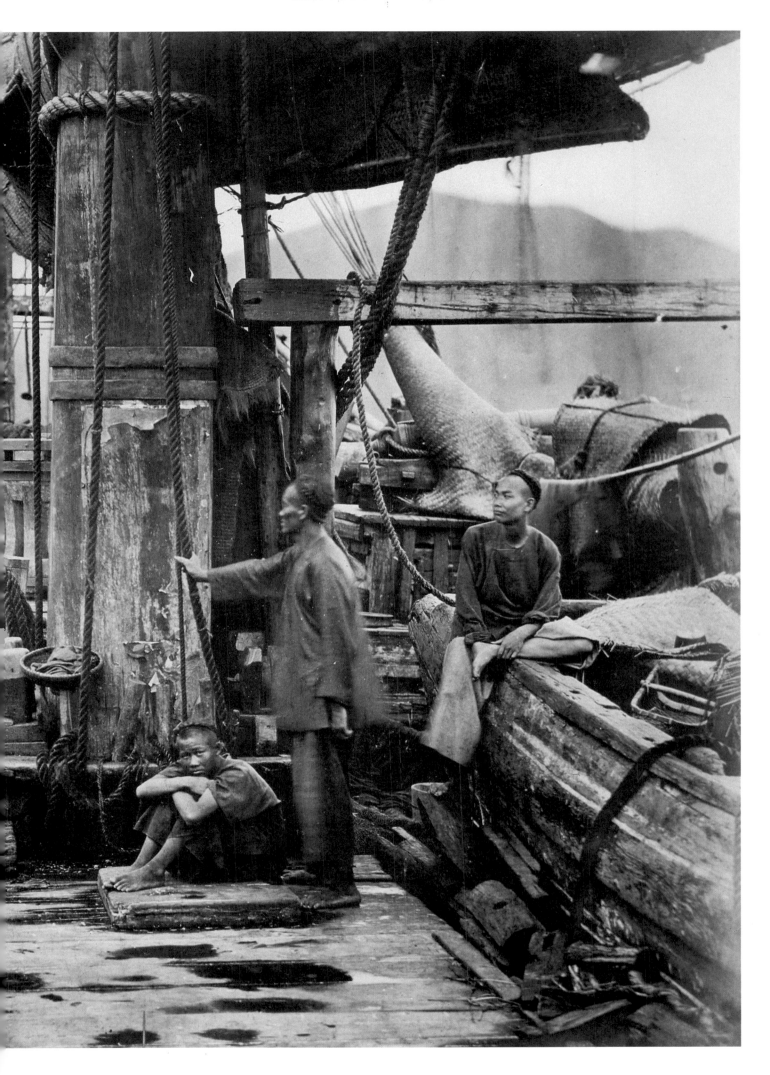

John Thomson, On Board a Junk, c. 1868.
Fotogalerie Dröscher, Hamburg.

231

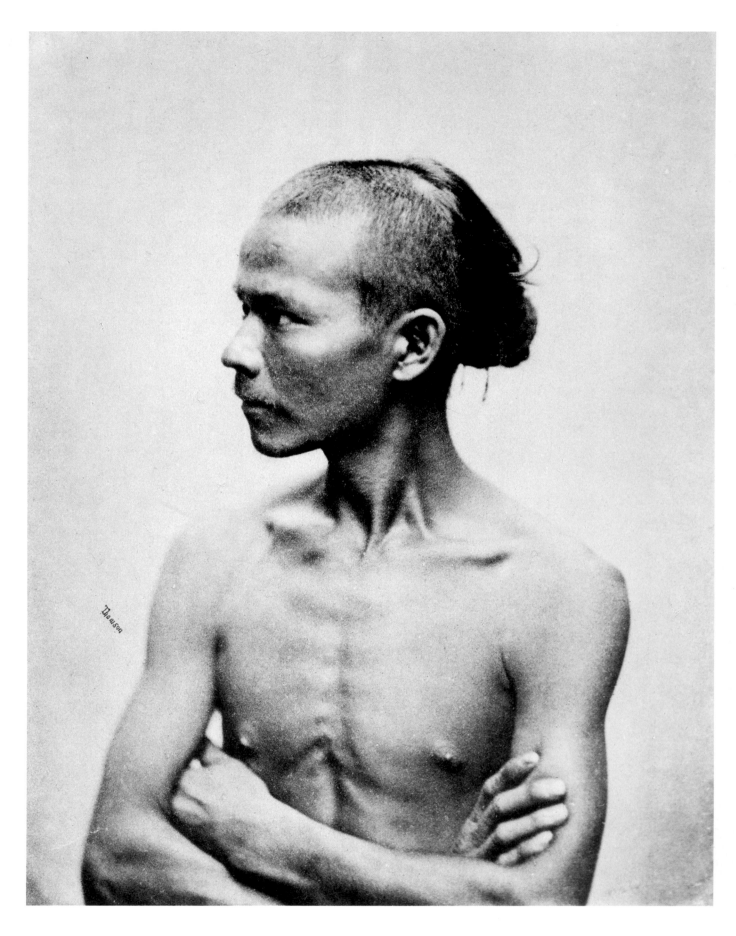

John Thomson, Chinese Coolie, c. 1870.
Collection Bernd Lohse, Leverkusen, West Germany.

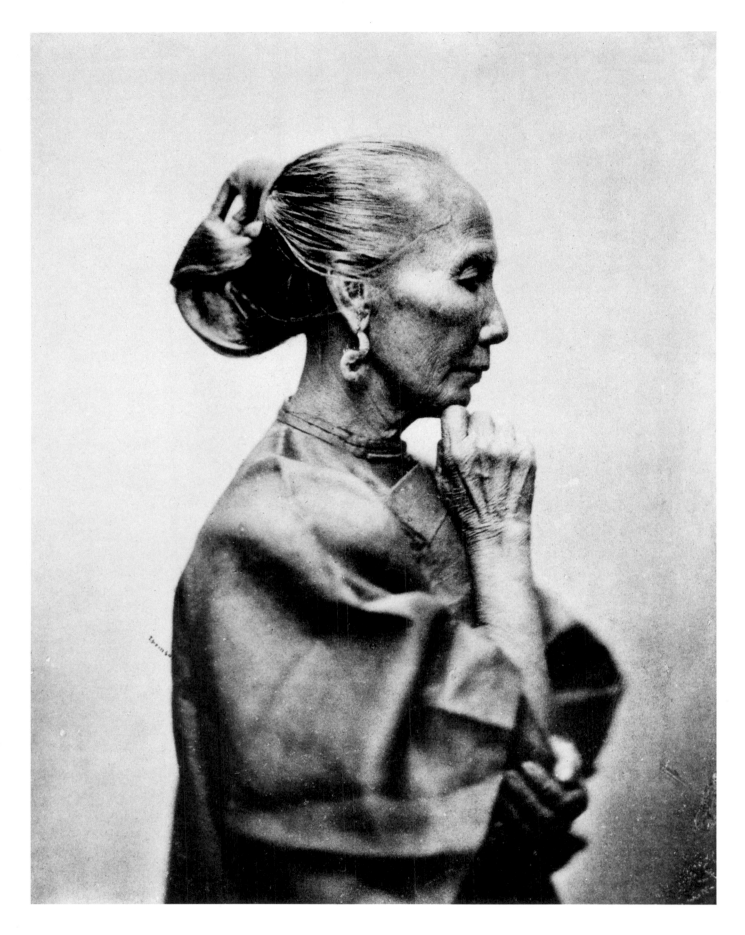

John Thomson, The Aged (Types of the Laboring Class), c. 1870.
Collection Bernd Lohse, Leverkusen, West Germany.

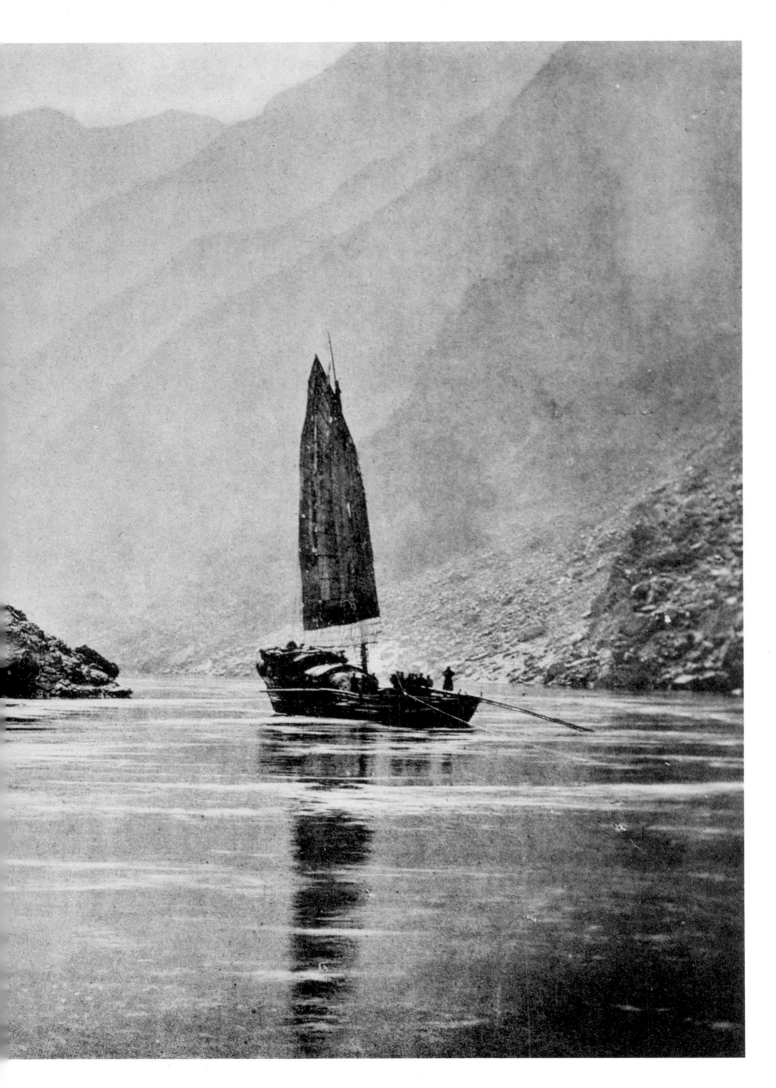

John Thomson, Szechuan Trading Boat in the Gorges of the Yangtze, c. 1871.
Collection Bernd Lohse, Leverkusen, West Germany.

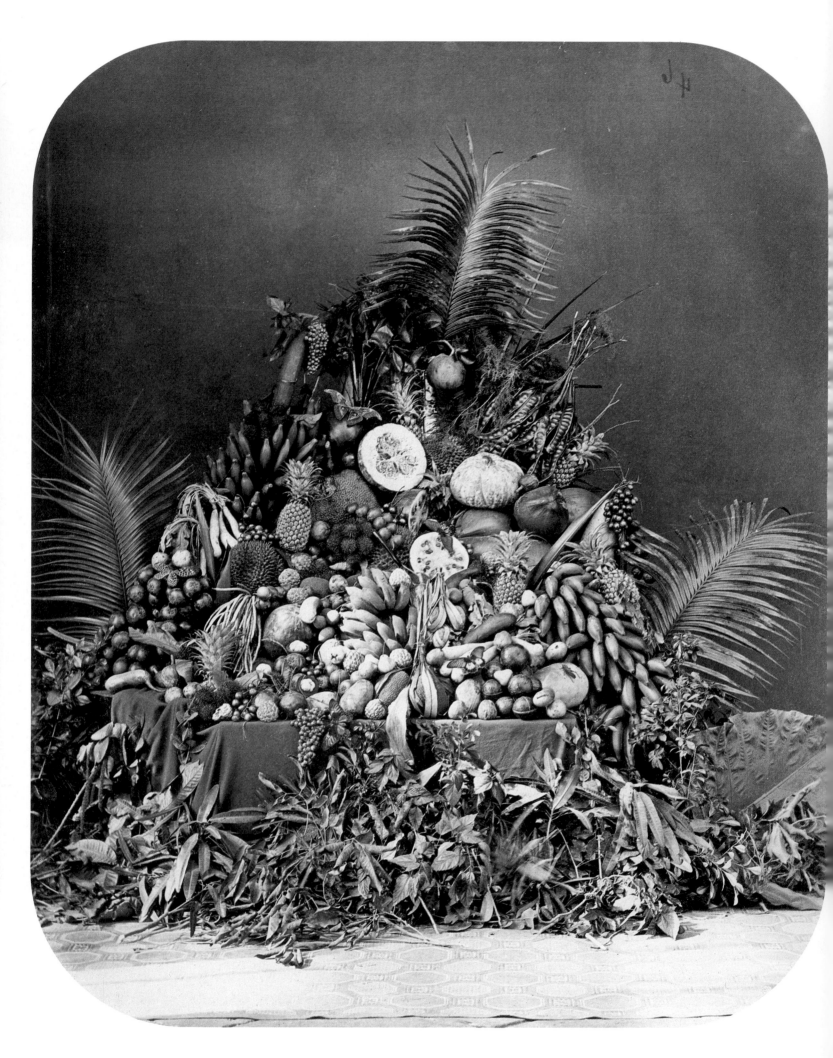

John Thomson, Still Life with Exotic Fruit, c. 1868.
Collection Daniel Wolf Gallery, New York.

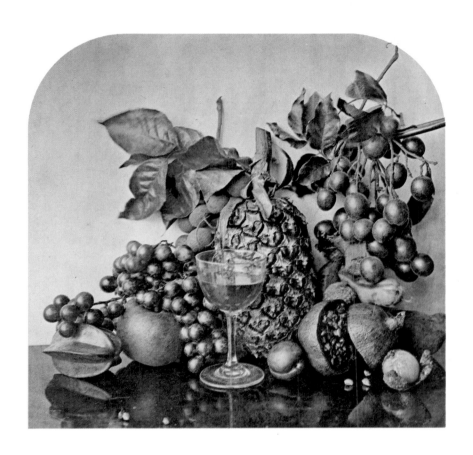

John Thomson, The Fruits of China, c. 1868.
Collection Bernd Lohse, Leverkusen, West Germany.

Still-life subjects enjoyed great popularity in the 19th
century, and even Thomson tried his hand at them,
piling bananas, pineapples, dates, melons,
pomegranates, lychees, mangoes, and papayas into a
delectable pyramid. A close look even reveals the
presence of butterflies and beetles.

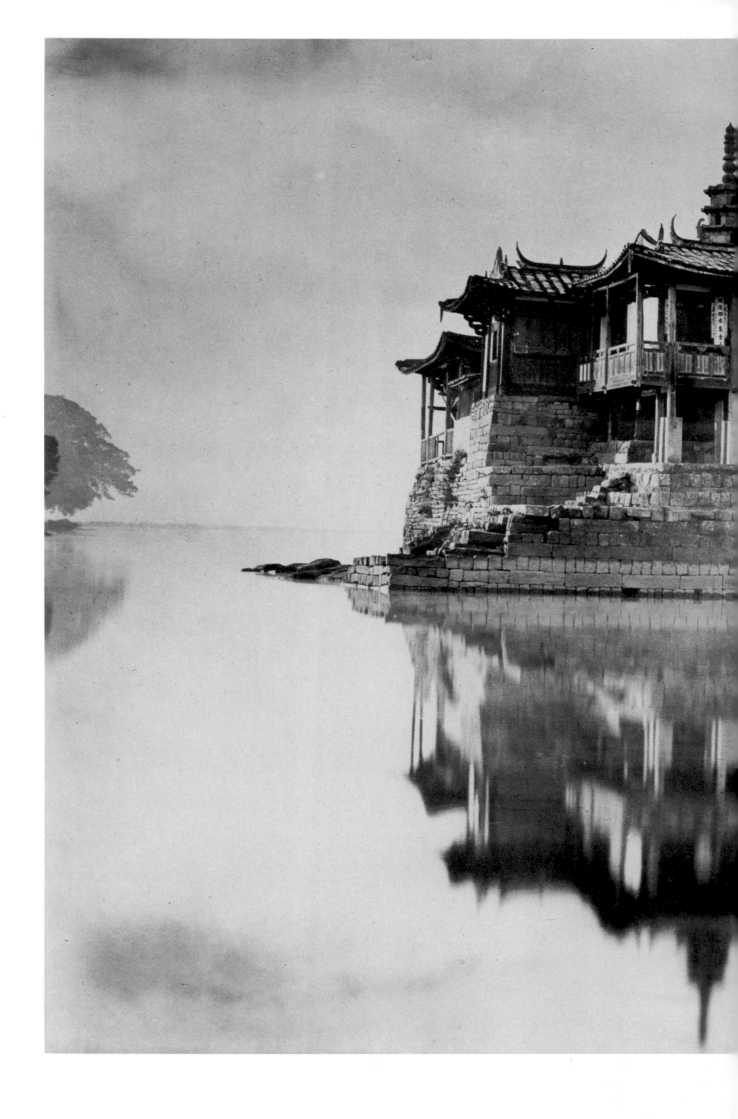

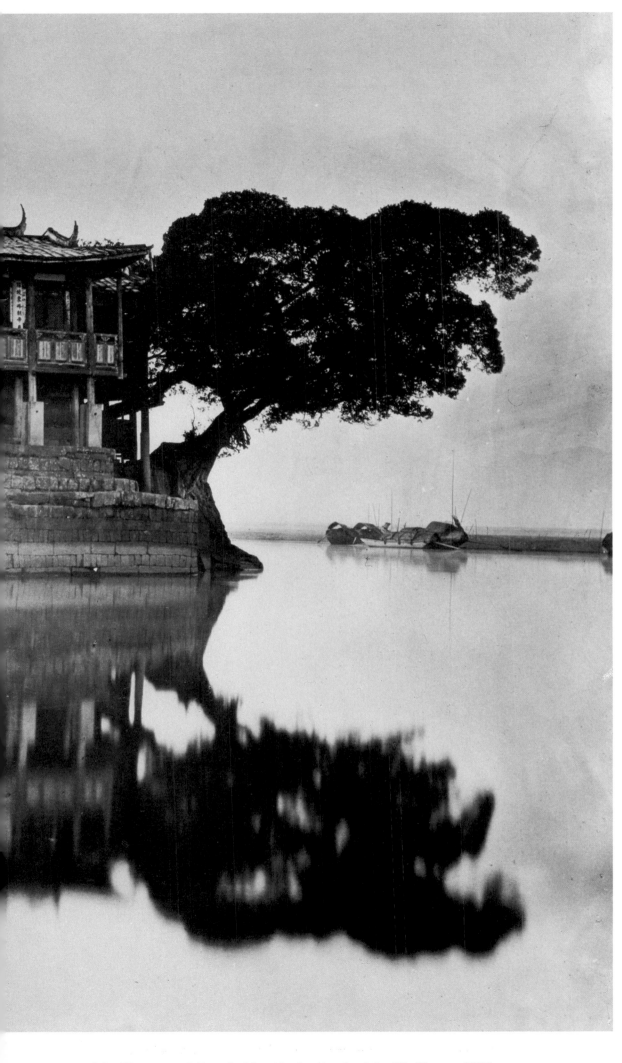

This temple was dedicated to the goddess of the sky, whom the river fishermen revered. According to a Chinese legend, the banyan tree owes its growth to divine intervention since it can take root even in a rock.

John Thomson, A Pagoda Island in the Mouth of the Min River, c. 1870.
Collection Stephen White, Los Angeles.

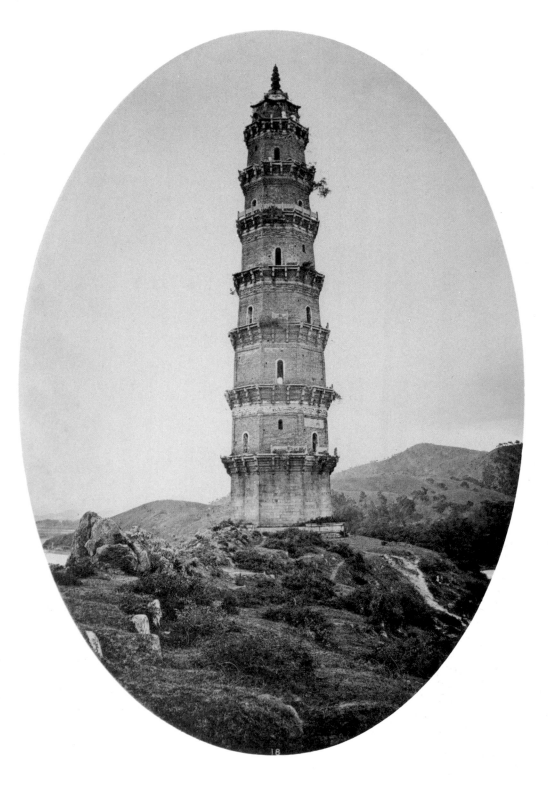

John Thomson, A Pagoda in Southern China Near Chaochow-fu, c. 1868.
Collection Bernd Lohse, Leverkusen, West Germany.

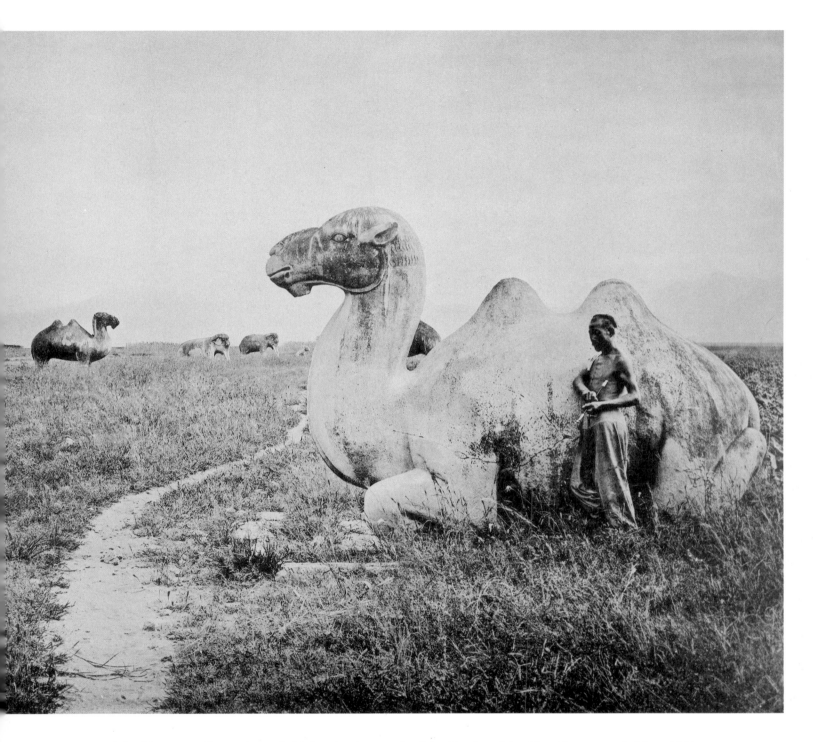

John Thomson, Stone Animals Lining the Approach to the Tombs of the Ming Emperors, Peking, 1871.
Collection Stephen Wise, Los Angeles.

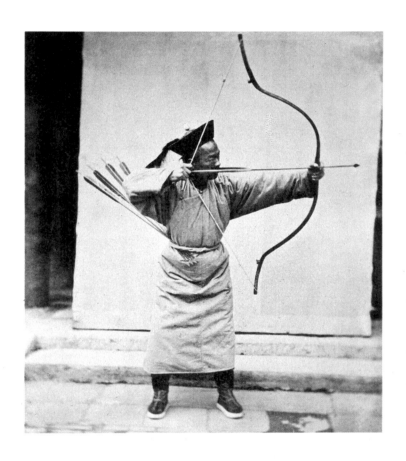

John Thomson, Manchu Soldier, c. 1868.
Collection Bernd Lohse, Leverkusen, West Germany.

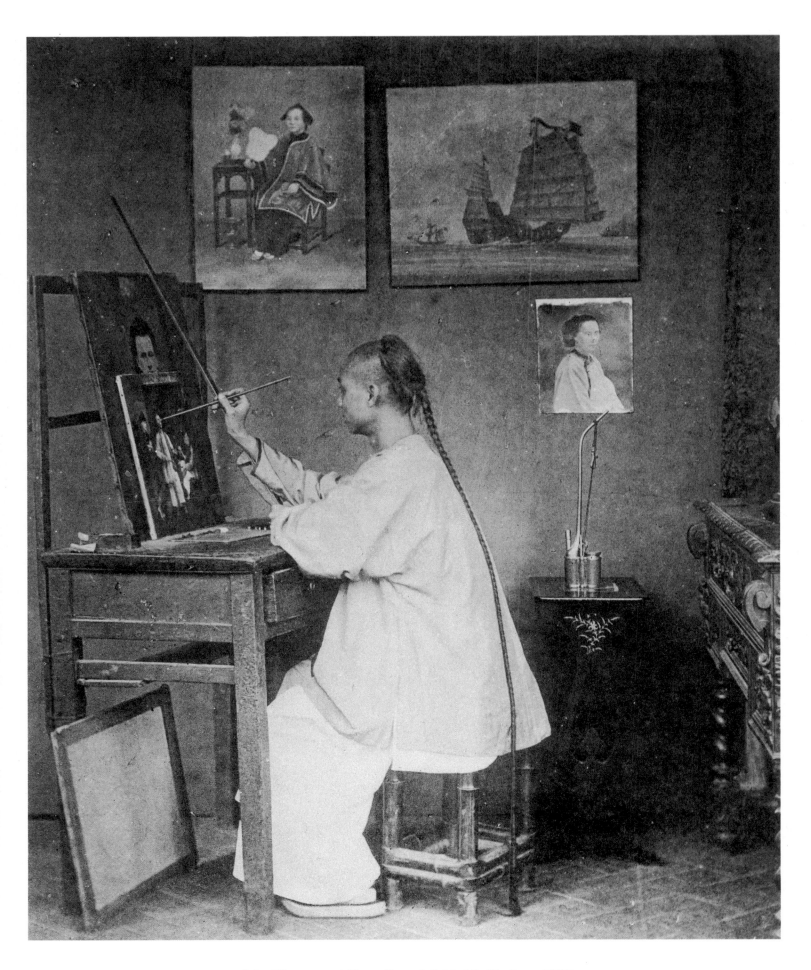

John Thomson, A Hong Kong Artist in His Studio, c. 1868.
Collection Bernd Lohse, Leverkusen, West Germany.

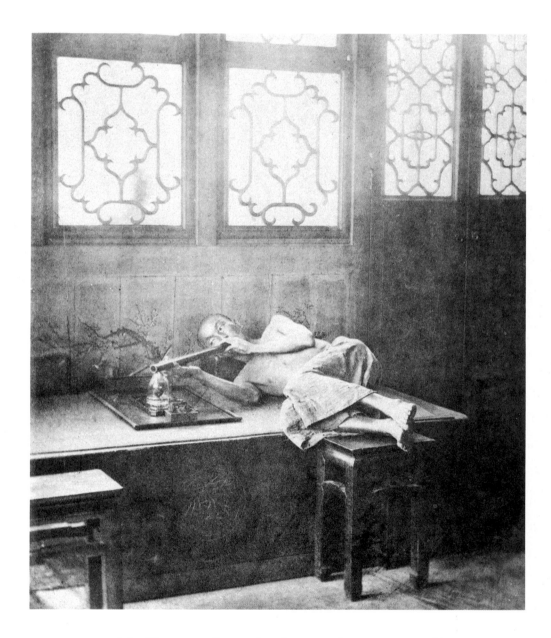

John Thomson, Opium Smoking in a Restaurant, c. 1868.
Collection Bernd Lohse, Leverkusen, West Germany.

7
China
An Ancient Culture
Caught Forever

I n John Thomson's photograph of a Chinese opium smoker the subject lies on his hard cot inhaling through a bamboo pipe. Surrounding him is a room as bare as a prison cell, except for an ink drawing faded from exposure to the sweet vapors of the "madman's root."

A Scotsman, Thomson saw at first hand how opium could become one of the cruelest vices, gradually poisoning and finally destroying the addicted. The kind of opium generally available was diluted with opium ash and thus poor in quality. Thomson reported that he had never seen anything so horrible or so nightmarish as the opium dens, whose skeleton-like occupants lay stretched out on wooden benches barely visible through the smoke and oblivious to the world.

The photographs made by Thomson document the bitter experience of a country in upheaval. Seventeenth-century China saw its economy, industry, morality, and culture disappear in the sweet stench of opium, a gift from the colonizing Europeans.

During the Middle Ages China had imported opium in small quantities for medicinal use only. But in the 19th century the British encouraged the trade, since the East India Company was harvesting India's poppy fields and shipping opium illegally into China. In 1810 five thousand crates weighing twenty pounds each were unloaded in Canton alone and the contents sold to dealers. In port cities tens of thousands of Chinese lived by drug dealing, many of them river pirates, coolies, smugglers, and even civil servants.

Addiction spread like wildfire, causing opium dens to appear in every town and village. While dulling hunger and

Woodcut reproduction of Thomson's photograph of an opium smoker (page 244). Not until the photoengraving process had been invented could photographs be used as newspaper illustrations.

pain, the drug also induced sleep and lethargy. Nothing the Emperor did could arrest the epidemic. Even threats of a hundred lashes or three years at hard labor went unheeded.

In 1840 the Chinese government decided to deal with the matter once and for all. The campaign began with the Emperor stating that every measure would be taken to stimulate the sluggish economy and reinforce national defense. A period of country-wide withdrawal would last one year, during which time all stocks of opium had to be destroyed. Anyone who remained addicted at the end of the twelve months would be executed.

The Governor of the southern provinces forced the British to hand over the twenty thousand crates of opium in their possession. He then had two million pounds of the drug stacked along the shore, boiled in huge vats, and finally poured into the sea. Such was his determination to rid China of every last grain of the pernicious stuff. But the Governor had only begun, for now he ordered every foreign opium smuggler executed and his ship confiscated. Simultaneously he prohibited trade with the British, raised an army, and set up defenses all along the coast.

The British reacted in the summer of 1840 by invading Macao with 15 warships carrying 15,000 soldiers. Thus began the first Opium War (1840–42), which ended with what 19th-century historians hypocritically called the "opening of China to the West." After signing the Treaty of Nanking on August 29, 1842, China had to pay 21 million silver dollars in restitution and reimbursement for the 20,000 crates of destroyed opium.

It also ceded the rocky island of Hong Kong to the British, who made it a crown colony, and opened the coastal towns of Canton, Amoy, Fuchow, Ningpo, and Shanghai to British trade and residence. This meant that opium would again be imported. Within a few years other Western powers received commercial and residential privileges.

Henceforth, one war after another concluded with China making more concessions and reparations to the British, all

of which resulted in the country's progressive ruin. Ever-greater numbers of foreigners made their profitable forays into China, and in the wake of the soldiers came the consuls and the merchants, the tourists and the photographers.

By 1860 photographers could get around in China, overcoming whatever difficulties lay in their way. Before them, the only travelers had been missionaries saving souls, botanists seeking unknown specimens, and prospectors poking the ground for mineral deposits. Barely passable roads led into the interior, and as late as 1895 the country had little more than two hundred miles of railway track. Visitors did not speak Chinese any more than the Chinese had mastered foreign languages. The typical photographer found 19th-century China's population peculiar, its customs barbaric, and the appearance of its people grotesque. According to Jean-Paul Sartre, the colonial mentality loved to make cultural comparisons, pointing out that one man cut his hair, while the other braided it, just as one used a fork and the other chopsticks. Thus, if one was straightforward, the other had to be devious.

At the dentist's in Canton, 1895.

Pictures by this sort of photographer reduced the China of the Opium Wars and generalized poverty to a series of genre scenes. They offer such picturesque views as the traveling restaurant in which coolies dragged across a town square a bamboo contraption complete with porcelain dishes, a charcoal brazier, and an opium pipe for dessert. They also depict a visit to the dentist in which the torturer pulls a tooth with a pair of pliers while his assistant holds the poor victim's head. Then there is a photograph showing "Chinese brutality" whereby criminals condemned to death had to stand on their toes in a cage until their strength gave out and they strangled themselves. Also caught by the camera was the white man, the dandified European gentleman posing in a factory next to female workers clad in rags.

Studio photographers "painted" with their cameras. This was because their Chinese subjects prescribed strict rules for how they should be posed. One photographer reported that

the natives insisted on being photographed from the front so that both ears would be visible. Feet had to be placed to show they were the same size, and hands must be on knees with all fingers accounted for. If someone had grown an extra-long fingernail, that status symbol needed to receive special attention. Each studio was equipped with a vase of flowers and a side table on which to display the arrangement. Since the white-painted mask constituted the ideal of facial beauty, faces, according to Austrian Baron Stillfried, had to be as pale and white as possible. Thus, any shadow that showed up in the developed portrait was retouched until eyes, mouth, and nose became simply black holes.

A legendary institution enjoyed something of a monopoly on photography in China. Originally called "The Firm," it was founded in Hong Kong in 1860 by Charles Weed and, over time, underwent many changes in ownership. Photographers bought into the company between 1860 and 1877, but as soon as they had made money, the practitioners sold their shares to someone else, seized their profits, and returned to Europe. Each successor took over both customers and plates. From time to time "The Firm" changed its name, from Floyd and Co., for instance, to Victoria Gallery and later to Hong Kong Photographic Rooms. By 1877 "The Firm" owned more than ten thousand negatives, left behind by eleven photographers.

The most famous genre photographer and portraitist was M. Miller. In his pictures, taken mostly in the studio, ferocious warriors draw their swords, scribes work at their art, fat mandarins peer out of collars that flare like bird's wings, and British civil servants with top hats and boiled shirts sit four-square in front of the camera like John Bull in a *Punch* cartoon.

Such exotic photographs were as much a part of the tourists' loot as a bale of Chinese silk, a tea service, or a lacquer screen. In the décor of Victorian parlors the photograph album functioned rather like the modern coffee-table book. After all, a studio photograph of beggars in

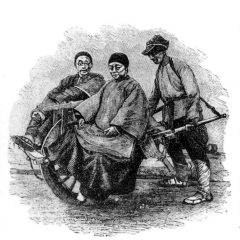

In the cheaper editions of his books, Thomson allowed his photographs to be reproduced as woodcuts.

picturesque rags provided a diversion comparable to what could be had from a peep show. However, a street photograph of Ling, the beggar who fed on rotten fish and whose daughter became a prostitute and died of tuberculosis at an early age, belongs not to the realm of genre but to that of documentary photography.

Thomson, in contrast to the genre photographers, did not take his pictures in the studio. He went into the street, mixed with the people, and ventured into opium dens, into shops and factories. Unlike the genre photographers, he had a number of things to say about his subject, such as Ling, the real beggar.

Although little is known about Thomson, it has been established that he was born in Scotland in 1837 and died eighty-four years later in London. After studying chemistry in Edinburgh, he began his career in photography by taking pictures of buildings and monuments. A small announcement in Hong Kong's *Daily Press* in 1869 indicates that he was married: "Nov. 21, married 19th, Rose Villa, John Thomson, Esq. to Isabel, daughter of Capt. P. Petrie."

Thomson went to the Far East for the first time at the age of twenty-four, but illness cut short his journey to Singapore and Cambodia. On his second trip in 1864 he

John Thomson and his wife Isabel on the terrace of a house in Canton.
Published here for the first time, this photograph dates from 1869.

spent ten months in Penang. A year later he opened a studio in Singapore, and it is assumed that he arrived in Hong Kong in 1868. During the next five years the young photographer traveled five thousand miles across China, through Szechuan and Hupei provinces, along the coast of Fuchow and up the Yangtze. According to his own reports, Thomson penetrated into regions where the natives had never before seen a white man.

The Chinese understood perfectly well that they were being photographed, since Thomson's unwieldy wooden camera could not be ignored. Moreover, candid snapshots were out of the question at a time when exposure required ten to twenty seconds.

Thus, Thomson worked like a reporter, talking to people in the street for hours, questioning them about their lives, making notes. When he thought he understood the situation, he set up his tripod and asked his subject to pose without moving. Some of the natives took Thomson for a devil. The superstitious Chinese were often convinced that his camera was an instrument of black magic, which he put into place in order to see through mountains and houses. Thomson reported being stoned "on more occasions than one." When he tried to photograph the historic bridge across the Han River near Chaochow—as important in China as London Bridge in England—the inhabitants assumed that the man with the cannon wanted to shoot down the pylons and cause the bridge to collapse. As a mob came running from the marketplace armed with mud and rocks, the intrepid photographer sought refuge in his boat.

Thomson had little love for the coolies accompanying him on his trip up the Yangtze. To his disgust, he found that they never washed or changed their clothes. Worse, they kept him awake at night with their opium smoking and their drinking until all hours. Sometimes they even set off fireworks. In the morning it was impossible to rouse them, and they spent the day dozing. When his boat reached the Upper Yangtze, Thomson had to wait until the river goddess had

After his return to England, Thomson photographed the street vendors and beggars of London, collecting the pictures in a book entitled *Street Life in London* (1877).

been placated with a sacrifice, which added the blood of the boat's poor rooster to the river water.

Thomson was one of the first travel photographers to perform as a reporter as well. Describing a street scene, he explained that Ahong, one of the subjects, had spent all his life in the public spaces of Kiukiang selling soup, just as his father had done before him. Born into a family of bouillon makers, Ahong had learned at an early age the secrets of operating a small soup kitchen on street corners at certain hours of the day. The picture includes an illiterate dictating a letter to a scribe. This professional also functioned as a storyteller and doctor, who was said to have succeeded in curing seventy-one different diseases of the human eye.

Elsewhere Thomson caught coolies bent, veins bulging, under heavy loads, women patiently sorting tea, sailors on junks laden like Noah's ark, complicated hairdos of "quality

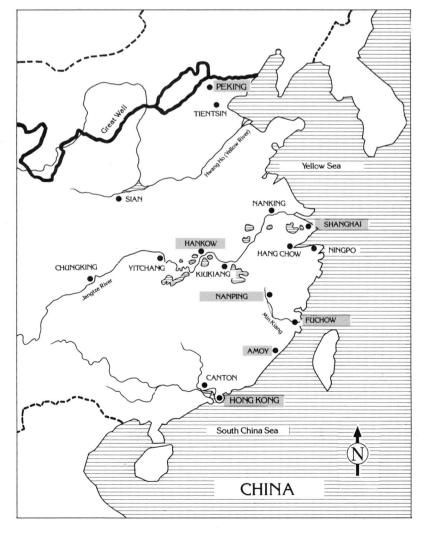

Between 1868 and 1872 Thomson traveled 5,000 miles throughout China.

folk," and Chinese ladies' unwrapped "lily feet," which, he reported, did not smell like the most beautiful and holy of flowers. He also captured the beggar-king of Fuchow and ragpickers collecting old clothes and gnawed bones to sell to intermediaries.

In Peking, Thomson photographed Wang, a guard outside a suburban hotel who twirled a rattle to keep away thieves. At night Wang crouched on the cold stone steps of the hotel, every so often calling to a colleague down the line who would call to another a little farther on until their cries sounded through the whole city.

Thomson's vision of China as the poorhouse of the world was a portent of the future, long before anyone had heard of the "Third World." The photographer published six books about a disintegrating empire, among them *Illustrations of China and Its People,* the four volumes of which came out in 1873–74. After returning to Britain, he continued his particular brand of social commentary with *Street Life in London.* Almost half a century before such reformers as America's Lewis Hine and Germany's Heinrich Zille, this book concerned itself with those who had fallen through the cracks in the system as their nations joined the ranks of world powers.

When Thomson illustrated a book about slum life, the author of the text, Adolphe Smith, found chapter titles for this "Beggar's Opera" that remind modern viewers of Berthold Brecht. A caption accompanying the photograph of a woman selling strawberries simply repeated the subject's street cry: "Strawberries, all ripe, all ripe." Had Engels been a photographer, he would have taken these pictures and Karl Marx would have used them to illustrate his *Communist Manifesto.* Thomson's photographs of China and London forecast the revolutions that would finally erupt in the 20th century. They were also the first examples of objective photography.

8. The American West

Pioneering with Colt and Camera

William Henry Jackson, Carleton Watkins, Eadweard Muybridge

Just as settlers had been awed by the vastness of the New World, photographers found the virgin territory endlessly fascinating. They rattled across the prairie in their darkroom wagons, loaded their laboratories on the patient backs of mules, and rode into the mountains. The pictures they made celebrate the beauties of the Wild West in views of waterfalls, mountain ranges, canyons, and immense, empty valleys.

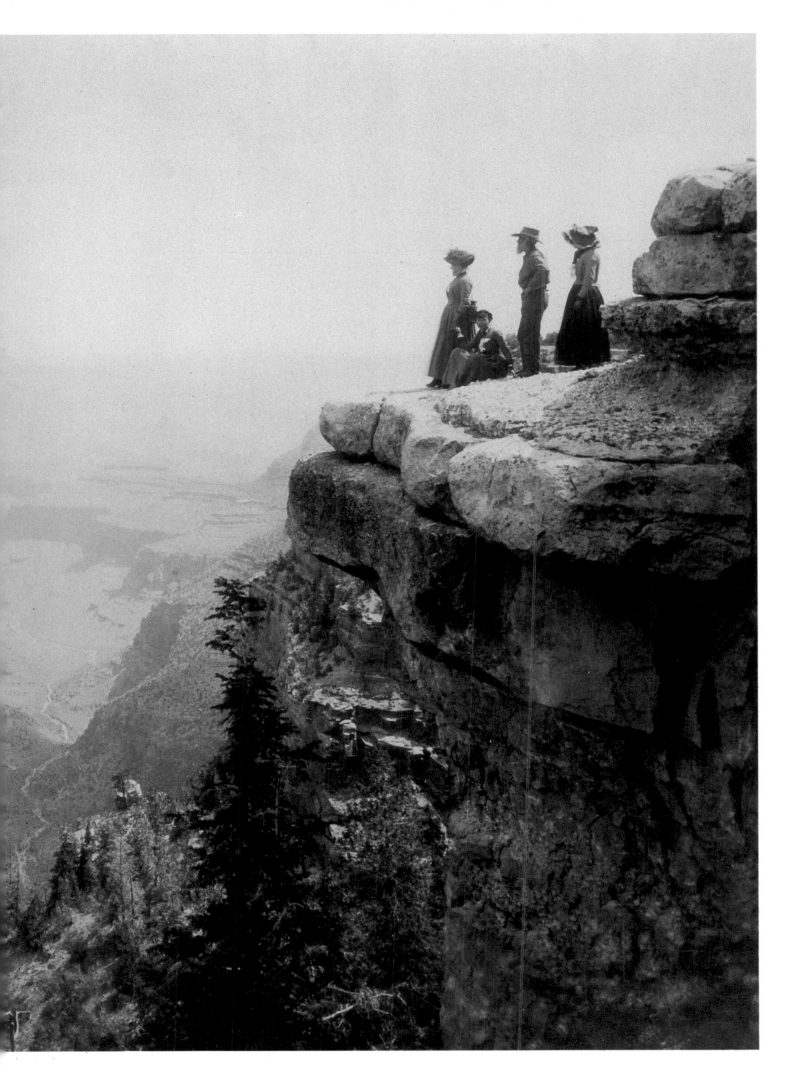

Carleton Watkins, Tourists Looking into the Grand Canyon of the Colorado River, c. 1880.
Daniel Wolf Gallery, New York.

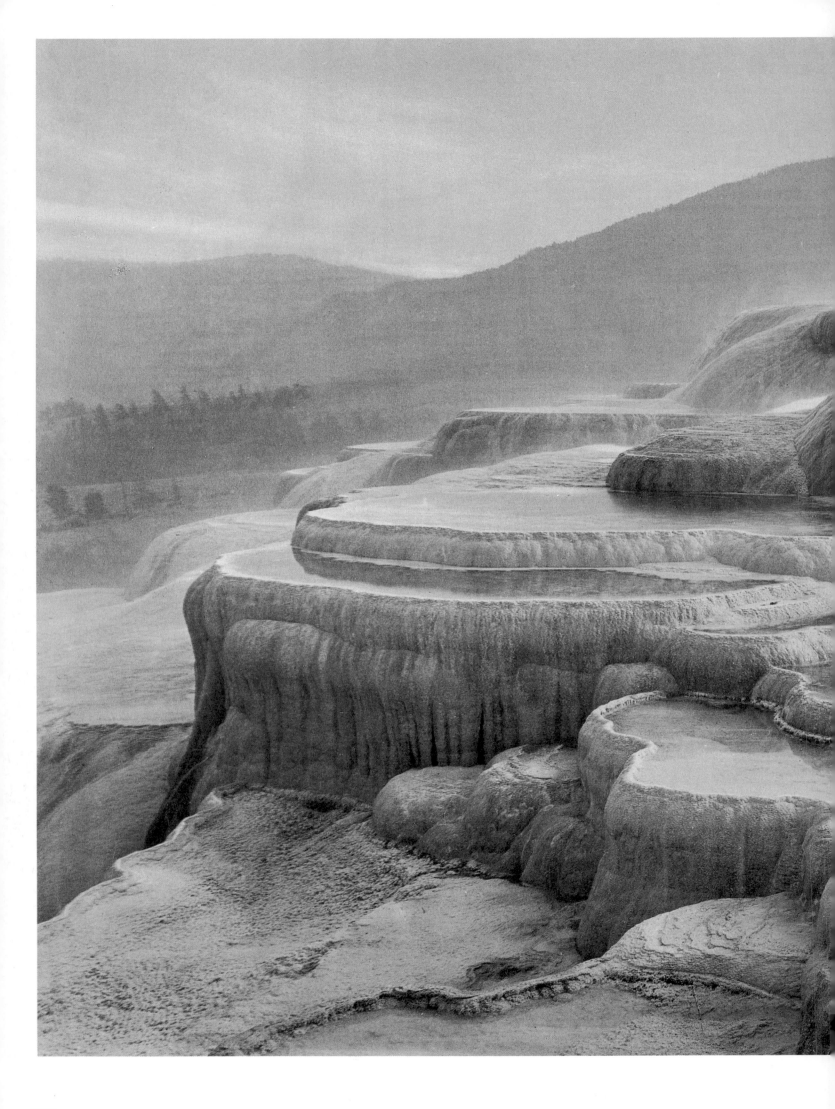

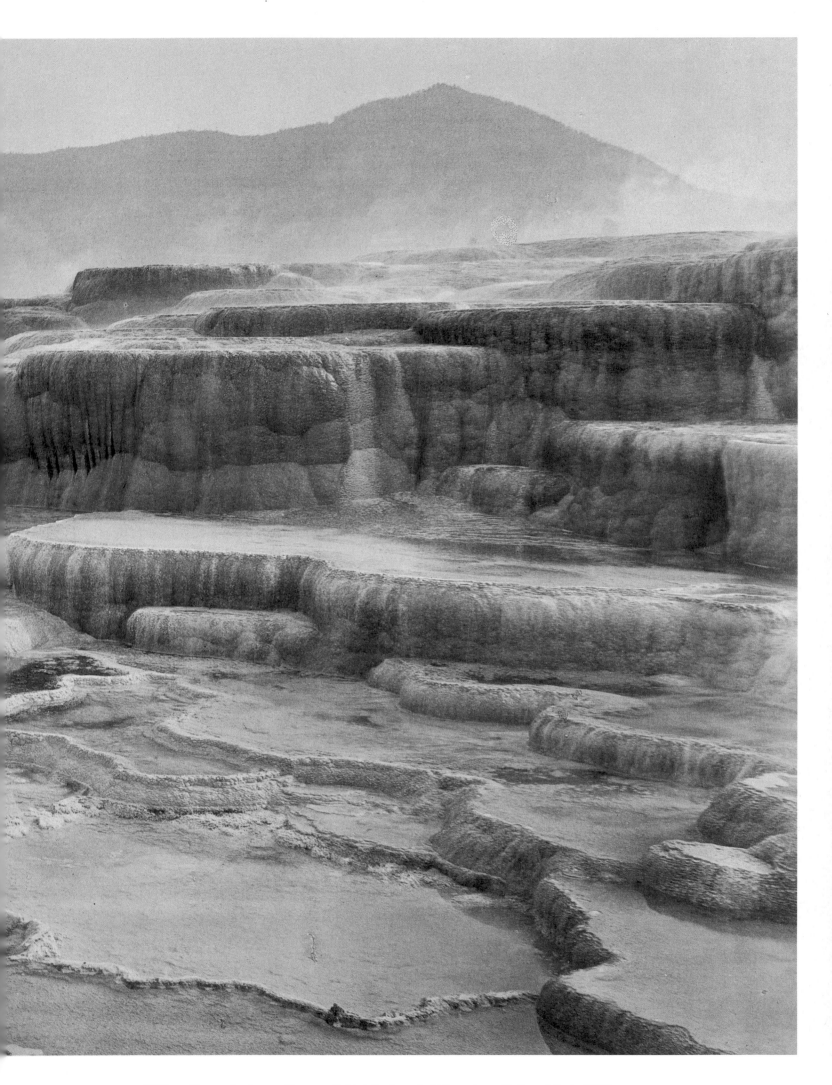

William Henry Jackson, Mammoth Hot Springs in Yellowstone National Park, 1878.
International Museum of Photography, George Eastman House, Rochester, New York.

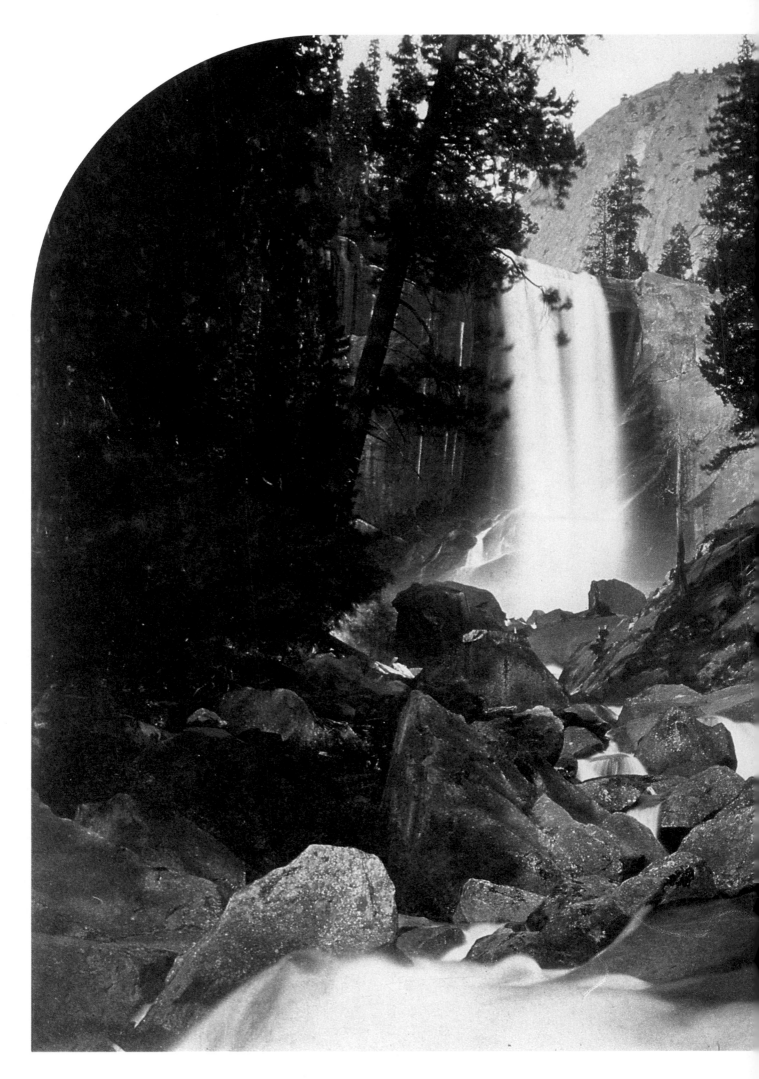

Carleton Watkins, Vernal Falls in the Yosemite Valley, c. 1865.
International Museum of Photography, George Eastman House, Rochester, N.Y.

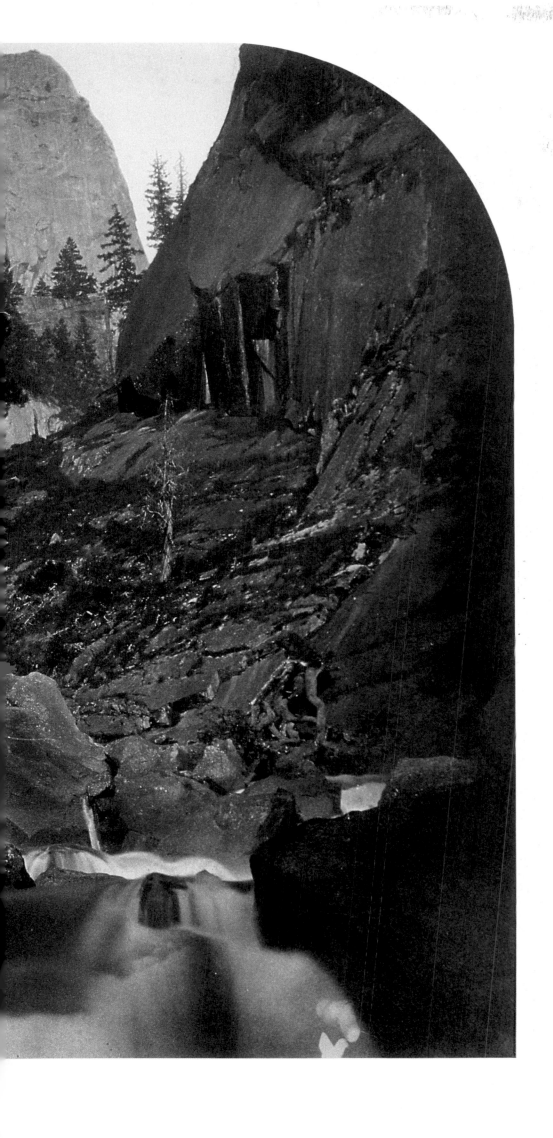

SIERRA SAN JUAN

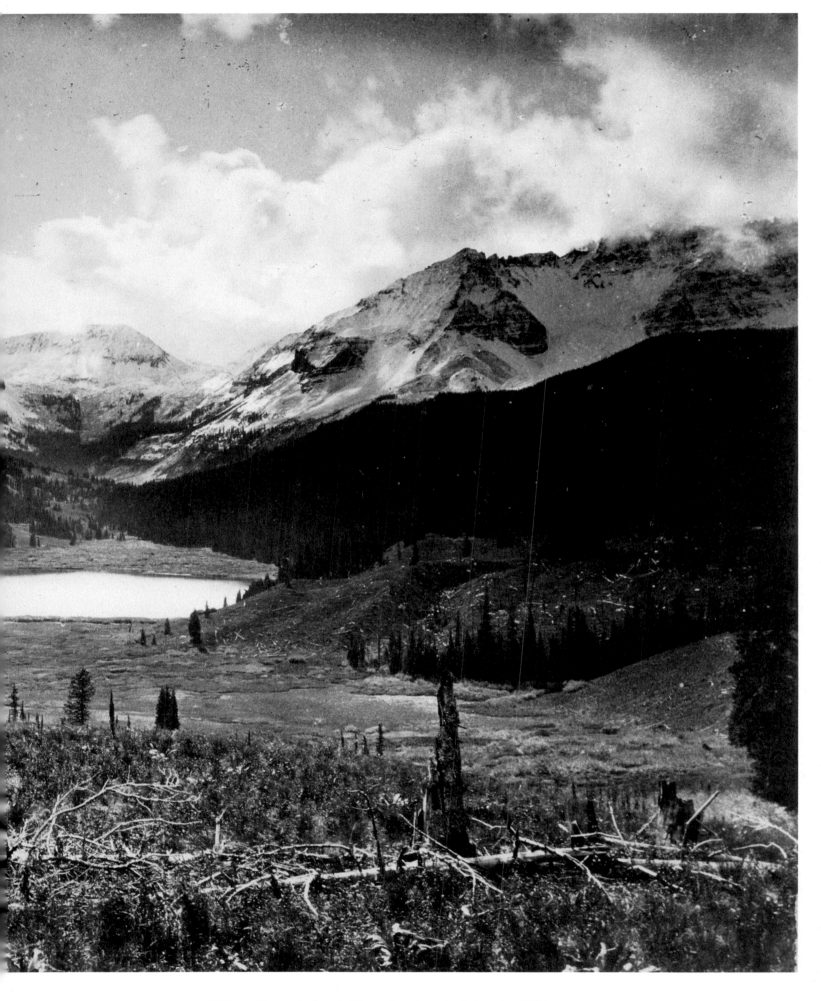

William Henry Jackson, Sierra San Juan in Colorado, 1874.
International Museum of Photography, George Eastman House, Rochester, N.Y.

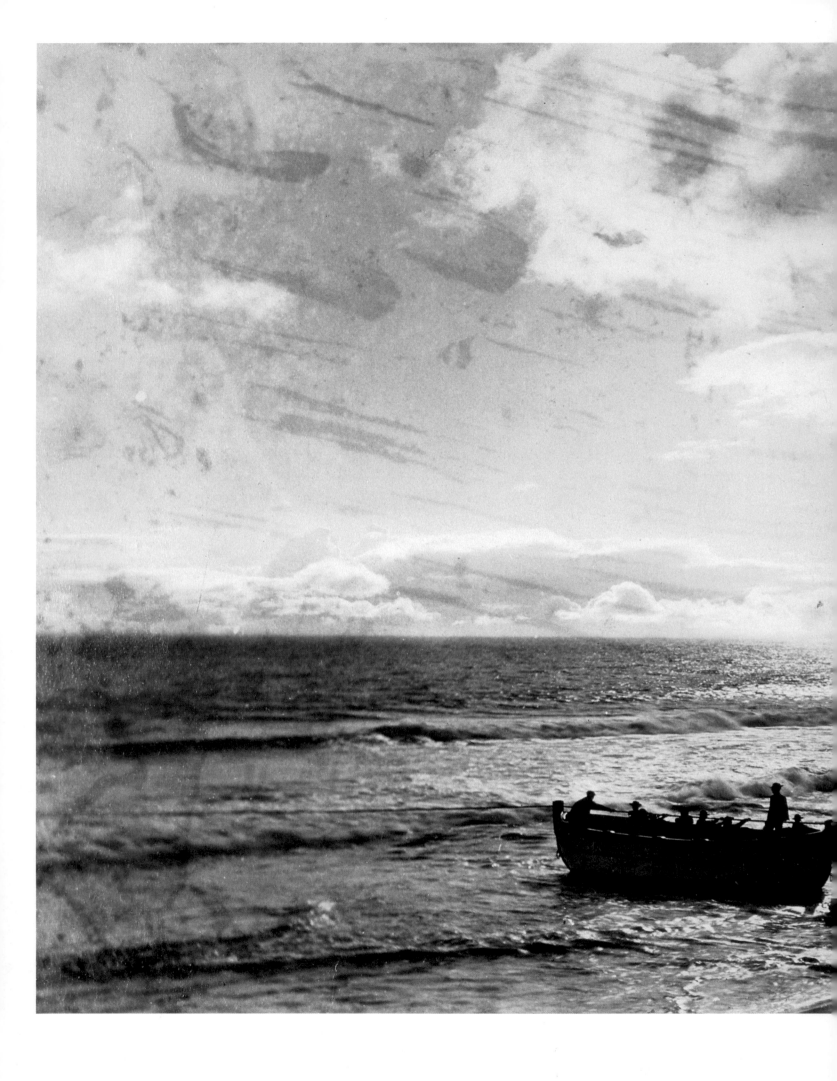

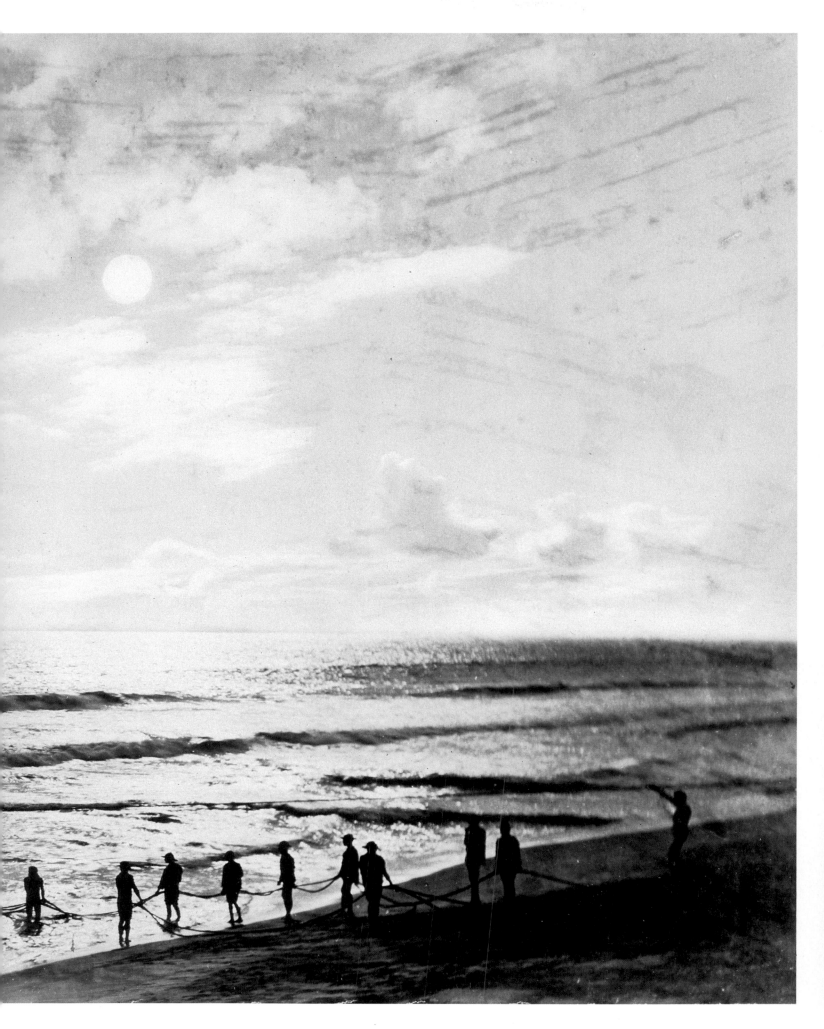

Eadweard Muybridge, Return of a Coffee Launch by Moonlight at Champerico, Mexico (with painted moon), c. 1870.
International Museum of Photography, George Eastman House, Rochester, N.Y.

Jackson's mule Hypo was a good pack animal, thanks to a back as fat and upholstered as a sofa. Among the members of the various wilderness expeditions, Jackson had the reputation of being an expert at tying down and securing even the most breakable or unwieldy bits of equipment. He liked to work with wide-angle lenses because their great depth of field reduced time exposure. But the wider angle proved satisfactory for aesthetic reasons as well as for technical ones, a fact readily apparent in Jackson's pictures.

255. TRAIL IN THE SAN JUAN M TS

William Henry Jackson, Trail in the San Juan Mountains above Cunningham Gulf, Colorado, 1875.
International Museum of Photography, George Eastman House, Rochester, N.Y.

William Henry Jackson, Outing in the Rocky Mountains, c. 1875.
International Museum of Photography, George Eastman House, Rochester, N.Y.

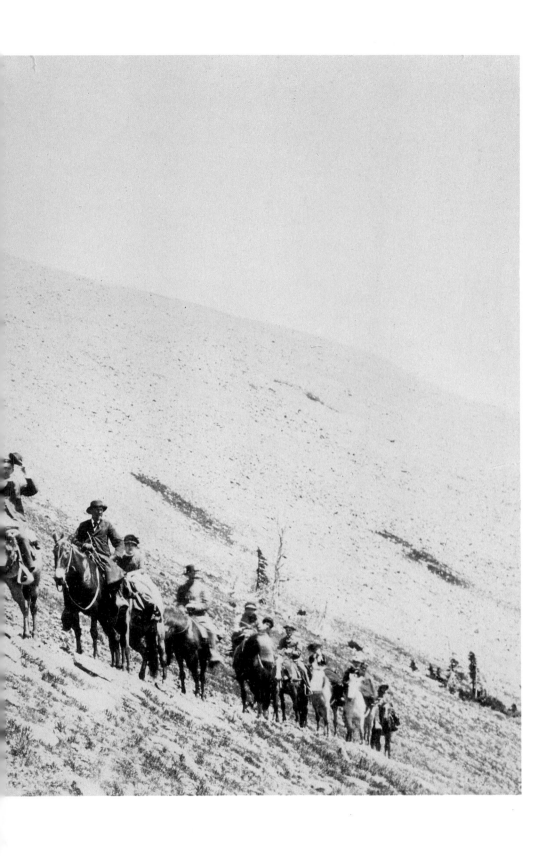

William Henry Jackson, The Mammoth Hot Springs in Yellowstone Park, c. 1870.
International Museum of Photography, George Eastman House, Rochester, N.Y.

Jackson's first photographs of Yellowstone's geysers and sulphur springs proved that the wonders the trappers had described really existed. This picture of the Mammoth Hot Springs was given to every member of Congress in 1872, the year in which President Grant declared Yellowstone the first national park in the United States.

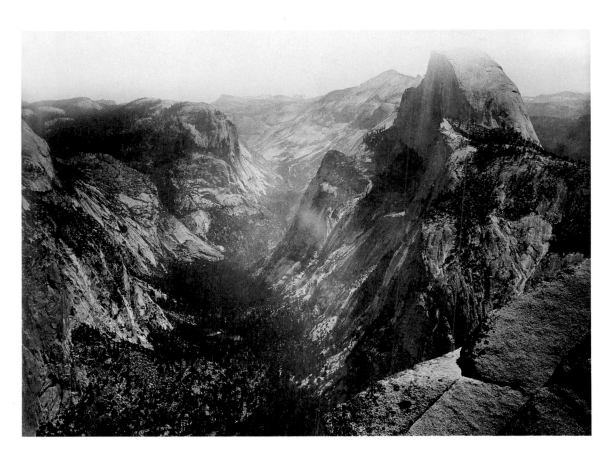

Carleton Watkins, "Half-Dome" in the Yosemite Valley, 1866.
Library of Congress, Washington, D.C.

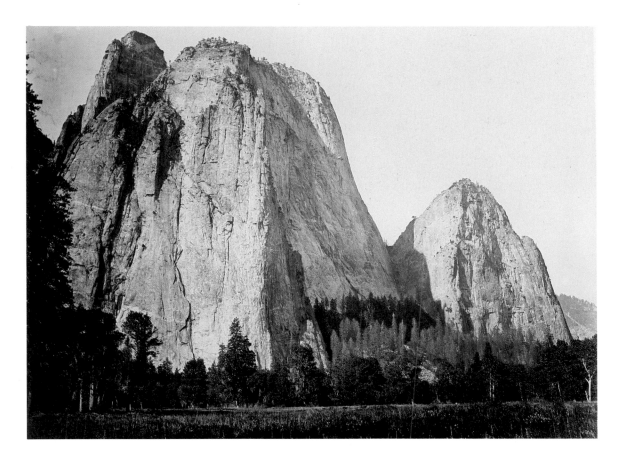

Carleton Watkins, Cathedral Rock in the Yosemite Valley, c. 1866.
Library of Congress, Washington, D.C.

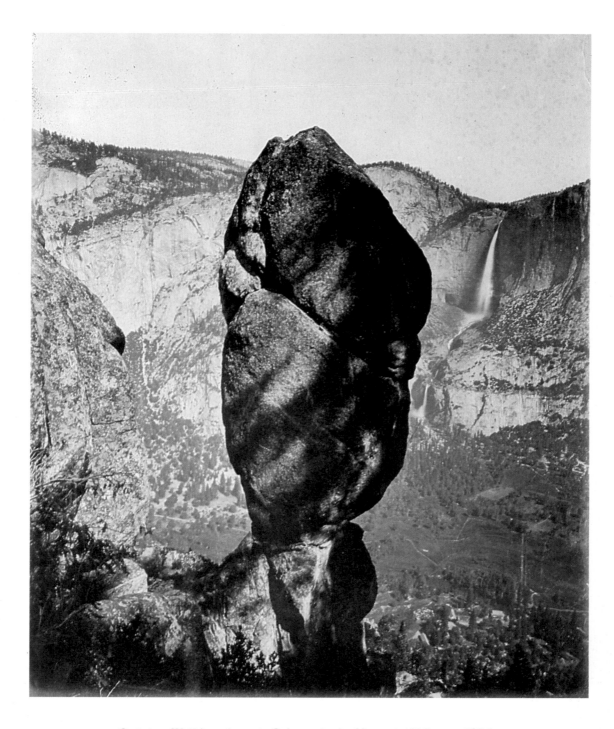

Carleton Watkins, Agassiz Column in the Yosemite Valley, c. 1874.
Daniel Wolf Gallery, New York.

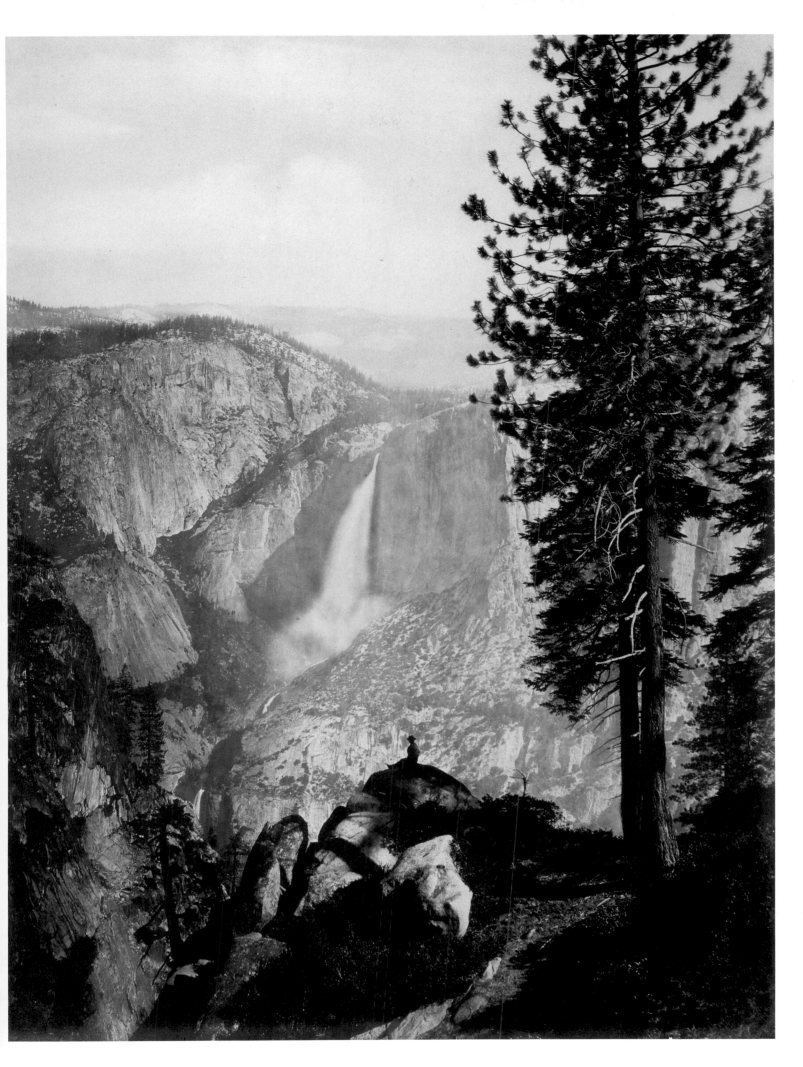

Eadweard Muybridge, Upper and Lower Yosemite Falls from Glacier Rock, 1872.
Oakland Museum, Oakland, Calif.

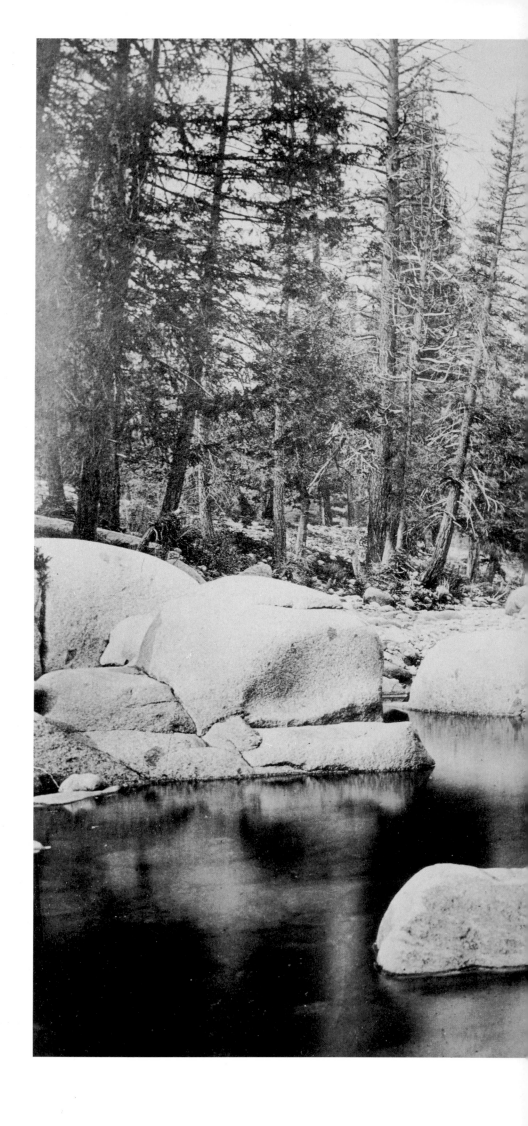

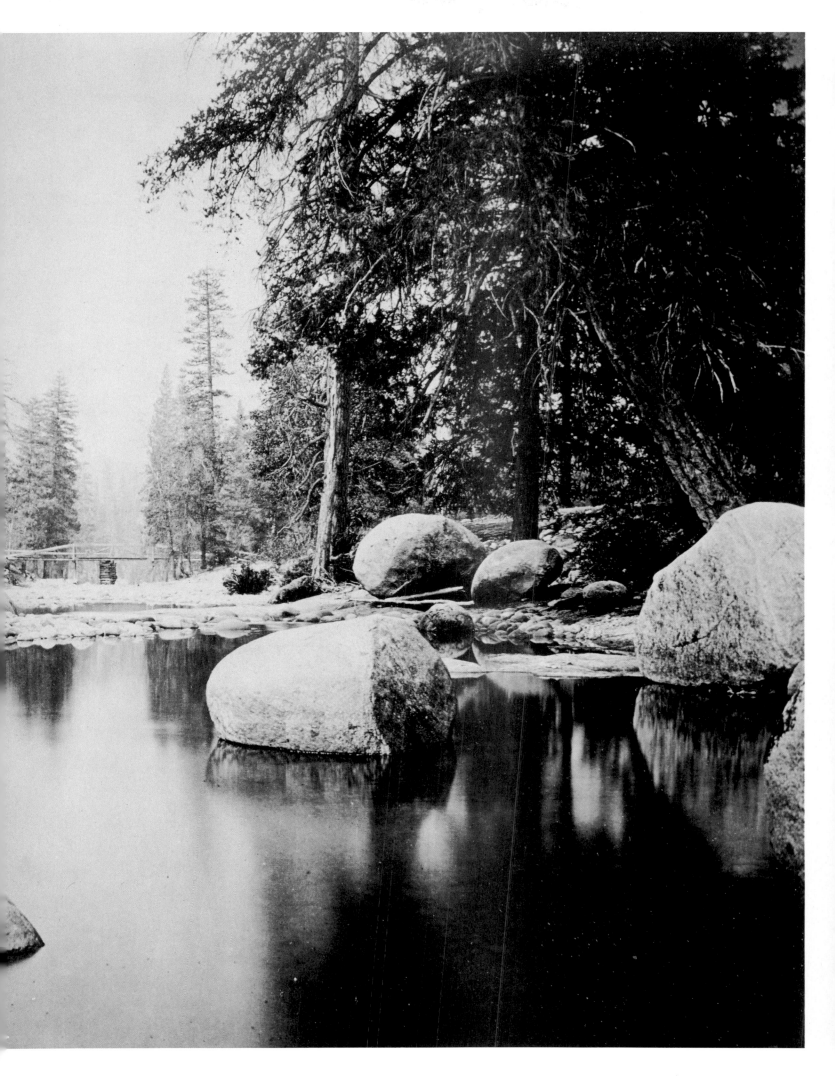

Eadweard Muybridge, Merced River in the Yosemite Valley, 1867.
International Museum of Photography, George Eastman House, Rochester, N.Y.

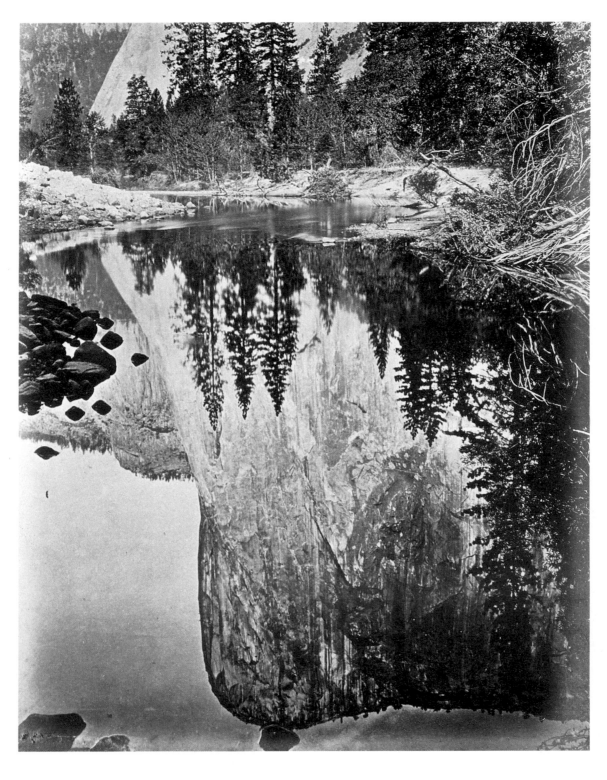

Eadweard Muybridge, El Capitán Reflected in the Merced River, 1867.
International Museum of Photography, George Eastman House, Rochester, N.Y.

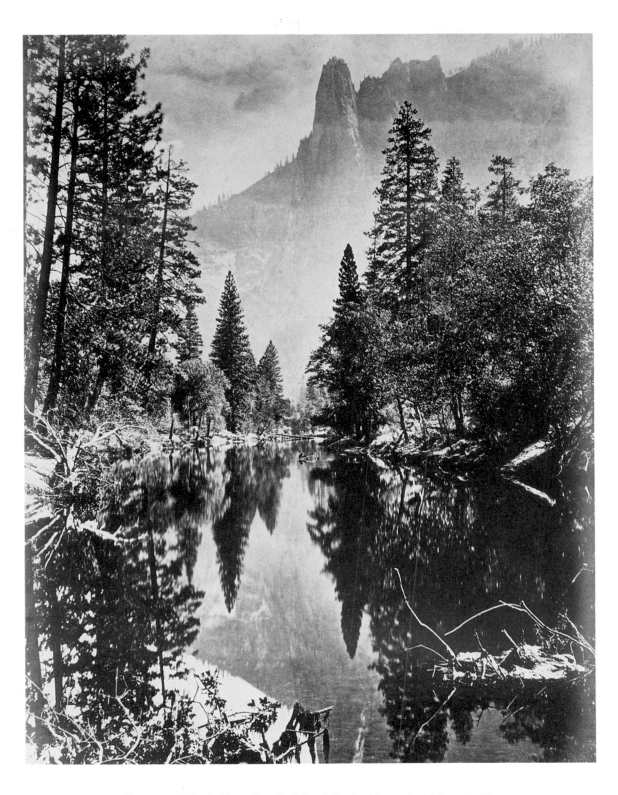

Eadweard Muybridge, Sentinel Rock in the Yosemite Valley, 1867.
International Museum of Photography, George Eastman House, Rochester, N.Y.

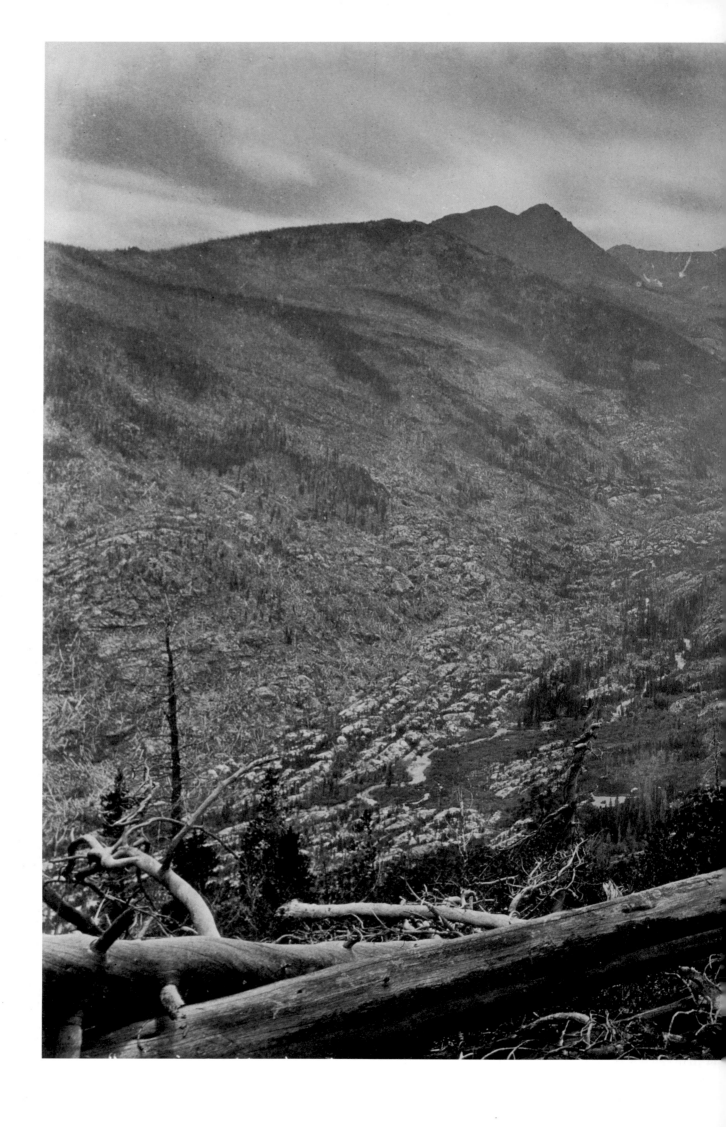

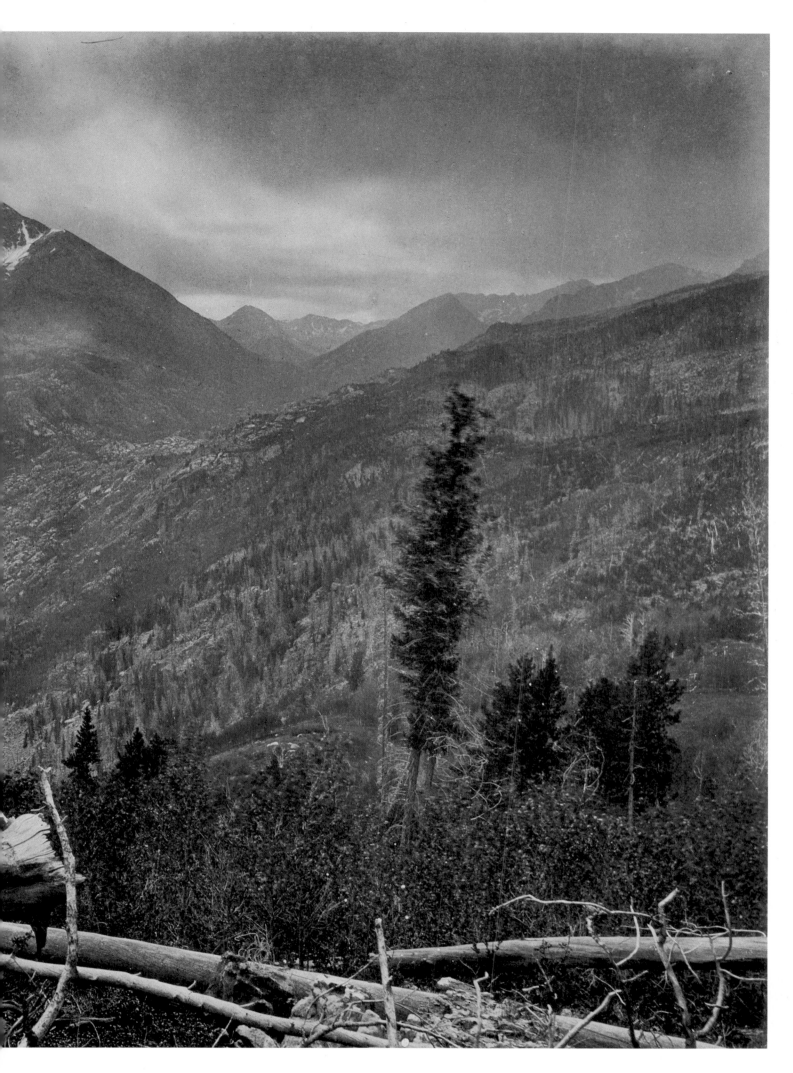

William Henry Jackson, Sheep-Back Rocks ("Roches Moutonnées") in the Rocky Mountains, 1873.
International Museum of Photography, George Eastman House, Rochester, N.Y.

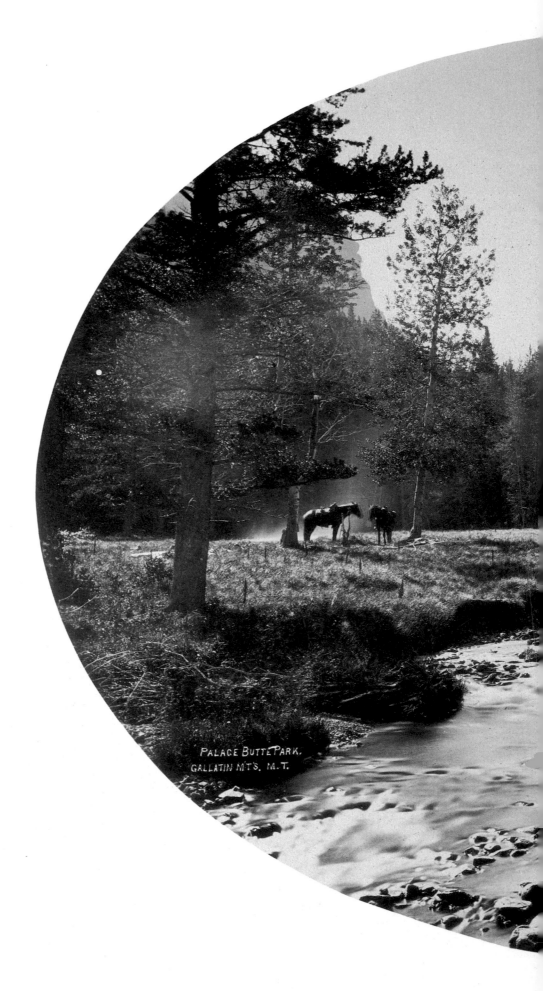

Jackson, as official photographer to Ferdinand Hayden, the first director of the United States Geological Survey, took photographs that to this day represent everyone's fantasy of the rugged life. In 1872, of course, it was rugged indeed. The members of the expedition slept on buffalo skins and shot their own steaks.

PALACE BUTTE PARK.
GALLATIN MT'S. M. T.

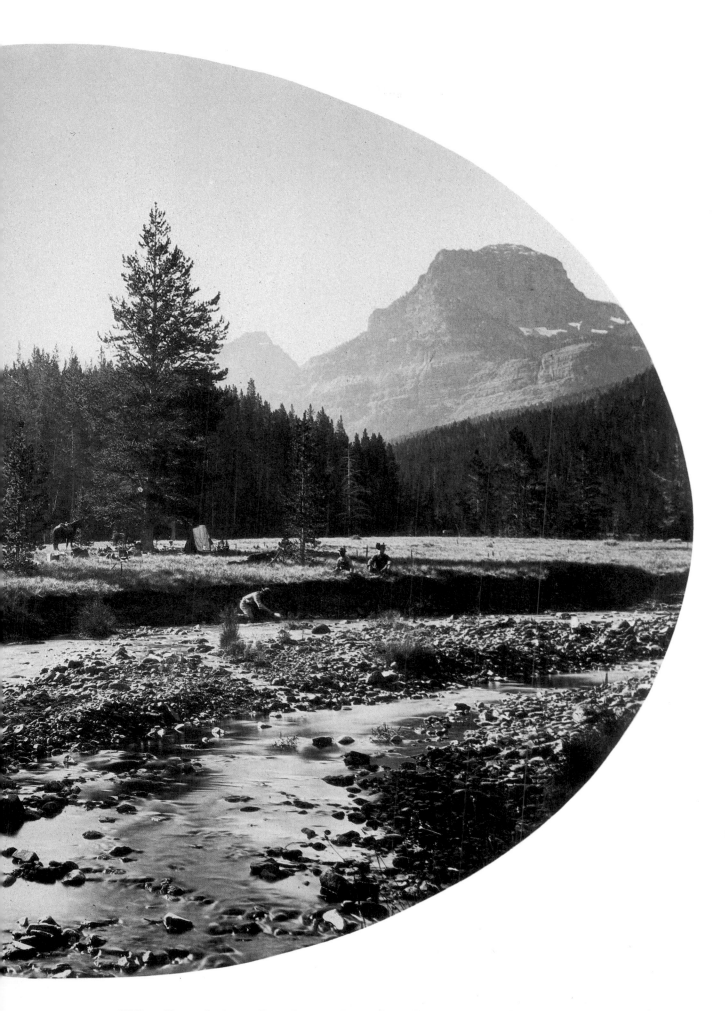

William Henry Jackson, River Bend in Palace Butte Park, Montana, 1872.
International Museum of Photography, George Eastman House, Rochester, N.Y.

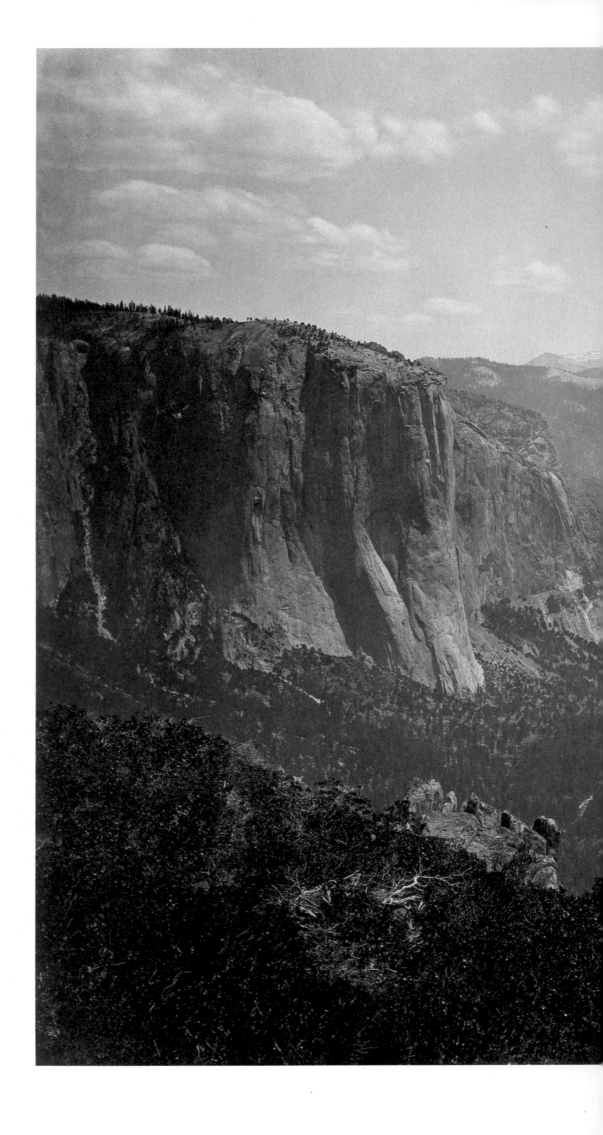

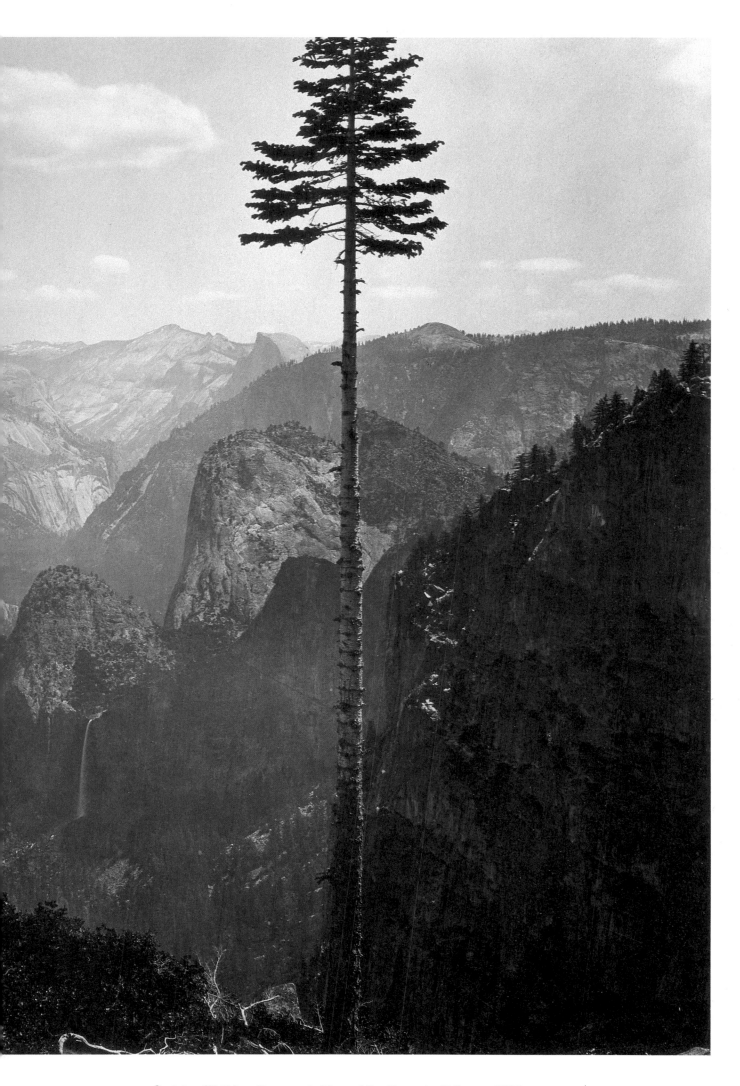

Carleton Watkins, Panoramic View of the Yosemite Valley, c. 1865.
Library of Congress, Washington, D.C.

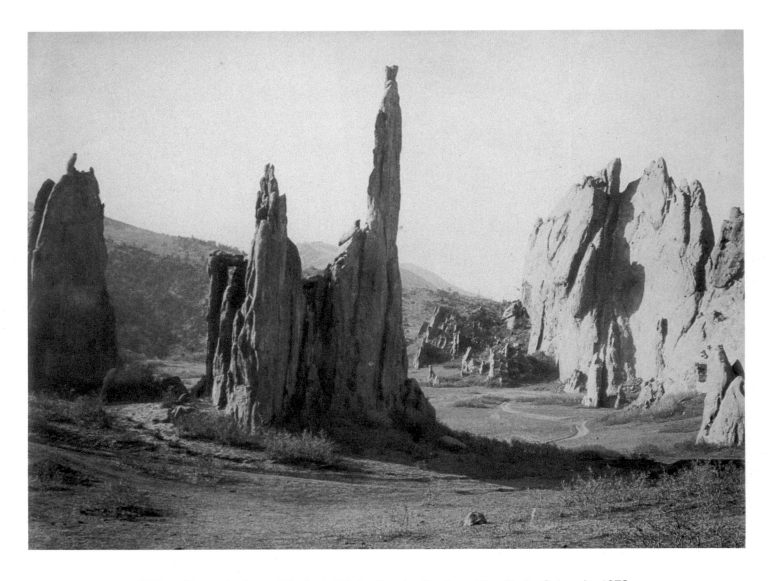

William Henry Jackson, "Cathedral Spires" in the Garden of the Gods, Colorado, 1873.
International Museum of Photography, George Eastman House, Rochester, N.Y.

Jackson photographed the landscapes of the West as
natural monuments, unwittingly paving the way for the
tourists of the future. On the other hand, Jackson's
pictures helped arouse the interest of Congress and
thus contributed significantly to the establishment of
Yellowstone as a national park.

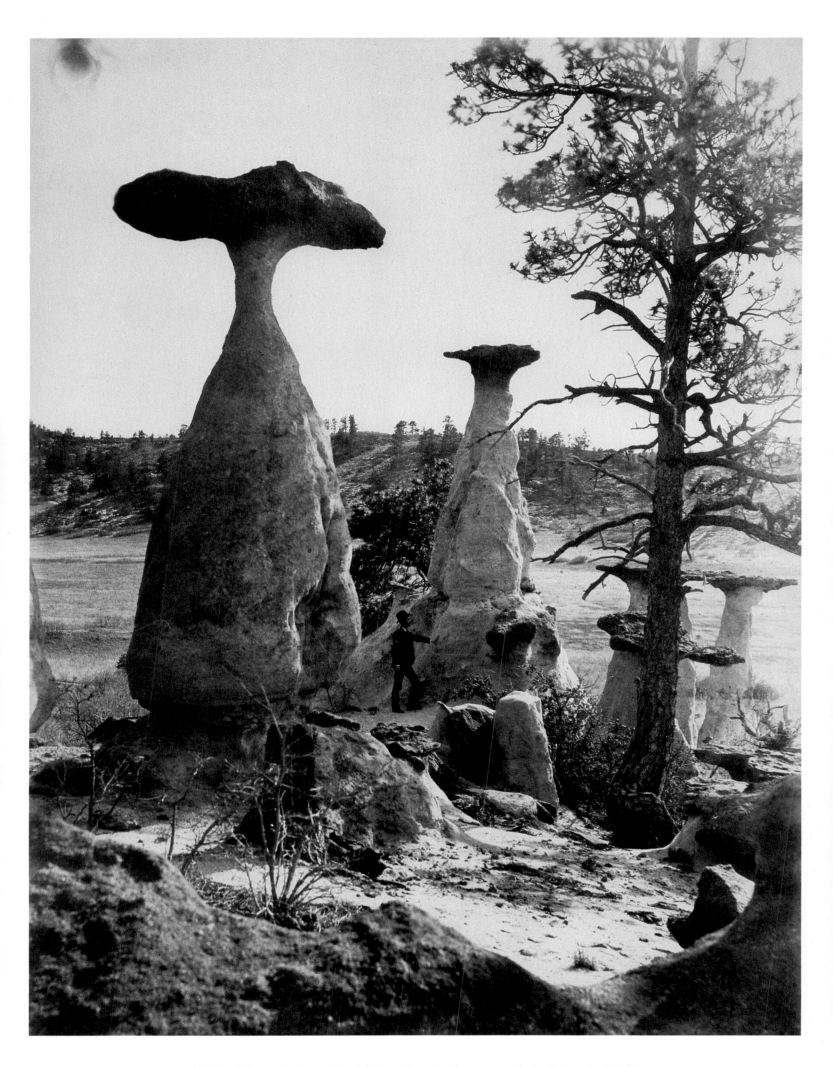

William Henry Jackson, Rock Formations in Monument Park, Colorado, 1873.
Daniel Wolf Gallery, New York.

The subject of Jackson's most famous photograph, the Mountain of the Holy Cross, was immortalized in both poetry and painting. When spring storms sweep the peaks clean, snow lodged in the crevices reveals the cross.

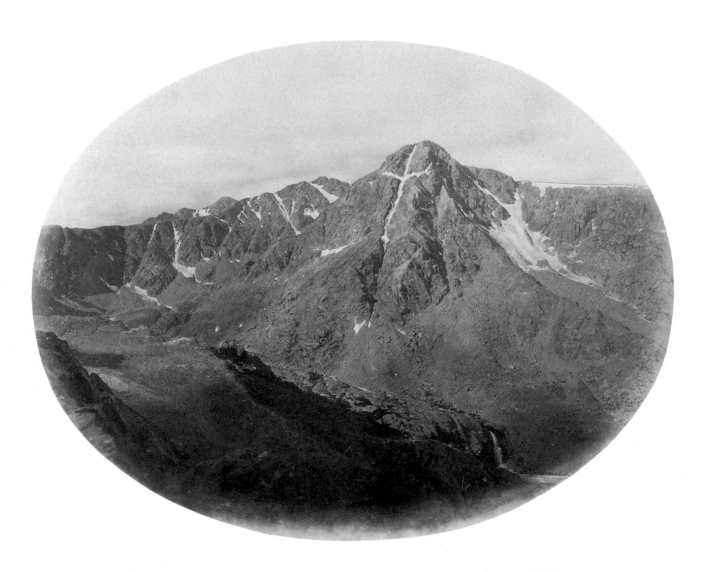

William Henry Jackson, Mountain of the Holy Cross in the Rockies, 1873.
International Museum of Photography, George Eastman House, Rochester, N.Y.

8.
The American West
Pioneering with Colt and Camera

On Saturday, April 4, 1866, William Henry Jackson left his parents' house in Troy and took the train to New York City. At twenty-two he was lovelorn, and getting away from home seemed to offer the best cure. The young man traveled light, taking along a seabag, a sketchbook, and a Western hat. For people in Jackson's situation the magic word in those days was "the frontier," which the inhabitants of the Eastern Seaboard imagined to be somewhere west of the Mississippi. Going West was a necessity for some, and an adventure for others. In either case the journey provided an abundance of hardship, deprivation, and anxiety. In his autobiography, *Time Exposure,* Jackson recalled that everyone left jobless after fighting in the Civil War or anybody with a broken heart went West as a matter of course.

Jackson and his siblings had played with cameras at an early age. Photography entered the family when the senior Jackson, a Scottish immigrant, bought one in the early 1840s because it was becoming the fashionable thing to do. Soon, however, he lost interest in the device and gave it to his sons. Jackson remembered playing with the camera before he could walk.

William Henry Jackson (1843–1942).

At the age of twelve, Jackson was earning pocket money painting backdrops for the local theater. The work so impressed one of the town's photographers that he employed the boy to retouch photographs, his job being to bring out detail and, with watercolor, to add a romantic glow.

His ability with brush and pen stood Jackson in good stead during the Civil War, when a Colonel noticed that the recruit was more adept at drawing than at warfare. It seemed

a good idea to use such talent to record the daily routine of the barracks. For a year, therefore, Jackson sketched forts and entrenchments, the raising and lowering of the flag, and other incidents in the life of ordinary soldiers. In the evenings he read the current thrillers, which proved to be a great deal more adventuresome than reality, even in wartime.

On his return to Troy, Jackson found life unexciting there too, even though the age was one of great events. As the tightrope artist Blondin crossed Niagara Falls, President Buchanan and Queen Victoria held their historic conversation over the first transatlantic cable. But the most sensational news of all came when a letter from San Francisco reached New York in only twenty-four days!

Once in New York, Jackson had little idea of what to do next. His last dime spent on a glass of milk, his best shirt sold off his back, and his watch pawned, he was reduced to sleeping in a police station offering shelter to runaways. Then, he noticed an ad in the *Morning Herald* seeking cowboys at a rate of twenty dollars a month.

Four weeks later Jackson had become a bullwhacker, one of thirty taking a herd of cattle across the prairie from Nebraska City to Montana. He compared the group to a miniature foreign legion, since it consisted of veterans, farmers, and the unemployed. Nicknamed "Mustang Jack," Jackson carried a .44 caliber Colt with which to shoot birds

William Henry Jackson in his "Mustang Jack" days.

A page from Jackson's sketchbook.

and antelope for meat. With a spoon-shaped pair of pliers normally used for casting bullets, he pulled his comrade Sam's aching tooth. The cowboys started their campfires with "bull chips"—dung dried in the sun. When their heads were not shaved completely, turning them into what they called "dead rabbits," the cattle drivers developed skill at cutting one another's hair. At night Jackson sketched by the light of his kerosene lantern, drawing scenes of cowboy life, the covered wagons with their flapping canvas, the wind ruffling the prairie grass, the slow, laborious trek of the new settlers, and a buffalo stampede in which the artist was almost trampled to death. A hundred years later, Jackson's drawings had become classic, textbook illustrations of the Old West.

On his last trip to Omaha as a cowboy, Jackson earned $20, $19.50 of which he spent on a suit, while the remainder went for a shave. He then looked up his brother Edward, a professional photographer, and the two opened a studio. Located between Chicago and St. Louis, Omaha had become a market center for farmers and a place of recreation for the ever-changing army of workers on the Union Pacific Railway. Consequently, the Jackson brothers enjoyed a sizable clientele, composed of sewing circles and political clubs, wealthy ranchers and pious Quakers, along with hotels and saloons seeking publicity shots. But "Mustang Jack" soon got bored with all the studio work. He later recalled how he hoisted himself onto the roof of the studio just to see a piece of open country, and, when that was not enough, how he climbed hills on the outskirts of town so as to take in the prairie and its sweeping horizon.

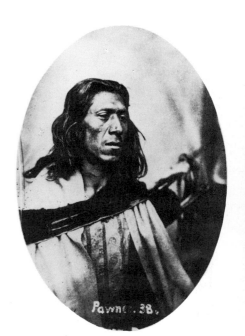

A Pawnee Indian.

Jackson became what he called a photographer-tramp, traveling with a darkroom wagon and, as long as his plates lasted, photographing Indians and their doomed culture. For a small gift, such as a packet of tobacco, a knife, or an old leather jacket, the Pawnee, Oto, and Winnebago chiefs posed for him in all their exotic splendor.

It could be said that photographers like Jackson used their cameras to "write" the chronicle of their heroic era. In

the late 1840s they followed prospectors stricken with gold fever, and in the 1860s they joined the army of workers laying railroad tracks across a vast and largely unexplored country.

California became part of the Union in 1848, the result of a war that also cost Mexico the territory of New Mexico. Although the United States paid fifteen million for the two regions, it deducted three million for reparations. The deal proved to be one of the best in American history, because even before the treaty had been ratified, gold was discovered on John Sutter's farm. California, long considered a wilderness impossible to cultivate, now turned into an El Dorado, especially for young men tired, as Jackson was, of life in the cities. Only three years before the Gold Rush, Daniel Webster had proclaimed that it would be ridiculous to bother with a territory full of wild animals and backward natives, of sandstorms and drifting dunes, of deserts spiked with cacti and swarming with prairie dogs.

Arriving in droves, the Forty-niners reached California by way of stormy Cape Horn, across Panama, or, in most instances, overland by covered wagon. Large, sturdily built from heavy planks, and carried on wheels measuring some six feet in diameter, the wagons were drawn by as few as two horses or as many twelve. Whole families, with all their belongings, traveled in them, across rivers, prairies, and mountain passes.

In May 1849 more saloons opened in San Francisco than in all its previous history. Meanwhile, thousands of settlers were camping along California's rivers. In places like Poker Flat and Hangtown, Red Dog and Skunk Gulch, one could scratch $100 worth of gold straight from the ground in a single day—and spend it in an hour at the grocery store, since a dozen eggs cost $10, a loaf of bread $25, and a bed as much as $500. Along with the groceries and whiskey brought to the improvised shanty towns, the traveling salesmen also offered the .44s invented by Samuel Colt.

And as the prospectors arrived, so did the photographers. Some of the latter opened studios in the

A gambler and his Colt, portrayed in a daguerreotype from the California Gold Rush days.

boom towns and photographed gold diggers showing off handfuls of nuggets, staking their claims, or proudly posing in front of their brand-new blockhouses. This was when the "mug shot" entered the history of photography. On a drinking spree between robberies, Jesse James and his gang marched into a Kansas City studio and had themselves photographed with drawn pistols. Allan Pinkerton, the detective, published the picture, and the outlaws were caught when a cowhand recognized them.

Few photographers went off into the prairie on their own. And for good reason, since rattlesnakes abounded, while no antidote to their venom had been found. Waterholes existed, but not with water fit to drink. Horses could also be had, but they easily broke a leg. Moreover, Indians remained a formidable presence. Ridgeway Glover left Philadelphia in 1866 "to illustrate the life and character of the wild men of the prairie" for *Leslie's Illustrated Weekly Magazine*. A few months later he was found minus his scalp.

Carleton Emmons Watkins became a photographer by chance. About 1850 he and his friend Collis P. Huntington followed the siren call of gold and made their way to California. In the spring of 1851, while working in a San Francisco warehouse, Watkins was asked by the photographer Robert Vance to fill in for the indisposed operator at Vance's San Jose studio. Inasmuch as Watkins had never taken a photograph in his life, Vance had to show

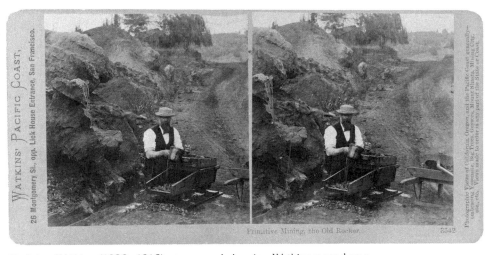

Carleton Watkins (1829–1916), stereocard showing Watkins posed as a prospector for gold.

him how to pose subjects and how to render a silvered copper-plate light-sensitive with iodine. Treating these instructions rather lightly, Vance suggested that Watkins simply pretend to take the photographs, after which the sessions could be repeated once the operator had regained his health. The most important part of the assignment was to make sure nothing got stolen. But Watkins took his job seriously, reading all he could find about daguerreotypes, experimenting with chemicals, and making photographs just to prove he could. When Vance's assistant conveniently failed to resume work, Watkins was given the job. Five years later he had his own studio in San Jose, with an ad in the local newspaper that read: "Babies!! Babies!! Bring on your Babies!!"

In 1861 Watkins took a wagon and a dozen mules into the Yosemite Valley to photograph its many natural wonders, such as the three thousand feet of vertical stone known as El Capitán, the sharp peaks of the Three Brothers, the egglike top of Half Dome, and the mountains reflected in the Merced River. Ten years later the·whole world knew about the Yosemite Valley and Carleton Watkins.

Watkins liked things big, nature included. His cameras were the size of a modern television set and his plates mammoth in their proportions. The equipment he carted about weighed three times that of his itinerant colleagues. Even the well-made, gilt-stamped albums he gave to his friends were enormous, but so heavy that the recipients could barely lift them.

Watkins returned often to the Yosemite, taking the same views again and again. One of his favorite spots was known to tourists as Watkins Point.

In 1867 Watkins opened a sumptuous studio, called the "Yosemite Art Gallery," on San Francisco's Montgomery Street, where he sold large prints framed in walnut. To advertise his work, Watkins took space in the West Coast papers to announce that he had spent his life camping near mountain streams and dragging heavy equipment to the top of mountain peaks for the purpose of offering his customers

these grand views. Europeans discovered Watkins' amazing work at the Paris Universal Exhibition of 1867. A Berlin photographer visiting the fair reported that Watkins' landscapes were the talk of the French capital, mainly because, in his opinion, Europeans believed America still to be the New World, realistic depictions of which could not fail to arouse interest.

Equally impressive were the photographs of Watkins' great rival, Eadweard Muybridge. Born Edward James Muggeridge in Kingston-on-Thames on April 9, 1830, the son of a grain dealer, the young Muybridge had changed his first name out of reverence for a pair of eponymous Anglo-Saxon Kings who had been crowned at Kingston. A further attempt at shaping his life came at the age of twenty-two, when he sailed for America, answering the call of California's gold, the discovery of which had spread its fever even to England.

Muybridge changed his name more than once. Traveling in Guatemala, he signed his photographs Eduardo Santiago Muybridge. But in San Francisco he was Muygridge at first, possibly the result of a typographical error, and finally Muybridge. After purchasing a darkroom wagon, he gave himself yet another name, this one worthy of a rock star: "Helios, the Flying Camera." Muybridge inscribed it, along with a painted image of the winged emblem, on the canvas wall of his wagon.

Eadweard Muybridge (1830–1904).

In his advertisements Muybridge declared Helios prepared to accept orders from all comers to photograph anything: animals, ships, houses, country estates, in the city or elsewhere along the entire Pacific Coast. The press praised his photographs as "splendid, wonderful, exquisite, beautiful, sublime," and described in detail the rigors involved in obtaining the shots. They reported with awe how the photographer had waited throughout days for the right weather, cut down trees that spoiled the view, hung from a rope to reach a particularly dangerous spot, and continued alone on a difficult trek after his porters had refused to go on.

The writer Helen Hunt Jackson, who disliked San Francisco and whose novel *Ramona* condemned the white man's treatment of California's Indians, recommended that tourists in San Francisco either leave town with all due speed, by carriage or sailboat, or spend an incomparably entertaining morning in the presence of Mr. Muybridge's photographs.

Among the landscape photographers of his time, Muybridge was the Impressionist. He liked dawn, dusk, and shadows. In the Yosemite Valley he photographed the sun-dappled Merced River, but his favorite motif was the wall of El Capitán reflected in water. The public admired his moon pictures, a fact that amused his colleagues since the moon was painted in. Muybridge sold his photographs in series under such titles as *Mammoth Trees, San Francisco Views, Geysers,* and *Principal Places of Interest on the Coast.* Among the subscribers were government officials, society folk, and California's best-known painters.

In the early 1870s Muybridge married Flora Stone, a divorcee half his age. When she bore a son, Muybridge realized that the child could not possibly be his. The real father was probably an English immigrant named Harry Larkyns, a con man working in the Yellow Jacket Mine. Muybridge waited for some time and then one day shot Larkyns through the heart. In despair at his deed, he offered his own carriage and wanted to take the dying man to the hospital himself. Such a reaction made the photographer's subsequent plea of insanity all the more plausible. The defense lawyer found dozens of witnesses to Muybridge's eccentric behavior. One of them pointed out that a sane man would not balance on a rock 3,400 feet above sea level just to make a photograph more interesting. The judge agreed that a normal man would do no such thing, and since all the jurors were men and Larkyns clearly got what he deserved, Muybridge was acquitted.

The most important meeting in Muybridge's life was with Leland Stanford. The former Governor of California was

Leland Stanford, millionaire horse lover and Governor of California.

rich, mad about horses, and unstinting in his financial support of Muybridge. He also had the most beautiful house on the West Coast, thirty miles from San Francisco, as well as a private racetrack in Palo Alto where the world's fastest horses competed. Stanford's own stable consisted of two hundred thoroughbreds.

Legend has it that Stanford and another millionaire connoisseur of horseflesh disagreed about whether a galloping horse at one point in its stride has all four legs off the ground. Stanford thought it did, and his opponent bet $25,000 that it did not. The issue could not be decided with the naked eye, and so the opponents invited Muybridge to settle it once and for all with his camera. Meanwhile, the photographer had invented one of the first practical shutter mechanisms and for six years had been experimenting with a battery of cameras lined up and timed to photograph an event in progress. The light-sensitivity of photographic plates had so increased since 1872 that they now yielded an image after an exposure of only 1/1000 of a second. When Stanford's test took place in June 1878, reporters were there en masse, after which the *San Francisco Chronicle* gave this detailed account:

> On one side of the track is a rough shed in which are the lenses and cameras, twelve in number, and on the opposite side is a large screen of white canvas stretched over a scantling fence some thirty feet long and eight

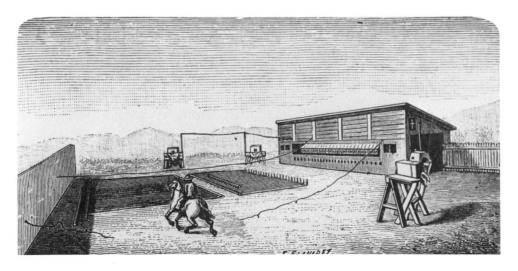

In an experiment with rapid exposures, the horse breaks wires strung across the track, thereby tripping the shutters as it moves parallel to a line of cameras.

feet high, with a backward declination of some sixty degrees. On the upward edge of this canvas are shown the figures one to twenty consecutively, severed by vertical cords at twenty-one inches distant, and at the bottom of this canvas was a board showing horizontal lines that represented four, eight, and twelve inches above

THE LEVEL OF THE TRACK.

About two feet from the same canvas, but on the track, was a slight wooden ledge, and between the two at every number between four and sixteen was stretched a galvanized wire at about an inch from the ground, each wire connected with its numbered lens on the opposite side, the wires being taken underneath the track. The investigation thus far was very simple, as it was apparent that the inner wheel would pass over the projecting wires and by a simple arrangement on the other side would close the circuit. But, then, arose the question as to how this could be utilized to take a picture in the estimated incredible fraction of time of the two thousandth part of a second—in which period the lenses had to be exposed and closed. This was effected by a very ingenious contrivance in the shutters of the camera, to the upper and lower parts of which were adjusted very powerful springs, and when the electric current was arrested they were released, and in crossing they exposed a space of about two inches, and in this space of time that represented but a flash of lightning, the passing figure is fixed on the highly-sensitized glass, even to

THE MINUTEST DETAIL.

The ground over which the experiment was to be made being covered with slack lime, so as to catch even each footstep of the stride, all was duly prepared, and Abe Edgington, with Charles Marvin holding the reins, appeared on the track to show by twelve almost instantaneous photographs the true story of the stride of the horse.

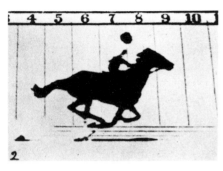

An historic photograph in which Eadweard Muybridge proved that a galloping horse lifts all four legs off the ground at once, but in a bunch under the belly, not stretched fore and aft, hobbyhorse fashion, as previously depicted by painters.

The whole process took place in a "flash of lightning," after which Abe Edgington, the horse used in the test, and Muybridge had made photographic history. From then on, equestrian painters found themselves forced to learn new tricks, for at one point in his stride, Abe Edgington's four feet were indeed all off the ground, but, to everyone's shock, not in the "hobbyhorse attitude"—front legs stretched forward and hind legs backward—always represented in art, but rather when bunched together under the belly.

Using his battery of twelve cameras, Muybridge made a hundred thousand studies of humans and animals in motion during the 1880s. For his human models he went to the University of Pennsylvania, where selected professors and

students moved before his camera nude but with great dignity. They ran and rowed, boxed and climbed stairs, played cricket and performed acrobatic feats.

Some of Muybridge's most important work can be seen in *Animal Locomotion: An Electro-Photographic Investigation of Consecutive Phases of Animal Movements,* published in 1887 with 781 photoengravings. The book enjoyed great popularity in Europe, and in Germany, for instance, it was bought by a number of well-known Romantic painters.

A prolific and untiring inventor, Muybridge also developed a duplicating process and a forerunner of the modern motion-picture projector, which he called a "zoopraxiscope." In this device photographs were mounted on a disk that, when rapidly rotated, recaptured the original motion of the subjects and cast it in enlarged images on a screen. Had Muybridge not become impatient with his machine, he would certainly have invented moving pictures.

During the 1860s and 70s almost all the photographers in the American West worked for railway companies.

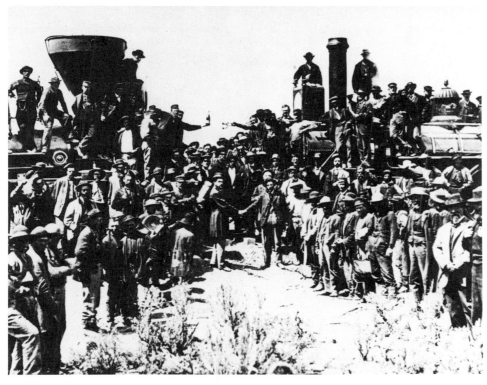

The climactic moment when a worker on the Central Pacific Railway and another from the Union Pacific Railway toasted each other on May 10, 1869 .

President Lincoln had signed the Pacific Railway bill on July 1, 1862, and six months later the Union Pacific and the Central Pacific began their drive towards each other from east and west. With their final link-up, the United States could boast its first transcontinental railway. The whole enterprise assumed heroic dimensions, and much of the harrowingly difficult construction had been carried out by Chinese coolies from California and Irish laborers from New York.

These workers lived in movable tent cities—huge work camps complete with bars, dance halls, and gambling dens. Their food consisted of black coffee, bread, and meat, the latter served in tin dishes nailed down on wooden tables. When one shift had finished, water was poured over the table, and the next shift sat down.

For six years the two armies of workers rolled across the continent, leveling the roadbed, filling river channels, building bridges, and blasting tunnels. Along the way they endured, and sometimes actually survived, blizzards, attacks by Sioux and Cheyennes, and utter exhaustion. On May 10, 1869, outside Ogden, Utah, the cowcatchers of the first two locomotives touched, whereupon Leland Stanford drove in a golden spike to secure the final rail. Among the many photographers to record the historic moment, A. J. Russell and Charles Savage got the best shots, pictures that are used to illustrate textbooks even today. They depict two workmen toasting each other with champagne, while the two chief engineers, Samuel S. Montague of the Central Pacific and Greenville M. Dodge of the Union Pacific, shake hands.

William Henry Jackson missed the great event because he was getting married to Mary (Mollie) Greer. After a six-day honeymoon traveling down the Missouri on a steamboat, Jackson put his wife on the train and went off in the opposite direction to take photographs.

In 1870 Ferdinand Vandeveer Hayden, the geologist, paid a visit to the Jackson brothers' studio. As a young man, Hayden had explored the Yellowstone and Missouri rivers, collecting rocks and fossils by the cartload. He even earned a

Sioux nickname: "the man who picks up rocks." Impressed by Jackson's photographs, Hayden recruited the photographer to accompany him on his next expedition.

For a decade Jackson and Hayden explored the wilderness on behalf of the American government. Back home, the public found Jackson's photographs of these unknown regions of their country as fascinating as the first moon pictures that captivated a much later generation of Americans. In the 1870s maps treated the West as a blank, which scientists and photographers were eager to fill by means of whatever information they could collect. Among the many questions raised at the time were: Could the settlers cultivate the land? Was there coal? Water? Minerals? Would the climate be tolerable?

In 1867 Hayden had been put in charge of the United States Geological Survey. Accompanied by Charles King and George Wheeler, he made four major expeditions, which were in effect universities on wheels. While the geologists collected rocks to be analyzed for their mineral deposits, botanists and zoologists recorded flora and fauna. Others climbed mountains to measure their height and gain an idea of the

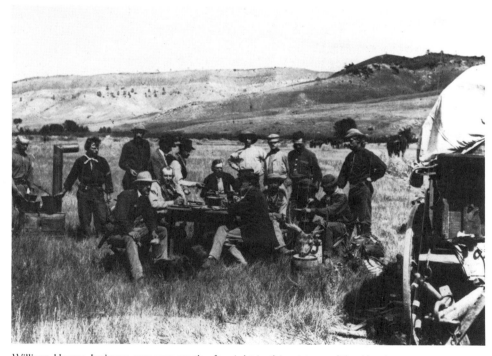

William Henry Jackson appears on the far right in this picture of the Hayden expedition picnicking on the prairie.

region's topography. Dressed like cowboys, they rode three miles for every mile mapped, up the mountains, down into the valleys, back and forth across the prairie.

Jackson and his fellow photographer Timothy O'Sullivan recorded in detail the topographical makeup of a country few Americans had ever seen. Their landscape photographs proved to be important documents, and the official report of the survey stated that "the two thousand or more photographs. . . have done very much, in the first place, to secure truthfulness in the representation of mountain and other scenery."

The expedition members had to be rugged, able to sleep in the open and handle a gun. Many of them were already mountaineers and thus knew how to paddle a canoe, walk great distances, administer first aid, and diagnose infections. Most of the leaders of these expeditions were Civil War veterans, and Hayden himself had served as an army surgeon. The army, moreover, provided Hayden's parties with a certain amount of equipment, such as four ambulances used to transport tents, blankets, food, and scientific instruments, in addition to two covered wagons eminently suitable for smaller forays. Little wonder that the camps followed the army pattern, with neat stables and kitchens and, of course, the Stars and Stripes fluttering above them.

For Jackson, even the everyday life of an exploration into the wilderness eventually became routine. He got up every morning at three, after the cooks had collected their firewood. Breakfast was served on buffalo hides or newly made wooden tables. In the morning the men drank black coffee, but in the evening they switched to a mixture of water, milk, coffee, and whiskey. Having made their plans for the day, the team would go off in small groups, some to measure the depth of a river, others to pace off the circumference of a lake, yet others to collect fossils.

If they wanted dinner, the surveyors had to be back in the camp promptly at six o'clock. If the hunters had bagged nothing that day, the meal consisted of dried fruit softened in

Sectional view of Jackson's darkroom tent, with the photographer spreading collodion on his glass plates.

water. After dark the men worked on their notes, wrote in their diaries, or cleaned guns by the light of kerosene lamps. In the event of a rainstorm, flannel shirts had to be dried at the campfire. By eight the party was ready for sleep.

Jackson succeeded in varying the routine. Wrapped in blankets, he sometimes spent the night on rock outcroppings or some river bank miles from camp in order to take advantage of the early light. He described how signs of civilization, such as smoke from a farm or the camp drifting across the landscape, could ruin his motif.

Jackson's most important assistant was a packer whose sole job was to strap glass plates, water bottles, and test tubes so securely on the mule's back that they would not be damaged should the animal kick, scratch its flanks on trees, or suddenly jump into the air. Jackson himself was considered an expert at such packing. To assure the safety of fragile and cumbersome objects, he chose the fattest mule, a beast upholstered like a sofa and capable of swaying, litter fashion, along narrow footpaths. While Jackson photographed, Hypo his mule was hobbled and allowed to graze.

When cold weather came, the expedition repaired to Washington and set up winter quarters in a government building on the corner of Pennsylvania Avenue and Eleventh Street. There Senators and Congressmen passing along the corridor could sniff the unfamiliar odors emanating from Jackson's laboratory. With the help of his diaries, the photographer would catalogue and mark his negatives, while the scientists prepared their reports and drew maps. It is said that when spring came, Hayden's men got a dreamy look in their eyes and could be observed buying blankets and foul-weather gear.

Once back in *terra incognita,* they went to work. The Yellowstone region and Colorado's mountains had never before been described by witnesses, much less photographed. Such scanty accounts as existed were caricatures, and maps often indicated mountains and glaciers

where reality consisted of prairie and meadow. Meanwhile, the unknown spaces gave rise to legends endlessly retailed around trappers' campfires and gold diggers' saloons—such as the story of "Colter's Hell." Seeking refuge from hostile Indians, John Colter was the first white man to camp in what would become Yellowstone Park, whence he returned with tales of bubbling springs and malodorous water cascading down rocky terraces. Although incredulous, everybody repeated the story, never failing to embroider it in the process.

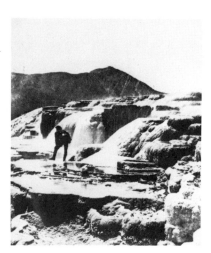

Thomas Moran, the painter, in the first photograph of the Soda Springs in Yellowstone Park.

Although General Henry D. Washburn and Nathaniel P. Langford established the facts about Yellowstone in the course of a well-equipped expedition in 1870, they too provoked disbelief. A reader of *Scribner's Monthly* wrote that Langford must be the world's champion teller of tall stories. Hayden, however, believed him, which was a good thing since science without faith cannot prevail.

Even so, the Hayden party could hardly trust their eyes—indeed they ended up rubbing them—once confronted, in March 1872, with Yellowstone's hundreds of steaming geysers and hot springs. The scene resembled a huge industrial park, with columns of white smoke like those belching from the chimney stacks of Pittsburgh.

The first photograph ever made of the Yellowstone springs resembles a painting by the German Romantic master Caspar David Friedrich, who so often posed a solitary figure against a vast and spectacular landscape. Jackson captured the painter Thomas Moran, one hand on his kneee, staring into the waters bubbling and racing down rocky terraces. Around the campfire at night the men invented names for these natural phenomena. One tall geyser became the "White Cathedral," while a spring was dubbed "Bathtub." A particularly noisy one earned the name "Locomotive."

The legend of Colter's Hell forgotten, Hayden's scientists bathed their feet in the steaming springs and discovered the beneficial properties of sulphur and mud. They caught trout and cooked them in natural hot water. Washing his plates in the boiling spring, Jackson discovered that they dried faster.

Meanwhile, Hayden was thinking ahead. He had a premonition about these great virgin spaces, for his men were already returning from mountains where trappers and prospectors had left their litter behind. Worse, he heard of plans to build hotels with "a view of the geyser." Deciding that Jackson's photographs were more eloquent than words, he presented them collected in albums to every member of Congress when the Senate and House took up the national parks debate for the last time. The beautifully bound albums bore the recipient's name stamped in gold and contained the first photographs of the Grotto Geyser, the Mammoth Springs, and Jupiter Terrace. In March 1872 President Grant signed the new law, and Yellowstone became America's first national park.

The illustrated newspaper published by Frank Leslie reported that Hayden's expedition had made Yellowstone as famous as the land of the *Thousand and One Nights*. According to Alfred Stieglitz, who in the 1880s was studying photography at the Berlin Polytechnic, people lined up in the German capital to see Jackson's photographs, which were bigger than anything ever seen before and even approached the miraculous.

Jackson's picture of Holy Cross Mountain was indeed a miracle. For an instant in 1869, William Brewer had seen a peak in the Rockies with a white cross on it. Then clouds closed over the scene. Subsequently the phenomenon was discovered to have been produced by a pair of crevices in the face of the mountain, and it became visible when the spring storms blew away surface snow, leaving the snow buried in the cross-shaped fissures to show white when viewed from a distance. Jackson's photograph of this wonder sold by the thousands. It hung in every government office; Longfellow wrote a poem about it; and it inspired Thomas Moran to paint one of his most famous pictures, a work that now hangs in the United States Capitol.

By 1879 Hayden's expeditions had cost the American taxpayer almost $700,000. The photographs made by

Timothy O'Sullivan were collected in leather-bound albums that took two men to carry. Jackson's splendid, if wordless, *Wonder Places* went for $1,000 a copy.

In 1879 Jackson moved to Denver. With the advent of the railway, the "Queen of the Mountains" experienced an unprecedented boom. Real estate values went up like geysers in Yellowstone Park, and in a single year seven thousand new citizens arrived. Jackson enjoyed a flourishing business—but he soon hit the road again.

Nothing could stop such a compulsive traveler. In his long life Jackson and his one-horse studio visited every corner of North America, from the White Mountains to Mexico, from Canada to Colorado. He took photographs for a dozen railway companies, using the "Jackson special," a darkroom car drawn by a locomotive. Sometimes he perched on top of a work train and from that vantage point focused on whatever he found interesting along the way. He was not even above shooting sights already famous, such as Teapot Rock, which really resembled a teapot, complete with handle and spout; Echo Cliffs, a narrow pass in which all train engineers lustily blew their whistles; the Phantom Curve; and the Thousand Mile Tree, marking that spot on the Union Pacific's journey from the West to the East Coast.

In 1898 Jackson became a partner in the Detroit Publishing Company. He received $5,000 for doing so, as well as $25,000 for his negatives, which the company was thereafter free to use. During the early years of the 20th century this picture factory flooded the world with Jackson's products. As a publicity stunt, the company mounted an exhibition in a special car and added it to some of the trains then running. Annual sales totaled seven million photographs, posters, and postcards. Every hotel lobby in the known world displayed one or another of Jackson's views, from geysers in Yellowstone Park to Holy Cross Mountain.

One day Jackson was approached by the World Transportation Commission, an institution founded to study the problems of world traffic and to collect material for a

William Henry Jackson at the age of ninety-four, painting a scene from his expedition with Ferdinand Hayden, the first director of the United States Geographical Survey.

traffic museum in Chicago. The photographer was to spend three years traveling around the world. In fact, he did it in only seventeen months, and came back feeling as if he had competed with Phileas Fogg. The American Secretary of State had alerted his Ambassadors and Consuls everywhere, with the result that Jackson journeyed in considerable comfort.

In all, Jackson saw Europe, raced through North Africa as well as around the periphery of Australia, and took photographs in Bombay, Tokyo, and Vladivostok. Before going on this 100,000-mile trip, he had signed a contract with *Harper's Weekly*, which was to publish one photograph each week at $100 a shot.

When Jackson died in a New York City hospital on June 30, 1942, he was ninety-nine years old, and his wilderness had long since become a legend. During one last interview a

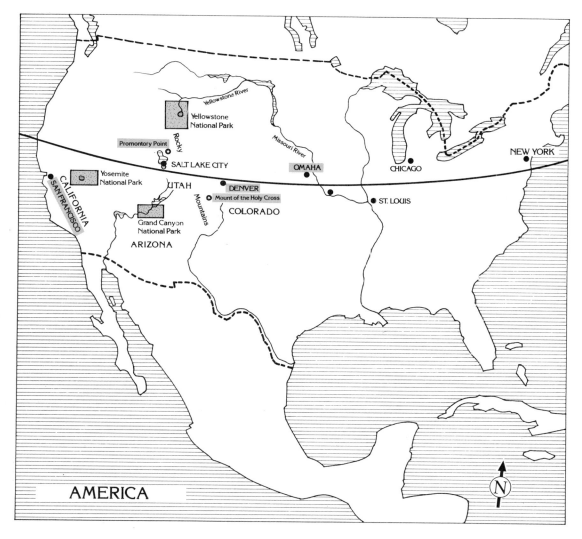

Scientists and pioneer photographers made three expeditions to the American West, during which they investigated the 40th Parallel, the Rocky Mountains, and the area around Yellowstone National Park.

reporter referred to him as an old-timer, whereupon Jackson proudly pointed out that he was no fossil, that, on the contrary, he had gone riding regularly right into his ninety-fourth year!

The World in Color

Record It While It Lasts

Albert Kahn and Burton Holmes

Frédéric Gadmer, Monastery Near Aleppo, Syria, 1921.
Albert Kahn Collection, Hauts-de-Seine, France.

Color photography came into being around the turn of the century, and an ineffable nostalgia clings to the early pictures made with the process. While millions of tourists were snapping away with handy small cameras, the pioneers of color photography traveled with cumbersome wooden cameras and fragile autochrome plates. The Parisian banker Albert Kahn fitted out operators for forays into the four corners of the world to record vanishing cultures, and only recently have the fruits of this endeavor been rediscovered.

Stéphane Passet, The Harbor at Constantinople, 1919.
Albert Kahn Collection, Hauts-de-Seine, France.

Frédéric Gadmer, The Village of Marran in the Syrian Desert, 1921.
Albert Kahn Collection, Hauts-de-Seine, France.

Such photographs document a dying world, and the
man who financed them, Albert Kahn, commissioned
the work believing the subjects would soon be a thing of
the past.

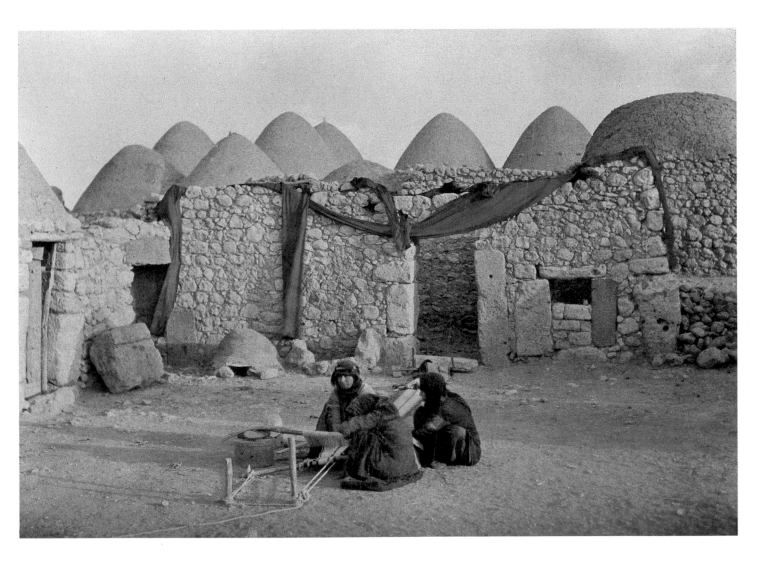

Frédéric Gadmer, Marran Women Weaving, 1921.
Albert Kahn Collection, Hauts-de-Seine, France.

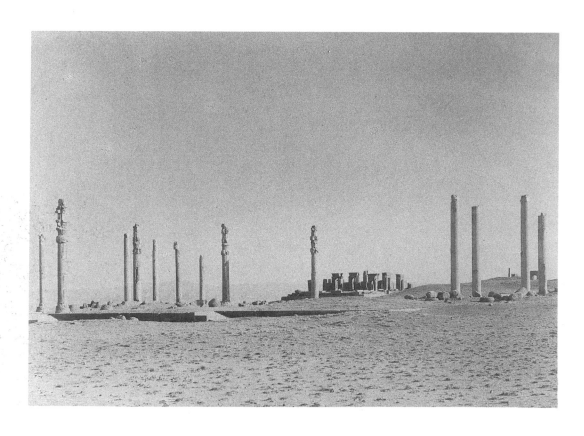

Frédéric Gadmer, Royal Audience Hall at Persepolis, 1927.
Albert Kahn Collection, Hauts-de-Seine, France.

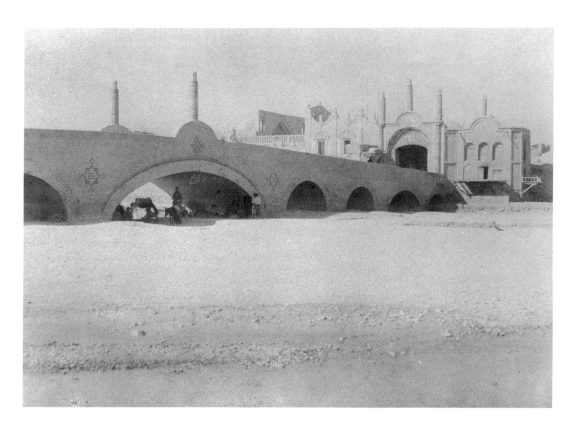

Frédéric Gadmer, The Holy City of Kum, Iran, 1927.
Albert Kahn Collection, Hauts-de-Seine, France.

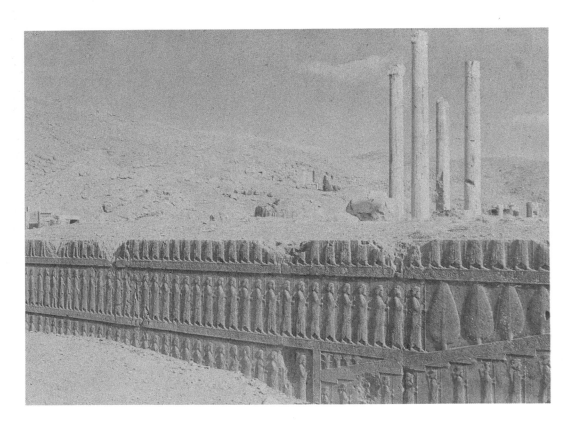

Frédéric Gadmer, Ancient Frieze at Persepolis, 1927.
Albert Kahn Collection, Hauts-de-Seine, France.

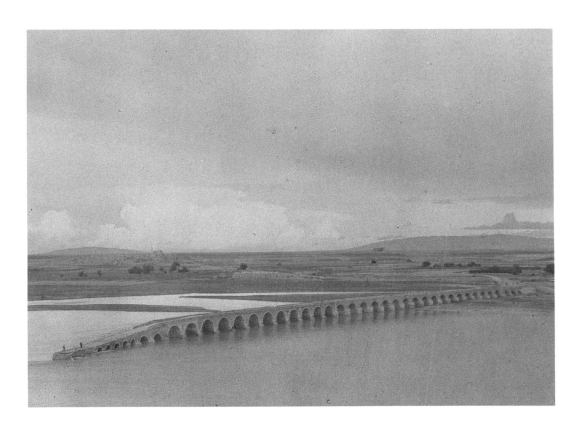

Frédéric Gadmer, Bridge Across the Tigris at Mosul, Iraq, 1927.
Albert Kahn Collection, Hauts-de-Seine, France.

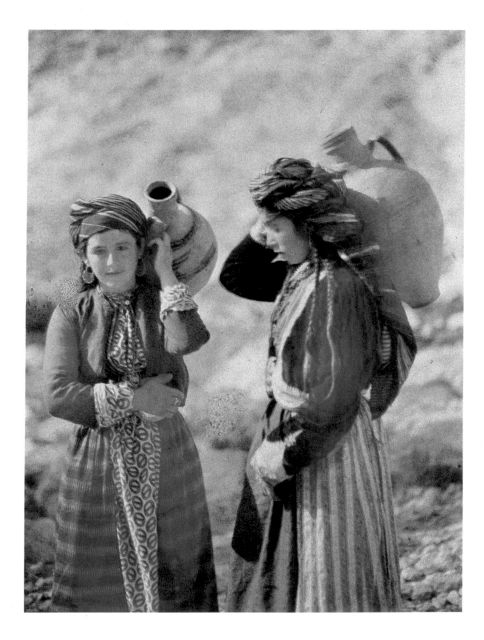

Frédéric Gadmer, Kurdish Women in Iraq, 1927.
Albert Kahn Collection, Hauts-de-Seine, France.

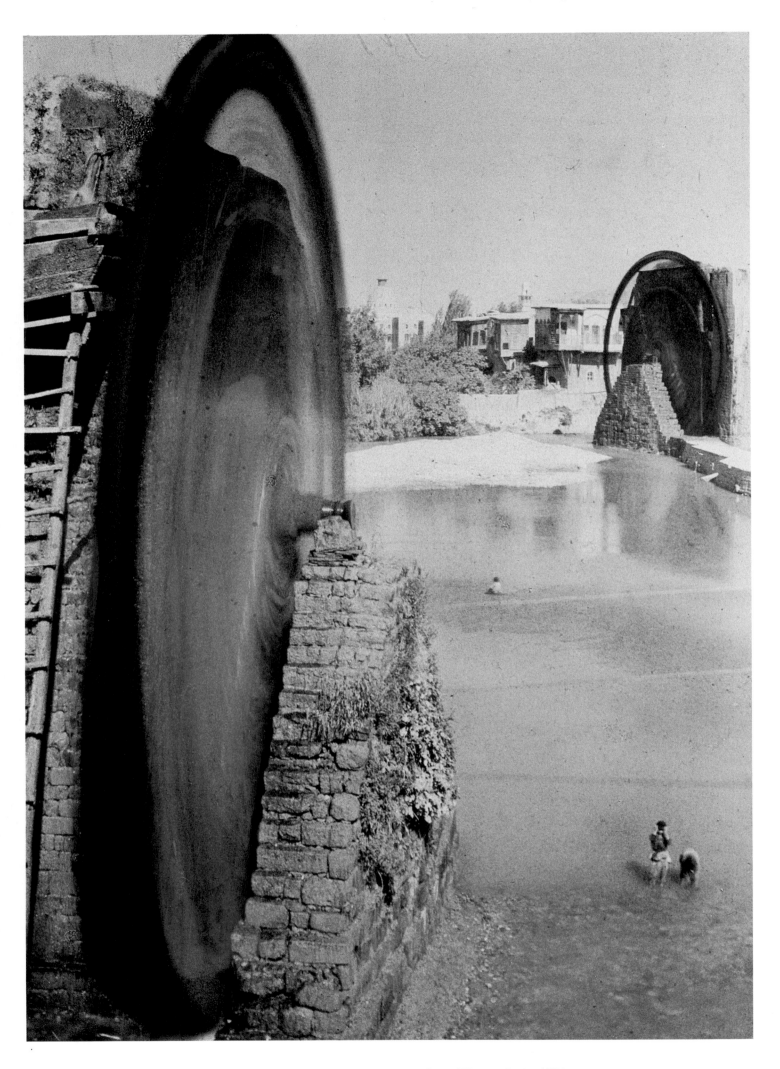

Frédéric Gadmer, Waterwheels in the City of Hama, Syria, 1921.
Albert Kahn Collection, Hauts-de-Seine, France.

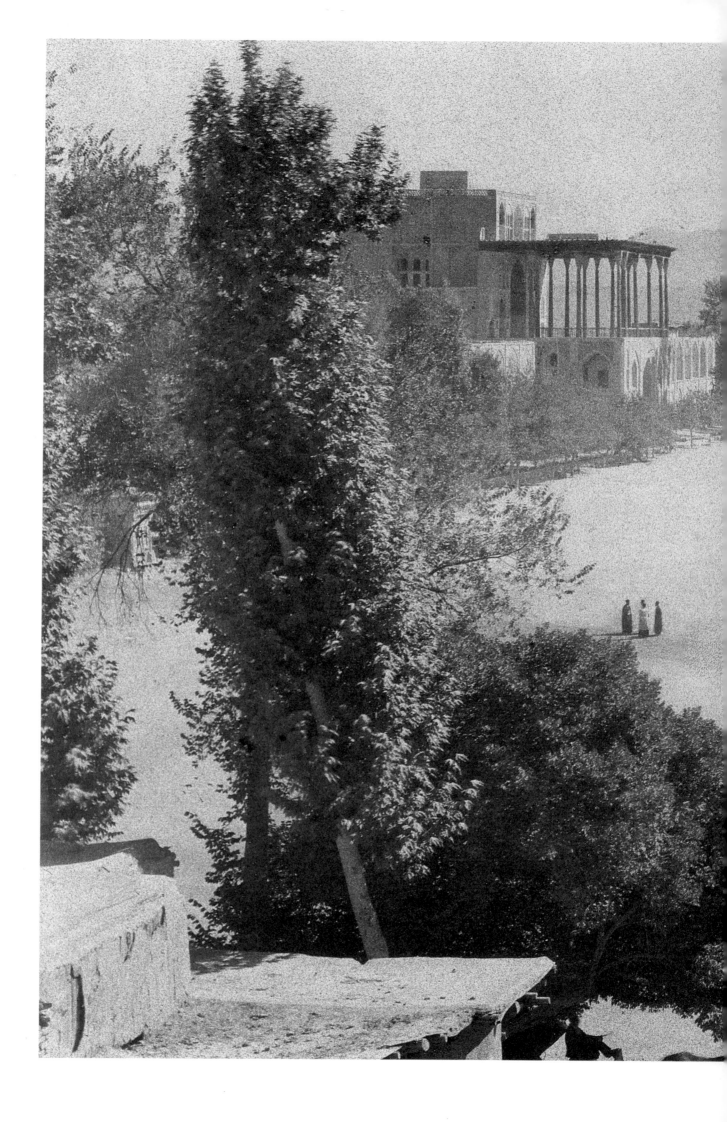

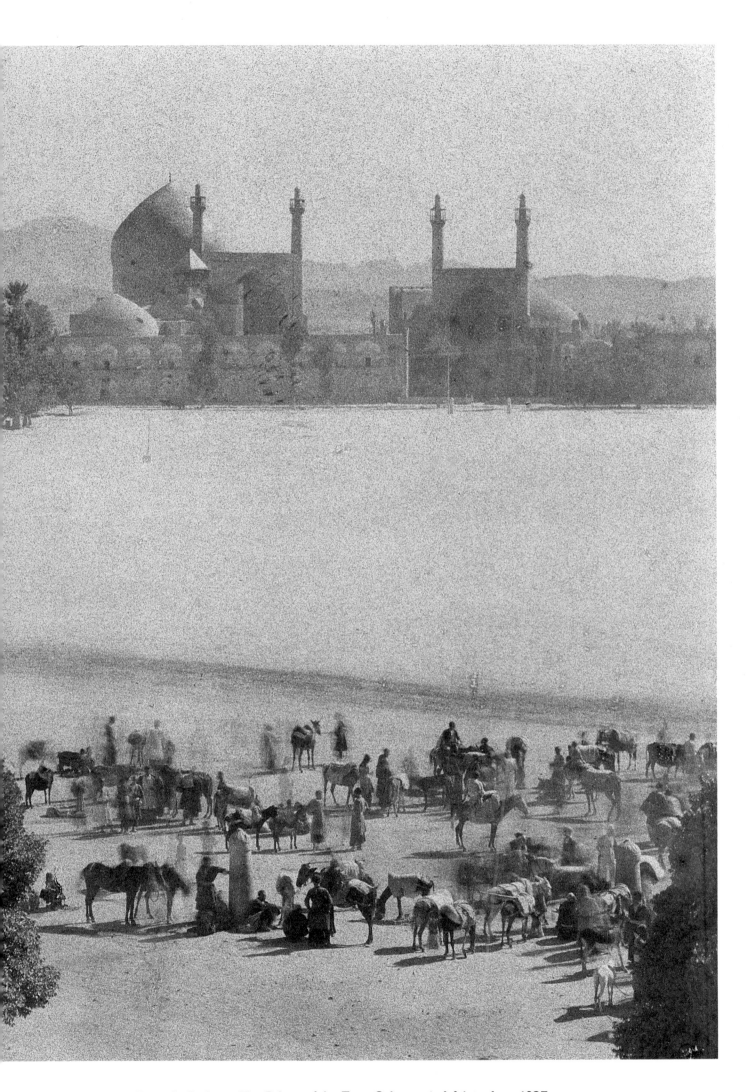

Frédéric Gadmer, The Palace of the Forty Columns in Isfahan, Iran, 1927.
Albert Kahn Collection, Hauts-de-Seine, France.

Auguste Léon, Young Dervish in Bursa, Turkey, 1913.
Albert Kahn Collection, Hauts-de-Seine, France.

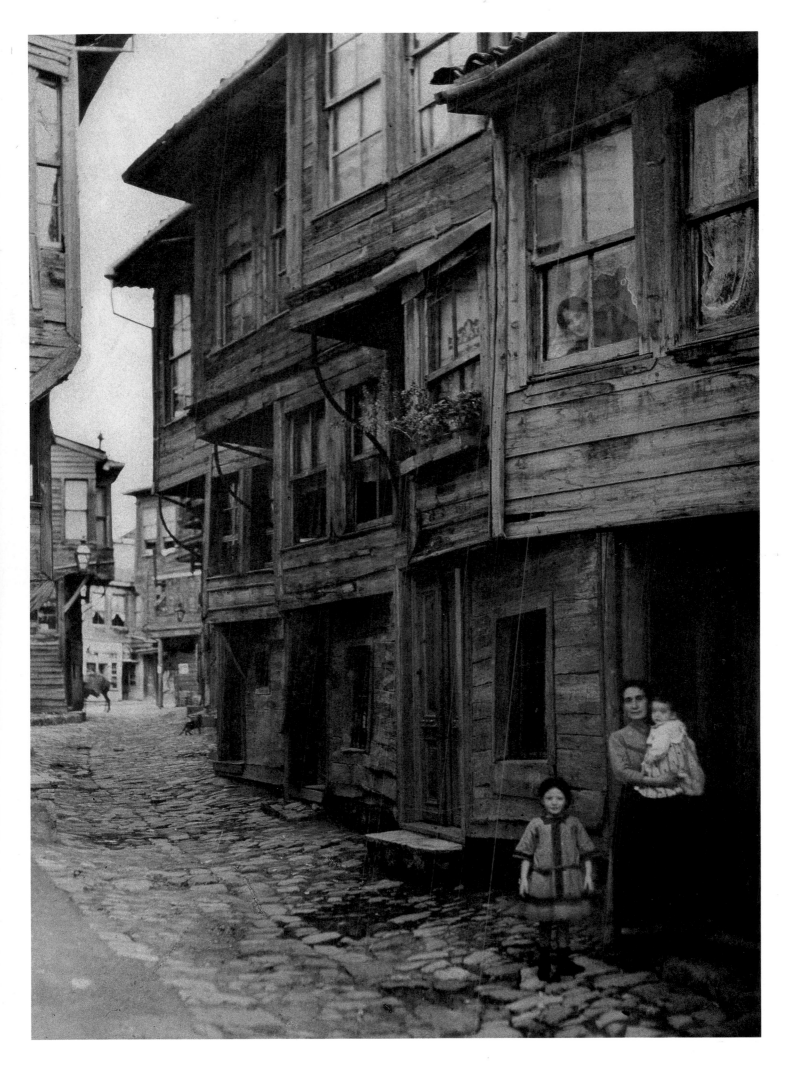

Stéphane Passet, In the Jewish Quarter of Constantinople, 1919.
Albert Kahn Collection, Hauts-de-Seine, France.

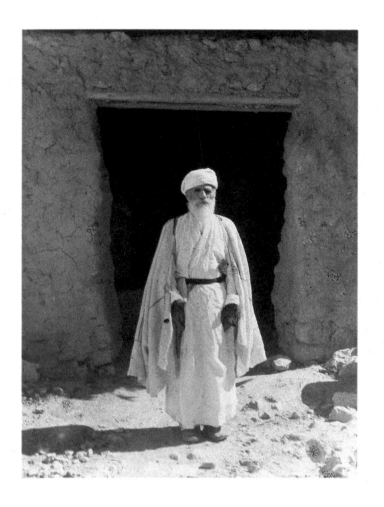

Frédéric Gadmer, Iraqi Bedouin, 1927.
Albert Kahn Collection, Hauts-de-Seine, France.

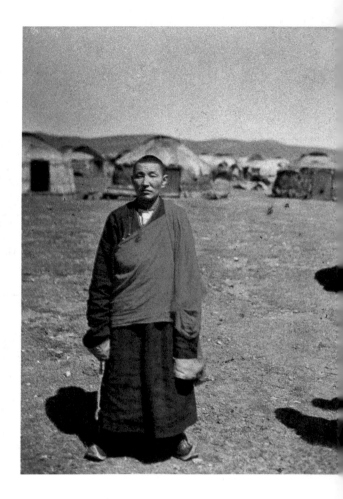

Stéphane Passet, Shepherd in Mongolia, 1913.
Albert Kahn Collection, Hauts-de-Seine, France.

Kahn asked his photographers not to admire a
landscape but rather to analyze it. The same intention
applied to the people they photographed. Jean Brunhes,
the geographer in charge of Kahn's "operators,"
planned their routes and told them exactly what to do.
Their pictures were meant to foster ethnological
progress, not curiosity.

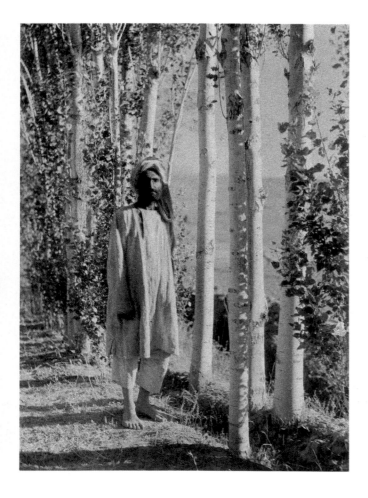

Frédéric Gadmer, Afghan Peasant, 1928.
Albert Kahn Collection, Hauts-de-Seine, France.

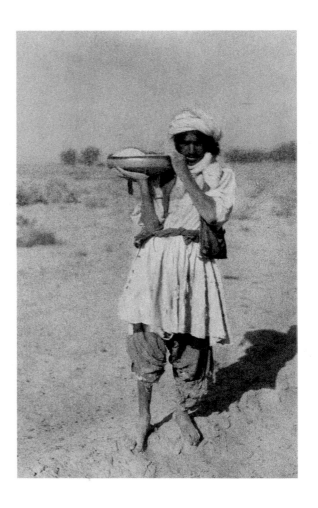

Frédéric Gadmer, Afghan Shepherd, 1938.
Albert Kahn Collection, Hauts-de-Seine, France.

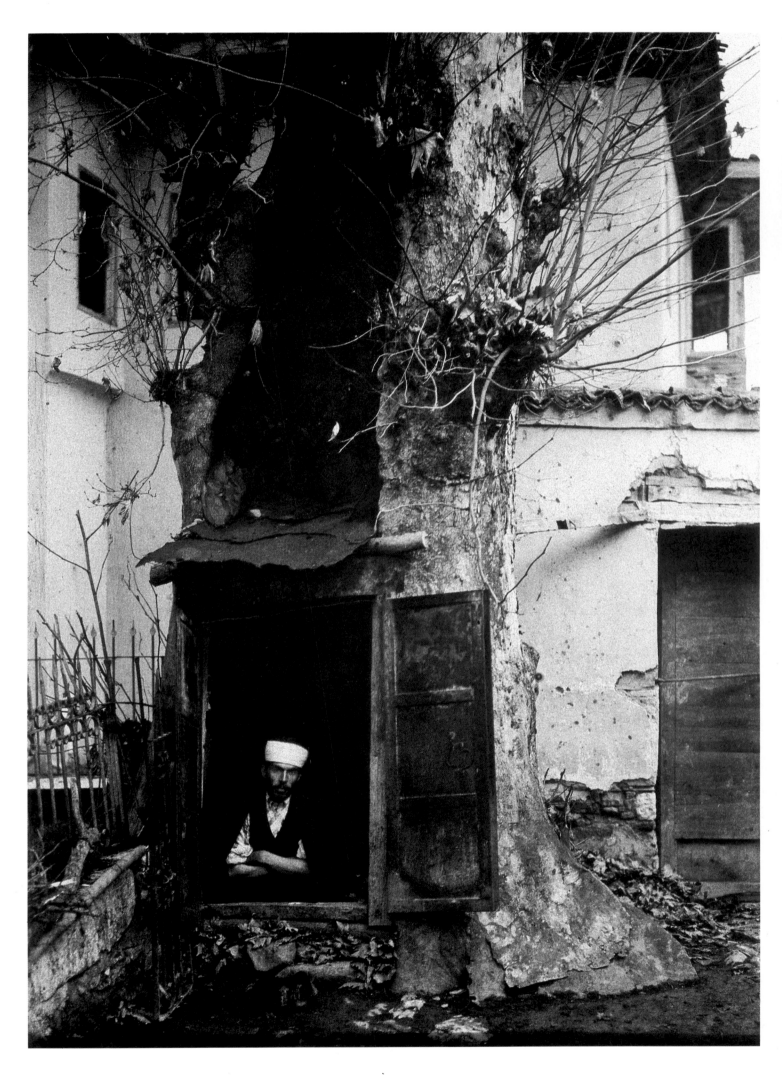

Frédéric Gadmer, Tree House, Turkey, 1923.
Albert Kahn Collection, Hauts-de-Seine, France.

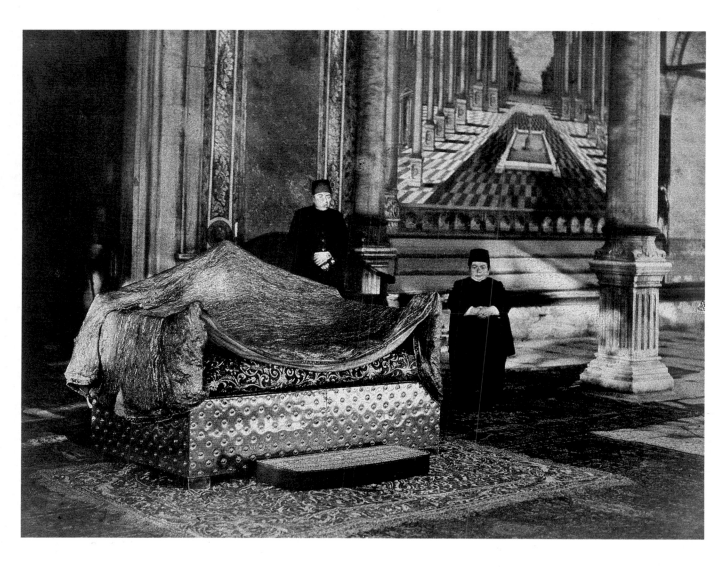

Frédéric Gadmer, Audience Hall of the Sultan in Constantinople, 1922.
Albert Kahn Collection, Hauts-de-Seine, France.

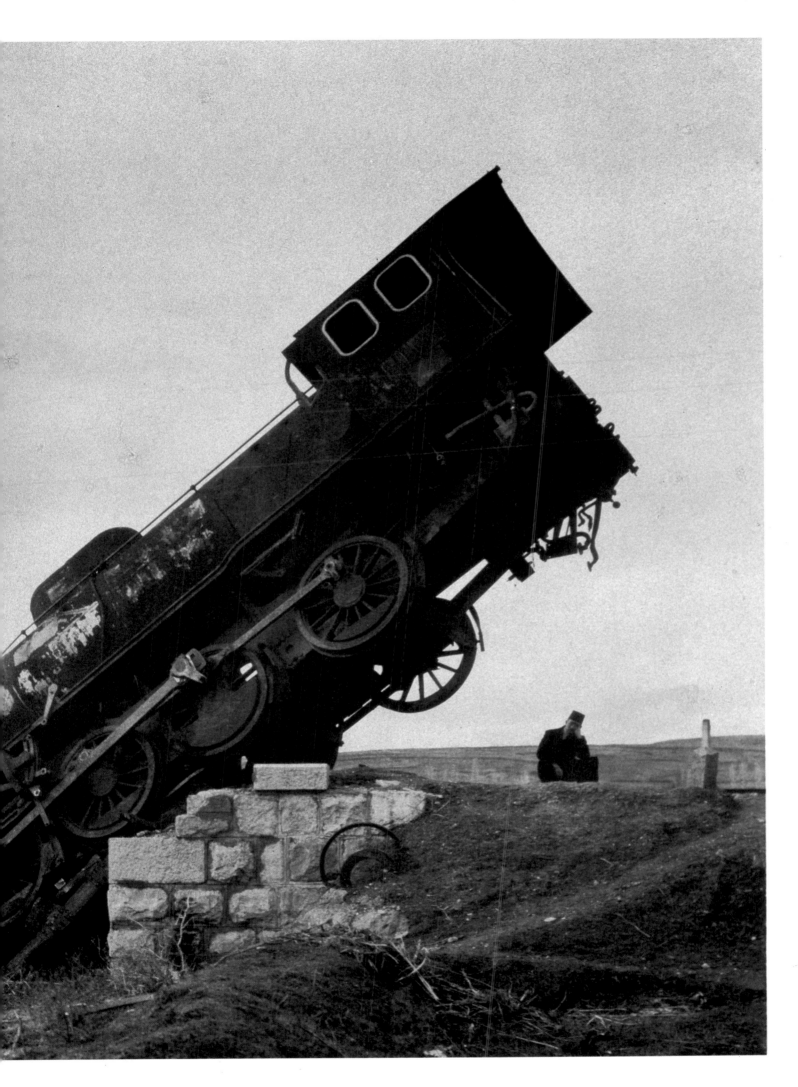

Frédéric Gadmer, Derailed Train in Turkey, 1923.
Albert Kahn Collection, Hauts-de-Seine, France.

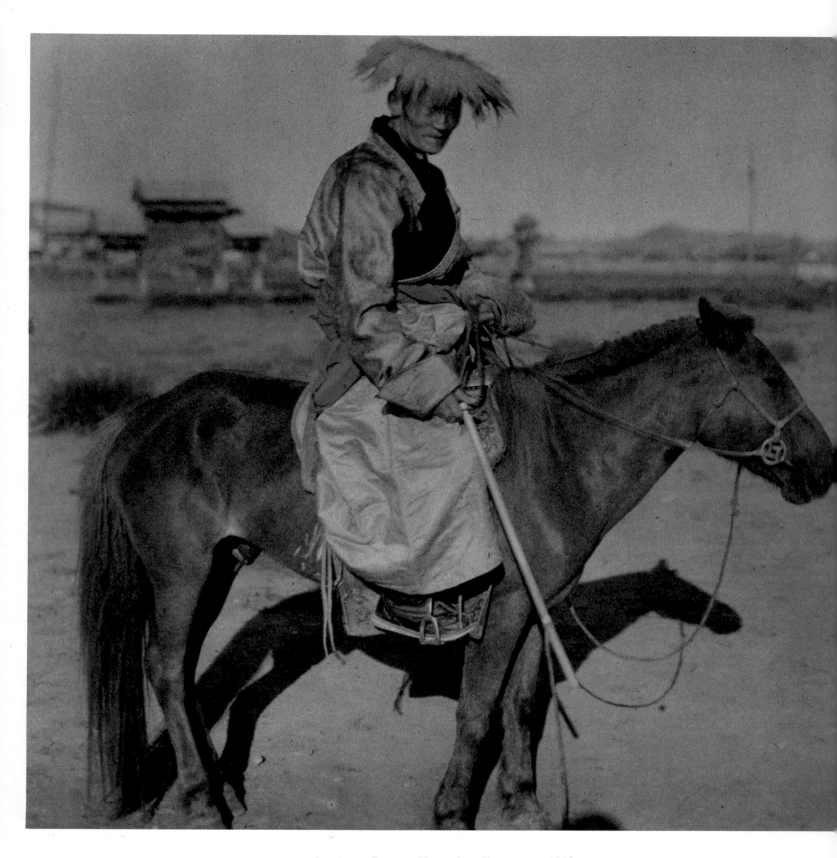

Stéphane Passet, Mongolian Horseman, 1913.
Albert Kahn Collection, Hauts-de-Seine, France.

Autochromes, once enlarged many times their original size, resemble Impressionist paintings. This occurs by virtue of the autochrome process, which involved an overall screenlike filter composed of tiny grains of potato starch, each dyed orange, green, or violet and each capable of transmitting light rays of its particular hue. Together they produced not only a picture in natural color but one textured by the starch particles to resemble a painting done in the pointillist manner. The advent of color photography required that black-and-white photographers rethink their approach, since the filtering grains made longer exposures necessary. Then, too, they had to seek a certain harmony among the colors in their subjects, which posed problems in the Middle East, where the brilliant costumes of the natives stood in contrast to the pastels of their settings.

Because of the long exposures they required, dark subjects or evening landscapes presented considerable technical difficulties in early color photography, which explains why most autochromes were almost always taken during the day. This sunset in the Mongolian steppes, with all its stark simplicity, must be considered a technical feat.

Stéphane Passet, Sunset in Mongolia, 1913.
Albert Kahn Collection, Hauts-de-Seine, France.

The World in Color
Record It While It Lasts

Paris, 1871. In the aftermath of the Franco-Prussian War, the revolutionary, if short-lived, days of the Commune were over, the Communards checked by government troops and an armistice with Prussia declared. A witness describing the scene compared the resumption of normal life to a phoenix rising from the ashes. While the wounded convalesced and judges debated the fate of insurgents, cafés slowly filled again with absinthe drinkers and domino players, promenaders returned to the boulevards, and new posters appeared on billboards.

Jules Verne was among the many enjoying an early summer day. Fascinated by what he saw in Thomas Cook and Co.'s window, he decided on the spot to go around the world in record time. Verne had been born in Nantes in 1828. As a boy he began dreaming of faraway places, an affliction he shared with many provincials. In springtime he tended to sit on the banks of the Loire gazing at sailboats, and in summer he hung around the sailors at Chantenay. At the age of eleven Verne stowed away on a three-masted schooner, but never reached its destination. The first stop happened to have been at a French port, where his father waited to take him home.

For all the thought he had given his long-projected trip around the world, Verne lacked the money for even a small portion of the journey. Thus, with the help of prospectuses from Cook's, he simply traveled in his head. On the assumption that boat and train schedules were reliable, he concluded that it was possible to circumnavigate the globe in eighty days. The hero to achieve this feat on an imaginary trip was christened Phileas Fogg.

Jules Verne (1828–1905).

Title page to the first edition of *Autour du monde dans quatre-vingts jours,* Paris, 1874.

Fogg timed his daily rituals to the minute. Robot-like, he got up every morning at the same time, sat down to breakfast at the same time, walked to his club in the same number of steps, read the same newspaper, and played whist with the same partners. Of the various alternatives to such a life, he chose not flight into adventure, but travel with a stopwatch, somewhat like 20th-century man on a package tour.

Whether in Bombay or Hong Kong, New York or Yokohama, Phileas Fogg interested himself in nothing but schedules. He heard only the ticking of the station clocks, listened only to the station master's announcements, and made sure his passport was stamped, proving that he had been there. Once arrived at the International Hotel in San Francisco, Fogg felt as if he had never left home, since the menu offered oyster stew and Chester cheese with biscuits.

Fogg's servant, Passepartout, suited his master well, recalling, in a way, Don Quixote's Sancho Panza. From his experience of India, for instance, Passepartout mainly remembered mosques, minarets, temples, fakirs, pagodas, tigers, serpents, and Hindu dancing girls. When it was explained to him in China that the mandarins' robes were yellow because this was the Emperor's color, he thought it funny without quite knowing why. Passepartout did know, however, that the Mormons in America practiced polygamy.

When the first installments of *Autour du monde en quatre-vingts jours* appeared in *Le Temps* in 1872 to instant acclaim, the paper's circulation tripled and the editors received stacks of letters inquiring after Phileas. Translated into thirty languages, the book appeared in installments in hundreds of newspapers. In 1874 it began running as a play, with the first of four thousand performances given at the Porte St. Martin. The success of Verne's imaginative flight inspired Thomas Cook and Co. to offer a similar trip around the world—in ninety days, however.

Like every era, the *Belle Époque* created its own legends. Some of them served as prototypes of upward

A camera for the tourist: France's "Pascal," 1900.

mobility, like the man who began as a dishwasher and ended up a millionaire, thereby giving ordinary human beings something to dream about. For the scientifically minded, there was the lonely but brilliant inventor of machines destined to change the world. A colonial age, it produced the globetrotter who traveled around the earth not in any sovereign's service, but for his own amusement, and, on his return, reported just where the service had been good and where inferior.

Usually it was good. Wherever the white man went, coolies, pages, waiters, porters, Pullman attendants, maids, *concièrges*, taxi drivers, ticket sellers, deck stewards, shoe-shine boys, captains, and couriers catered to his every need. It is unlikely that he encountered true hospitality anywhere, but as along as he received the service for which he paid, the European world traveler seemed content.

Towards the end of the last century the world grew progressively smaller as new means of transport gave travelers access to the most faraway and exotic places. John Thomson's China, Francis Frith's Egypt, and Samuel Bourne's India ceased to be fairytale outposts of civilization and became stops on the world tour undertaken by increasing numbers of people. In 1871 the Swiss built the first cog railway up the Rigi above Lake Lucerne; in 1885 the Benz car, with three wheels and belt drive, rattled through the streets of Berlin; and at the end of the century Thomas Cook's great dream of "railways for the masses" had come true.

Within a span of sixty years railroad tracks in the United States grew from 30 to 200,000 miles. When the first railway line went into service between Orléans and Rouen, the German poet Heinrich Heine, a long-time resident of Paris, thought that a new chapter in world history had begun. To Heine, it seemed as if mountains and forests were converging on Paris, as if he should soon be able to smell the blossoms of German linden trees. He could almost feel the waves of the North Sea lapping at his doorstep. But the machine was to disappoint the poet. A century later the North Sea is full of oil

spills, and were he in Paris today, Heine would be choking on exhaust fumes.

Two men—Thomas Cook and Karl Baedeker—provided everything a traveler needed at the turn of the century. While the one invented the package tour and the coupon, the other published guidebooks luring the traveler to places where he would meet others of his kind. Cook and Baedeker made sure that their customers saw historic and interesting sites, and only those. They even suggested that travelers have their pictures taken in St. Mark's Square among the pigeons—a practice popular to this day.

Cook organized all kinds of excursion, and every one of them was for pleasure, even if taking the waters at a spa, or making pilgrimages to churches and historic battlefields, happened also to be good for one's physical or spiritual health. Cook's great moment came, however, when he took charge of Queen Victoria's unofficial visits to the South of France, arranged Ulysses S. Grant's European tour, and planned as well as directed the German Emperor's pilgrimage to the Holy Land.

Where Maxime Du Camp and Francis Frith had earlier set up their darkroom tents, Cook built roads. One ran from Jaffa to Jerusalem and another from Haifa to Nazareth. In a way, Cook spread a carpet before the German Emperor and his retinue of a hundred and twenty. Thus, instead of hailing Wilhelm II, the multitude cheered Frank Cook, Thomas' grandson, who rode at the head of the procession and was heard to comment, with an understandable touch of smugness, that the Crusaders would have fared better had Cook's taken them in hand. The machines making travel easier were now joined by a machine that made seeing easier. Whereas Francis Frith had practiced a craft, the turn-of-the-century tourist operated a mechanical device. In 1888 George Eastman had invented a camera using a roll of film, and had coined a sure-fire slogan to launch it: "You press the button, we do the rest." In his advertisements Eastman said that his machine was so easy to handle that anyone would

Advertisement for George Eastman's roll-film camera.

The box camera and its roll of film.

achieve perfect results merely by mastering four easy procedures: focusing, pressing the button, turning the key, and pulling the string. When a hundred pictures had been taken, the camera and ten dollars were sent to Kodak in Rochester and returned two weeks later with prints and a fresh roll of film. During the first year, Eastman sold thirteen thousand cameras. Twelve years later, there were four million amateur photographers in England alone. Once the camera had become a plaything for the masses, people began to visit and snap instead of observing and absorbing what was before them. Soon, thousands of Eastman's customers were making trips to the Yosemite Valley to take thousands of photographs from Watkins Point, the view made famous by Carleton Watkins. The critic Walter Benjamin has said that this was when the world began to be reduced to a postcard.

Twenty years after Jules Verne had sent Phileas Fogg off on his sensational journey, hordes of European tourists were following in his footsteps. Sons of rich parents and writers looking for material, widows with fortunes to spend and titled folk whose estates were run by managers took to spending much of the year abroad. They could be found in hotels on

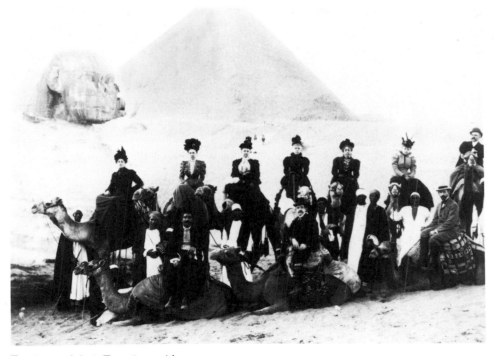

Tourists and their Egyptian guides posing before the Sphinx.

the shores of Lac Léman, boarding ships at Marseilles, crossing the Red Sea to India, and reaching Tokyo by way of San Francisco.

The Middle East proved especially popular. There, far from the cold, damp winters of northern Europe, the expatriates sat under palm trees in dry, sunny Aswan, inspected Baalbek in the spring, and even spent the summer in Jerusalem, which offered a cooler clime. Francis Frith had taken months to reach Aswan. Now, the trip required only twenty days, spent aboard a luxurious and generously provisioned boat chartered in Cairo.

Among the provisions brought along by the travelers themselves were photographs, chosen like pine nuts in the souk prior to embarkation. Baedeker recommended a shop called Hyman and Co., which sold photographs by a favorite local photographer, Sébah. At Cairo tourists could have seen the works of Antonio Beato, proudly displayed in Shepheard's Hotel. To satisfy demand, the French photographer Bonfils increased production by setting his wife and son to work. They turned out fifteen thousand albumen prints and nine thousand stereocards of the Holy Land alone.

To prepare for Egypt, the educated traveler always wanted to peruse the photographs of Maxime Du Camp and Francis Frith. Thus, he knew the sights from every angle before leaving home, and he would soon have similar access to the "tourist attractions" of most other countries as well. But the 19th century's traveling photographers did not simply record sights; rather, they sought to capture the essence of landscape or see landscape as monument. Misinterpreting these aims, the early tourist traveled through America looking for postcard scenes, visiting Niagara Falls but not the country. In Peking he made directly for the Great Wall without ever wandering through the streets to absorb the atmosphere. As long as he could sit comfortably in one of Taormina's better hotels, the mountains of Sicily held no appeal for him, once he had seen their hidden treasures, the glorious Greek temples. He made sure he posed before the Sphinx but

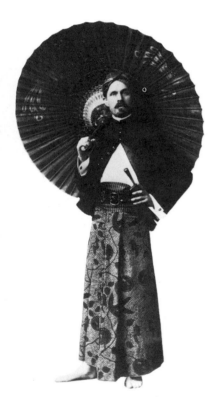

Burton Holmes (1870–1958).

ignored the Biblical scenes along the Nile. Travel was becoming a sightseeing tour, its memories mere souvenirs.

A number of the great tourists, such as Joseph Conrad, Blaise Cendrars, and Somerset Maugham, wrote books about their travels, while others kept diaries for posterity or their own amusement. One of the most famous of them—Burton Holmes—recorded his globetrotting in photographs. Holmes had awakened to the wonders of the earth when his grandmother took him at the age of nine to a lecture by John L. Stoddard about the Passion Play at Oberammergau, an experience that Holmes insisted had changed his life. A few years later he went with his grandmother on a grand tour of Europe, the proper thing to do for a rich young man from Chicago. In 1892 Holmes spent five months traveling in Japan, and by the time he returned home his avocation had become a profession.

For his first lecture about Japan, Holmes sent two thousand invitations on Japanese paper to people whose names he had selected from both his parents' address book and the Blue Book. When the time came, the lecture hall was full, and the budding authority earned $700.

Subsequently, Holmes once again saw the man who had sparked his interest in travel, this time in the lobby of a Munich hotel, reading a Baedeker. But only when by chance they had adjacent seats at the Passion Play did Holmes muster the courage to introduce himself. As a result, Stoddard and Holmes became partners.

Stoddard was the sort who, when in Scotland, predictably photographed the famous hexagonal basalt columns of Fingal's Cave in the Inner Hebrides, just as he made a beeline for the Garden of Gethsemane in the Holy Land, the onion domes of the Moscow Kremlin, and the Alhambra in Spain. Paris meant the Place de la Concorde, where so much blood had been spilled that he felt all the water in the world could not wash it away.

Stoddard was a sentimental man. Thus, he photographed only what had nothing to do with present

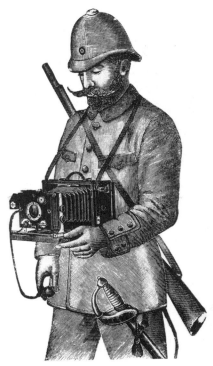

By the end of the 19th century, the "wet process" had been superseded by handy travel cameras.

reality, and remained forever on the alert for perfect, unspoiled sites, or landscapes unsullied by industry. He also refused, in his photographs at least, to acknowledge the effect of his own culture on those of other countries, deliberately eschewing all evidence of industrialization.

Such nostalgic refusal to face disturbing facts has remained the tourist's attitude to this day. Travelers along the highways of North America photograph prairie solitude, not the billboards with their inane messages. In Cairo they ignore the cacophonous traffic jams and train their cameras on the contrived exoticism of the souks. The rice planters of India must be seen carrying their harvest in baskets, since plastic buckets evoke no romantic feelings!

Holmes copied his idol's manner religiously. His lectures exuded the presumed sophistication of the world traveler, as he amused his audience with stories about frivolous Paris, the canals of Venice, adventures in Mexico. He wrote books awash in clichés, shamelessly reiterating that no one could resist the charm of Paris or fail to be impressed by London. His slides, tinted by hand in Japan, offered up the world as a cavalcade of colorful scenes.

Whenever Holmes appeared it was a society event. His audience knew that he was one of them, that he traveled first class, met his peers on the Orient Express, lodged only in the best hotels, and crossed the Atlantic aboard the fastest and most luxurious ships. His public also knew that he liked to travel in charming or important company. In Austria this was provided by Maria Jeritza, the opera singer, in Ethiopia by the Duke of Gloucester, and in Hollywood by Mary Pickford.

Like racing-car drivers and zeppelin pilots, globetrotters on the order of Stoddard and Holmes became cult figures in an era intoxicated by speed and fascinated by the shrinking universe. As in a Maugham novel about British colonials, they lived well because it was expected of them. In a Manhattan apartment called "Nirvana," Holmes tended his palm trees and played with his Persian cats. At the end, he was determined even to depart this life in style, setting down in

his will that his ashes should be placed in a favorite Siamese urn.

Holmes did his best to surpass Phileas Fogg. He traveled around the world 6 times, crossed the Atlantic 30 times and the Pacific 20 times. He spent 55 summers abroad and gave 8,000 lectures during 53 winter seasons, earning $5 million. He drove the first car in Denmark, brought the first movie camera to Japan, and boarded the Trans-Siberian Railway on its maiden journey. Between 1890 and his death Burton Holmes missed not a single production of the Passion Play at Oberammergau.

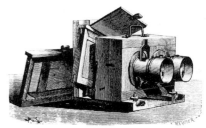

Stereoscope camera with two lenses.

Holmes spoke eight languages. When *Who's Who* listed him as having been everywhere except South Africa, he hastened to remedy the situation. Arriving in Capetown in 1937, he went straight to the post office and sent a cable to the publication's editor. The Holmes career proved to be the longest of its kind, surviving competition from vaudeville, cabaret, radio, television, and even movies. A year after the end of World War II Holmes had returned to business, advertising a slide lecture entitled "Beautiful Bali," which, given the times, did very well.

It was photography itself, however, that had the most brilliant career in the era of the great globetrotters. Between 1860 and 1900 photography became a mass medium, changing the world's perception of itself as irrevocably as

Stereoscope picture of the Tower of David in Jerusalem.
Viewed through a stereoscope,
the two pictures merge to produce a three-dimensional effect.

television would in our own time. Photography opened a window that could never again be closed. And it became ever wider in a flood of stereographs, paired images made with a twin-lens camera that seem uncannily three-dimensional when viewed through a stereograph. From the 1860s onward no Victorian household could be without its set of stereocards. In 1865 the London Stereoscopic Company sold half a million pictures by convincing its customers that every home required its stereoscope. Brochures touted the apparatus as capable of introducing glaciers and rivers, great monuments and exotic cities right into people's houses, thereby providing invaluable entertainment for young and old alike. Stereographs brought upper-class women everywhere the latest models of *haute couture,* and for men they provided the female "academies" then thought essential to stag parties. Once lined up in pubs like pinball machines, stereoscopes generated, among other things, an epidemic of wanderlust, which only a few could satisfy. Stereographs offered escape from the boredom of everyday life into a dreamworld, however unattainable. One of the pictures illustrates the point. It shows an overstuffed Victorian parlor, crammed with bric-à-brac, palms, and mirrors. While two young women embroider sofa cushions, their father presses his face to the stereoscope. He has escaped into another, more exotic world without ever leaving the room.

Another way of making the world more accessible was to put bits of it on postcards. This time-saving invention had been introduced by the Austrian post office in 1869, thanks to a postmaster general who was too lazy to write letters and who found much of his own mail too long-winded to finish reading. In his opinion, a small card without an envelope should be sufficient for business and personal messages alike. Little did he realize that with his help letter writing would become a lost art.

Picture postcards achieved popularity first in Germany, and for a while German postcards even flooded the British market. A typical postcard sender of the time was B. Philip,

who wrote to his wife: "This is a most awful torturing death. Kind regards." The opposite side of the card showed a Chinese criminal in a death cage.

Despite worry that postmen and servants might read the mail, the time of the postcard and the picture postcard had come, and nothing could arrest their development. "Beautiful spots," sights of every description, views of monuments, picturesque corners, strange landscapes, pictures of people in unfamiliar dress were sent off by the thousands. The postcard's greatest triumph came in 1889 at the Paris World's Fair, where tourists could mail a sweeping panoramic view of the city taken from the highest platform of the Eiffel Tower. And what better way to prove to friends and relations at home that one had really been there?

Traveling had become a status symbol and buying postcards a social duty. In 1900 a traveler reported in a magazine that he had joined a group to climb the Rigi in Switzerland. Upon reaching the top, he saw to his utter amazement that his fellow mountaineers immediately stormed the hotel counter where postcards were sold! Five minutes later they were all scribbling furiously. The traveler gained the distinct impression that his companions had climbed the mountain not so much for pleasure as for proof that they had done it.

Like posters for cosmetics and other consumer goods, postcards were perfect advertisements for the various spots considered tourist attractions. Around the turn of the century the image of every palace, castle, fortress, town hall, monument, canyon, spa, and pilgrim church could be had on a postcard. In 1910 France alone printed 123 million postcards, and the world's mails processed about 7 billion.

For the postcard publisher, photographs constitued raw material subject to improvement. By adding fluffy clouds to views of Alpine glaciers or Norwegian fjords, he could render them less forbidding, just as Arcadia appeared more clearly expressed once he had intensified the green of trees and the blue of sky.

The reproduction business even attracted Francis Frith and William Henry Jackson, who began by manufacturing stereocards but then went on to issue large editions of postcards. Jackson sold forty thousand of his negatives to a Swiss firm for commercial use; later he became a partner in the Detroit Publishing Company, then the largest postcard manufacturer in the United States. On his pilgrimage to Frith's Reigate factory in 1971, Bill Jay found room after room stacked with crates filled to overflowing with hundreds of thousands of postcards.

From the moment they first appeared, postcards enjoyed the status of collectibles, such as antiques or other rare objects. The card showing a Japanese shrine replaced the lacquer box and a view of the Pyramids the scarab from a Pharaoh's tomb. Some collectors acquired postcards the way Phileas Fogg acquired visa stamps. Henry Miller's collection, for instance, contains views of pilgrimage churches and grottoes, skyscrapers, harbors, medieval castles, and cathedrals, Chinese pagodas, dungeons, rivers, famous tombs, illuminated manuscripts, Hindu gods, Balinese women, and Samurai, waterfalls, caves, and the *Manneken-Pis* In Brussels.

At the turn of the century, when the mania for postcards reached its peak, the world had been photographed to death, and photography, in the words of the critic Walter Benjamin, had lost its "aura." With printing machines in full command of what had once been a craft, photographs were flooding a market that now began to show symptoms of boredom.

Fortunately, the pioneer spirit burst through one more time. This occurred when the Lumière brothers made color photography commercially feasible by simplifying the filtering procedures used in earlier experiments to create a single photographic plate—an autochrome—capable of simultaneously separating and reassembling the light rays of the three primary colors. The technique involved covering a photographic plate with tiny grains of starch, one-third of which had been dyed orange, one-third green, and one-third

The "Picture Automobile," advertising for trips with the camera.

violet, all evenly spread over the entire surface of the plate. After exposure and development, the negative had to be reversed into a positive, which thereupon became a positive transparency whose myriad pinpoints of color recombined in the eye as an image with the full spectrum of hues found in the original subject. When projected, the pictures had a slight texture, caused by the granular filter, that gave them a certain resemblance to Impressionist paintings.

In the autumn of 1908, Albert Kahn, a rich Parisian banker, told his chauffeur to bid his family farewell since the two of them were to go around the world. A week later Kahn and his driver had boarded an ocean liner, installed with a considerable amount of luggage that included two autochrome cameras of the "Verascope Richard" brand, a Pathé movie camera, and four thousand plates for stereographs. At this particular moment, such a journey—to Tokyo and Shanghai via San Francisco—might be seen as an unlikely enterprise. But as he watched the industrial age produce more and more machines, among them the first aeroplanes, and the newly affluent middle-class dream of never-ending progress, while also preparing for World War I, Kahn felt certain that it was only a question of time before the world as he knew it would be gone forever. Thus, for the benefit of posterity he took it upon himself to record the landscapes and the ways of life that seemed most threatened with irremediable change or utter destruction.

Indeed nostalgia or even melancholy seems to be vaguely present in all the autochromes made by Kahn and the early photographers. In them water as smooth as silk flows across calm landscapes, no breeze ever rustles the foliage, and smoke rising from a chimney stands still like a column of frozen steam. But such serenity was inevitable, since autochromes required exposures thirty times as long as those for black-and-white film.

Kahn's "operators" traveled like the early photographers, laden with elaborate equipment, including autochrome cameras, of course, but also padded wooden boxes for the

341

glass plates, suitcases packed with everything for a night in the open, arsenic soap to rub on leather straps against termites, kerosene lamps, chemicals, and airtight boxes lined with zinc for exposed plates. And nothing went without its "fragile" stickers printed in different languages.

The only reports surviving from Kahn's expeditions were written by one of the photographers, Stéphane Passet, who corresponded with colleagues about autochrome techniques while also describing what he saw and photographed. For example, when the bodies of the faithful were burned on the banks of the Ganges, Passet wrote how their bones cracked, their skulls burst, and their innards sizzled before the ashes could be sprinkled on the waters of the holy river. He would also seem to have taken great care with his glass plates. In 1912, after photographing hordes of Mongolian horsemen galloping across the steppes, Passet only reluctantly allowed the Trans-Siberian Railway to transport the plates.

Albert Kahn's progress from poor Jewish law student to millionaire and the greatest private benefactor in the history of photography offers a story worth noting. It began in the late 1880s, when Kahn, the son of an impoverished Alsatian dealer in various types of animals, was living in a tiny Paris attic on sixty francs a month, out of which he even paid his tutor. After two years of that existence, young Kahn went to work in the small bank of the brothers Goudchaux, with whom he made the strangest contract the financial world had ever seen. Against a promise of a fifty percent partnership, he would undertake to raise profits from fifty thousand to a million francs. Kahn earned his partnership, and by 1900 he owned the bank, thanks, he explained, to his ability to predict events, such as the unprecedented diamond boom in South Africa. Then, as his shares soared, the great banker discovered he had a special mission, prompting him to start a foundation called *Autour du monde.* It made grants of fifteen thousand francs to selected students who were to travel abroad, for the purpose of meeting their peers in other countries and learning different ways of life. Kahn wanted

nothing in return for his largesse, and when one of the grantees sent him a diary of his travels, Kahn returned it unread.

Like many people with a rags-to-riches background, Kahn was a little peculiar. For instance, he always wore a felt hat, shiny with age, and a shabby alpaca coat, while indulging himself in a stable of luxurious cars, among them a Panhard Levassor, two Mercedes, and a Daimler. He was also a vegetarian with a great appetite for fruit and vegetable juices and raw carrots, but the spices used in his simple dishes were specially imported for him from Madagascar and the Congo. He seems to have considered frugality a proper antidote to an excess of accumulated wealth. Moreover, Kahn prophesied eternal peace, yet helped finance France's war effort. To improve the living conditions of his employees, he offered them free lodging and free medical treatment—the sort of things for which Socialists were then mounting the barricades—but could never bring himself to say "hello" or shake their hands.

Albert Kahn (1860–1940).

Kahn put the geographer Jean Brunhes in charge of his autochrome archive. A methodical man, Brunhes left nothing to chance or to the mood of the photographers. He mapped their routes, calculated their budgets, stipulated the duration of their missions, the number of plates they could count on, and even how they were to photograph. For example, if it was a matter of recording a village, they had first to do an overall picture, then individual streets, and finally the inhabitants. In regard to the latter, Brunhes prescribed that they be photographed from all sides, so that their dress could be easily studied. As insurance against a broken plate, the photographers were to make two exposures. Above all, they must not be captivated by the superficial beauty of a motif, because it was not enough to admire a landscape, one had to analyze it!

The public could see the picture collection in the "Universal Archive" only when, once a year, Brunhes organized an exhibition in one of the large halls at the

Sorbonne. There he gave lectures illustrated by photographs brought back by Stéphane Passet, Georges Chevalier, Roger Dumas, Auguste Léon, and Frédéric Gadmer, depicting street vendors in Serbia, Turkish nomads, newspaper boys among the ruins of Rheims after World War I, rice planters in Indochina, and road workers in Japan.

The historian Marc Ferro has said that Albert Kahn was the first systematically to document the working classes at their jobs. Not only did he collect tens of thousands of autochromes for his archives, but he also clipped countless articles from newspapers and magazines, which he then reprinted in so-called bulletins for distribution among politicians and bankers. Kahn also collected trees from around the world and in his Boulogne garden grew pine and beech trees from the Vosges, cedars from Lebanon, and dogwood from Japan. As complements to them, he imported a Japanese teahouse, bronze incense burners, a Shinto shrine, and a bonsai collection, along with two Japanese gardeners to maintain the miniature trees. The focal point of this private park on the banks of the Seine was a copy of the imperial bridge at Nikkó. But whereas in Old Japan only a chosen few had permission to cross the bridge, Kahn reserved his Boulogne bridge exclusively to himself. The banker's doctor recalled that no one in Boulogne had ever seen the garden or knew what went on behind the cast-iron fence.

Kahn may not have invited the locals, but from time to time he did summon famous people such as the Indian philosopher Rabindranath Tagore and the poet Paul Valéry, the politician Raymond Poincaré and the writer Rudyard Kipling, the Maharajah of Kapurthala and Cardinal Louis Ernest Dubois, Archbishop of Paris. Kahn planned their reception very carefully. Upon arrival, the guests walked in the garden talking and perhaps deciding the fate of the world. Following dinner, as soon as it was dark enough, they were shown the most beautiful autochromes from the archives. But Kahn never appeared at these functions, although the

painstaking nature of the arrangements attested to his involvement. A visitor remembered that when he arrived, all the red flowers in the garden were blooming, and by the time he left late at night the garden had been transformed into a mass of blue.

Like many catastrophes, the end came at night. Black Friday ruined Kahn, along with thousands of others. The government took over the "Universal Archive," without knowing what disposition to make of 72,000 glass plates and 140,000 meters of film. In the wake of world-wide economic crisis, a stack of glass caused little concern. Meanwhile, Kahn went into hiding at Boulogne, like an animal about to die, his doctor thought. The bailiff had left the great man a bed, a chair, a table, and a microscope for diversion. As he got older, Kahn became more and more convinced that he would live forever. Thus, even though ill, Kahn waved the doctor away. He died on November 13, 1940.

Kahn was the last great patron of travel photography. Nowadays people tour like Phileas Fogg and photograph like Burton Holmes. Their traveling assumes the character of work, and they photograph what thousands before them have

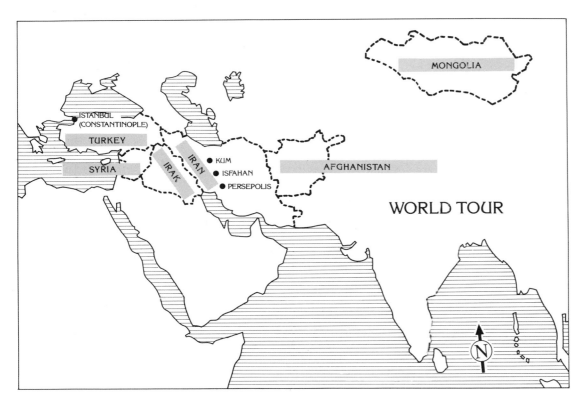

Kahn's operators photographed throughout the world, not just in the Middle East and Mongolia, where the picture reproduced on these pages were made.

already photographed. "This gives shape to experience: stop, take a photograph, and move on," says Susan Sontag in *On Photography.* "The method especially appeals to people handicapped by a ruthless work ethic—Germans, Japanese, and Americans. Using a camera appeases the anxiety which the work-driven feel about not working when they are on vacation and supposed to be having fun. They have something to do that is like a friendly imitation of work: they can take photographs."

In our own time camera-toting tourists have beaten paths into every corner of the globe. Visiting the ancient Inca fortress of Machu Picchu, one treads on Polaroid film packs, and empty roll-film boxes litter the way up Japan's holy mountain, Fujiyama. Even outer space has its garbage, the consequence of a space flight during which an astronaut dropped a camera that now circles the globe like a satellite.

Today, travel photography is organized. At the famous Kodak Color Show in Hawaii, for instance, the master of ceremonies says "now," the girls in their leis freeze for a second, and the visitor snaps his picture, certain of having a perfect souvenir. Members of a safari in Kenya can practically "book" the animals of their choice. Hilton's Salt Lick Lodge provides a so-called "animal call," whereby the telephone operator wakes you when "your" beasts—lions, for instance—appear at the watering hole.

Stacks of "how to" books have been written to help the neophyte photographer find his way. They even tell him how to take his own postcards. The first thing he must do, it seems, is buy postcards, which show the angles from which to capture the famous motif. A manual may go so far as to indicate the best time of day to photograph the Statue of Liberty, the best distance for shooting the Eiffel Tower, what to photograph in Acapulco. Should the neophyte find himself at the Mexican resort, he is advised not to venture from his beach hotel. All he needs to do is put down his drink and, with a wide-angle lens, snap water-skiers and surfers from where he sits.

French sociologists found that honeymoon couples always photograph the same things: the Bridge of Sighs in Venice, the *Manneken-Pis* in Brussels, the *Little Mermaid* in Copenhagen. The best proof of their thesis was a newly married shoemaker from Lyons who took his bride to Paris in August 1979. On this most private trip of his life the man photographed Versailles ten times, the Eiffel Tower eight, the Tuileries six, and Notre-Dame, the Champs-Élysées, and the Arc de Triomphe twice each.

The wide, open spaces of the American West, made known by the hazardous photographic expeditions of Watkins, Muybridge, and Jackson, have today become a sort of tranquilizer for big-city dwellers. Urbanites can even take this nature pill without ever leaving their concrete bunkers. No longer does the slogan "escape" invite participation in exotic and perhaps dangerous adventures but rather advertises picture books in Time-Life's Wilderness Library. There, the reader has only to turn the page in order to be borne away on a fantasy of distant canyons, majestic rivers, imposing peaks, solitary deserts, and paradisaical forests.

Admittedly, of course, those now eager to undertake journeys of discovery must do it through their own minds, since no wilderness or virgin territory remains to be discovered. But some intellects are as vast as a continent, as undiscovered as the Old West once was, as full of surprises as the classic East. There is a whole new generation whose members have grown up aware that the only trip available to them, or worth making, leads into their own heads.

Biographies

Felice Beato

Much remains to be learned about the extraordinary career of the photographer known as Felice Beato, who was reportedly born in Venice but later became a British citizen. The year 1854 found him in Malta working with James Robertson, the chief engraver for the royal mint in Constantinople. Together Beato and Robertson covered the Crimean War, shooting scenes not only there but also in Constantinople, Athens, Egypt, and the Holy Land. By 1857 Beato had reached India, in time to focus his camera on the Indian Mutiny. Three years later he was in China, where he caught the second Opium War. Beato then moved to Japan in 1864 and formed a partnership with Charles Wirgman, a war artist from the *Illustrated London News*. Despite the murderous reaction of the Samurai, Beato succeeded in making an extensive photographic record of Japan's centuries-old feudal society just before it would be submerged by Western-style industrialization. In the process, Beato himself responded to Japanese traditions and added hand-coloring to his photographs, a practice then utterly alien to European taste. Beato's life dates have yet to be firmly established.

Samuel Bourne (1834–1912)

The son of a Staffordshire landowner, Samuel Bourne took up photography in 1858, even before he began working as a Nottingham bank teller in 1860. Two years later Bourne journeyed to India, where he became the partner of Charles Shepherd, whose photographic studio, located in Simla, was the oldest on the Subcontinent. Bourne spent ten years in India (1862–72), during which period he carried his camera into almost every province. His three Himalayan expeditions alone assured him a place in the history of photography. In the course of the final expedition, made in 1866, he became the first photographer to reach the source of the Ganges and the Manirung Pass (elevation 18,000 feet). Having accomplished these objectives, Bourne went home to England in 1867 and married. He then returned to India with his family, remaining there until 1872, when he took up permanent residence in England. Now he made a successful entrée into textile manufacturing, which, however, did not prevent his accepting the presidency of the Nottingham Camera Club. In 1912 Saumuel Bourne died in Nottingham at the age of seventy-eight.

Maxime Du Camp (1822–94)

A writer with access to private wealth, Du Camp thought it would be diverting for himself and a friend to make a trip to the Middle East, at a time when many fantasized about such an experience but few attempted to transform it into reality. After studying the calotype process with Gustave Le Grey, Du Camp persuaded the French Ministry of Education to dispatch him on a survey of archaeological sites, with the writer Gustave Flaubert going along for the fun of it. The journey lasted almost two years, during which time Du Camp produced 220 calotypes, 125 of which Louis-Désiré Blanquart-Evrard published as *Egypte, Nubie, Palestine et Syrie*, the first book about the region to be illustrated with actual photographs, all of them albumen prints tipped in by hand. Thereafter, Du Camp worked only as a writer.

Marc Ferrez (1843–1923)

Brazilian-born Marc Ferrez grew up in Paris after both his parents died in 1851 and left their seven-year-old son in the care of the sculptor Alphée Dubois. Upon his return to Rio around 1859, Ferrez entered into an apprenticeship under George Leuzinger, a lithographer whose son-in-law, the Mannheim engineer and botanist Franz Keller, taught Ferrez the principles of photography. At the age of twenty-one Ferrez opened his own studio, whence he set forth to photograph the landscapes and sights of 19th-century Brazil. Meanwhile, he also worked as official photographer to the Brazilian Navy. In 1876 he joined the American geologist Charles Frederick Hartt on an expedition sponsored by the Brazilian Geological Commission. This took him to Bahia Province and into Brazil's northern jungles, where he took the first pictures ever made of the Botokudo Indians. Ferrez also experimented with microphotography and photographed a solar eclipse. His pictures won many national and international prizes. Brazil's Emperor Dom Pedro II, himself a passionate photographer, made Ferrez a Knight of the Order of the Rose. In 1895 the photographer obtained the

Brazilian rights to the Lumière cinematographic projection system, and in 1907 he opened the Pathé Cinema in Rio.

Francis Frith (1822–98)

Francis Frith came from a Quaker family in Chesterfield. After an apprenticeship under a cutler, he went to work for a wholesale greengrocer in Liverpool. His interest in photography developed around 1850, when he took employment with a printer. In 1856 Frith left England and made the first of three extended trips to Egypt and Palestine. Three years later he ventured up the Nile beyond the Fifth Cataract, some 1,500 miles south of Cairo and well beyond where any photographer had gone before. His book, *Egypt and Palestine Photographed and Described*, published in a 2,000-copy edition that involved hand-tipping 140,000 albumen prints, was the most expensive publication of its time. In 1860 Frith established Frith and Co. in Reigate, England, a firm that became 19th-century Europe's largest manufacturer of photographic images. At one time Frith's warehouse at Reigate maintained a stock of a million photographs, stereocards, and postcards representing subjects and sites from all over Europe.

William Henry Jackson (1843–1942)

A native of Keesville, N.Y., the twenty-two-year-old Jackson took off for the "Wild West" in 1866 and became a cattle drover. The following year he and his brother opened a portrait photography studio in Omaha, Nebraska. Between 1870 and 1877 Jackson made eight trips into the American frontier as the official photographer for the U.S. Geological and Geographical Survey of the Territories, which made him the first photographer to enter the Yellowstone region and the first to make a picture of the Mount of the Holy Cross in the Colorado Rockies. His photographs did much to help persuade the U.S. Congress to pass legislation making Yellowstone a national park. In 1879 he established the Jackson Photographic Co. in Denver, specializing in pictures commissioned by railway companies eager to entice tourists aboard their trains. The year 1894 found him on a world tour, from Australia through Japan and Russia to Europe. Four years later he became a partner in the Detroit Publishing Co., which proceeded to flood the world with Jackson's pictures. As an old man, Jackson received a commission from the U.S. Park Service to print scenes of the Old West from memory.

Eadweard Muybridge (1830–1904)

Born Edward James Muggeridge at Kingston-on-Thames, Muybridge left England and moved to America about 1852, drawn there by the California Gold Rush. By 1856 he had become the proprietor of a bookstore in San Francisco, whence he launched a photography career that would bring distinction in both landscapes and motion studies. His first fame came in 1872 with the colossal plates he made of the Yosemite Valley, works favorably compared to the renowned 1861–66 series made by Carleton Watkins. In 1872 Leland Stanford commissioned Muybridge to photograph his racehorse Occident as it moved past a series of cameras each wired to expose its plate as the animal came into view, the purpose of the experiment being to prove that a trotting horse had all four feet off the ground at some point in its stride. The success of the venture led to a long series of experiments in recording human, as well as animal, motion carried out at the University of Pennsylvania. To make the sequences of stills produce the illusion of motion, Muybridge devised his zoopraxiscope (1879), a machine that projected the image sequences in a way that anticipated the motion-picture film projector. At the end of his life Muybridge returned to England, where he died at Kingston in 1904.

John Thomson (1837–1921)

Little is known about the early life of the Scotsman John Thomson, except that he was born in Edinburgh in 1837. Studies in chemistry at the University of Edinburgh may have led him to photography. In 1862 Thomson made his first foray into Asia, where he visited Malaya and Indochina. For reasons of health he returned to England briefly in 1866, during which time he became a member of the famed Royal Geographic Society. The year 1867 saw the publication of Thomson's first volume of albumen prints: *The Antiquities of Cambodia*. The following year, the photographer went all the way to China, where, in Hong Kong, he married. Between 1868 and 1872 he traveled some 5,000 miles throughout imperial China, from the northern coastal cities of Amoy and Fuchow through the inland regions, up the Yangtze to Szechuan Province, and finally to Peking. Thomson returned to England in 1872 and there published his *Illustrations of China and Its People* (1873–74). In *Street Life in London* (1877–78) he offered the first book of photographs made specially to document social problems. Ironically, at the

end of his career he worked as a portrait photographer in fashionable, aristocratic Mayfair. Twenty-six years after his return from China, Thomson published a book of reminiscences entitled *Through China with a Camera.*

Carleton E. Watkins (1829–1916)

Like thousands of other Americans and immigrants, Watkins went West at the end of the 1840s. The future photographer was twenty-two years old when he left his native New York to seek a fortune in the California Gold Rush. But instead of gold, he found his true vocation when, in 1851, he filled in for a stricken "operator" at the San Jose photography studio of Robert Vance. Watkins then stayed on and eventually became one of the great pioneers of American landscape photography. In 1861, accompanied by a dozen mules and a darkroom wagon, he made his first trip into the Yosemite Valley. Later he took part in an expedition throughout California. Watkins specialized in landscape pictures made with mammoth glass plates measuring 15½ x 20½ inches. To exhibit them he opened the Yosemite Art Gallery in San Francisco in 1867, about the same time that he won worldwide fame by showing his photographs at the great international exhibitions. Such good fortune did not last, for as he grew older Watkins became blind, and in 1906 the San Francisco earthquake and fire destroyed his studio, plates, and file of prints. Watkins' work, its quality and originality, would not be rediscovered until after 1945. Albums containing prints made by the master himself are now extremely rare and very expensive.

Bibliography

Allen, Charles. *Raj: A Scrapbook of British India: 1877–1947* (265 illustrations). London, André Deutsch, 1977.

Andrews, Ralph W. *Photographers of the Frontier West: Their Lives and Works: 1875–1915* (242 illustrations). New York, Bonanza, 1965.

Baier, Wolfgang. *Geschichte der Fotografie* (313 illustrations). Munich, Schirmer-Mosel, 1977.

Bartlett, Richard A. *Great Surveys of the American West* (40 illustrations). Norman, Okla., University of Oklahoma Press, 1962.

Beers, Burton F. *China in Old Photographs: 1860–1910* (166 illustrations). New York, Charles Scribner's Sons, 1978.

Bernard, Bruce. *The Sunday Times Book of Photodiscovery: A Century of Extraordinary Images: 1840–1940* (214 illustrations). London, Thames and Hudson, 1980.

Brown, Mark H., and William R. Felton. *The Frontier Years: L.A. Huffman, Photographer of the Plains* (125 illustrations). New York, Bramhall House, 1955.

Brown, Mark H., and William R. Felton. *Before Barbed Wire: L.A. Huffman: Photographer on Horseback* (124 illustrations). New York, Bramhall House, 1956.

Buckland, Gail. *First Photographs: Peoples, Places, and Phenomena as Captured for the First Time by the Camera* (248 illustrations). New York, Macmillan Publishing Co., 1980.

Buckland, Gail. *Reality Recorded: Early Documentary Photography* (205 illustrations). Greenwich, Conn., New York Graphic Society, 1974.

Bull, Deborah, and Donald Lorimer. *Up the Nile: A Photographic Excursion: Egypt 1839–1898* (132 illustrations). New York, Clarkson N. Potter, 1979.

Caldwell, Genoa, and Irving Wallace. *The Man Who Photographed the World: Burton Holmes Travelogues: 1886–1938* (340 illustrations). New York, Harry N. Abrams, 1977.

Capa, Cornel, and Weston J. Naef. *Behind the Great Wall of China: Photographs from 1870 to the Present* (110 illustrations). New York, Metropolitan Museum of Art, 1972.

Coke, Van Deren. *One Hundred Years of Photographic History* (110 illustrations). Albuquerque, N.M., University of New Mexico Press, 1975.

Driggs, Howard. *The Old West Speaks: Water-Color Paintings by William Henry Jackson* (68 illustrations). New York, Bonanza, 1956.

Edkins, Diana. *Landscape and Discovery* (15 illustrations). Hempstead, N.Y., Hofstra University, 1973.

Fabian, Rainer. *Die Fotografie als Dokument und Fälschung* (185 illustrations). Munich, Verlag Kurt Desch, 1976.

Fagan, Brian M. *The Rape of the Nile.* New York, Charles Scribner's Sons, 1975.

Fagan, Brian M. *Comparative Photography: A Century of Change in Egypt and Israel: Photographs by Francis Frith and Jane Reese Williams* (46 illustrations). Carmel, Calif., The Friends of Photography, 1979.

Featherstone, David, and Russ Anderson. *Carleton E. Watkins: Photographs of the Columbia River and Oregon* (51 illustrations). Carmel, Calif., The Friends of Photography, 1979.

Ferrez, Gilberto, and Weston J. Naef. *Pioneer Photographers of Brazil: 1840–1920* (115 illustrations). New York, Center of Inter-American Relations, 1976.

Fowler, Don. D. *"Photographed All the Best Scenery": Jack Hiller's Diary of the Powell Expedition: 1871–1875* (53 illustrations). Salt Lake City, Utah, University of Utah Press, 1972.

Gernsheim, Alison and Helmut. *A Concise History of Photography* (285 illustrations). London, Thames and Hudson, 1965.

Goetzmann, William H. *Exploration and Empire: The Explorer and the Scientist in the Winning of the American West* (166 illustrations). New York, Alfred A. Knopf, 1966.

Goodrich, L. Carrington, and Nigel Cameron. *The Face of China: 1860–1912* (152 illustrations). New York, Aperture, 1978.

Haaften, Julia van, and Jon E. Manchip White. *Francis Frith: Egypt and the Holy Land in History Photographs* (77 illustrations). New York, Dover Publications, 1980.

Hershkowitz, Robert. *The British Photographer Abroad: The First Thirty Years* (86 illustrations). London, Robert Hershkowitz, 1980.

Horan, James D. *The Great American West: A Pictorial History from Coronado to the Last Frontier* (1,150 illustrations). New York, Crown Publishers, 1959.

Horan, James D. *Timothy O'Sullivan, America's Forgotten Photographer* (413 illustrations). New York, Bonanza Books, 1966.

Jackson, Clarence S. *Picture Maker of the Old West: William H. Jackson* (393 illustrations). New York, Charles Scribner's Sons, 1947.

Jackson, William Henry. *Time Exposure* (61 illustrations). New York, G.P. Putnam's Sons, 1940.

Jammes, André and Marie-Thérèse. *En Egypte au temps de Flaubert: 1830–1860* (8 illustrations). Paris, Kodak-Pathé, 1980.

Jensen, Oliver, and Joan Paterson Kerr. *American Album* (225 illustrations). New York, American Heritage Publishing/ Ballantine Books, 1970.

Kossoy, Boris. *Origens e Expansão da Fotografia no Brasil: Século XIX* (94 illustrations). Rio de Janeiro, Edição Funarte, 1980.

MacDonnall, Kevin. *Eadweard Muybridge: The Man Who Invented the Moving Picture* (148 illustrations). London, Weidenfeld and Nicolson, 1972.

Mangan, Terry W. *Colorado on Glass: Colorado's First Half-Century as Seen by the Camera* (585 illustrations). Silverton, Col., Sundance Publications, 1975.

Miller, Helen Markley. *Lens on the West: The Story of William Henry Jackson.* Garden City, N.Y., Doubleday, 1966.

Morgan, Murray. *One Man's Gold Rush: A Klondike Album: Photographs by E.A. Hegg* (119 illustrations). Seattle, Wash., and London, University of Washington Press, 1967.

Naef, Weston J. *Early Photographers in Egypt and the Holy Land: 1849–1870.* New York, Metropolitan Museum of Art, 1973.

Naef, Weston J., and James N. Wood. *Era of Exploration: The Rise of Landscape Photography in the American West: 1860–1885* (314 illustrations). New York, Metropolitan Museum of Art, 1975.

Newhall, Beaumont. *The History of Photography from 1839 to the Present Day* (210 illustrations). New York, Museum of Modern Art, 1964.

Newhall, Beaumont and Nancy. *T.H. O'Sullivan: Photographer* (40 illustrations). Rochester, N.Y., George Eastman House, 1968.

Newhall, Beaumont, and Diana E. Edkins. *William H. Jackson* (100 illustrations). Dobbs Ferry, N.Y., Morgan & Morgan, 1974.

Oettermann, Stephan. *Das Panorama: Die Geschichte eines Massenmediums* (203 illustrations). Frankfurt, Syndicat Autoren-u. Verlagsgesellschaft, 1980.

Phillips, David R. *The West: An American Experience* (214 illustrations). Chicago, Henry Regnery, 1973.

Photography: The First Eighty Years (298 illustrations). London, P. & D. Colnaghi & Co., 1976.

Pollack, Peter. *The Picture History of Photography: From the Earliest Beginnings to the Present Day.* (624 illustrations). New York, Harry N. Abrams, 1969 (rev. ed.).

Scharf, Aaron. *Pioneers of Photography* (170 illustrations). New York, Harry N. Abrams, 1976.

Schöttle, Hugo. *DuMont's Lexikon der Fotografie: Foto-Technik–Foto-Kunst–Foto-Design* (186 illustrations). Cologne, DuMont, 1978.

Schreiber, Hermann. *Die Welt in einem Augenblick* (57 illustrations). Tübingen and Basel, Horst Erdmann Verlag, 1969.

Sembach, Klaus-Jürgen. *Amerikanische Landschaftsphotographie: 1860–1978: Eine Ausstellung de Neuen Sammlung München* (53 illustrations). Munich, Neue Sammlung, 1978.

Skopec, Rudolf. *Photographie im Wandel der Zeiten* (1,018 illustrations). Prague, Artia, 1964.

Smithsonian Institution. *The American Land* (349 illustrations). Washington, D.C., 1979.

Steegmuller, Francis. *Flaubert in Egypt: 1821–1880.* London and Boston, Atlantic-Little, Brown, 1972.

Stenger, Erich. *The March of Photography* (159 illustrations). London and New York, Focal Press, 1958.

Taft, Robert. *Photography and the American Scene: A Social History: 1839–1889* (316 illustrations). New York, Dover Publications, 1964.

Tausk, Peter. *Die Geschichte der Fotografie im 20. Jahrhundert, Von der Kunstfotografie bis zum Bildjournalismus* (235 illustrations). Cologne, DuMont Buchverlag, 1977.

Time-Life Books. *Travel Photography* (163 illustrations). New York/Amsterdam, 1972–73.

Truettner, William H. *National Parks and the American Landscape: Catalogue of the National Collection of Fine Arts.* Washington, D.C., Smithsonian Institution, 1972.

Warner, John. *China, the Land and Its People: Early Photographs by John Thomson* (142 illustrations). Hong Kong, John Warner Publications, 1977.

Welling, William. *Photography in America: The Formative Years: 1839–1900: A Documentary History.* New York, Crowell, 1978.

Wiegand, Wilfried. *Frühzeit der Fotografie: 1826–1890* (185 illustrations). Frankfurt, Societäts-Verlag, 1980.

Worswick, Clark. *Princely India: Photographs by Raja Deen Dayal: 1884–1910.* (124 illustrations). New York, Pennwick Publishing, 1980.

Worswick, Clark. *Japan: Photographs: 1854–1905* (113 illustrations). New York, Pennwick Publishing and Alfred A. Knopf, 1979.

Worswick, Clark, and Jonathan Spence. *Imperial China: Photographs: 1850–1912* (134 illustrations). New York, Pennwick Publishing, 1978.

Worswick, Clark, and Ainslie Embree. *The Last Empire: Photography in British India: 1855–1911* (159 illustrations). New York, Aperture, 1976.

Picture Credits